MB Moley

THE PHOTOGRAPHER'S
DIGITAL STUDIO

Transferring Your Photos Into Pixels

By Joe Farace

D0073974

LightSpeed Publishing
Glen Ellen, California

Peachpit Press
Berkeley, California

The Photographer's Digital Studio

Joe Farace

Peachpit Press

2414 Sixth Street
Berkeley, CA 94710
510/548-4393
800/283-9444
510/548-5991 (fax)

Find us on the World Wide Web at:
http://www.peachpit.com

Peachpit Press is a division of Addison-Wesley Publishing Company.

Copyright © 1996 by Joe Farace

Editor: Scott Calamar
Cover design and Cover illustration: TMA Ted Mader Associates
Interior design and Production: Michele Cuneo

Notice of Rights

Notice of Liability

ISBN 0-201-88400-3

9 8 7 6 5 4 3 2 1

Printed and bound in the United States of America.

Dedication

This book is dedicated to the memory of Ernie Mau, former editor of *CompuServe* magazine's review section. He helped me become involved with computers when I was still writing with a Smith-Corona electric typewriter. Although he's been gone for over five years, a day does not go by that I don't think of him. I'm sorry he isn't around to see this book published.

Acknowledgments

A book like this cannot be done without the assistance of many people, and while there are many people who helped, several people deserve special attention.

Vern Prime is an experienced camera repair person as well as the most technically knowledgeable person about IBM-PC and compatible computers that I've ever met. Another friend who was a source of inspiration and infor-

mation is Barry Staver, a *People* magazine photographer and fellow digital imager who gave me many imaging tips from the "real world." Kevin Elliott of Cies Sexton Photographics provided similar grounding on the best way for photographers to work with service bureaus and has, over the years, been a source of help in my personal and professional photography.

I am grateful for the assistance of Nancy Napurski of Epson America, who has been a great help to me with this and other digital imaging projects. The same is true of Mark Strobel of Fargo Electronics, who introduced me to what can be done with dye-sublimation printers. Special thanks to Sonya Shaefer of Adobe Systems for keeping me current on information about Adobe Photoshop. A big thank you goes out to Kristin Keyes of MetaTools, publishers of Kai's Power Tools. I would also like to thank Chip Partner of Saphar and Associates for keeping me up-to-date with the latest developments in Kodak's Photo CD system.

I would also like to thank three individuals, without whom this book would never have been published. A big "thank you" goes to Peachpit Press publisher Ted Nace who believed in me enough to give me a chance to write about digital imaging for photographers. Similarly, LightSpeed Publishing's Scott Calamar and Joel Fugazzotto worked with me to translate my thoughts and ideas into what you're holding in your hands. It was Scott's insistence on including the many hands-on sections that, I believe, make this book more useful than it might have otherwise been. And Joel's design supervision make the book look better than I would have thought possible.

Last, I would like to thank my wife, Mary, for her encouragement in this project, my fine art photography, and my life. I would not be half the writer, photographer, and human being without her love and support.

All of these wonderful folks are responsible for the good things you will find between the covers of this book. Any errors and omissions you find are all mine.

Table of Contents

Part IV Output 251

INTRODUCTION

 ## Taking the Next Step

 This book is designed for those amateur and professional photographers who, having mastered the many and different aspects of conventional photography, would like to explore the brave new world of digital imaging.

 The Photographer's Digital Studio has been written for people who already know how to create images using conventional photographic equipment and techniques, but may not be familiar with their digital equivalents. For some, moving from silver-based to digital imaging can be intimidating because it involves learning how to use a completely new set of tools. In recent years, there have been major advances in camera technology, but most of these changes have been evolutionary—not revolutionary. Yet photographers easily accepted auto-focus, multi-mode, auto exposure cameras controlled with liquid crystal display panels. Becoming a digital

photographer, or *pixographer*, involves using a computer in ways quite different from balancing your checkbook or playing DOOM. For some shooters this transition will not be a challenge, and for those less familiar with computers, it can be intimidating. It is to this group that this book is dedicated.

What is digital imaging anyway? First, it's not something that's totally new. Digital imaging is simply an extension of the same kind of camera and darkroom techniques photographers have been using for over a century. The tools may seem different, but they are no more of a radical change than turn-of-the-century daguerreotypists encountered when switching to glass plate negatives.

Digital imaging is simply a process that converts photographs into their mathematical equivalents in much the same way that conventional photography converts silver grains into snapshots. There are totally digital methods for creating photographs and they will be examined briefly, but the book's main focus is on using the same cameras, lenses, and film you already own and using your computer system as an electronic darkroom. That why it's titled *The Photographer's Digital Studio*. The digital photographs shown in this book, with few exceptions, had their origins as film exposed to light with conventional 35mm single lens reflex cameras. And while some digital images may appear unrealistic, even fantastic in nature, you can use the same techniques to produce images that appear completely natural but are quite different from what you originally saw in your viewfinder. Since creating both kinds of images can be fun, both ways of working with digital imaging will be explored within these covers.

Is It Real or Digital?

This next statement may come as a surprise: Not all images can be successfully manipulated. Just as with conventional silver-based images, almost all digital photographs can be improved by increasing their sharpness, contrast, and cropping, but the better the photograph is, the less you can do with it digitally. Truly great photographs can almost never be improved—digitally or otherwise. Imagine, if you will, manipulating W. Eugene Smith's "Walk to Paradise Garden" or Arnold Newman's "Portrait of Stravinsky." I don't think so.

Fortunately, while many of us aspire to the level of these two masters, most of us will never make it. This means that our photographs *can* be

improved and enhanced by digital manipulation. The photographs that benefit the most from digital imaging techniques are those that start out as mundane but, after being digitized and even combined with other, seemingly ordinary snapshots, can be combined into a single dramatic photograph. It is often these less-than-successful photographs that make the transition from boring to striking. The other category of successful digital images are those that were conceived from the very beginning—previsualized—to integrate digital elements to achieve the photographer's vision.

Computing for Photographers

My goal is to keep all of this information light. I want to make sure this book is easy to read for everyday people, not just technical gurus. I think digital imaging, like photography itself, should be fun. To that end, I'll try to keep the use of buzzwords to a minimum, but acronyms and technical terms are unavoidable, just as they are in any technical description of traditional photographic techniques. Where possible, I'll relate how computers handle digital images to the way a camera works with silver-based ones. A Glossary of Terms is also included.

The emphasis of *The Photographer's Digital Studio* will be on assembling the kind of computer tools a pixographer needs and explaining why you need them. There are many kinds of computers. There are supercomputers made by companies like Cray, used by NASA and the military to perform calculations at speeds so fast they're almost impossible to measure. And there are specialized computers, like models from Silicon Graphics, that create digital effects for movies and TV shows like *Babylon 5*. But that's not what this book is about. It's about the kind of computers the average photographer can purchase at his or her local Circuit City, Best Buy, or CompUSA store. Consequently, this book will focus on hardware and software solutions available for Macintosh and Windows-based computers. Along the way there will also be plenty of real-world tips and road maps showing ways around the pitfalls that await unsuspecting digital imagers.

The Photographer's Digital Studio starts at the beginning and assumes you either already have a computer or are thinking about buying one. I've also assumed that you understand conventional photographic concepts and darkroom techniques but not how computers deal with images. That's why

the first part of the book prepares you to understand how silver images become digital ones by comparing your computer to a digital darkroom. Since the requirements for digital imaging are different from word processing, you may need to upgrade your computer system to meet photographic specifications or purchase a new computer to help you properly get started in digital photography or *pixography*. The rest of the book provides the information you need to assemble a computer system that produces the kind of images you want to create.

Part I of this book is called Computers for Photographers. It looks at how digital images are constructed and what concepts and equipment are needed to effectively work with photographs on a computer. If silver grains form the basis upon which conventional photography technology is built, it is *pixels*, or picture elements, that are the basic building blocks of digital images. To work with hardware that uses pixels instead of silver grains to produce photographs, you'll need to understand the relationship between pixels and computers. Computer systems, like camera systems, are composed of different, complementary parts that function together to achieve a single goal. In the case of your camera system, that objective is the creation of exciting images. Your digital imaging computer has the same goal. This section will introduce photographers to the basics of how computers work with digital images and why certain components are required to create digital photographs. If you're already comfortable with computer basics, feel free to skip this section and start reading Part II.

Part II is called Image Acquisition. Digital photographers don't *shoot* photographs, they *acquire* images, and there are three ways this can be accomplished. Making a photograph with a digital camera may seem like the easiest way to produce a digital image, but there are limitations to this approach. Part II will look at digital and video cameras and compare the ease of use and results obtained from them versus using scanning technology and Kodak's Photo CD process. This section will also look at the film and print scanners and other equipment needed to convert existing silver-based images into digital form

Part III focuses on Image Manipulation and Enhancement. Of all the different aspects of digital imaging, image enhancement has generated the most interest and excitement—probably because that's where most of the fun is. You can use image enhancement and manipulation techniques to improve

and change images much as you would accomplish similar effects in a traditional darkroom, but in a digital darkroom you don't have to work in the dark or get your hands wet. And more often than not, achieving dramatic effects is easier to produce digitally than working with paper and chemicals.

Part IV covers Output. Image output is one of the least talked about elements, yet it is the final aspect of the digital imaging process. Output can be displayed in many different forms: An image can be viewed on a screen or transferred to other computers in digital form. To print your images directly from your computer, you can use the growing number of inexpensive color printers from companies like Epson, Fargo, and Hewlett-Packard. Another alternative is to output your image to a color laser copier. Images can also be converted back into a silver-based form or, you can reverse the process from digital to analog and have your digital image output as film. Once back into silver-based form, you're free to use this new image to project or make prints in a traditional manner.

A Few Final Thoughts

I have made every effort to ensure I covered the most useful photo-related hardware and software products currently available, but there may be several reasons why your favorites may not appear.

It may be too new. If the last generation of personal computing belonged to the desktop publishers, the next one belongs to digital photographers. This trend has caused a tsunami of imaging products for Macintosh and Windows computers. With new products and new versions of products being announced daily, it's possible I could have missed one or two brand-new products.

I may not have heard of it. For the reasons just stated, keeping track of new products can become overwhelming, and I might easily overlook a few. If I missed one of your favorites, I'm sorry and will try to include it in the next edition.

It may be too expensive. It's my intention that all the products that appear inside these pages will be affordable for the amateur, aspiring professional, and working pro on a budget. While some space will be given to digital cameras that cost over $10,000, their inclusion is more by way of a comparison to converting analog images into digital form.

The manufacturer or publisher may not want to cooperate. It's been my experience that computer companies are much like the people you meet every day; some of them will go out of their way to help you, and others won't give you time of day. Fortunately, there are plenty of heroes too, and they'll be mentioned in the appropriate sections.

One Last Thing

Photography is an uneasy alliance of science and art, and photographers sometimes become more interested in the technology than the images. This pursuit can translate itself into the search for perfect optics or chemistry to produce "the ultimate image." Unfortunately, the kind of "absolute truths" present in conventional photography are not so straightforward in digital imaging. Digital imaging has changed more in the last five years than photography has changed in the past 150. The best product or technique to accomplish a photographic effect today may be obsolete tomorrow. I ask only that you not be frustrated by this uncertainty but instead look at the digital imaging process as a journey of exploration, learning new things every day.

The products mentioned in these pages represent those that I have worked with on a daily basis, but what I'm using one day may be different the next. For that reason any products mentioned represent what Joe Farace uses and in no way is considered an endorsement by Addison-Wesley, Peachpit Press, or LightSpeed Publishing. Product shots were provided by the manufacturers but most of the original photographs and all of the screen shots were made by me and are © Joe Farace. Some photographs, however, were from Corel's library of stock images on Photo CD. When Corel images from are use, the disc is identified in the body test or photo caption.

PART

I

P A R T I

COMPUTERS FOR PHOTOGRAPHERS

The tools photographers use to create images have changed greatly over the past 150 years. So it should come as no great surprise to any student of photographic history that they are changing again.

Like any change, there are those that are resistant and want to keep doing things the same way they have. Luckily photography has a "big tent" and accommodates traditionalists as well as those who are interested in what digital imaging technology can do for them. This book has been written for the "others," those who want to find new ways and new directions for producing creative images.

One impediment to working with digital imaging tools is that many of them are computer-based. Studies from Eastman Kodak show that photography is, largely, an "uncomputerized" profession. This lack of computer experience and knowledge is part of the reason digital imaging has been slow to catch on with some pros and amateurs.

This section of the book has been designed to introduce you to the equipment and accessories you will need to use—and understand—in order to achieve the same level of photographic skill you currently have using traditional methods. In the next two chapters, you will find a sampling of the kind of computer tools that, I believe, will change the face of photography as we know it.

PIXOGRAPHY

Pixel Power

As a well-equipped photographer you probably own a camera bag stuffed with lenses and accessories and more often than not, a darkroom full of equipment, chemicals, and paper. Over the years you've carefully accumulated all of these tools for one purpose—to produce the best possible photographs. Your computer is a digital combination of camera and darkroom that allows you to create exciting images in new, as yet unexplored ways. Like many contemporary cameras, there are two main functional ingredients in a computer system: hardware and software. One is useless without the other. Hardware is the physical (hard) combination of components that lets a computer compute—it's the actual, physical computing machinery. Software is the (soft) list of instructions that enables hardware to function as it was designed. On a modern camera, for example, the LCD display panel on top that shows aperture and shutter speed is part

of the camera's hardware, but it's the camera's software that tells that display what F-stop the lens is set on and what shutter speed has been selected.

There are two general classes of small computers: Those built to the IBM standard and those that comply with the Apple Macintosh standard. IBM called its first personal computer the PC, but this term has fallen into general use to identify any computer that meets the specifications originally set by International Business Machines. Sometimes, you will hear non-IBM PCs called clones although this term has fallen out of favor as companies, such as Compaq Computer, sell more PCs than IBM. More often, these computers are called IBM-compatibles or just PC-compatibles. This year will see the first Macintosh clones being built by several companies that have licensed Apple's technology. They are forbidden by their licenses to call these computers "Macintosh," so it will be interesting to hear what term gets accepted as Mac-compatible.

Because they represent all data (including photographs) by using numbers or digits, computers are digital devices. These digits are measured in *bits* or binary digits. Binary is a mathematical system based on working with the numbers one and zero. This is an ideal method for computers because electrical signals can be represented by electrical current being positive and negative—or on and off. Each electronic signal therefore becomes one bit, but to represent more complex numbers or images, computers must combine these signals into larger 8-bit groups called bytes. When 1024 bytes are combined, you get a kilobyte, often called just "K." When you combine 1024 Kilobytes to produce a number or picture, you have a megabyte (MB) or meg. These days it's possible to see some relationships that use a billion bytes or a gigabyte of data.

If you look closely enough at any photograph, you will see silver grains. Isn't that what Antonioni's film *Blow-Up* is all about? When the hero enlarges the photo he made in the park to mural-sized proportions, he is unable to tell if the object he is looking at is a gun or several pieces of silver grain. If you could look closely enough at a photograph on a computer screen, you would see the digital equivalent of grains—*pixels*, or picture elements. A computer screen is made up of many thousands of pixels, and pixels appear in clusters or triads. Each pixel is actually a combination of three colored dots placed close to one another. On the screen, combinations of these pixels produce the colors you see. A triad contains three dots, one each for red, blue, and green. In case you're wondering, that's why

computer monitors are often prefixed with the letters RGB. In a typical RGB monitor, three electronic "guns" fire three separate signals (one for each color) at the screen. If all three guns hit a single pixel's location, it will appear white on the screen. If none of the guns hits a target pixel, it will be black.

The location and color of each pixel is also controlled by your computer. The number of bits of data associated with each pixel determines the visual quality of your photograph and is measured as *bit depth*. Bit depth refers to the number of bits assigned to each pixel. Let's look at the typical choices in bit depth for computer screens:

- **1-bit:** If a computer has the ability to display 1 bit per pixel, each pixel can either be black or white. This is called a monochrome system, and these monitors are usually sharper and emit less radiation than color models.

- **4-bit:** Some computers, especially laptops, offer 4-bit video capability, which translates into 16 shades of gray or color.

- **8-bit:** Essentially the standard display for today's computers. With an 8-bit color depth, you can see 256 colors or levels of gray. An 8-bit system can work well for black & white photographs, but is just barely adequate for critical evaluation of a color photograph. Images on an 8-bit system will not be displayed 100 percent accurately, and photographs will look posterized and consequently, less realistic.

- **16-bit:** Fast becoming a new minimum standard and has the potential to display 32,000 different colors. At 16 bits and above the video signal must be split into thirds providing one each for the red, blue, and green channels. Your computer devotes 15 bits to color (5 bits per color channel), and the one remaining bit is used to overlay all these colors. In practice, you get 32,768 colors and when fewer colors are displayed, another color is substituted for the "correct" one. This shows up on screen as a slightly posterized image.

- **24-bit:** Each pixel on a screen can handle up to 256 colors, which lets systems display 16.7 million colors. A 24-bit model provides true photographic quality.

■ 32-bit: Often when someone is talking about 32-bit color they really mean 24-bit. Only a few computers offer 32-bit capabilities. Typically they allocate one byte (8 bits) for each of the primary colors and the final byte to display images from sources such as videotape. The additional byte adds functionality but not more colors.

Since 256 levels of gray are displayed on an 8-bit system, that's all you really need when working with black and white digital photographs, but if you plan on working with color images, you should use a computer that has a 24-bit display. Some devices, including digital cameras, are capable of higher color depths up to 42 bits (14 bits per pixel) for greater color fidelity, and these will be covered in Chapter 3.

▖ RGB & CMYK Color

If you've ever made Type R prints from slides in your own darkroom, you're already familiar with working with the *additive* color filters of red, blue, and green used by computers. If so, the RGB setup used by computer monitors should make perfect sense to you. If not, the concept is built around how different colors of light blend together.

The primary additive colors of red, blue, and green, when added together, produce white light. In the areas that they overlap, red and blue form magenta, green and red produce yellow, and green and blue create cyan. These resulting colors are *subtractive,* and filters using varying intensities of the colors are used when making Type C prints from color negatives. When the subtractive colors are added together they form not black, but a dark brown. That's why black must be added and why four-color process uses cyan, magenta, yellow, and blacK for accurate photographic reproduction.

Fortunately, darkroom workers who make prints from color negatives don't have to bother with "K" or black filters to produce prints. For magazine reproduction, an image must be separated into varying percentages of cyan, magenta, yellow, and black, which is why CMYK film output are called "separations." Most comprehensive digital imaging programs can produce color separations directly from within the program, eliminating another generation in the reproduction process. Computer printers also use CMYK dyes and inks to produce accurate, photographic-quality prints.

All output devices, including monitors, are measured by resolution. Pixel resolution measures the total number of dots of light on a monitor and ultimately determines the on-screen quality of that image. A digital photograph's *resolution*, or image quality, is measured by an image's width and height in pixels. When a slide or negative is converted from silver grain into pixels the resulting digital image can be made at different resolutions. The higher the resolution of an image—the more pixels it has—the better the visual quality. An image with a resolution of 2048x3072 pixels has better resolution and more photographic quality than the same image digitized at 128x192 pixels. At lower resolutions, digital photographs often have a coarse, grainy appearance that make it difficult to evaluate an image when looking at it on screen. Unfortunately, a rule of thumb is that as the resolution of a device increases, so does its cost.

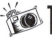 The Need for Speed

Let's face it, most of us are hardware snobs—that's part of what makes us photographers—who would like to see the choice of which platform to use boil down to the microchip or *CPU*, Central Processing Unit, inside the computer. The decision of which hardware to use is related more to the overall processing power of the computer than the kind of silicon it's made of. All cameras use the same kind of photo/optical engineering, and you can make great photographs with an old Nikon F or a brand-new N90s. But pixographers need to have enough computing power to handle the kind of images they will be working with. Shooting wildlife or sports photography is possible with a 50mm lens, but the photographic experience will be much better—and less frustrating—when armed with a 400 or 800mm lens. Choosing the right computer is a matter of finding one with enough power to process digital images to minimize frustration, and expediting creativity by processing that data as fast as possible.

Like a camera body, the computer's case is the box that contains all the other components of the system. Cases come in a variety of shapes from a flat "pizza box" to a vertical "mini-tower." Both of these cases look exactly how they sound. The difference in case size and shape is important because it indicates how many accessories can be housed inside of them. Regardless of how big or small a case is, there are certain components they must hold. If you open the case, the largest item you will see is the motherboard, or as

Apple Computer prefers, logic board. The motherboard is a flat, thin printed circuit board that holds other components which are either soldered or plugged into it. The most important component on the motherboard is the CPU. The CPU is the device that really runs your computer. There are two basic families of CPUs: Intel and Motorola. There are alternative microprocessor chips to Intel but they all follow Intel's standard. How well any chip processes data is determined by how many bits of information it can process at one time. The larger the number of bits it can simultaneously process, the faster it can process your data. Think of it as a highway. The more lanes you provide, the more cars can travel on it at one time. A 32-bit CPU, for example, processes data twice as fast as a 16-bit model.

To help identify the different classes, computer chips have numbers or (lately) names to identify them. When someone refers to a "386," it's usually an Intel 80386 32-bit computer chip. Intel followed the 386 chip with a 486 and later a 586, which they named Pentium, both of which are significantly faster than the 386 chip. Apple Computer's chips are made by Motorola, and their 32-bit equivalent to the 386 chip is called 68030 or just "030." Apple's faster chips are the 040 and PowerPC, which competes for raw processing power with Intel's Pentium. Besides the number of bits it can process at one time, the most important aspect of the CPU is how fast it can process. This is measured by the CPU's clock speed. You'll be able to

FIGURE 1-1:
The computer's motherboard is the basic building block for an electronic darkroom. This is a Micronics motherboard for an IBM-PC compatible computer. The large socket marked "Intel" is where an Intel CPU chip would be inserted. The four white plastic and metal strips in the lower right-hand corner are SIMM slots to hold the computer's memory. (Photograph courtesy Micronics)

spot the clock on the motherboard, because it looks like a miniature sardine can. Clock speed is measured in megahertz (MHz) or thousands of cycles per second. The faster the clock speed, the faster the CPU can process data. Therefore if you see a computer labeled 486/50, you know it has a 486 CPU running at a clock speed of 50 MHz. Until recently, Apple has hidden the clock speed of its computers. If you see a Power Mac 8100/100, you know that the last number refers to clock speed, but you'll need an Apple catalog to know that the 8100 designation is used for their top-of-the-line computer using the PowerPC chip developed jointly with IBM and Motorola.

Processing speed is extremely important to digital photographers. It's like shooting photographs under low light conditions. Under these difficult lighting situations, you'll usually switch to films with a faster ISO speed so you can capture images more easily. The speed of the CPU is equally important when manipulating digital images because of the large number of bits that make up a digital image. While slower microprocessors can work, expect (as the traffic reporters say) delays. These processing delays can vary from annoying to maddening depending on what you are doing with the image. No matter which kind of computer you decide to use, you should get one with the fastest CPU you can afford. If you prefer an IBM-PC or compatible, you should only consider a computer with a 486 or Pentium processor, and Macintosh users should stick with models containing 68040 or Power PC chips.

Random Access Memory...

...or RAM is that part of your computer that temporarily stores all data while you are working on it. This data is volatile, which means that if you lose power or turn off your computer before saving it, the information disappears. Most contemporary motherboards, like the Micronics board in the previous illustration, feature several raised metal and plastic slots that hold RAM in the form of *SIMMs* (Single Inline Memory Modules.) A SIMM is a group of memory chips mounted on a small plastic card, and its capacity is measured in bytes, such as 1MB, 4MB, 8MB, 16MB, and 32MB. SIMM slots vary in number, and how many you have depends on the size of the case and motherboard. Some Macintosh models have only one SIMM slot, while

other Macs and PCs will have as many as eight. Although the more RAM you have the better, there are economic considerations too. Having more slots means having the ability to use more of the less expensive SIMMs, instead of fewer, more costly ones. The software that runs the computer and enables you to do digital imaging requires a minimum amount of RAM. If you don't have enough, the computer displays an error message that says, in effect, TILT. That's why you should install as much RAM as you can afford, but having less than 16MB on either a PC or Mac will create bottlenecks when working on digital photographs. An important rule of thumb when working with digital images is that you can never have too much memory.

There is a separate set of memory chips in some computers that affects pixel resolution and the number of colors displayed. On PCs this memory is contained on a separate video board. These chips are called Video Random Access Memory or VRAM. You must have enough video memory to address all the pixels on the monitor multiplied by the number of bits of color resolution per pixel. For example, an 8-bit video system displaying 256 colors requires twice as much memory as a 4-bit per pixel system displaying 16 colors at a time. Some computers allow you to expand display capability by installing VRAM SIMMs to increase color depth. Like standard memory, the more VRAM you have, the merrier.

Catch a Bus

On your computer's motherboard you'll see rows of plastic and metal strips that look as if they're designed to have something inserted into them. They are called slots, or bus slots, and they accept printed circuit cards that allow accessories or devices to be attached. There are many kinds of cards manufactured by many different companies and, depending on the type of card that is inserted in the slot, they allow your computer to accomplish different tasks. Selecting the card to do the job you want is comparable to deciding which manufacturer's 35-70mm lens you should add to your camera system. To find the right lens, you should read product reviews in magazines and talk to your friends about their experience with theirs. Do the same thing with cards.

In order for input and output devices to function they must be physically attached (by cables) to a card inserted into a slot. In the PC world, you will find 8-bit, 16-bit, and 32-bits slots and, depending on the motherboard

FIGURE 1-2:

Having enough video memory, or VRAM, lets digital photographers use 24-bit displays to see on-screen images that look like real photographs. Apple's Monitors Control Panel software allows users to set how many colors they see. The amount of colors will be determined by how much VRAM is installed.

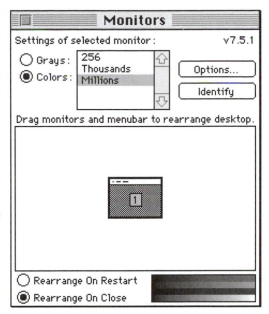

design, you will find one or two of each type of slot installed. One way to identify the different kind of slots is that as they increase from 8 to 16 to 32 bits, the slot gets longer. Inside a Macintosh you will find NuBus, PDS (Processor Direct Slot) and PCI slots. A NuBus card automatically tells the CPU what its function is, but a PDS slot is passive and is used for specific functions, like the board that allows the Macintosh to emulate the IBM-PC environment. Some cards have connectors that stick out the back of the computers. These are called *ports* and allow different external devices, like printers, to be connected to them. Often these ports are built into the motherboard, which is always the case with Macintosh computers. There are many kinds of ports and slots for both PCs and Macs. The size and number of slots determine the expandability of your computer.

For a digital photographer, the graphics display is the most important part of the computer system and consists of two parts: the graphics controller (also known as a graphics card) and the monitor. The graphics card plugs into a bus slot on the motherboard and has a port that sticks out the back of the computer's case. This video port is the place where you plug a cable

that connects the monitor to the card. Choosing the right graphics card is as important as choosing a monitor. You can buy a 24-bit board but it may be limited in the amount of colors it can display by the DRAM (Dynamic Random Access Memory) chips it has installed. Good boards have either 2 to 4MB of DRAM or room to add more. Make sure the video board you buy has enough memory or can be expanded. In Macintosh systems, the video card function is built into the motherboard, but space is provided for VRAM (Video Random Access Memory) SIMMs to expand the quality of the video display.

The slots in IBM-PC and compatible machines come in a wide variety of types. It's important to know what kinds of slots are on your motherboard so you can install the appropriate matching card. Here's a quick round-up of the types, you'll find:

- ISA: These slots are the Industry Standard Architecture type you find in almost every PC. The typical graphics card is designed for an ISA slot.

- VL bus: Stands for VESA Local Bus. VESA means Video Electronics Standard Association. This is a group of industry manufacturers who set standards for high resolution, high performance video devices. VL bus cards will not work in an ISA slot.

- PCI local bus: Personal Computer Interconnect is the faster successor to the VL bus and often will sit alongside an ISA slot on a motherboard. Until recently, PCI slots were limited to IBM and compatible machines. In their latest computers, Apple Computer has abandoned their propriety NuBus slot architecture in favor of the PCI bus. If you can't beat 'em, join 'em.

- MCA: Micro Channel Architecture is found only on some IBM brand PS/2 machines and in few others. This standard was touted by IBM as the next big thing in bus design, but not many manufacturers were as enamored of it as IBM was.

- ACCESS bus: Provides two-way communications between peripherals and the CPU. ACCESS bus eliminates the need to install complex files or drivers (more on drivers later).

- PNP: Plug & Play slots are similar to the ACCESS bus in their ability to communicate. This is the "next great standard" developed by Microsoft as part of the long-awaited Windows 95 operating system. Plug & Play slots allow the computer to recognize any card inserted into it through exchange of information. For the user this means lower setup costs, ease of use, and reduced need of technical support. Every Macintosh computer has always had plug & play capabilities but Apple Computer never bothered to give a name to this feature.

Hot and Cold Storage

Devices connected to the computer are divided into two general classes: input and output. Input devices are those pieces of hardware that allow data to be entered into the computer, and include items like a floppy disk drive. Output device are those that take information and allow it to leave your computer. The output category includes printers.

One of the most obvious devices attached to the motherboard is the floppy disk drive. Before we look at the drive, let's look at the floppy disk itself. This is a round, thin disk coated with the same kind of ferrous oxide used on audio cassette tape. The most common disks are 3.5 inches wide and are encapsulated in an almost square protective shell. A sliding gate (or shutter) in the shell opens a slot that allows the drive to read or write onto the magnetic material. The older 5.25-inch disks have a different construction, including an open slot in their shell to allow the drive to read the data on the disk. Because 3.5-inch disks are housed in a plastic shell, they don't "flop" very much. This "floppy" designation goes back to the days when 5.25-inch and 8.5-inch flexible (or floppy) disks were encased in thin paperboard shells, so they really did flop. The 3.5-inch disks used in recent Macs or PCs hold 1.44MB of data. Older versions held 720K (800K on a Mac), so the new ones have the designation "High Density." Since photographic image files are usually quite large, they seldom fit on a single floppy disk. One exception to this rule is the Pictures on Disk service offered by Seattle FilmWorks that will be covered later in the book. The floppy drive is both an input and output device and is connected to the motherboard. Inside the drive is a read/write head that looks much like the arm of a phonograph turntable, except that instead of being fixed, it can move in

and out to find data or write data onto the disk. (Of course phonograph arms did not write—except those in arcades!)

A computer's hard disk falls into the category of *storage*, rather than being considered an input or output device. Data, including photographs, are stored there until you need to access them (as opposed to floppy disks, or other removable media). A hard disk consists of a single or multiple rigid (hard), non-flexible disks. Like the floppy drive, it has a read/write head or multiple heads on multi-disk drives. Once data is written to it, you can think of your hard drive as a file cabinet that holds all the data inside your computer. Like a file cabinet, you can access this data whenever you want and it's still there after you shut the computer down. The capacity of hard disks is measured in megabytes, but unlike the 1.44MB that's standard for floppy disks, hard drives come in many different and larger sizes. Any computer you will buy will already have a floppy drive and hard disk installed, and until you outgrow the hard drive (which will be sooner than you think) you won't have to worry about replacing it. In the early days of personal computing, a 20MB drive was standard, but this quickly changed to 100MB, and now anything smaller than 500MB is unacceptable for digital imaging. Fortunately, prices of hard disks have dropped as fast as the need for greater capacity has grown.

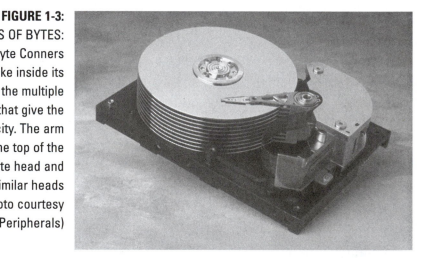

FIGURE 1-3:
BILLIONS OF BYTES:
This what a 4-Gigabyte Conners hard drive looks like inside its case. You can see the multiple disks (platters) that give the drive its large capacity. The arm extending over the top of the drive is the read/write head and there are similar heads beneath it. (Photo courtesy Conners Peripherals)

Motor Drives

Hard drives are often called fixed drives—and for good reason. They are a fixed size. But what happens when you outgrow the hard disk that came with your computer? Studies have show shown that new computer owners typically replace their hard disks within the first six months of owning their Macintosh or Windows machine. If you already have a large enough hard disk (500MB or larger), the best solution may be a *removable media drive*. Removable media drives are those computer peripherals that use cartridges that can be easily removed from the drive and have many advantages for computer users, especially digital photographers. Here are a few of the most common reasons for wanting a removable media drive:

- Back-ups: If you don't know what a computer crash is, eventually you're going to find out. The read/write heads on a hard disk float a microscopic distance above a hard disk's platter. Misalignment, dust, and grime can cause that head to "crash" into the disk's surface. When that happens, it is possible that all or some of your data will be lost. One way to protect yourself is by copying all of that data onto removable media and storing it away from your computer. You can then use the removable media to restore your original data. Back-ups are a cheap form of insurance and removable media drives make backing up less of a chore than copying the contents of your hard disk onto 100 or more floppy disks.

- Portability: There will come a time when you want to take an 85MB photographic file and have turn it into a negative or transparency. While there are methods that allow you to transfer the contents of your photographic file across 10 or 20 floppy disks, that's clearly not the best way to accomplish your goal. Removable media drives have the storage capacity to hold one or more large files. You can take the cartridge to the service bureau and leave it with them while they turn digital data into silver images.

- Expandability: You can have many different cartridges for one drive, and even create special cartridges for special purposes. You can have one that holds all your financial records, as well as others that

contain digital images. The financial data cartridge can be stored in a safe deposit box adding to its security. There are many, many uses in the area of expandability, but there is one major theme: a removable media drive is a hard disk you can't fill up.

Removable media drives are available in two basic types:

- Magneto-Optical (often called just plain optical): Data storage devices that write data to a disc using both magnetism and light (in the form of a laser beam). Disadvantages: They're expensive and are typically slower than today's hard disks.

- Magnetic: Removable disks originally developed by IBM that place the read/write head (identical to that on a hard disk) and disk platter inside a sealed cartridge. By keeping head and disk intact, greater speed and capacity was achieved. This type of drive was originally called "Winchester," but this term is now used to refer to any fixed hard disk.

Removable Disc or Removable Disk?

Optical (laser-based) discs use technology so that when an image or file is recorded onto a disc, a laser beam cuts or melts small indentations into its surface. On the playback side, a typical drive uses a similar laser to read those dents and translates them into data—or photographs. The round, flat objects using laser technology are properly called *discs*.

Magnetic media drives, on the other hand, use the same technology floppy disks have used since they were introduced. A disk is coated with magnetic material and a read/write head records the files or images onto this platter. On playback, the same kind of head reads the magnetically encoded data and displays the files on your monitor. These round objects are properly called *disks*.

Optical drives are available from many different manufacturers. Companies like Pinnacle Micro market mid-size removable drives based on optical technology. Their Tahoe 3.5-inch optical drive is a fully writable optical drive that can also read and write older 128MB discs. Its average seek time (the time it takes to find a file the computer has asked for) is about double that of a removable magnetic drive but the cartridges cost about half as much. Unfortunately, the drives are more expensive than equivalently-sized magnetic drives. For larger capacity storage, optical media drives really shine. Pinnacle also offers a 1.3GB optical drive that's bigger than any other removable drive. With an access time of 19ms, it's almost as fast as a magnetic drive. For storing large amount of photographic image data, the Pinnacle 1.3GB drive has no comparison.

No doubt, the most popular cartridge magnetic drives are from SyQuest Corporation, which has over 90 percent of the removable magnetic market. SyQuest drives use off-the-shelf hard disk components housed in a proprietary plastic shell. The advantages are that the drives are almost as fast as the fastest hard drives and are less expensive than an equivalently-sized optical drive. On the other hand, the cartridges are more expensive than opticals. The other disadvantage, which SyQuest shares with all removable drives, is that because they are removable, they are more difficult to seal against dust and environmental hazards like cigarette smoke. For that reason, SyQuest recommends the use of a removable dust shield on the front of their drives.

One of the most interesting removable drives is the Bernoulli Box. The name comes from an 18th century Swiss scientist named Daniel Bernoulli who originally demonstrated the principles of fluid dynamics. A Bernoulli box uses a combination of both floppy and hard disk technologies. Unlike a traditional hard disk in which read/write heads float over a rigid disk, the Bernoulli disk is flexible (it's made of similar material to floppy disks), is spun at high speeds, and bends to be close enough for the head to read it. During a power failure, a hard disk must retract its head to prevent a crash, whereas the Bernoulli floppy naturally bends down. Bernoulli drives are made only by Iomega Corporation. Originally introduced in 1983 as a 10MB 8-inch disk cartridge, the current capacity of their 3-inch drives is 230MB.

Digital Film

You can think of these removable cartridges as digital film. They are the places where you can store the digital images you create. If you started storing these, sometime huge files on your hard disk, you will quickly fill up even a 2GB drive. Removable cartridges allow you to save your images "off-line." When you need them, all you have to do is reach for the cartridge that contains your images, insert it into the drive, and start digital imaging. That's why I feel the most important features of a drive for digital photography are small cartridge size—for ease of storage—and low cost per cartridge. Access time is less important for this application. The current winner in this digital film sweepstakes is Iomega's Zip drive.

With a street price under $200, Iomega's Zip drive offers the best price/performance in removable storage available today. Using a propriety combination of hard disk read/write heads and Bernoulli-like flexible disks, Zip produces an average seek time of 29ms compared to 14ms for SyQuest's more expensive 105MB drive. Average seek time for 44 and 88MB SyQuest drives is 20ms, but Zip seems as fast as a 44MB unit I compared it with. It's also quieter. Pocketable, preformatted Zip cartridges, scarcely larger than a floppy disk, are less expensive too. Street price for a 100MB cartridge is $19.95, compared to $60 for a 105MB SyQuest. Iomega's 25MB cartridge is $9.95, while a 44MB SyQuest costs $55.

Software for Mac and Windows includes backup, file cataloging, and Zip disk duplication. There's also Iomega's Disk Tools, a collection of disk/drive management utilities that offers read/write disk locking and protection, formatting, diagnostics, hard drive emulation, and Guest software, which permits temporary use of a Zip on another computer. The Guest software compliments the optional adapter that lets you connect Zip to your PowerBook and the optional soft carrying case. Since Zip only weighs a pound, I expect users to take advantage of these inexpensive accessories and the smaller, universal power supply.

These are all the pluses for the Zip. Here are the minuses: Zip is a new format. How well it is accepted by service bureaus, printers, and the graphics industry will have an effect on how rapidly the Zip format is adopted. SyQuest isn't sitting on their laurels and has released a similar low-priced 135MB removable drive. Although the SyQuest cartridge prices

FIGURE 1-4:
Iomega Corporation's Zip drive measures 7.10"x5.35"x1.47", takes little desktop space, and has rubber feet on two sides allowing for vertical or horizontal placement. (Photo courtesy Iomega Corporation)

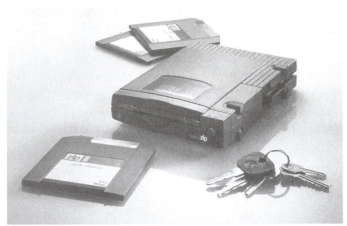

are expected to be slightly higher than the Zip's, the greater penetration of SyQuest products, in general, in the graphics industry means it should get wide acceptance too. Obviously, the format incompatibility of the two competing cartridges leaves the user stuck in the middle of another Beta versus VHS battle. Zip may have been first, but being first doesn't always win format wars, as Sony proved with Betamax. With Iomega's years of experience with their Bernoulli drives and reputation for quality it will be a tough battle.

Variations on a Theme

While variations of removable drives abound, the most popular Read-Only removable mechanism you'll find is a CD-ROM drive. CD-ROM stands for Compact Disc Read Only Memory and the drive is based on the same laser technology used by CD music players. Because they use a laser beam instead of the magnetic drive's read/write head, CD-ROM drives are considered optical devices. Unlike your removable optical drive, a CD-ROM is a read-only device. The 5-inch discs look identical to music CDs and are encoded with data by laser beams that produce indentations in the disc's surface. Inside the CD-ROM drive, another laser reads the bumps and dents and converts them into data. CD-ROM discs have immense storage capability and can hold over 600MB of data, making them ideal for storing the large files digital images require. CD-ROM drives are inexpensive and a typical drive costs

under $200. CD-ROM drives also come in a more expensive, writeable form, called CD-R.

Panasonic announced a new low-cost (under $1000) optical drive that can read and write to a 650MB removable optical disk and read conventional CD-ROM discs. With an average seek time of 165ms, the Panasonic PowerDrive2 won't set any speed records but represents an interesting blend of removable optical technologies.

VISUAL ELEMENTS

Macintosh vs. Windows

Choosing between a Macintosh and Windows computer may not be as difficult as choosing your favorite monster from Japanese films. In fact, it may come as a disappointment to most photographers that choosing the right computer system for digital imaging is not completely a hardware-related decision, but one more related to finding the operating system you're most comfortable with. An operating system, often called OS, is the master software that controls the computer. When you turn on any computer, the OS is the first thing that gets loaded into the computer's memory. The OS interacts with your computer's ROM (Read-Only Memory) or BIOS (Basic Input Output System) chips to accomplish tasks like controlling the hardware components of your system and how they interact with you through on-screen and keyboard/mouse communications. The most common operating systems are Microsoft Windows, the Macintosh OS,

MS-DOS (Microsoft Disk Operating System), OS/2 (IBM's Operating System/2), and UNIX, with Mac and Windows leading the pack.

People have been arguing about the merits of Nikon versus Canon versus Minolta cameras for years, but photographers all over the world are creating great-looking photographs using all three brands of cameras. The Mac versus Windows question is a similar quagmire, and photographers tend to be as passionate about their choice of computer system as they are about their camera systems. In a similar vein, both Mac and Windows systems use a graphical user interface, or GUI, that makes them simpler to use than text-based operating systems such as were found in early IBM-PCs and Apple II computers.

Microsoft Windows is a GUI that makes IBM-PC and compatible computers easier to use, but at the same time, slower. That's because Windows is an "environment" that requires MS-DOS to work. (That's what slows it down.) The newest version of Windows, called Windows 95, is not as reliant on its DOS underpinnings and now stands on its own. Any Windows screen is divided into, well, windows that contain separate information. Windows set a standard that makes working with different kinds of programs a similar experience. Windows uses graphical representation of programs and documents called icons. Using a mouse, you can double-click on an item to cause an action to occur. Mice for Windows come in many styles and types and include one, two, and three-button models.

The Mac OS, while certainly not the first GUI, was the first to popularize the use of icons and mice. Because the interface is an integral part of the operating system, it is faster and more consistent than Windows. The same is true of applications. Since Apple specified the interface from the beginning, software manufacturers were quick to adopt standards, even between vastly different kinds of programs. Apple Macintosh models use a single-button mouse. The Mac, unlike all previous versions of Windows, has always let users take advantage of the maximum amount of RAM without having to write scripts or run utilities similar to Microsoft's MEMMAKER. Maximizing the use of RAM is important to pixographers because photographic images and the software that manipulates them work better with as much RAM as you can throw at them.

Windows users will tell you that their GUI is the same as the Mac's, but that's only partially true. Even Windows 95, while a quantum leap in

intuitive interface design, is different from the Mac OS. The functionality of most cross platform (available for both Macintosh and Windows) digital imaging programs is almost identical, which leads many photographers to believe there is no difference between Macintosh and Windows platforms. The differences between these platforms lie in the way each computer performs basic digital housekeeping. If you're undecided about what system is right for you, go to a store that sells both IBM-PC compatible and Macintosh computers and ask a sales person to show you how each computer handles' the following operations.

1. Insert a floppy disk and search its contents.

2. Show the contents of a hard disk and find a specific file.

3. Launch that file and the application that created it.

4. See what steps are required to install software onto the hard disk.

5. Ask what hardware and software are needed to install peripheral equipment and what a user must do if he or she decides to install this equipment him or herself.

Seeing these operations in action will help you decide which system operates the way you do, and can do much to minimize buyer's remorse after you've bought a computer.

▐▌ Windows On a Mac?

While some pundits have suggested that offering the ability to run Microsoft Windows-based software on a Macintosh is just a checklist item—a purchasing manager can specify Macs without having to worry about being fired—it still remains an item of some interest to Mac users who covet Windows-only software. There are two basic ways to accomplish the emulation of the Windows environment on a Macintosh: hardware and software. Hardware options include Apple's own DOS-compatible card for the Power Macintosh and Reply Corporation's DOS On Mac card. At Macworld Expo '95 these products were joined by

Orange Micro's MS-DOS Coprocessor. The MS-DOS Coprocessor supports 1024x768 video with 256 colors on any Macintosh monitor, and has connections for modems or a printer. Three models of the board are available, providing emulation of everything from a 486/25 up to a 486/100. All three hardware solutions allow you to copy and paste text between the PC half of your computer and the Mac half as well as share files on the Mac hard disk.

Insignia Solutions offers a software-only solution to emulating the Windows environment on a Macintosh. SoftWindows 2.0 is the latest version, and it provides full IBM-compatibility with up to 486-style performance. SoftWindows 2.0 allows users to run all PC-based imaging software and even print PC files on their Power Macintosh computer. The product comes with Windows 3.11 pre-installed and supports the full enhanced mode some digital imaging programs require. Besides 486 emulation, SoftWindows 2.0 provides bi-directional text and graphics copy and paste. So if you're working in a Windows image enhancement program like PhotoWorks Plus, you can copy a photograph and paste it into your Macintosh desktop publishing program. For sound support, SoftWindows integrates your Mac's audio hardware, speakers, and microphone into the Windows Sound System. I've been using a pre-release version of SoftWindows 2.0 for some time and

FIGURE 2-1:
The best of both worlds? Insignia Solutions' SoftWindows 2.0 provides full IBM-compatibility with up to 486-style performance on a Power Macintosh computer. SoftWindows 2.0 allows users to run all PC-based imaging software and even print PC files.

I've been impressed with the seamless switching between Macintosh and PC environments. Through a licensing agreement with Microsoft, Insignia Solutions has access to the source code for current and future versions of Windows. This means Insignia will offer a Windows 3.11 to Windows 95 upgrade after Windows 95 ships. When compared to hardware solutions, SoftWindows is also the least cost solution for running Windows on a Macintosh. While there were some attempts a few years ago to run the Mac OS under Windows, the hardware product that produced the emulation disappeared from the marketplace.

What Do I Use?

I'm mentioning the equipment I use, not to brag or endorse one manufacturer over another, but to provide you with background information. The major drawback of most product reviews is that the writers never reveal what kind of system they are using. If they say a particular program or piece of equipment is slow, what are they using as a yardstick? Telling you about the computer equipment I used in preparing this book will, hopefully, provide you with a basis for evaluating my comments about products that appear later on.

All of my computer equipment has been assembled with one overriding philosophy: to get the best value out of my hardware and peripherals. I long ago discovered that having state-of-the-art equipment and paying state-of-the-art prices was not for me. Early adopters spend very little time as king of the hill. The computer industry moves so fast that within a few months of buying a top-of-the-line computer, users quickly find newer, better models being introduced—at a lower price. Sometimes you can put this fact to work for your benefit as happened to me when I decided to upgrade my Macintosh. My old Mac IIci seemed too old and too slow for the demands of the latest digital imaging programs, so I decided to get a new Mac. At the COMDEX '94 trade show, Apple announced a newer, faster, cheaper top-of-the-line 8100/100 Power Macintosh. The problem was that the new model had rumored problems in its ROM chips so everyone waited to buy it, which depressed the prices. I took advantage of this fact and negotiated a price that was $1500 less than that shown on the price tag. If you don't think you can wheel and deal in a computer superstore, you are wrong.

Salespeople in computer stores are usually willing to make some kind of a deal on all but the latest, hottest models. Don't be bashful; just ask.

Now that you know what kind of Mac I use, let me tell you about my Windows computer. This generic computer started life as a 286 machine. Over the years, with hardware and motherboard swaps, it has gradually evolved into a 486/50 MHz computer. The components, which now include a single 3.5-inch floppy drive, are housed in a mini-tower case that also contains all of my PC-based peripherals. While the 486 is fast, you may wonder why I don't have a Pentium-powered machine. It's not that I'm worried about the Intel chip's calculation problems, it's more a matter of price. Intel has announced a next-generation chip that's faster than the Pentium and is due to ship by the end of 1995. I expect to repeat my above Mac experience when Pentium prices begin to drop when the new microprocessor chip is readily available.

When All Else Fails

The safest purchase decision is to buy the same kind of computer your photographer friends have—especially if they're knowledgeable about their use. Chances are that when you announce you're going to buy a computer, these folks will appear out of nowhere demanding that you buy the same kind of system they have anyway. The biggest advantage of this approach is that when you have a problem you'll always have someone to call. No matter what the salesperson says when they sell you a computer, after you get it out the door you're on your own. If you can pick up the phone and call your pal and ask him or her, chances are you'll get a straight answer to your problem.

There's an old computer adage: Find the software you want, then get a machine that runs the program. That's just as true today as when 64K seemed like a lot of memory. If the programs you're interested in are available for both computer systems, like many digital imaging programs, you'll have to make a decision. Spend some time with friends that have Macs and PCs, and find the one that appeals to you. Your final choice should be based on a single question: What environment are you more comfortable with? Nowadays there is little price differentiation between Macs and PC, but that

wasn't always the case. In 1984 I paid $2500 for a 128K Macintosh with an ImageWriter dot-matrix printer. Expensive, you bet. Over time the price/performance issue of Macintosh and Windows computers has diminished as both types are available from discount electronic stores and computer superstores. One of the best things you can do to improve your ability to use your computer—no matter what your level of experience—is to join a user's group. These groups are full of knowledgeable people who love the same kind of computer you have. User groups are really fan clubs whose members are full of the same kind of unbridled enthusiasm that any collection of enthusiasts has. You can learn a lot that can help you in your day-to-day operation and you just might make a friend or two. You can find user's groups through computer dealers and regional computer publications like *Computer Currents* and *ComputerUSER*.

 # Your Digital Viewfinder

Your monitor is your computer's viewfinder. It is how you see the digital images that you create. That's why it's important to understand how the video graphics portion of your computer works. When purchasing a camera, you want to know what percentage of the finished film frame is seen in the viewfinder. For your digital imaging computer you want to know the same thing—in other words, is what you see what you get, or WYSIWYG.

Industry studies have shown that new computer owners typically replace two components in their system within the first year. The first item they replace is the hard disk, but the second item they replace is the monitor. First time computer purchasers often feel they must take the monitor that's bundled (included as part of the package) by the dealer. Not so. Because you must have the right combination of graphics card and monitor to effectively evaluate your digital images and any changes you make to them, choose the right monitor, not one a salesperson is hyping.

The color display consists of a monitor and a graphics adapter card inside the computer. The combination of both components will determine how good or bad your photographs will look on screen. Since the IBM-PC was introduced, there have been a confusing array of names and standards for the graphic adapter boards used, but thankfully it's getting simpler. *VGA*, Video Graphics Array, is now the minimum video display standard for

Windows computers. IBM introduced this standard in 1987 when it launched the PS/2 system. Unlike previous standards, VGA had the potential of displaying millions of colors. Not all VGA systems display this number, and how many colors they can display is dictated by the card's design. A standard VGA system displays 16 or 256 colors at a resolution of 640x480 pixels. This resolution is the same as a typical consumer television set and often a good TV, like a Sony XBR, looks better than your computer because it has better color depth resolution.

Because monitors look like television sets, many computer users get confused when shopping for a monitor. For instance, when you trade-in your 19-inch for a 30-inch Sony TV, you expect to see the same image you saw on your old TV, except bigger. This doesn't happen with monitors. With a larger screen, greater resolution is possible. This enables you to see *more* of the same image. A 15-inch monitor can display a 800x600 pixel image, while a 19-inch model lets you see 1280x1024 pixels. Like televisions, monitor manufactures overstate the screen size somewhat. NEC is honest enough to admit that their XE15 15-inch monitor has a 13.8-inch viewable area.

Other than screen size and resolution, the next most important factors in evaluating your choice of monitors is dot-pitch, refresh rate, and whether

FIGURE 2-2:
DOT PITCH: A good monitor, like the multi-scan NEC MultiSync XV15 shown here, has a dot pitch of .28mm, a refresh rate of 75Hz, and is non-interlaced. (Photo courtesy NEC)

the monitor is multiscan or interlaced. Here's what to look for when shopping for monitors for digital photography:

- Dot pitch: The classic definition of dot-pitch is the distance between the red (center) dot of two adjoining pixel triads. The smaller this number, the sharper the picture will be. A good monitor, like the NEC MultiSync XE17 has a dot pitch of .28mm. Anything greater than that number, and the quality suffers; any distance smaller and the quality improves even more. A monitor with a dot pitch of .41 would be considered unusable for digital photography (or anything else), while one with a dot pitch of .25 would be superb.

- Refresh rate: Often called vertical scanning frequency, measures the amount of flicker you see on your monitor. A computer screen, like a TV set, is constantly re-energizing its phosphors. To display resolutions higher than 640x480, the monitor must have a horizontal scan rate of at least 35 *Hertz*, or Hz. (Hertz is a measure of electrical vibrations, and one hertz equals one cycle per second.) The minimum acceptable refresh rate is 70 Hz, and at this speed your screen is redrawn 70 times per second. Higher frequencies mean the image has more stability and better display quality. Newer, more expensive graphics cards support higher vertical scanning frequencies, like the 72 Hz European standard. Make sure your graphics card matches or exceeds the refresh rate of your monitor.

- Multiscan: MultiSync is a trademark of NEC, but many computer heads throw the term around when describing any multiscan monitor. On a typical monitor, a scanning beam starts at one corner and traces a single pixel-wide horizontal line, then goes on to trace the next line. How fast the monitor scans both horizontally and vertically varies depending on the kind of graphics card used. A multiscan monitor is one that automatically matches the signal sent to it by the graphics card (or Apple motherboard). A multiscan monitor does all the work, making sure board and monitor match. If you don't have a multiscan monitor, it's important that your graphics card matches the scan rate of your monitor. This inconsistency of scan rates is common in the PC world, but not with the Macintosh. Nevertheless, multiscan monitors work well with a Mac.

■ Interlaced: On an interlaced monitor, the electron beam making the scans takes two passes to form a complete image, while a non-interlaced monitor traces each row consecutively. Interlaced monitors are less expensive, but the amount of screen flicker they produce is unacceptable for use in digital imaging—or any other application for that matter. Don't buy an interlaced monitor. For the few bucks you'll save, you will pay for it with eye strain.

Drivers Make It Happen

All PC video cards come with a driver, which is a small software program that enables your computer and the video card to communicate with the monitor. How well a driver does its job can affect the way your screen updates information. Because conflicts can arise, drivers are regularly updated by manufacturers of graphics cards and most companies will send you an update, if you request it.

How drivers can affect performance, including how many colors can be displayed, can be illustrated by this story: To see 24-bit video on your monitor, you'll need a video board capable of displaying these images. When I upgraded my PC, I installed an NEC monitor and 24-bit video card. The card was pre-installed with one megabyte of DRAM, but to display more than 256 colors, I installed an additional megabyte. Using the Display Properties Control Panel of Microsoft's Windows 95 (see Figure 2-2), I found the drivers provided by the manufacturer did not allow me to display the expected 64,000 colors! I called the company and heard the kind of statement that sends the shivers down any computer user's spine. The board I had purchased "was no longer being manufactured." It was replaced with a newer, better model, but (sorry) the drivers for the new board were not compatible with the one I had bought. And no, they never produced new drivers for the board. The customer service rep suggested I call the company that manufactures some of the chips they use. They, he told me, often have "generic drivers that they update frequently." He then gave me the chip number and the phone number of the chip company's technical support. When I called them they were more than happy to send me a disk with their latest drivers for boards that use their chips. I installed the new driver on my PC and was able to see 64,000 beautiful colors. The moral of

FIGURE 2-3:
The Display Properties
Control Panel of
Microsoft's Windows 95
allows you to set the
visual characteristics of
your display system. Like
Apple's Monitors Control
Panel, you cannot set
the quality of the display
greater than the hard-
ware permits.

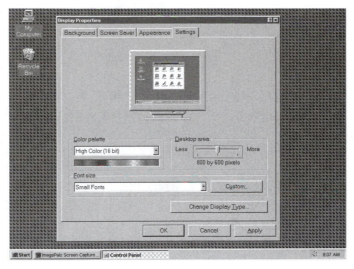

this story is that video drivers make a difference in both image quality and performance, and sometimes you have to be persistent to get what you need. A tip of the hat to S3 Incorporated, the chip manufacturer, for solving my driver problem.

With Macintosh's built-in video capabilities, there are no video drivers. The operating system software has a utility called Monitors that lets you set the amount of colors the monitor will display. Monitors checks the VRAM that is installed and only allows you to select the maximum amount of colors that the video memory can display.

Photographic File Formats

When photographs become digitized (and the next chapter will tell you how that's accomplished) they become files. A file is a specific combination of information used as a single unit and may contain different types of data, including text, numbers, graphics, and photographs. So far, so good, but sometimes confusion occurs because there is no one true photographic file format. In fact, there are almost 100 of them designed for specific programs and specific computers. This Tower of Babel situation creates confusion among new digital imagers. They want to know which one is the "right" one to use and when. As usual there is no one true answer to those questions

and, in fact, there can be many different—and correct—answers to the same question. There are three general classes of file types that graphics, like photographs, can use:

- Vector: Images saved in this format are stored as mathematical formulae which describe the shapes that make up that image. When vector files are viewed on your computer screen or printed, the formulae are converted into a dot or pixel pattern. Since these pixels are not specified as part of the file itself, the image can be resized without losing any quality. Photographs are not typically saved in this type of format. Some computer users, especially Mac users, call this file type *object-oriented* and you will often see that term used on graphic drawing programs. Vector files have the same technology as Adobe uses with its PostScript fonts and the same advantages—you can make any image or font as big as you want, and it will retain its quality. See the sidebar for the types of vector files.

- Bitmapped: These files are often called *raster*. In television terminology, a raster is the pattern of horizontal lines traced by the electron beam on a picture tube. With bitmapped files, which are more common for photographs, the pixels that make up the image are defined when the file is saved, which effectively establishes the resolution of the image. Smaller resolution files can, therefore, only be viewed or printed in smaller sizes, while higher resolution images have more flexibility in displaying. The simplest bitmapped files are monochrome images composed of only black and white pixels. Vector graphics are displayed as a *bitmapped* images on your monitor.

- Metafile: These hybrid files accommodate both bitmapped and vector data in the same file. While seemingly more popular in the Windows environment, PICT, one of the most popular Macintosh graphics format, is a metafile.

Depending on the software, the application for the image, and the output method you are using, all of your digital graphics file needs can be satisfied by using any one—or all—of these three file types. Which brings up an important rule of thumb about photographic files: As the resolution

of the image increases, so does file size. As file size increases, greater demands are made on your hard disk and CPU to deal with these large files, in other words, you need more space and speed. That's why *compression* technology was invented. Compression is a method of removing unneeded data to make a file smaller without losing any data, or in the case of a photographic file, image quality. Having a smaller file while retaining image quality means your hardware can work on the files faster and you can store more images on your hard disk. There are many techniques and technologies for compressing graphics, and how well each works depends on what is more important to you: file size or image quality.

◗ Common Macintosh and Windows Graphics File Formats

When translating image files from one format to another, it helps to understand what all the acronyms mean.

CGM: Computer Graphics Metafile. A vector graphics format that is designed to be portable from one PC-based program to another.

EPS, EPSF: Encapsulated PostScript format. A metafile format that contains two elements: the bitmapped image and the PostScript code that tells your printer or output device how to print the image (see PostScript).

GIF: (Pronounced like the peanut butter.) The Graphics Interchange Format developed by CompuServe is the Rodney Dangerfield of graphics file formats—it don't get no respect. It is completely platform independent and the same bitmapped file created on a Macintosh is readable by a Windows graphics program. A GIF file is automatically compressed, and consequently takes up less space on your hard disk. Because some software considers GIF files to be "indexed" color, (see below) not all graphics programs read and write GIF files, but many do. The "get no respect" aspect of GIF is that often R-and X-rated photographs in GIF format are available from on-line services and bulletin boards. Some people have come to associate the file format with these types of images, therefore leading to the erroneous assumption that a GIF file is automatically one that features erotic images. The future of the GIF format is, at this time, uncertain. When CompuServe developed

the format it used, it included, as part of the design, the Lempel-Ziv-Welch (LZW) compression algorithms, believing this technology to be in the public domain. As part of an acquisition, UNISYS gained legal rights to LZW and a legal battle has ensued. The way it stands now, reading and possessing GIF files (or any other graphics file containing LZW-compressed images) is not illegal, writing software that creates GIF (or other LZW-based files) may be.

INDEXED COLOR: Indexed color images contain a limited number of colors, and some are called "pseudocolor." The number of colors of a typical indexed color photograph is usually 256 or less. Pseudocolor images are grayscale images that display variations in gray levels in color rather than shades of gray and are most often used for scientific and technical work.

JPEG: Is an acronym for a compressed graphics format created by the Joint Photographic Experts Group, within the International Standards Organization. Unlike other compression schemes, JPEG doesn't use a single algorithm, and it is what the techies call a "lossy" method. LZW compression is lossless—meaning that no data is discarded during the compression process. JPEG was designed to discard any information the eye cannot normally see. JPEG is an excellent way to store 24-bit color images and is superior on-screen to 8-bit photographs when viewed on a good monitor, but the compression process itself can be slow.

PCX: Is not an acronym (it doesn't stand for anything) and is a bitmapped file format originally developed for the popular program, PC Paintbrush. Most Windows and DOS graphics programs read and write PCX files.

PICT: As a well-behaved metafile, PICT files contain both bitmapped or object-oriented information. Some people love PICT files because they are excellent for importing and printing black & white graphics, like logos, into drawing programs, but others hate them because they don't always retain all the original image's information.

POSTSCRIPT: A programming language created by Adobe Systems that defines all the shapes in a file as outlines and interprets these outlines by mathematical formulae called Bezier (pronounced Bez-e-ay) curves. Any PostScript-compatible output device uses those definitions to reproduce the image.

TIFF: Tagged Image File Format is a bitmapped file format developed by Microsoft and Aldus (now Adobe). A TIFF file can be any resolution from black & white up to 24-bit color. TIFFs are supposed to be platform independent files, so files created on your Macintosh can (almost) always be read by a Windows graphics program.

WMF: Windows Metafile Format. A vector graphics format designed to be portable from one PC-based program to another.

File Translation Tools

Whether Macintosh and Windows devotees like it or not, we're living in a cross-platform world. Sharing information across platforms can be as important as sharing it across continents, maybe even more so. As in diplomacy, the only thing standing in the way of better communications is a difference in language. The key to successfully translating the many word processing and graphics file formats running amok in the Windows and Macintosh worlds is having software that can translate the file type you have into the file type you need.

Digital photographs come in an often bewildering variety of file types. You find PICT, TIFF, BMP, PCX, PCD, and some file types unique to Windows, DOS, or the Macintosh, and every time a new graphics software package is announced, the publisher feels obligated to create a new file format. When Apple Computer introduced its first digital camera, it also announced a new graphics format for the camera called QuickTake. Not all software companies write a particular file format in the same way, producing variations or "flavors" of the so-called standard. Further complications can arise when you try to take a graphics file created on one platform and use it on another. When you run across a file you can't open, it's time to reach for specialized file translation software.

When converting graphic files between Macintosh and Windows computers, it helps to have software that allows your computer to read (or mount) disks formatted on the other machine. Apple's Macintosh PC Exchange lets Macintosh computers read disks formatted on IBM-PC and compatible machines as well as disks for Apple II computers. Macintosh PC Exchange is included with Apple's System 7.5 Operating System package

and is frequently bundled with software on computers sold in computer discount stores. The only requirement to use it is that your computer has what Apple calls a SuperDrive floppy disk drive. All recent Macs are so equipped, so this is only a problem for older Macintosh computers. If in doubt, check your manual. On the other side of the cross-platform issue, programs, like Pacific Micro's Mac-In-DOS, allow Windows computers to read Mac-formatted disks.

One of the best Macintosh file conversion bargains around is Kevin Mitchell's shareware GIF Converter. For a $40 shareware fee, GIF Converter displays and converts a number of common Mac and PC graphics files. PC users might want to check out Graphics Workshop, a shareware program that handles many different file formats. Any one of these programs would be a good choice for the person who only needs to occasionally convert a file.

◗ Shareware and Freeware

Shareware is a creative way of distributing software that lets you try a program for up to 30 days before you're expected to pay for it. The registration fees for shareware are usually quite modest and range from five bucks up to $100. (Some authors just ask for a postcard, or "beer and pizza money," or donations to a specified charity.) As a thank you for your payment, authors often will send you a printed manual, an enhanced version of the program or a free upgrade—or, at no charge, additional products they've developed.

Freeware is a form of shareware that is just what it sounds like—it's free.

Shareware and freeware programs are available through user-group software libraries, on-line services and catalog vendors like Educorp. Unlike commercial software developers, freeware and shareware authors encourage users to copy and distribute their products; commercial distributors generally must ask permission first and shouldn't charge excessive fees for disk duplication and shipping. The object is to eliminate the middleman and get software directly to the user, who is free to pay for what he or she likes and keeps. As in the spirit of the pioneer days, everyone's credit is good because he or she is paying on the honor system. Shareware is one of the greatest ideas to come out of the computing community.

When the conversion gets tough, many photographers reach for DeBabelizer for the Mac and HiJaack Pro for Windows. (The latest version of HiJaack is 3.0, and it's now part of the HiJaack Graphics Suite for Windows.) Both programs do more than convert file formats, and HiJaack Pro does a lot more. It also lets users view, enhance, convert, and print graphic files created in DOS, Windows, Sun, and Macintosh environments.

FIGURE 2-4:
The file conversion aspects of HiJaack Pro 3.0 is only part of an extensive package of graphics utilities offered by Inset Systems. With a street price under $100, this is one of the best graphics deals available for Windows. (Photograph ©Mary Farace)

FIGURE 2-5:
DeBabelizer is a Macintosh-based file conversion utility that can convert photographic files from Windows to Macintosh and vice versa. Its Open dialog provides data on the file as well as providing a large preview of what the image looks like.

HiJaack Pro can read and write 18 vector, 30 bitmapped, and 24 different fax formats. Its Open dialog includes an "All Known Types" entry giving easy access to different kinds of files. The program reads and displays more graphic and fax file formats than any other Windows program (I've tested) and includes modules for screen capture utility and image management. The Browser image management module has an attractive interface but is slow and doesn't display thumbnails as well as a dedicated imagebase product. Equilibrium Technologies DeBabelizer and its less expensive sibling, DeBabelizer Lite, are Macintosh programs that translate graphics, video, and animation files. The program's large "preview" window in its Open dialog is so big you would have to consider this part a file viewing application. Equilibrium Technologies appears to have placed more emphasis on functionality than design, and DeBabelizer's interface is not as polished as most Macintosh graphics programs. DeBabelizer can adjust hue, saturation, and value of an image and can correct images for output to video. One of the program's coolest features is "Remove Background." Working within a dialog box, the program lets you specify parameters that will "drop out" the background—even complex ones—away from a foreground subject. It takes a little practice, but it works.

Conversions Made Easy...

Well, some are and some aren't. Keep in mind that Windows-based programs are biased in favor of converting more DOS and Windows formats than Macintosh files. The same is true of Macintosh conversion programs. Keep this in mind when you're trying to pound a square file into a round hole. The only solution for the "impossible" file conversion may be to obtain the original, creator application and save the file in a more "portable" format. As a last resort, you can also take the file to a service bureau, and for a modest fee the company will usually be able to covert the file into a format you can use.

P A R T

P A R T II

IMAGE ACQUISITION

Photographers have always employed a number of euphemisms to describe their pursuit of exciting images. They have been known to "shoot" brides, "take" pictures of kids, and "snap" photos of their pets. So, it's not surprising that digital photographers have produced several euphemisms of their own. The most popular is that they don't "shoot" photographs at all; they "acquire" images. And there are several different ways to do just that: digital cameras, scanners, and lab processes developed by Eastman Kodak and Seattle FilmWorks.

Photographers looking for ways of achieving "the ultimate image" may be disappointed to learn that there is no one perfect way to create digital images. Whether using digital or conventional methods, every photographer has a different goal and different kinds of pictures in his or her mind's eye. Newspaper shooters have different needs than advertising photographers, and the advanced amateur trying to create an exhibition quality print will need different tools than the insurance agent who is trying to photograph a

hail-damaged car for a claim form. Just as in using any silver-based photographic process, you need to match the digital tools to what each individual is trying to accomplish.

This section looks at the different tools available to create original digital images or to take your existing silver-based photos and turn them into pixels. This first image acquisition section looks at what hardware is available as I write this. Over time, changes in both design and specifications will most likely occur in many of the cameras in this category, and they will ultimately evolve in products that rival conventional cameras in capability and price. But not yet. In the meantime, using a digital camera for image acquisition may appear to be the simplest way to create digital images. Or is it?

DIGITAL AND VIDEO CAMERAS

Traditional photographers are most familiar with acquiring images through the lens of a camera. This chapter will bring you up to speed on the new generation of digital and video cameras.

Digital Cameras

The current generation of digital still cameras falls into three general categories: digital point & shoot, 35mm-style field cameras, and professional studio equipment. There's an old photo lab adage that says "Quality, Price, or Speed. Choose any two." I find it interesting that this age-old maxim applies just as well to the digital world as it does to silver-based printing and processing. All digital cameras rigidly adhere to this rule and the old adage of "you pay for what you get" strictly applies.

Digital point & shoot cameras are built to a price point, so you get price and speed—immediacy of imaging—but quality will be at the lower end of the digital imaging spectrum. Less expensive digital cameras typically have the sensitivity equivalent of ISO 100 film and can store anywhere from 8 to 32 images for up to a year. Once acquired, these images must be *downloaded* from your camera through a cable connected between the camera and either the printer port or modem port of your computer. (Download in computerese means "to receive information." The opposite term is upload.) This means if you plan on shooting more than 32 images at one time, you'll need to bring along a laptop computer to download the images after the camera gets full. And it's not just the inconvenience of carting another piece of equipment along with you, the cameras themselves, although inexpensive by digital standards, are not really cheap. Few photographers would be impressed by a $700 camera that sports a non-interchangeable 50mm F2.8 lens and only focuses to four feet, but that's state-of-the-art for digital cameras under $1000.

35mm-style digital field cameras provide quality and speed, but price begins to erode as the cameras start costing as much as a Honda Civic. When you move up to studio cameras, the quality and speed components are emphasized, while the cost of a typical camera approaches that of a Lexus.

Point & Shooters

The first group of electronic still cameras contains the digital equivalent of those popular auto-everything, point & shoot 35mm cameras that cost less than $100. These cameras are designed to be used by non-professionals or casual users to capture images where ease of acquisition and low cost are more important than image quality. Point & shooters tend to be people such as real estate agents, insurance adjusters, and other documentarians who want to paste their photographs into desktop published documents that will be printed on low or medium resolution laser or ink-jet printers. Digital point & shoot cameras are also great for fun. If you want to take a picture of the new baby or boat and paste it into a letter to grandma, these cameras will do a great job. Expect to pay for the convenience, however. Most cameras in this category are pushing the $1000 mark and the higher the resolution, the higher the price.

One of the most striking features of *all* digital point & shoot cameras is how little they look like, well, cameras. Instead of using the paradigm of the conventional 35mm camera, all manufacturers, including Eastman Kodak who should know better, have thrown convention to the wind, giving us a collection of cameras that look like everything from piccolos to hand scanners.

Apple's QuickTake 150 digital camera looks more like a pair of binoculars than a digital camera. The QuickTake 150 is a 24-bit camera that can store up to 32 standard-quality or 16 "high-quality" 640x480 images in its 1MB of memory. The lens is the equivalent of a 50mm "normal" lens on a 35mm camera. The camera's sensor gives it the equivalent of an ISO of 85 and like any good point & shoot camera, it has a built-in flash that works from 4 to 9 feet. All of these specifications mean that the QuickTake 150 will make its best photographs outdoors. The camera includes a screw-on, close-up lens that will let you make photographs as close as 10 inches. The QuickTake 150 comes with a serial cable that connects to your Macintosh and a copy of Apple's capable image-editing program, called PhotoFlash 2.0.

Dycam is honest about the capabilities of their digital cameras; they aim them strictly for "documentation" use. The company offers four models. The top-of-the line grayscale model 3XL is capable of shooting 250 8-bit snapshots in low-res mode, or up to 36 images at a resolution of 496x365. The 4XL is a 24-bit color model capable of taking 100 images in low-res and 36 images at 496x365. Both cameras weigh just 10 ounces, are small enough to fit in a purse, and are compatible with PC and Macintosh computers through the serial port. Both cameras come with software that enables users to adjust an images' brightness, contrast, and sharpness.

Although they co-developed Apple's QuickTake 100, Eastman Kodak's under $1000, DC 40 digital camera is the first to bear the company's name. The DC 40, shown in Figure 3-1, offers a high-resolution (756x504) 24-bit color sensor, with a maximum capacity of 48 "standard" images before downloading, interchangeable lenses, automatic exposure, and up to 800 exposures from a single set of lithium batteries. The camera focuses from four feet to infinity with its standard lens, which is equivalent to a 42mm lens on a standard 35mm camera. Screw-on lenses that most photographers will recognize as attachments, and not really interchangeable lenses, are available for wide angle, close-up, and telephoto shots. Shutter speeds vary from 1/30 to 1/175 second with lens apertures ranging from $f/2.8$ to $f/16$,

but users can override the automatic exposure using a "lighter-darker" switch on the camera. The camera has an equivalent ISO speed of 84. The DC 40 includes a self-timer, flash override, and tripod socket. Images can be transferred from the camera through a standard RS232C interface cable to a Macintosh or Windows computer. The camera ships with PictureWorks Technology's PhotoEnhancer software that lets users view images as thumbnails, perform simple color correction and retouching, and permits the photographs to be exported to other applications as PICT, TIFF, or EPS files.

Logitech's FotoMan Pixtura is a 24-bit color digital camera designed specifically for users of IBM-compatible PCs. The FotoMan Pixtura costs under $1000, and can store 48 high-resolution (768x512 pixels) or 144 standard-resolution (384x256) images in memory for later downloading through your computer's serial port. FotoMan Pixtura features an average life of 800 to 1000 pictures per battery set. An LCD panel display located on the back of the unit includes a battery level indicator, picture counter, and timer, thus helping users keep track of the camera's functions. Users can purchase an optional AC adapter for FotoMan Pixtura, as well as supplementary lenses, filters, cases, and other accessories.

FIGURE 3-1:
Kodak's DC 40 binocular-like point & shoot offers a high-resolution (756x504) 24-bit color sensor, with a maximum capacity of 48 "standard" images. The camera focuses from four feet to infinity with its standard lens, which is equivalent to a 42mm lens on a standard 35mm camera. (Photo courtesy of Eastman Kodak)

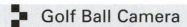

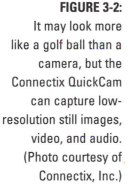 Golf Ball Camera

It's a camera, it's a camcorder, it's a...golf ball. Connectix's golf ball-shaped QuickCam, shown in Figure 3-2, is both a video and still digital camera. Image resolution is 320x240 pixels in 4-bit grayscale, and video images are captured at 15 frames per second (at 160x120 resolution) instead of the video standard of 30fps. But waddya expect? It only costs $99. The camera has a 65 degree field-of-view providing the equivalent of a 38mm lens on a 35mm camera, and focus is fixed from 18 inches to infinity. The software that's included lets you capture a single-frame image in either BMP or TIFF formats. The QuickCam even has a built-in microphone to capture audio—if your computer is set up for audio input. The Macintosh version connects to the computer's serial port, and a parallel port version is available for Windows machines. There's no other product in its price range that does what it does. If you want to take digital snapshots for print or electronic reproduction, you'll like QuickCam.

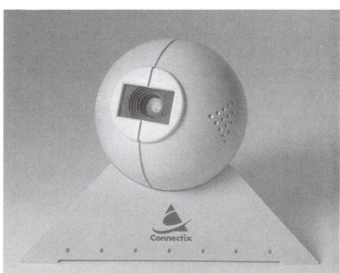

FIGURE 3-2:
It may look more like a golf ball than a camera, but the Connectix QuickCam can capture low-resolution still images, video, and audio. (Photo courtesy of Connectix, Inc.)

FIGURE 3-3:
Is QuickCam for you?
Judge for yourself with
this example of a still
image. (Photo courtesy
of Connectix, Inc.)

Professional Field Cameras

If you want to move up to a pro-quality camera with interchangeable lenses, the next step is the digital field camera, most of which are based on conventional 35mm camera bodies. It's a big step up to that next level and prices jump from under $1000 to over $10,000. These cameras are used by photojournalists on tight deadlines and photographers who do their work on location. This category uses the same lenses as most pros already use, so they can instantly be integrated into their camera system. Resolution of this class varies from modest to high, and the current price points limit their use to professional photojournalistic applications or the well-heeled.

If this class of cameras resembles conventional 35mm professional cameras it's because most of them are based on existing silver-based designs. Eastman Kodak's professional cameras represent a strategic alliance with traditional 35mm camera manufacturers to offer a family of digital cameras that are essentially digital imaging backs attached to professional camera bodies from Nikon and Canon. Since many of the camera's features are similar, let's look at what they have in common first.

All the cameras use a full-frame CCD imager to deliver 36-bit color (12 bits per RGB color) digital images. (A Charged Coupled Device is the same kind of device used in video camcorders to capture images electronically.)

The Kodaks have the ability to store images on *PCMCIA* (Personal Computer Memory Card International Association) cards, and feature a built-in microphone for voice annotation. The cameras store images on removable media compatible with its PCMCIA slot and can serve as a card reader when users are ready to retrieve their images. A standard SCSI cable connects the camera directly to a Macintosh or IBM PC or compatible computer. Software shipped with the camera enables Macintosh users to acquire image information from the camera's card reader and separate software allows PC users to move image information into TWAIN-compliant programs. (TWAIN is a hardware/software standard that allows users to *acquire* digital image information from inside Windows applications.)

◗ PCMCIA Cards: Digital Film?

PCMCIA is an acronym for Personal Computer Memory Card International Association. The cards that are referred to in the organization's title are small credit-card sized modules that were originally designed to plug into standardized sockets of laptop and notebook sized computers. To date, there have been three PCMCIA standards: Type I, Type II, and Type III. The major difference between the types is the thickness of the cards. Type III cards are 10.5mm thick, Type II are 5mm thick, and Type I are 3.5mm thick. The modules come in many varieties depending on the type and thickness. There are PCMCIA cards for additional memory, hard disks, modems—you name it. It seemed pretty obvious that this would be quickly adapted to digital cameras as a means of storing large image files.

The Kodak DCS 420 Digital Camera features a full-frame CCD imager delivering a resolution of 1.5 million pixels, at a motor drive-like rate of 5 images in 2.25 seconds. The DCS 420 consists of a special electronic back fixed to the body of a Nikon N90 camera. It features a battery pack good for 1000 images per charge. Users can choose from exposure-equivalent ISOs ranging from 50 to 400 in color and from 100 to 800 in black & white.

The Kodak professional DCS 460 digital camera features a 3060x2036 pixel CCD imager delivering a resolution of 6 million pixels. The imager resides inside an electronic back attached to a Nikon N90 body camera.

Once the camera is powered up, the time to the first shot is only 0.25 seconds. Subsequent images then can be captured approximately every twelve seconds. The DCS 460 features a battery pack good for at least 300 images per charge, with a recharge time of one hour. The DCS 420 and 460 support virtually all functions available on the Nikon N90, including autofocus, self-timing, and a range of metering modes. They will accept all Nikon F-mount lenses used by the silver-based film version of the camera. The DCS 460 camera is available in three models: DCS 460c (color), DCS 460m (black & white), and DCS 460IR (infrared; available only by special order). All models ship with an AC adapter/charger, Macintosh cables and driver software, and manuals.

Professional photographers will be able to capture high-resolution digital images with Kodak's digital back for medium format cameras that use interchangeable magazines (backs) and 4x5 large format studio and field cameras. The Kodak Professional DCS 465 digital camera back features image resolution of 3060 x 2036 pixels, single-shot color exposure, 36-bit color, and an ISO equivalent of 100. You've probably already figured out that the back is based on the same technology now being used by Kodak's DCS 400-series digital cameras. Kodak is working with camera manufacturers, such as Hasselblad and Sinar, to adapt DCS 465 technology to their equipment.

Kodak has also announced the EOS DCS 5, a digital camera based on Canon's EOS-1N camera. Developed in cooperation with Canon, the EOS DCS 5 camera features a burst rate of 2.3 images per second for 10 images, the advanced functions of the Canon EOS-1N, an 1.5 megapixel CCD sensor (1524 x 1012 pixels), 36-bit color, removable PCMCIA storage (both hard disk and flash memory cards), a battery pack capable of delivering up to 1000 images per charge, and a built-in microphone for voice annotation. The camera provides exposure equivalents from 100 to 400 in color and 200 to 800 in black & white. Kodak software shipped with the camera enables both Macintosh and PC users to acquire image information from the camera's card reader. A standard SCSI cable connects the camera directly to a Macintosh or IBM PC or compatible computer. Kodak and Canon have also joined forces to produce two other digital cameras. Canon will market the EOS DCS 3 digital camera, which captures 1.3 million pixels at equivalent film speeds up to ISO 1600. In addition, a 6 million pixel EOS DCS camera will be marketed by both companies.

Digital Twins

The Nikon E2 and E2s, along with their siblings the Fujix DS-505 and DS-515, are a set of twin cameras that share many (maybe all) of the same features. Both pairs of cameras store images on a PCMCIA card and feature the Fujix name on the side and the Nikon name on the pentaprism. Each card has a capacity of 15MB and stores up to 84 JPEG compressed images captured at a resolution of 1280 x1000 pixels. Photographers using the DS-505 or E2 can acquire images at up to a one frame per second, and the more expensive DS-515 or E2s models' continuous exposure features will allow them to take up to seven continuous shots at three frames per second. While not matching conventional cameras, this speed should be enough for the short bursts of shots fired by most sports photographers. Image data on the "exposed" card can be transferred as digital images to any PC or Macintosh equipped with Fuji's PCMCIA card reader. Besides the memory card, each camera has an output terminal for direct downloading of captured images, in addition to a video output terminal (in both NTSC and PAL video formats) allowing continuous monitoring of exposed images. This latter feature will be especially useful for professional studio and portrait photographers who want instant previews of their work in progress.

The Fujix DS-505 and DS-515, and Nikon E2 and E2s, (see Figure 3-4) are interchangeable lens digital cameras that use a 1.3 million-pixel CCD and digital image processing technology to deliver full color, high-resolution

FIGURE 3-4:
It's a Nikon, it's a Fuji. Whatever you call it, this collaboration of Nikon and Fuji Photo Film has produced one of the most versatile 35mm-style digital field cameras that's capable of fitting the camera bag of any Nikon-using professional.
(Photo courtesy of Nikon USA)

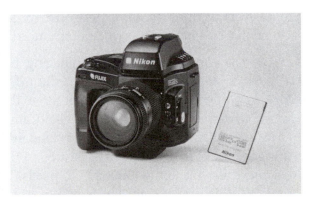

images. The camera's condenser optics concentrate the image onto the 2/3-inch CCD enabling it to capture the entire viewfinder. This concentration of light on the CCD gives the camera the sensitivity equivalent of ISO 800 film and a switch boosts the effective speed to ISO 1600 for low-light situations. The DS-505, DS-515, E2, and E2s function as any conventional single lens reflex camera and feature auto focus, auto exposure, and auto white balance as well as offering full professional camera capabilities equivalent to Nikon's top-of-the-line F4 model. Since the bodies carry the Nikon name and lens mount, they are compatible with a wide range of lenses, flash, and professional accessories and allow Nikon shooters to pack an electronic body along with their conventional equipment like the N90s.

In the Studio

The high-end digital cameras and interchangeable camera backs for medium and large format cameras are aimed strictly at professional in-studio use. These cameras are designed to be used by advertising photographers who create images from art director's sketches and often convert finished images directly into separations suitable for printing in four-color publications. Some backs require view cameras and must be directly connected to a computer, and it's not unusual for special high output lighting to be required to minimize image capture time. These cameras and camera backs create megapixel images in large file sizes, but capture the high quality needed for advertising and catalog work. The image quality is as good as film and most of the cameras in this class will provide a nine f-stop range of color and density. While some silver-based films will provide a 10-stop range, no one is denying that the quality of output of these cameras is the equal of conventional film technology. Only the price is standing in the way of wider acceptance by entry-level pros and advanced amateur photographers.

This category contains digital imaging backs that are designed to be attached to existing professional medium-format and 4x5 view cameras. Price, as you will see, also limits their use to the most high-profile, high budget photo project. The Dicomed Digital Camera, priced at $21,500, inserts into any 4x5-inch view camera like a standard film holder. Designed for capturing still images, the camera back uses an Eastman Kodak RGB CCD array to achieve a resolution of 6000x7520 pixels. The single-pass device can capture a 130MB, 36-bit color image in 3 to 15 minutes, depending on lighting

conditions. The camera back, which requires high-intensity studio lamps for shorter exposures, comes with a 1GB hard disk, dual SCSI ports, and a 20-volt battery pack, along with software to control camera settings, such as color balance, contrast, and composition. The camera back has independently programmable electronic shutters for each color channel, digital signal processors to control color correction, and three 12-bit analog-to-digital converters that provide a variety of f-stops.

Leaf Systems' $55,000 CatchLight single-exposure digital camera back features a CCD capable of capturing 42-bit images (14 bits per color channel) at 2048x2048 pixels. The CatchLight works with the Hasselblad 553 ELX and 500 EL series, Mamiya RZ67, and professional cameras. You'll need a Power Macintosh 8100 with 72MB of RAM and a free NuBus slot to accommodate the unit's interface card. The back ships with a native Power Mac utility for capturing and handling photos.

PhotoPhase Inc. offers five high-resolution digital camera backs that connect popular professional cameras to a Macintosh computer. Backs for the Hasselblad 503 and 500CM, Mamiya RZ67, and Fuji GX 680 cameras have a frame size of up to 2.4x2.4 inches and the backs for 4x5 view cameras have a maximum exposed frame of 2.8x3.9 inches. The backs provide resolutions ranging from 4000x4000 to 5000x7142 pixels. Each camera back requires a PhotoPhase CC1 Camera Computer, which connects to the Mac by way of a SCSI cable. The CC1 records images directly to the hard disk and performs image processing and translation of images into TIFF file formats. The camera backs come with software that displays images, provides tools for adjusting color, tonal range, and gradation.

Sony's $15,000 CatsEye DKC 5000 digital camera (Figure 3-5) features real-time, full-color image capture of 1.3 million pixels. The CatsEye is a professional studio camera capable of producing 2 images in 10-bit color at a resolution of 1520x1144. An Expansion Memory kit allows the creation of eight additional images and prints directly to a Sony Digital Color Printer without using a computer. The camera has the ability of working at ISO speeds of 100, 200, and 800 and an electronic shutter capable of speeds from 4 seconds to 1/10,000th of a second, making it ideally suited for the creation of in-studio portraits. Other features portrait photographers will enjoy are compatibility with existing strobe or "hot lights" and the ability to adjust zoom, focus, and aperture manually or by remote control.

FIGURE 3-5:
Sony's odd-named CatsEye system is a "bridge" studio camera that combines the price point (and resolution) of a field camera with features a professional studio photographer—especially portrait shooters—will appreciate. (Photo courtesy of Sony)

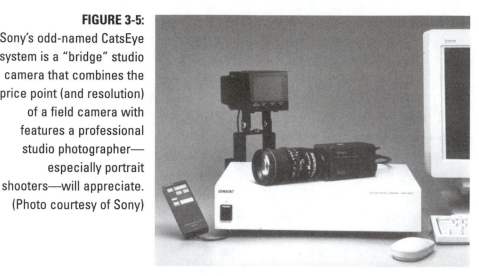

Video Cameras

Because of their inherent low resolution, consumer level video cameras and camcorders don't provide the highest quality form of digital image acquisition. If you're interested in "the ultimate image" this would not be your method of choice. There are, however, many photographers who want to take advantage of the ease of use, low-cost (comparatively), and availability of video cameras. That's why they are a great way to acquire images used in creating driver's license photographs and other forms of ID photography.

It's tricky to convert an NTSC television signal into a computer's video signal. One of the biggest problems is that there are differences in the horizontal and vertical scan rates between the television and computer video graphics. To get a computer to display or acquire NTSC video there must be a device that converts the scan rates between the two. Keep in mind that the old computer saying of GIGO (Garbage In, Garbage Out) especially applies to video capture hardware and software. If you make a (high resolution) 4x5 copy negative of an 8x10 print made with Kodak's now defunct (11x17mm) disc camera, the quality of the copy—although high resolution in nature—will be only as good as the original it photographed. There are several different types of conversion hardware. Manufacturers sometimes

offer all three types or often just one. So you'll know the difference between them, here is a quick look at video conversion:

- Video encoders: Are not technically converters. With this kind of device, the hardware does not perform any actual scan conversion. That function is performed by the control software. This process works because all video display cards are, to some extent, programmable and they can be made to change their video output parameters (including frequencies) by software manipulation of the card's BIOS. The advantages of this type of system are that the hardware is inexpensive, and the output will support 8-bit image quality up to 640x480. The disadvantage of this approach is that not all video cards will do what the software tells them. This goes back to the non-standard "standard" of computer video that abounds in the IBM-PC environment. Last, support for Windows 3.1 is limited. How well this method works with Windows 95, at this writing, remains to be seen.

- Line converters: Convert the horizontal frequency of computer video to that of TV. The hardware stores up the computers' horizontal lines, then displays them at the lower NTSC rate. This kind of device does not typically convert the vertical frequency and requires the vertical frequency of the graphics card to match that of the TV—60MHz. The software that accompanies these devices can be run to set the vertical frequency of 60MHz. These types of device have much more widespread compatibility with video cards and can display up to 24-bit video. Line converters are then, necessarily, more expensive and still can have incompatibilities with some video hardware.

- Frame converters: These devices use the hardware to convert both horizontal and vertical scan rates. This kind of converter is completely independent of the input video and computer. Because all controls and features are built into the converter, it will convert any Mac or IBM computer without requiring any kind of control software. An overlay feature allows the converter to synchronize the timing of its converted video to another video source—such as the output of a VCR. Once the two signals are in synch, the hardware mixes the

converted computer display and live video. This may be the most expensive method, but it is truly independent of the computer, so it will work with any computer or graphics display.

Video Capture Products

At COMDEX '94, Play Inc. introduced its new Snappy video capture module that looks like the easiest-to-install desktop video product available for Windows computers. All you have to do is plug the compact module into the parallel port of your PC, connect a camcorder or VCR to it, and when you see what you want on your computer's screen, you simply click "Snap" and the software freezes the video. The bundled software includes a mixer that can enhance the images after you've captured them. For a list price of $199.95, Play includes several interesting digital image manipulation programs. Another interesting video capture product is Media Cybernetics MRT VideoPort Imaging Systems. The resolution of the digitized image can be adjusted up to 768x768 pixels, the maximum resolution of a standard PAL (European) video signal. What's unusual is that the board is available as a PCMCIA card that can be installed in any laptop or notebook computer. Bundled with the board is Imager software that can enhance captured video images as well as scanned or Photo CD photographs.

One company that's long been involved in video capture using personal computers is Digital Vision. Their family of ComputerEyes products set the original industry standards for video capture. The ComputerEyes/1024, for example, is under $600 and is a ISA bus board designed to capture 24-bit video data from any source at a resolution of 1024x512. The board can also capture motion video clips at the NTSC standard 30 frame per second rate. For simpler connection, Digital Vision offers the ComputerEyes/LPT model, shown in Figure 3-6, for under $400. Instead of requiring a board installation, the LPT uses your computer's parallel port and can capture 24-bit color or 8-bit grayscale images with a maximum resolution of 640x480. Software bundled with both ComputerEyes products lets you save the images in standard graphics file formats. For use with Macintosh computers, the ComputerEyes/RT uses a SCSI interface to capture 24-bit images at a resolution of up to 512x512.

FIGURE 3-6:
Digital Vision's
ComputerEyes/LPT video
capture system uses your
computer's parallel port,
making it ideal for use
with laptop computers
connected to camcorders.
(Photo courtesy of
Digital Vision)

Pros and Cons

By now you may be asking: What is the right tool to use for my work—a digital camera or video capture system? The answer boils down to asking yourself several questions:

- What is your budget?

- How will the images be used?

- What is the source material?

Let's look at them in reverse order. The quality of the original or source material may be the single most important means of determining which method will work best for you. Some applications are a slam-dunk. If you're a video producer, using video capture is the best way to get "real" video images into your newsletter, storyboards, or promotional material. The same is true for the production of digital IDs. Instead of using Polaroid instant film and cameras—in which you have to actually expose a frame of film (and pay for it) before you know what the ID portrait looks like—you can grab a frame off a video camera and examine it on screen before outputting to a digital printer. Video conversion and capture are a good source

of acquisition for the person whose main product is video tape and who has only occasional need of a digital still image as well as a way of documentation, where the resolution of the final image is not critical.

When resolution becomes an issue, you'll want to examine the digital camera alternative and match the price of the camera and its resolution to the required output. How the images will ultimately be viewed will define the required resolution for acquisition. If you need photographs of a new home to place in a For Sale flyer, a $55,000 Dicomed camera back is clearly out of the question. The right equipment would be a digital point & shoot camera—if timeliness is a concern. On the other hand, if you need to make photographs of every house on a block for zoning purposes—and resolution isn't critical—using a camcorder to photograph the block (while someone else drives down the street) gets it done quickly and with little fuss.

The question of budget brings us back to the inevitable quality, price, and speed equation. It doesn't matter if a Kodak DCS 460 is the perfect camera for your application if you don't have the $11,000 one of these cameras costs. In fact, all of these questions boil down to: quality, price, and speed, choose any two.

When you're finally finished with your analysis, you may find that none of these methods truly satisfy your digital imaging acquisition needs. In that case, it's time to look at the next step: scanners.

SCANNERS

Scanners are useful hardware peripherals that convert traditional photographic images or film frames into digital form. These devices accomplish this by passing a light-emitting element across your original—scanning—and transforming the analog image into a group of pixels that is ultimately stored in a digital file. There was a time, not so long ago, when scanners were so expensive only large advertising agencies and service bureaus could afford them. Now, scanners have a wide range of prices to fit everyone from the casual snapshooter and independent designer to professional and advanced amateur photographers. As hardware prices have dropped, scanners have become an indispensable peripheral for pixographers.

Scanner Varieties

Scanners come in three basic types with variations on each theme. Hand-held scanners let you do all the work—you digitize an image by physically

rolling the scanning element across the face of an original print. Hand-held scanners have the advantage of being inexpensive (after all, you supply the labor) but the disadvantage of being limited by the width of the scanner's head. Some hand scanners include software that allows you to "stitch" separate scans together. How well this process works depends on the steadiness of your scan and the software itself.

Hand scanners are great for occasional scans, but if you want better results you'll need to get a desktop scanner. Sometimes called "flat bed" scanners, desktop scanners look like small copy machines and, in fact, there are similarities in how they work. (Some scanner companies, like Hewlett-Packard and Canon, include a "Copy" utility that enables the scanner to make prints of the scanned document on your laser or ink-jet printer.) All good, i.e., photographic, color scanners will provide 24-bit color depth images with each of the channels containing 256 colors. More upscale scanners offer a 30-bit depth scan that uses three 10-bit channels. Thus, 30-bit scanners, such as the Epson ES-1000C, allow you to create scans containing 1 billion colors. Epson's 30-bit system works a little differently and stores the best 24 bits in digital form. Need more bit depth? Microtek offers a 36-bit scanner, the ScanMaker III, that provides up to 68 billion colors. Flatbed scanners come in different resolutions and the one that's right for you will be the one that matches the resolution and quality of what you want for your final output. For most pixographers, a flatbed scanner is usually the answer but another variety, film scanners, allows you to scan negatives and transparencies in much the same way as flatbed scanners. They are usually more compact and their cost and design is based on the different film formats that they scan.

What Makes a Good Scanner?

The first scanners used in the publishing industry were drum scanners that were based on PMT (Photomultiplier Tubes). These scanners function by focusing a light source onto a small area of the original transparency that is mounted on a rotating drum. That's why they are called drum scanners. The light is directed onto mirrors and then through red, blue, and green filters before entering the photomultiplier tubes that act as optical amplifiers. Analog to digital converters then change the analog voltages coming from the PMT into digital form. This technology is capable of handling a wide

range of image density and produces high-quality output, but the complexity of the technology makes it expensive and requires skilled technicians to make it perform up to its capabilities.

Depending on design, flatbed scanners automatically make one or three passes across an original placed on flat piece of glass. Traditionally, scanners use a Charged Couple Device (CCD) array consisting of several thousand elements arranged in a row on a single chip. Three-pass CCD scanners use a single linear array and rotate an RGB color wheel in front of the lens before each of the three passes are made. A single-pass scanner uses three linear arrays which are individually coated to filter red, blue, and green light. The same image data is focused onto each array simultaneously. These days, scanners are measured by their *optical* as well and an *interpolated* resolution. Optical refers to the raw resolution of the scanner that's inherently produced by the hardware, while interpolated resolution is a software technique that's used to add pixels to simulate a higher resolution.

Another important measure of scanner performance and its ability to produce photographic quality scans is dynamic range.

In photographic terms, dynamic range refers to the range of f stops that an image contains. For film this range can be as high as nine or ten stops. A scanner's dynamic range depends on the maximum optical density that can be achieved and the number of bits captured. In simple terms, the greater the density range (4.0 is perfect) the greater the number of tones it can capture and the better the quality of the final scan. While film can handle 9 to 10 stops, the reproduction process is currently limited to four. That's where this magic number comes from. Until recently only expensive scanners offered a density range over 2.5, now more affordable scanners can perform at 3.0 or higher. By comparison, a Photo CD scan (see Chapter 5) has a dynamic range of 2.8.

How well your scanner performs depends on the software that accompanies it. I think scanner software is often more important than the hardware. No matter how high a scanner's resolution, if it's not easy to use, you won't be able to get usable results. This is especially true if you also plan on using your scanner for *optical character recognition* (OCR) of text.

One of the most important developments in making scanners easy to use is implementation of the TWAIN standard that allows compliant software

FIGURE 4-1:
Scanner software is just as important as the hardware and must make it easy for you to acquire the image. ScanTastic, which Epson bundles with its Mac-based scanners, gives complete software control over your scanner, including prescanning. (Photograph of child ©Mary Farace)

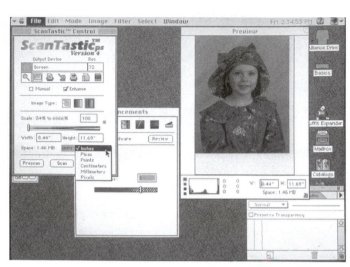

to scan text or images directly. When shopping for scanners, my recommendation is that you should base 60 percent of your decision on software and the rest on the hardware specifications.

Scanning represents the most popular way of creating digital images from analog photographs. In the following sections, I'll introduce you to select groups of scanners. The products that are included are not the only scanners available and represent a sample of the different hardware options.

Doing It by Hand

Hand scanners used to be the most common type of scanner available, but as the price of desktop scanners has dropped, the number of hand scanners available has greatly diminished. As this trend continues, I expect them to finally disappear. In the meantime, hand scanners represent the simplest, cheapest way to digitize small original photos, and here's an overview of what's available today.

What's Device Resolution?

In general usage, resolution refers to how sharp or (as non-photographers put it) "clear" an image looks on the screen or when printed or

imaged as film. Device resolution refers to the number of dots per inch (dpi) that a device, such as a monitor or printer, can produce. Device resolution for computer monitors can vary from 60 to 120 dpi, but don't confuse this with screen resolution which refers to the number of dots per inch in the line screen used by printers to reproduce a photograph. A 21-inch monitor has more pixels than a 13-inch one, and it's possible a monitor can display several different pixel-per-inch specifications. If you don't change the magnification level, what you see at 64 dpi is simply a closer look at the same photograph, and since the pixels are larger, it only appears to be *lower* resolution. Screen resolution is measured in lines per inch (lpi). Image resolution refers to the amount of information stored in a photograph and is typically expressed in pixels per inch (ppi). The image resolution of a photograph determines how big the file is. The important thing to remember is that the higher the image resolution, the more disk space it takes and the longer it will take to print or image.

Hand scanners come in resolutions that range from 100 to 800 dpi. Most are only about 5.5 inches wide, but can only scan a 4-inch-wide path at one time, which limits their use to smaller originals. They are available in both grayscale and color version. Artec offers two hand scanners for Windows users: The ViewScan/Gray 256 is an 8-bit grayscale hand scanner with user variable resolution from 100 to 800 dpi. The ViewScan/Color 16M, its color sibling, is a 24-bit hand scanner that offering resolutions from 100 to 1600 dpi. Artec includes a parallel port adapter allowing you to connect the scanner without having to install an interface card. If you're looking for a mobile scanner, you might try Artec's WalkScan Kit that runs off battery power, allowing you to take the scanner on the road.

Logitech offers a number of "ScanMan" grayscale and color hand scanners, including ScanMan EasyTouch, ScanMan 256, and ScanMan Color. The EasyTouch is a 256-level grayscale hand scanner that can scan at resolutions from 100 to 400 dpi. The scanner's size of 5.5 inches limits your scanning width but the software includes an AutoStitch feature that can match up multiple scans and merge them into images as large as 15x22 inches. How well AutoStitch software works depends more on the original image being scanned and how straight you can roll the scanner than on the software provided. Logitech also includes OCR software to convert scanned

text into digital documents. As with AutoStitch software for graphics, OCR with hand-held scanners can be tricky and your success converting scans into documents will depend on how steady and straight you scans are. Don't be discouraged. Practice! Logitech also bundles their own brand of image editing software that will let you edit 256-level grayscale images and even add color highlights to a black & white image.

A unique hand scanner is The DataPen, sold by Primax. It looks and is used like a pen, which makes scanning text very easy. Hand scanners are usually manual jobs, but their Color Mobile Pro, which is motorized, makes scanning easy with resolutions possible up to 1200 dpi. Why motorized? The scanner automatically changes speed according to the complexity of the image to minimize the inconsistencies inherent in the hand scanning process. The ColorMobile Pro is a combination of a motorized hand scanner with sheet feeding capabilities that have been designed to be used with laptop and notebook computers. It can scan color or grayscale images at resolutions from 100 to 400 dpi.

Primax's DataPen is (believe it or not) a pen-shaped hand scanner that transmits text data directly into any Windows or Macintosh word processing, spreadsheet, or database program. The ColorMobile Pro is a 24-bit *motorized* color hand scanner. This Hand Scanner 32 is a budget-priced

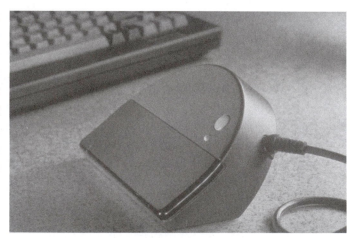

FIGURE 4-2:
Hand scanners, like Logitech's ScanMan Easy Touch, are the least expensive way for pixographers to convert silver-based prints into digital images. (Photo courtesy Logitech Inc.)

FIGURE 4-3:
The EasyPhoto
Reader, from Storm
Software, is the first of
a new breed of snapshot
scanners that make it
possible to turn 4x6 and
smaller prints into
pixels. (Photo courtesy
Storm Software)

unit ($89) with resolutions from 100 to 800 dpi that has been designed to scan any image into black & white and convert it into 256 grayscale.

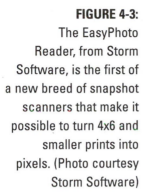 Snapshot Scanning

Positioned somewhere between hand scanners and flatbed scanners, Storm Software's EasyPhoto Reader may define a new class of small scanners. The EasyPhoto Reader is a small scanner—smaller than your mouse pad—that automatically scans snapshot-sized photographs. To use it, you place a photo in the feeder tray and press the start button. The scanner inputs the image directly into the EasyPhoto software. The scanner plugs into the parallel port so set up is a snap.

Flatbed Scanners

The number of flatbed scanners available can be bewildering to the new pixographer, and many sport names of film and camera companies. Shopping for a scanner is a matter of setting your goals for the type of images you will be starting with and what form your output will take. Ask

yourself what the maximum size of your original images will be. This tells you how big the scanner must be. Next, ask what will be the resolution of the output—in other words, what printer will you use. (Part IV, *Output* will take a look at output options and printers.) If you will be printing your images on a 300 dpi laser printer, you don't need a scanner that will produce a digitized image at 2700 dpi. If you do, the printer will merely discard the unused information. Next balance the performance of a scanner—how fast it will produce a digitized image—with price and resolution. Only then should you start shopping for a scanner. Here's a brief look of the scanners that are awaiting you in the computer store and through direct mail. For complete specs on most available flatbed scanners, see Appendix B, *A Look at Flatbed Scanners*.

Artec's 24-bit ViewStation scanner uses a cold cathode fluorescent tube instead of the more commonly used hot lamps. The changes give the "cold" version a life of 10,000 hours compared to 300 to 500 for hot lamp scanners. It takes 51 seconds to do a color scan of a letter-sized document or photograph. How might that compare with other flatbeds? Flatbed scanning speeds vary from 10 to 70 seconds, placing ViewStation slightly higher than an average. The scanner has an optional document feeder and transparency kit.

If you're looking for inexpensive high-tech-looking scanners, you might check out the Canon line. They are small, cheap, and look cool. They are fast, too. The 24-bit color IX-4015 Canon scanner has a grayscale scanning rate of 10 seconds. It takes 20 seconds to do a color image. The IX-4015 is available for both Windows and Macintosh computers.

Epson's new ES-1000C is a low-cost 30-bit color scanner that's useful for OCR applications as well as high quality photographic scans. A 30-bit scanning capability lets it recognize over one billion different hues, from which the best 24-bits are sampled and stored in digital form. The scanner has an Auto-Page Segmentation feature that automatically separates text from images and allows for simultaneous grayscale image scans and black & white text scans when both types are on the same page. Dual connects on the scanner make it possible for connection to a PC and Macintosh at the same time. The Mac version also includes the ability to scan multiple pictures at the same time. Both the ES-1000C and Epson's existing ES-1200C scanner is capable of either single-or-three pass scanning. When scanning an original photograph or piece of artwork, a single-pass scan is all most people require.

However, when scanning material that has been printed, a three-pass scan will almost always remove the inevitable moiré or dot pattern. Moiré (pronounced "mwah-RAY") is frequently encountered in scanning photographs. Moiré is a French word that means "zis pattern which drives ze eyes crazy!" It's an optical illusion caused by a conflict with the way the dots in an image are scanned and then printed.

Envisions' DynamicPro30 color scanner uses cold lamp technology that translates into lower power consumption and operating temperature, increased lamp life, and no warm-up time before use. Hewlett Packard's ScanJets 3p and 3c accept documents up to 8.5x11.7 inches and there's an optional 20-page document feeder. There's an optional adapter that can scan transparencies from 35mm up to the scanner's maximum page size. Microtek's ScanMaker III has a maximum scan size of 8.3x13.5. Its most impressive feature is a dynamic range approaching 3.4 that compares favorably with high-quality drum scanners.

UMAX Technologies offers the Gemini D-16, a dual-lens, 30-bit color flatbed scanner that delivers an optical resolution of 800x800 dpi and a hardware resolution of 800x1600 dpi. The dual lens concept is similar to a photographer using a standard lens to capture the normal resolution and switching to a telephoto lens for greater detail. Maximum scan size at 400x800 dpi is 8.5x11.5, but it shrinks to 4.25x11.5 when done at 800x1600 dpi. It's fast too. A color preview takes just 3.5 seconds and a single-pass 400 dpi scan of an 8 1/2x11-inch image takes 20 seconds. The scanner ships with UMAX's software that provides batch scanning, descreening to eliminate moiré patterns, and auto exposure. The software also provides three levels of Unsharp

FIGURE 4-4: Hewlett-Packard's ScanJet 3c is a typical desktop flatbed scanner. It's a 300 dpi 30-bit color scanner that can produce interpolated 2400 dpi images and grayscale images with 1024 gray levels. (Photo courtesy Hewlett-Packard)

masking, color inversion, auto scaling, sharpen and blur filters, and color balancing. A transparency adapter is optional.

◄ A New Class of Scanners

A new class of scanners has been introduced with the sole purpose of processing paper for OCR purposes or grayscale photographs for digital imaging use. There are not many of them, but if you're looking for a low-cost scanner for photographic purposes, this may be just what you need.

Epson's Personal Document Station's Text Enhancement Technology feature increases OCR accuracy by removing background colors and the miscellaneous artifacts that are found on faxed documents. The scanner comes with a 10-page tray that folds out of the way when not in use and feeds papers into the scanner at 4 pages per minute.

Plustek's PageReader 800 is not only a scanner but also makes 800 dpi copies and is a fax! Weighing less than a pound, this compact scanner is the approximate mass of a three-hole punch. Optical resolution is 400 dpi, which is interpolated up to 800 dpi, and it has a speed of six pages a minute when set in 200 dpi black & white mode. There's no off-on switch; it wakes up when you insert a page. The one-step OCR process automatically "retypes" printed documents into any Windows word processing program. PageReader 800 is for PCs only, and its interface card uses any available 8-bit slot. A more expensive parallel port portable version is available. Visioneer's PaperPort for Mac and Windows computers is an interesting hybrid scanner. Its ease-of-use makes it closer to a hand scanner than a flatbed scanner but its no-nonsense design and capabilities place it closer to a flatbed. There's no off-on switch. It turns on when you insert a page, and turns off when a scan is completed (a scan takes about six seconds). It can read documents as small as a business card or up to 8.5x30 inches. Both versions use a serial connection, and the drag-and-drop scanning software offers three modes: normal text, fine print, and photo. Once scanned, the *WordScan* OCR software lets you convert paper documents into editable text. There are also links to popular Macintosh and Windows fax, OCR, and word processing programs. Visioneer also includes *PaperPort Viewer* software that can be distributed with your digital documents so they can be viewed by other Macintosh or Windows users.

Film at Eleven

Slide and film scanners provide an alternative to using flatbed devices. One reason they're popular is that they eliminate a generation by scanning the original film. Besides removing the print phase from the process—a print is only an interpretation of the original film frame—you save the cost and time associated with having a print made. Because they scan smaller bits, film scanners take less desktop space too. The things to look for in a film scanner are similar to those you would use for a flatbed scanner:

■ What film sizes does it scan? If you only shoot 35mm, don't spend more money for a larger, more expensive scanner that can handle up to 4x5 sheet film sizes.

■ What is the scanner's optical resolution? Some recommend that a scanner have a resolution of 2700 dpi, but the resolution of your scanner still depends on the resolution of the output. Nevertheless, higher resolution scans are more important with slide scanners because the image that is scanned will be enlarged far greater than the image typically scanned with a flatbed scanner.

■ What's the dynamic range? Until recently only the most expensive slide scanners (those that cost more than $6000) offered dynamic range greater than 2.5; now more affordable scanners, such as Polaroid's SprintScan 35, offer a range close to 3.0.

Looking more like a film recorder than a film scanner, Agfa's Mac-only SelectScan has an optical resolution that's user-selectable from 720 to 4000 dpi. You know it's a serious production scanner when you take a peek at its micrometer-like film stage that holds transparencies from 35mm up to 8x10 sheet film, but SelectScan can also scan up to 8.5x11 reflective copy in a single pass. The scanner can also produce a dynamic range of 3.9, making it the most powerful scanner of all the models covered in this chapter.

The Kodak Professional RFS 3570 film scanner features custom-designed lenses and user-selectable image sharpening. It provides an operator-guided autofocus feature that saves time and performs automatic calibration. The RFS 3570 delivers previews in less than 10 seconds and lets you adjust color

and composition, cropping, color balance, and brightness. The scanner includes holders for 35mm mounted or strip transparencies and negatives, and 120 format film (for 6x7 cm, 6x6 cm). Optional holders are available for 6x9 cm, 6x4.5 cm, 4.5x6 cm, 46 mm, and 70 mm. The RFS 3570 offers any user-specified resolution up to 2000 ppi and produces color scans in under one minute at full resolution and 15 seconds at half resolution.

Nikon's Coolscan continues to set the pace for inexpensive 35mm film scanners (See Figure 4-5). The completely solid-state scanner uses red, green, and blue LEDs for illumination, which allow the scanner to achieve a full spectrum output with low power consumption and virtually no heat that could adversely affect the film. The Coolscan is a quiet, compact 24-bit scanner capable of scanning a slide or negative at up to 2700 dpi. This enables users to scan images at sizes up to 11x17 inches at 150 line screen quality. It can do all this in a single pass and is supported with the best software I've seen from any camera manufacturer. Scanning times will vary based on the original image, resolution selected, and the speed of your computer but modest sized (2x3 inches) scans set at 300 dpi take under a minute to complete. More on the Coolscan later on in this chapter.

FIGURE 4-5:
The Nikon Coolscan is a quiet, compact 24-bit slide scanner that's capable of scanning either 35mm slides or strips of negatives at up to 2700 dpi. (Photo courtesy Nikon USA)

Scanning Basics

Scanning graphics is never as easy as the salesperson who sold you the scanner promised it would be. This doesn't mean the process is difficult. You just need to be careful about what you scan and how you scan it. Before you buy a scanner, you need to ask yourself a few questions. How many scans a month do you do? If the answer is in the single digits you may not even need a scanner at all. Small numbers of scans can be done more cost effectively by a service bureau. Having your own scanner means that when you need an image scanned at 3:00 P.M. on Sunday, you can do it.

A Few Rules of Thumb

What are your quality requirements? Are you going to print scanned images on a 300 dpi laser printer, or are they going to be rendered on a high-resolution image setter? With low-res output, you may be able to get by with a less expensive scanner.

Rule Number 1: Match the Scanner Hardware and Software to the Output Device.

Trying to make the wrong scanner do a job it wasn't designed to do and justifying the results by saying "this is the best I could do with the equipment at hand" doesn't make the results acceptable.

As I mentioned in the beginning of the chapter, scanners for personal computers come in three basic types: hand-held, flatbed, and film. Flatbed scanners look like desktop copiers without a place to eject paper. Like a copier, you lift the lid, lay your photograph or artwork on the glass, and close it. The rest of the process is controlled by the scanner software. This process sounds simple, but unless the software can make a good scan of a complex image, like a photograph, getting it right can take as much skill and talent as creating the graphic did in the first place.

Rule Number 2: Scanner Software Is As Important, Maybe More So, Than the Hardware.

Before purchasing any scanner, make sure you feel comfortable with how the software works. Many scanner companies make good hardware, but the best photographic scanning software for flatbed scanners I've seen is

OFOTO from Light Source. OFOTO totally automates the scanning process and even allows you to straighten images that were scanned in at an angle. That doesn't mean you won't encounter problems. Some moiré patterns occur when scanning an image that has already been screened for printing. OFOTO includes sophisticated moiré elimination features to help you get rid of some moiré problems.

Rule Number 3: Don't Buy a More Expensive Scanner Than You Need.

What this rule really means is that often an inexpensive scanner will do all you want. If you need to scan photographs or complex logos, get a flatbed scanner, but hand scanners have always been a low cost alternative.

The widest path a hand scanner can typically scan is 4 inches. This may be adequate for small images, but it's obviously useless with anything larger. Some hand scanners include software that lets you make more than one pass across an image and then "stitches" these passes together. Whether the stitches show depends on the image and the disadvantage common to all hand scanners—how smoothly and evenly you drag the scanner across the graphic in the first place. This doesn't mean hand scanners are useless.

I use a LightningScan Pro 256 scanner to scan black & white logos and small photographs. In 1-bit graphics mode, LightningScan scans line art drawings and graphics as well as more expensive scanners. It's important you keep the scanning area on any scanner clean, but doubly so with a hand scanner because the glass surface is so small. During a scan, any imperfection or dust speck will be repeated dozens of times. Some image enhancement programs have a dirt and scratch removal menu item that can help some, but it's better to start with a clean scanner. Since scratches on the glass can cause problems, use a non-abrasive cleaner on the scanner's glass surface. Hand scanners are great for the person who needs to scan small logos, artwork, or cartoons.

One of the advantages of many flatbed scanners is that they include slide attachments as an (expensive) option, but if you're mostly going to be scanning slides, a film or slide scanner will be more convenient and a better choice. Not only that, but the slide scanner attachments often cost as much as the scanner itself! Nikon's Coolscan slide scanner is as simple to use as any other scanning device. The heart of Coolscan is its cold light source,

consisting of red, green, and blue LEDs that provide consistency without the long warm-up times experienced by flatbed scanners using "hot" lamps. On the front panel there's a slot for inserting slides or negatives. When the scanner starts, it grabs the slide and pulls it inside.

The scanner isn't subject to the vagaries of different film emulsions and seems equally at home with Kodak, Fuji, or Konica films, but some images will give it problems—just as they will with any scanner. Slides of a white horse on a background of green grass initially produced cyan results, and some wildlife images made on Kodak color negative film had this same "blue" look. The software permits control of brightness, contrast, color balance, and its gamma-curve editor lets you create custom color correction settings. The Coolscan will also scan black & white negative and positive images. For scanning negatives, Nikon includes a film holder that can be used with strips of 5 to 6 negatives. The film holder looks similar to a negative carrier used in a conventional photographic enlarger. It's probably a good idea to keep a can of environmentally friendly air next to your computer to blow off any dust specks that might attach themselves to your slide or negative just as you do in your darkroom. If you do, it will save retouching time later on.

Most scans consist of four major steps: specifying the size and resolution of the image, previewing the photograph, tweaking cropping and color, and finally scanning the image. Any further manipulation and modification of the photo will require image enhancement software, which will be covered in the next section of the book.

Rule Number 4: The Quality of the Scan Depends on the Original Image and the Software's Ability to Balance Sharpness and Color Quality.

Like all scanners, convenience is the main advantage of using a film scanner, while cost remains the major disadvantage. Maybe the scanner you need isn't a scanner at all. If all your scanning needs are from film (slides or negatives), Photo CD—see the next chapter for details—may be all you ever need.

Rule Number 5: If Your Budget Permits, Get the Highest Resolution Color Scanner You Can Afford.

If you only scan "flat art" like black & white logos or color photographs, a flatbed scanner will be best. That's because your future needs will increase

along with your expectations. Black & white flatbed scanners have all but disappeared as the prices on color scanners have dropped. If you only need to do occasional black & white or grayscale scanning, a hand scanner will do the trick. Don't overlook used scanners. I recently saw a used Apple grayscale flatbed scanner selling for $150.

As you'll discover in the next chapter, you won't find a higher quality scan at a better price than Kodak's Photo CD. If you can't wait for someone else to make the scans, look into a slide scanner. Remember, no single device can solve all your scanning needs or problems. Finally, before making any investment in a scanner, pick up a copy of *Real World Scanning and Halftones* from Peachpit Press. This excellent book is written by two guys who know scanners inside and out. Invest 25 bucks in the book before investing in any scanner.

Making Scans

Now it's time for a crash course in scanning. I'll show you how to use the ThunderScan hand scanner to scan a photographic print, and then we'll see how to scan a slide.

The software and hardware configurations for Thuderware's LightningScan Pro 256 are similar to most hand scanners, but before using it you may want to make a few adjustments. Even before that, you want to find a place to make smooth, straight scans. It's a good idea to tape down your original—you can use 3M's Scotch Brand Positionable tape. This tape has the same kind of semi-sticky adhesive used by Post-It Notes and doesn't leave any residue behind. It's also transparent enough so that if you roll the scanner over it, the tape is invisible. Call it stealth tape. (Scotch Brand Positionable is also a great tape to use if you have to tape medium-format negatives into the preformatted masks that most color labs use for machine prints.)

Here's an example of using a hand scanner:

- Step 1: Make sure to select the resolution you want. Pick what is appropriate for your project, and if you have any higher options it's a good idea to go to the next step. The LightningScan Pro 256 can do

a 400 dpi scan, and I usually select it even though I may only be printing at 300 dpi. Why? Using a hand scanner always involves a certain amount of compromise, so if you can squeeze a little extra visual quality out at the beginning, it's a good hedge.

⬛ Step 2: Select grayscale for scanning photographs—even if it's a color original, as was used in this instance.

⬛ Step 3: The only other control on the scanner is a lighten-darken control much like that found on Polaroid Instant Cameras. Until you get familiar with your scanner try the middle setting. With experience, you may find that scanning lighter or darker originals can be improved with slight adjustment of this control.

⬛ Step 4: Launch the ThunderWorks software that comes with the scanner.

⬛ Step 5: Select New Scan from the Scanner Menu, hold down the scanner button, and start scanning. Thunderware helps you make straighter scans by providing a plastic SnapGuide that attaches to the scanner head. It gives the scanner a square edge that, when used with the rule that's provided, will help you make straight, or reasonably straight, scans. If you go too fast, your computer will beep, telling you to slow down. If you're too pokey in lining up your scanner before starting, you'll get a time-out warning and have to click the Restart button.

⬛ Step 6: As you scan, a portion of the scan will appear in the window. This will be the first indication if your lighten-darken control wheel is set too light or dark. If so, stop the scan, adjust the wheel in the direction indicated on the scanner, and click the restart button. The only other problem you could run into when scanning is lack of memory for a particular image. If you don't have enough memory allocated to ThunderWorks (I have 4800K selected), you won't be able to complete the scan. Close the program, change its memory allocation, and re-launch.

■ Step 7: When the scan is done, click the Done button and the image will be placed into an environment that provides some controls over what you just scanned.

I know what you're thinking. If a hand scanner is that easy to use and doesn't cost too much, how good can the output be? Take a look at Figure 4-7 and see for yourself.

FIGURE 4-6:
ThunderWorks will never be mistaken for an image enhancement or manipulation program (see Chapter 6 for more information on that kind of program), but it does provide some useful controls.

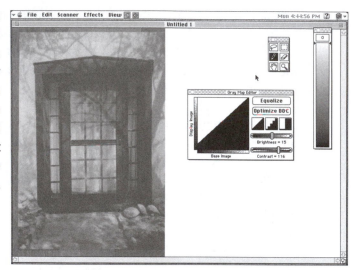

FIGURE 4-7:
This image was originally a 4x6 color print scanned with the LightningScan Pro 256 Scanner. The image was cropped (to remove extraneous areas, not part of the photograph) and the brightness and contrast were adjusted with ThunderWorks' slider controls. The image was then printed on an Epson Stylus Color at 720 dpi.

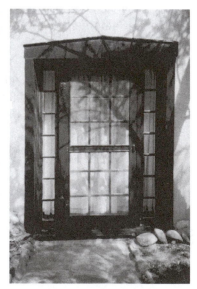

ThunderWorks provides "tack" and "skoogy" software tools that, if you're careful, can seamlessly join two scans. But any stitched-together scan suffers from the inherent deficiencies I mentioned earlier. Thunderware recently announced it will accept plug-in modules that use Adobe Photoshop's plug-in filter specifications. (For more information on plug-ins and what they can do for you, see Chapter 9.)

Scanning a Slide

The steps involved in scanning a photograph or transparency are similar for most flatbed and film scanners and include many common elements. To show what's involved in performing a scan, let's look at the steps involved in scanning a slide using the Nikon Coolscan:

■ Step 1: Insert a slide into the slot on the front of the Coolscan. Don't worry about orientation or which side the emulsion faces. (We'll soon get to making sure the slide is oriented properly.)

■ Step 2: Launch Nikon's Scanner Control software. When you do, you'll see the dialog box shown in Figure 4-8.

FIGURE 4-8: After you launch Nikon's Scanner Control software, you'll see a dialog that gives you control over an image before an after the scan.

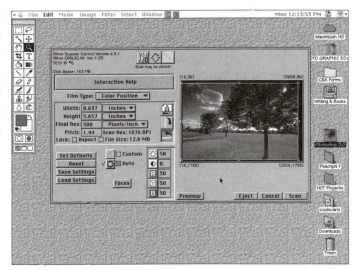

■ Step 3: Select the resolution at which you would like to scan the image. The resolution you select will be based on how your image will be used. If you're just pasting it into a newsletter that will be printed on a 300 dpi laser printer, pick 300 dpi. If the photograph's going into a glossy newsstand publication, you may want to choose the maximum resolution of 2700 dpi. Choosing larger resolutions results in large file sizes, and you must be capable of handling that size of image. That's why the software tells you how big the file is.

■ Step 4: Next you will perform a Preview Scan. A preview scan is a quick pass of the image at low resolution that allows you to see what the scanner sees. A cropping rectangle appears on the preview allowing it to be cropped—so when you do the final scan, you are only digitizing that portion of the image you are interested in. You can also change the orientation of an image. If you insert a slide or negative backwards or upside down, Nikon's software is sophisticated enough to let you click a button to flip the image back to normal. The same is true if the emulsion's facing the wrong way. Although the unit has built in autofocus, a manual focus control is available to let you adjust image sharpness. Scanner software also lets you tweak image brightness and color balance, so when you make the next, and final scan, it's as good as it can be.

■ Step 5: Click the Scan button and begin the scan. One of the major considerations about using any kind of scanner is how long it takes to produce a scan. The time a scan takes can vary based on the resolution selected and the cropping chosen. Nikon claims a 2.5-minute-per-image average time, but almost all the scans of the slides and negatives I make take less than that.

■ Step 6: Save the file in a file format that fits your application. The software allows you to save your images in PICT or TIFF formats and view them at multiple levels of magnification. As you can see, the Coolscan is as easy to use as a toaster, or is it?

Scanning the Horizon

There are all kids of scanners for all kinds of different needs. Whether you choose a hand-held, flatbed, or film scanner, keep in mind that your specific application and needs will determine what is best for you. Since there are so many different kinds of flatbed scanners, the chart in Appendix B compares relevant specifications for the products currently available. Like everything else in the wild, wild world of computing, expect specifications to get better and prices to drop, but sooner or later you have to make a decision. The chart will help you do that.

LAB PROCESSES

One of the easiest ways to digitize photographs is to have someone else do it for you. This is especially true if your digitizing needs are only occasional. Having images digitized with lab processes like Kodak's Photo CD and Seattle FilmWorks' Pictures On Disk is probably the least expensive way to get started with image acquisition. One of the major advantages to both processes is that neither requires that you make much of an investment in additional computer hardware, and both let you use the cameras and film you're already using. Photo CD does require a Photo CD compatible CD-ROM drive, and Pictures On Disk only needs a floppy disk drive—in other words, you probably already have the equipment needed to use both processes. Both Kodak and Seattle FilmWorks provide low-cost "gateway" software that can convert their proprietary image files into more popular Macintosh and Windows graphics file formats. Kodak's Photo CD system is cross-platform, and all of its products and software are compatible with Windows and Macintosh computers. Pictures On Disk is, currently, a

Windows-only product and service, although a Mac version is planned. Mac users interested in using Pictures On Disk can use Insignia Software's SoftWindows 2.0—but not any earlier version—to run Seattle FilmWorks' gateway software called PhotoWorks Plus 2.0.

 # Kodak's Photo CD

A lot has happened to Kodak's digital imaging products and services since the product's original introduction almost two years ago. The most significant cosmetic change is Kodak's announcement of a brand mark to be called Kodak Digital Science. This new brand name will appear, on a phased-in basis, on all the company's digital imaging hardware, software, and service offerings. Other changes include a major revamping of the Photo CD disc line-up, software that lets Macintosh and Windows users produce Photo CDs on their desktop computers, and an opening up of the Photo CD file format itself.

To get a Photo CD made, all you have to do is take your exposed, unprocessed film to a photofinisher who will turn your analog film images into digitized photographs. If you give them transparency film, you'll receive a box of slides along with a Photo CD disc containing all the images on the film. If you shoot negative film, you'll get a stack of prints along with the disc. Photo CD facilities can also digitize images from existing color slides

FIGURE 5-1:
Having a Photo CD made is the easiest form of image acquisition because somebody else does all the work. For the location of your nearest Photo CD dealer, call Kodak at 800-235-6325. (Photo courtesy Eastman Kodak)

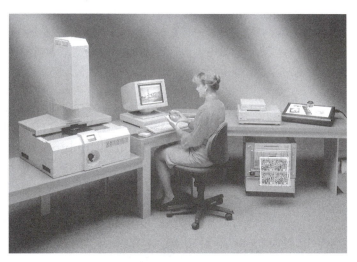

and black & white or color negatives. To produce a finished disc, a Photo CD Transfer Station converts your analog images to digital using a high-resolution film scanner, a Sun SPARCstation computer, image processing software, a disc writer, and a color thermal printer. During the process, each image is prescanned and displayed on the Sun's monitor. The operator checks the orientation (portrait or landscape) of the image and begins a final, high resolution scan. The digital image is adjusted for color and density. Each 18MB photograph is then compressed to 4.5MB using Kodak's PhotoYCC format image and is then written to the CD. A thermal printer creates an index sheet showing all the images transferred to disc and that is inserted into the cover of the CD's jewel case.

Initially, there were six different kinds of Photo CDs—now Kodak's new, more flexible strategy has simplified the number of categories to two disc types. They are:

Photo CD Master Disc: This format is designed for 35mm film, and each disc holds 100 high-resolution images. The discwriter writes five different file sizes (and five different resolutions), which Kodak calls Image Pac, onto the CD. Resolution of the images is stated as the number of vertical by horizontal pixels a photograph contains. On a Photo CD Master Disc these are:

- Base/16—128x192 pixels

- Base/4—256x348 pixels

- Base—512x768 pixels

- Base*4—1024x1536 pixels

- Base*16—2048x3072 pixels

Why five different sizes? The small thumbnail sizes are used by digital image cataloging programs, and the base version is used for viewing on your monitor, television, or Photo CD and CD-i players. Base*4 is for High Definition TV, and the highest resolution is for photographic quality digital printing. A subset of this disc type is the Pro Photo CD Master Disc, but anyone who shoots large format—amateur or professional—can use it.

Besides 35mm, Pro discs accept images from 120 and 70mm rolls and 4x5 sheet film. The Pro disc includes optional copyright protection and an optional sixth Base*64 resolution image that yields a size of 4096x6144 pixels. When an image is scanned, the processing lab enters the copyright information specified by the photographer (up to 180 ASCII characters), and each time the image is accessed by a compatible software application this text appears in a separate window. The copyright notification can't be removed even if the image is copied. If the disc is used in a stand-alone Photo CD player, the copyright information won't be displayed because the player's design doesn't allow images to be copied.

Under a new licensing policy, any software or platform developer can obtain a royalty-free patent license for encoding and decoding images in Photo CD's Image Pac format. This policy will enable people to read and write Photo CD images as easily as other common graphic file formats, such as TIFF and JPEG, with the added benefit of cross-platform compatibility.

The new Photo CD Portfolio II disc replaces the former categories of Print, Catalog, and Portfolio discs. Portfolio II discs can contain Photo CD Image Pac files and any other digital content providing a single disc type for customers in prepress, presentations, image archiving, and other applications served by the previous Photo CD disc formats. In conjunction with the new application strategy, Kodak introduced a software application that lets users write Photo CD Portfolio II discs with their desktop computers. Available previously only for UNIX, Kodak's Build-It Photo CD Portfolio disc production software will be available for Macintosh and Windows NT computers (more on this new software later).

■ Multi-session CD-ROM Drives

Besides being Photo CD compatible, the CD-ROM drive you choose should be multi-session. When you take a roll of 24 exposures into your dealer and ask them to make a Photo CD, you still have room for another 76 images. When you bring another roll of film in to add to a disc, that's called the second "session." Single-session drives will only read the first session on the disc. While most CD-ROM drives being made these days are multi-session capable, make sure any bargain drives you may be considering have this feature as well.

Digital Scans

Kodak's Photo CD is the least expensive, highest quality scan method you can find anywhere and is my first choice for scanning images because of:

- Compatibility: Photo CD may be the Rosetta Stone of graphics files formats. The same disc containing your photographs can be accessed by any Macintosh or Windows graphics program that recognizes the format, and with the recent unlocking of the format, that promises to be almost every graphics application.

- Price: It typically costs $25 to digitize a 24-exposure roll of 35mm film. If you have a large number of existing images to digitize, it's possible to cut a deal with your dealer for an even lower price per negative or slide. Whether you pay a buck an image or less, it's still much less expensive that purchasing a desktop scanner.

- Flexibility: Kodak's Image Pac format contains five levels of resolution. If you have images digitized using Kodak's Pro disc, you also have the option of adding a sixth file size with a resolution of 4096x6144 pixels. The Pro format even lets you mix and match Image Pac files, so you can choose to have some images digitized with the five basic resolutions and some with six. Having multiple resolutions on the same CD-ROM disc lets users work with a file size that fits the project and equipment they are working on and allows them to jam as many images on the disc as they want. If only five resolutions are selected, a Master Photo CD disc holds 100 images—in any format. If you have all of your photographs created with the six resolution Image Pac Pro, you can only store 25 images, regardless of film format.

- Quality: Kodak tells me that "the highest resolution level (4096x6144) Photo CD file captures all the image data 35mm film has to offer." Purists and pixel counters may dispute this, but my experience has been that when using the highest resolution files on both the Master and Pro Master disks, I can produce magazine-quality images and negatives that can print large, exhibition-quality prints.

- Efficiency: Each Photo CD disc can hold 100 images. By comparison, if you have the same 100 images scanned to the same resolution as Kodak's Image Pac format, it would require forty-one 44MB SyQuest cartridges or seven 270MB cartridges. Even if you use Iomega's new, inexpensive Zip disks, it would take 18 of them to hold the same number of images found on one CD.

Photo CD Hardware

While all you really need to work with Photo CD images is a compatible CD-ROM drive, Kodak offers two interesting hardware items for use with Photo CD discs. The Professional Image Library is an automated jukebox that holds as many as 100 discs and can store hundreds of thousands of images depending on the types of discs it contains. The Image Library is bundled with a copy of Shoebox (described later in this chapter), and the jukebox's Manager software automatically loads the searched-for CD into the double-speed, multi-session drive. Interactive CDs, the biggest breakthrough in coming years, will be a more affordable type of writeable CD-R drive. Kodak's PCD Writer 225 desktop CD writer includes a bar code reader that takes advantage of the ID number found on the inner hub of all Photo CD discs. The bar code lets you catalog large number of discs for archival purposes and makes their use practical in high capacity (100 disc) CD "jukeboxes" from Kodak and other companies. Kodak's writeable discs contain a coating that protects discs from fading, heat, or humidity and prevents scratches or dirt produced by rough handling. The discs only cost 25 bucks and as prices on recordable drives drop even more, I predict CD-R will be the next big format.

One of the joys of Photo CD is that you don't need a computer to see your digital images. Kodak offers a number of portable and desktop players that can be attached to your television set so you can watch your photographs without turning on your computer. Kodak's new portable player, called the N2000, offers a 60 percent speed improvement over its predecessor and a newly designed remote control that can be tethered to the player or operated in wireless mode. The inexpensive N2000 is also a full-featured audio CD player and has adaptive delta pulse code modulation (ADPCM) to support continuous sound, even when images are

FIGURE 5-2:
Photo CD players, like
this portable, allow you
to take your images
anywhere—and you don't
need to connect it to a
computer. What's more,
Kodak's portables play
music CDs. (Photo cour-
tesy Eastman Kodak)

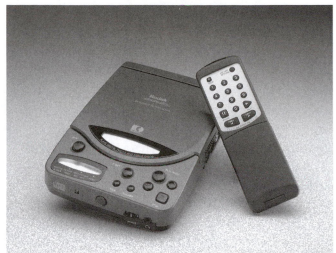

changing. The compact unit easily fits into a briefcase, and the player can operate on four AAA batteries or the included AC adapter. All of these features should make it useful to anyone using Portfolio II CD discs to make business presentations.

Photo CD Software

Kodak has produced a series of programs that make working with Photo CD images easy and fun. At base level, you'll find Photo CD Access Plus for Windows and Macintosh computers. This package lets users open and display Photo CD images as well as crop, zoom, and rotate them. You can save photographs in other file formats so they can be used with image enhancement programs that may not currently support the Photo CD format. There's even a low cost version of Photo CD Access for DOS computers. A variation of Access Plus is the Photo CD Acquire plug-in for Adobe Photoshop. While Adobe's latest version of Photoshop allows you to import a Photo CD image through its Open dialog, the methodology and steps are anything but logical. All versions of Photoshop since 2.5.1 read Photo CD files directly through the program's Open function, but the Photo CD Acquire module lets you crop, color correct, and sharpen an image while the file is being opened. You can also sharpen an image while importing it,

saving you one step. This is important because it's the first thing most users do after opening a Photo CD.

The latest Acquire version provides access to the higher resolution (4096x6144 pixels) images found on Pro Photo CD Master discs. This plug-in also lets you select the image's size and resolution and even change its color type to match the type of output device you will be using. When you launch the plug-in, you'll see an attractive dialog box that includes an Edit Image button that enables you crop, tweak color balance, increase or decrease color saturation, and change the brightness and darkness of an image—all before it's imported. The Image Info button gives you specifications on how this particular image was created as well as any relevant copyright information. The Kodak Photo CD Acquire plug-in is available for both Windows and Macintosh computers and has a list price of $59.95.

For even more control over your Photo CD images, you'll want a copy of PhotoEdge. Available for both Macintosh and Windows computers, this $139 package lets you enhance your photographs by sharpening them or smoothing them for a softer look. PhotoEdge's brightness-and-contrast tool lets you control over-or underexposure, and there are tools that let you zoom, change perspective, rotate, mirror, or crop your images. PhotoEdge is a great program for computer users who don't need or want to do extensive manipulation, but would like to export photographs into desktop publishing programs.

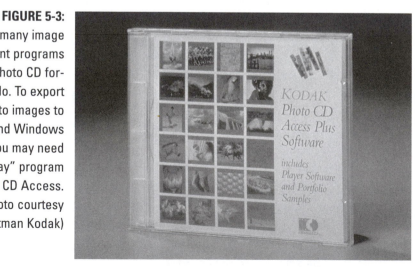

FIGURE 5-3: While many image enhancement programs read the Photo CD format, not all do. To export your photo images to other Mac and Windows programs, you may need a "gateway" program like Photo CD Access. (Photo courtesy Eastman Kodak)

FIGURE 5-4:
Kodak's Photo CD Acquire module allows you to select the resolution, as well as crop and sharpen, a Photo CD image while it's being opened.

Keeping Track of Images

If you have hundreds of digitized images, you're going to need some way to keep track of them. Kodak's Shoebox is one of the better image database programs available. This $345 Macintosh or Windows package helps automate the storage and retrieval of photographs by displaying thumbnails in a catalog that looks much like slides arranged on a lightbox. The program lets you assign caption and keyword data to each image so you can perform searches to find specific photographs or groups of photographs.

For multimedia fans, Kodak's Create-It lets even the most novice computer user produce presentations using simple, interactive menus and

built-in templates. Arrange-It is an advanced program that creates more sophisticated presentations and can import files from applications like Adobe Photoshop and Persuasion, Lotus Freelance, and Microsoft PowerPoint. The major advantage Create-It or Arrange-It presentations have over other multimedia software is that finished programs can be stored on a Photo CD Portfolio II disc and don't require a computer in order to run. All you need is a Kodak Photo CD player—for instance, their compact portable machine—and a monitor, and you can view an interactive presentation complete with sound, graphics, and photos. Create-It is currently available only for Macintosh computers for $245, while Arrange-It works with both Mac and Windows machines and costs $395.

Roll Your Own

One of the most exciting new software products is the Photo CD Portfolio Disc Production Software that allows you to create your own Portfolio II discs using Macintosh and Windows NT computers. Users are able to create their own Portfolio II presentations right on their own desktop or can use the software to store and distribute images in the Photo CD format. With the right equipment, Adobe Photoshop users can, for example, import and edit Photo CD images and write them directly onto a Portfolio II disc along with their original images. You can also choose the resolution of the images you distribute from among the multiple choices offered by the Image Pac format. One of the software's coolest features is its ability to translate an image in any graphics format into the Image Pac format. All this coolness comes at a price, however. The system requirements for the program are the most intense I've seen on any imaging product and includes 64MB RAM, a 2GB hard drive, SCSI acceleration card, and a double-speed CD writer. When all that's added to the $995 list price, it might be considered too much for some users, but like everything else in computers, I expect to see the price drop.

What's Next?

As part of Kodak's new digital direction, the company, along with IBM and Sprint, is working on improving the way computer users deal with images in computer networks. The traditional method of working with digital photos is based on sending a bitmapped image of a photograph, but Kodak wants to change that by using three separate technologies, starting

with the Photo CD format. Since an Image Pac formatted file stores photographs at multiple levels of resolution, network users will be able to work on-line with lower-resolution versions of an image, which transmit and display quickly, and can access the high-res version when needed.

A second part of this is implementation of FITS (Functional Interpolating Transformation System). In January 1995, Eastman Kodak Company and Live Picture, Inc. signed a technology and product development agreement covering a range of imaging applications. As part of the agreement, Kodak obtained a license to apply Live Picture's resolution-independent image viewing and editing technology to future Kodak digital imaging products. FITS is a way of formatting and manipulating millions of pixels so that images are stored as a sequence of subimages (from full resolution to low resolution) which are organized into discrete "tiles" or segments, making it possible to quickly access only the information needed to fill the screen and rapidly manipulate the image. This unique algorithm treats changes to an image separately from the image file itself, allowing real-time image editing and faster transmission. Last, there's an Image Access System platform, which makes it easy for people to file and retrieve images from a central image server. Kodak is working to combine these elements into a single standard for sharing images across networks. This standard will extend the value of the current Photo CD Image Pac format by adding a script, based on the FITS algorithm, that allows edits to be transmitted independently of the image file.

◆ Photo CDs and Digital Cameras: Working Together?

Let's come back to the old photo lab adage about "Quality, Price, or Speed. Choose any two." The least expensive way to produce a high-quality digital image is by using Kodak's Photo CD process. Here's why: First, you use the cameras and lenses you already have. Second, the only required computer hardware is a Photo CD-compatible CD-ROM drive, and prices for double-speed, multi-session drives are well under $200 for either internal or external versions. Compare that to the cost of even the least expensive digital point & shoot camera. It's a deal. Third, the cost of "Gateway" software is cheap too. Fourth, Photo CD is inherently cross-platform. A disc can be read by any Mac or PC whose hard

drive contains software that reads the Photo CD format—and that's just about every graphics program. Since Kodak announced the opening up of the PCD format, I expect PCD will take its place along BMP, PICT, and TIFF as a format that's widely written as well as read.

That just about covers quality and price, but what about other combinations of these three photographic attributes? When you take price out of the equation, speed is where digital cameras really shine. Photojournalists can deliver digital images to magazines and newspapers instantly by modem, and the companies that employ these photographers can afford the cost of both speed and quality. The same is true for advertising photographers, but it also works well for low-end users too. Digital point & shoot cameras can, over the long haul, save money for non-photographers who need to create images. Where does Photo CD fit in users of digital cameras? As CD-R drives become cheaper, expect software to be available that will allow non-photographers to use Photo CD as a photographic archive medium. Right now the only program available is Kodak's Photo CD Portfolio Disc Production Software that will allow you to create your own Portfolio II discs using Macintosh and Windows NT computers. Users will be able to store and distribute images in the Photo CD format.

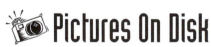

Pictures On Disk

As Contributing Editor to Shutterbug's *Digital Journal*, I get a lot of mail from photographers asking about the different ways they can take the photographs they create with their analog cameras and convert them into digital images. One question I often get is about the advantages and disadvantage of using the new breed of digital cameras from Nikon and Kodak.

Here's an actual question from a Shutterbug reader: "I thought using a digital camera might be the best way to eliminate the need for scanning images. Is that the best way to capture digital photographs?" And here's my answer: Right now, digital cameras fall into three general categories: low-bucks and low quality, high quality but expensive, and high quality but even more expensive. As I mentioned in Chapter 3, digital cameras are expensive for the resolution and exposure settings they provide, and for the

reasons stated there, they may not be the best choice for the average-to-advanced amateur photographer. These cameras settle the initial part of the question of digital image acquisition, but there's another, unasked question: What about your existing slides and negatives?

The answer to acquiring new images and digitizing existing film is Seattle FilmWorks' Pictures On Disk. This process is the least expensive way to get high-quality scans of your new and existing images, and it's the only system that delivers digital images on floppy disk. Since all PC users already have a floppy disk drive (again, this service is not yet available for Mac users), you don't need any new computer equipment, and since Pictures On Disk lets you use whatever kind of camera you already have, you don't need any new camera equipment either. What about backups? If you're traveling through Australia's outback and your digital camera goes kaput, can you afford to have another $20,000 body in your camera bag? For most of us the answer is no. If you're snorkeling off Australia's Great Barrier Reef, and you don't want to get your Canon EOS wet, you can always pick up one of Kodak or Fuji's recyclable cameras that are designed to go underwater to snorkeling depths. When you send the (now dry) camera to Seattle FilmWorks you'll find your digital underwater shots ready and waiting in your mailbox. The only alternative to this is to buy an expensive housing to hold your expensive digital camera.

The Cost Factor

Recently Kodak admitted that while they initially targeted amateur photographers for Photo CD use, the real users—and their new focus—would be on the professional market. Where does that leave amateur photographers? Pictures On Disk comes to the rescue.

Kodak's Photo CD process is an interesting product, but for the average amateur photographer it suffers from one major drawback—cost. The first and most obvious cost advantage is that since Seattle FilmWorks returns your digitized images on a floppy disk, you do not need any additional hardware other than that which is already built into your computer. Besides saving, at least, $200 to install a Photo-CD compatible CD-ROM drive on or into your computer, another savings is the actual cost of having an image digitized. Photo CD prices vary from $.80 to $1.25 per image, which means

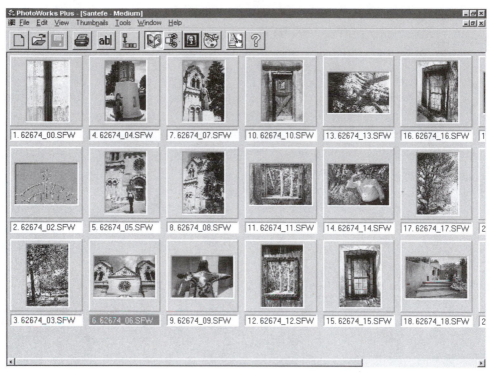

FIGURE 5-5:
Pictures On Disk uses a photo album model to store images
and access them. (Original photographs by Joe Farace)

that to have a 36-exposure roll of film digitized could run $28.80 to $45. A 24-exposure roll would cost $19.20 to $30. Compare this to Seattle FilmWorks' advertised price of $11.95 or $9.95 for having digital images made from existing slides, negatives, or prints. If you have Pictures On Disk made at the same time your film is processed, a 36-exposure roll costs $5.95 and a 24-exposure roll costs only $3.95.

In addition to cost savings, there are some frustration savings too. Microsoft has encouraged manufacturers of IBM-PC and compatible peripherals, like CD-ROM drives, to adopt a "plug-and-play" design to make installation easier for the average user, but this concept has not fully caught on with the manufacturers of computer accessories.

In my own case, here's what happened when I purchased an internal CD-ROM drive from a local computer superstore. I didn't get the cheapest one in the store and selected a middle-priced model from a respected manufacturer because I didn't want to have problems or incompatibilities. Unfortunately, I wasn't so lucky. I took the drive home, read the directions, and installed the drive and the required software. The only problem was it didn't work. When I called the store's customer service number, they told me that I needed a special cable to connect the drive to my sound card, and it was missing from the parts I had. So I drove 15 miles back to the store to pick up the missing cable. After I installed the cable, the only problem I had was that the drive didn't work. Back to the store again. The people were very nice and gave me a new drive. The only problem I had after I installed the new drive was that it didn't work either. After yet another 30-mile round trip, the store manager offered to install a third drive, but "would I mind coming back tomorrow to pick it up?" After a fifth 30-mile round trip, I finally got my CD-ROM drive installed and working. For many PC users, not having to deal with the cost and hassle of additional hardware makes the use of floppy disk media more attractive.

Pictures On Disk Are Flexible

When an image is written onto a Photo CD it is there forever. You cannot delete it or change it in any way. Let's face it, we all have some clunkers in the rolls of film that we shoot. PhotoWorks Plus allows you go into your Pictures On Disk disk and remove those images that may be less than the perfection we all strive for. This ease of editing means that we can, conceivably, store the images from more than one roll of film onto a single floppy disk. That makes POD a compact, space-efficient method of storing your digital images.

You can also perform basic image enhancements to your POD photographs and store the now improved version on the same disk on which Seattle FilmWorks placed the original image. At that time, you have the option of replacing the original image with the new one. In fact, if the disk isn't too crowded, you should be able to store both versions of some photographs on the disk. Because Photo CD is a Read-Only medium (That's what CD-ROM means: Compact Disk Read-Only Memory), it is impossible to save another version of an image onto a Photo CD disc. Unlike Photo

CD, Pictures On Disk is an interactive process that lets you save, delete, and modify images the way you want.

Less Is More

Even though both Photo CD and POD images are compressed, Pictures On Disk digital images are physically much smaller than Photo CD files. Compression is a technique that lets you make a file smaller and consequently, take up less space by removing information from the file that is irrelevant. When a compressed file, either POD or Photo CD, is opened, it is decompressed to its full size. A compressed color Photo CD file takes about 5MB on a disc. How big is a POD file? About 35K. That's less than 1/100th the size, with quality comparable to Kodak's base-level Photo CD scans. This smaller size is made possible by Seattle FilmWorks' proprietary scanning and compression technology. Having a smaller image file makes equipment requirements simpler and less expensive.

For example, Adobe Systems recommends a minimum of 10MB of RAM to run their Photoshop image enhancement program. The program actually requires three to five times the size of the original image in RAM in order to work on a file. This means you might need 54 to 90MB of RAM to work on the largest-sized Photo CD image, but Adobe provides a virtual memory scheme, called "Scratch Disk," that reduces the need for additional RAM. To make virtual memory work efficiently, you need to have a big hard disk with plenty of blank space. You need at least a 250 to 400MB hard disk to keep what you need and provide room for virtual memory.

In recent years, memory (RAM) and hard disk prices have gone down but I haven't found anyone giving these hardware components away. That means if you need a bigger hard drive or more RAM, you're still going to have to pay for it. Pictures On Disk files, on the other hand, are much more compact, and PhotoWorks Plus will run in as little a 4MB of RAM. Smaller POD file sizes means you need a less expensive computer to work with your digital photographs.

Pictures On Disk 2.0

The original Pictures On Disk was a DOS-based service. It allowed users to catalog their favorite photographs, build a custom on-screen slide show,

and add their favorite snapshots to a screen saver. The current Windows-based version of POD increased the resolution of the images to a size of 640x480 pixels that is five times greater than the original DOS process. The new POD image files increased the color depth to 24-bit and increased the number of colors per image up to 64,000. These improvements in the process have resulted in bigger, sharper, more colorful images. DOS die-hards don't have to feel left out; POD 1.2 is still available, but to take advantage of the high-resolution capability of the latest Pictures On Disk, you will need a computer capable of running Microsoft Windows.

Getting your family picnic, cousin's wedding, or new baby's photographs digitized on Pictures On Disk is easy. Just shoot the kind of film you prefer—slide or negative. Seattle FilmWorks processes all kinds of 35mm film, including Kodak, Fuji, Agfa, and Seattle FilmWorks' own brand of color negative film. The lab will also process and digitize print or slide film. Not only can you use whatever film you want, you can use whatever camera you want. If you're making photographs for exhibition or competition, you can use your new Nikon N90s, and if you're just shooting snapshots, you can create POD with your Olympus Stylus point & shoot camera. To try Pictures On Disk for yourself, call Seattle FilmWorks' toll-free number (800/445-3348) for ordering information.

FIGURE 5-6:
PhotoWorks Plus 2.0 is the "gateway" program that Seattle FilmWorks provides for Pictures On Disk. This retail package includes a copy of the program along with a roll of color negative film, a recyclable camera, and coupons for free film processing and digitizing. (Photo courtesy Seattle FilmWorks)

After Seattle FilmWorks processes your film, it is saved onto a POD floppy disk, and the photographs are compressed using a proprietary format called .SFW. The compact .SFW format makes it possible to squeeze 36 exposures of image data onto a single 1.44MB 3.5-inch floppy disk and allows for fast decompression of images. On a 486-based PC, it only takes 3 to 5 seconds to display an .SFW photograph. Because Seattle FilmWorks uses the .SFW format for delivering and storing images, you cannot read POD images without a copy of PhotoWorks Plus software. Fortunately, Seattle FilmWorks includes a two-disk set that contains both PhotoWorks Plus for Windows and PhotoWorks for MS-DOS, at no additional charge, with your first order of Pictures On Disk.

The Positives of Negatives

When your order comes back from Seattle FilmWorks, you'll find the images returned to you in three different forms. First, there are the prints or mounted slides you requested. Let's be honest, as great as digital imaging is, nothing will replace the sheer enjoyment of sitting down with your family and passing prints around to relive the experiences. (You can even get an extra set of prints for a nominal price.) Second, your negatives are safely tucked away in a separate pocket of the print envelope. The negatives' emulsion side is protected by a sheer plastic sheet, and a white paper strip is attached to one edge. On one side, there is a frame number that corresponds to POD file names, and the other side has a list of the available reprint and enlargement sizes. Last, your photographs will be delivered as digital images—Pictures On Disk—on a floppy disk. The advantage of this three-pronged delivery system is that you have prints to share with family and friends, digital images for fun and working with your computer, and the original negatives to make additional prints or reprints. Because you have the original negatives, you're able to make large prints for competition or for wall display.

Free Upgrades Too

Another advantage of using PhotoWorks Plus is that when you have film processed and images placed on Pictures On Disk, Seattle FilmWorks will automatically send you the latest version of the program. Right now they are shipping version 1.1. To see what version of the program you have, look

in the lower right-hand corner of the red disks that contain PhotoWorks Plus and read the version number printed there. If it's a later version than the one you currently have installed, install the new version. Like all good software products, PhotoWorks Plus is constantly being improved and newer versions will include fixes that can affect users of hardware that weren't available when the last update was produced. Installing the latest version of the program means you can avoid any future problems if you update your video card or motherboard.

So if you're looking for a quick, inexpensive way to digitize your photos without investing a lot of money in equipment, Seattle FilmWorks' Pictures On Disk service might be for you.

PART

P A R T III

IMAGE MANIPULATION AND ENHANCEMENT

This section of the book focuses on image enhancement programs and their add-ons. As a pixographer, you can use image enhancement and manipulation software to improve and change images much as you would produce similar effects in a traditional darkroom. The advantages of working in a digital darkroom are that you don't have to work in the dark, get your hands wet, or breathe quasi-toxic chemicals. And more often than not, achieving dramatic effects is easier to accomplish digitally than by using light sensitive paper and photographic chemicals. Image editing also offers the greatest number of programs and variety of available software.

Part III takes a practical look at the many Windows and Macintosh programs available to digital photographers. In this section, you'll also find tips on working with digital images to find buried treasures hidden within them. It all goes back to making photographs: Joyce Haber, the *Los Angeles Times* successor to Hedda Hopper, introduced the idea of the "A" and "B" list, and I think we can safely assume that there are also "A" and "B"

photographs. When I shoot a roll of film, perhaps (if I'm lucky) one or two of the images will be great. These are "A" shots or "selects." On the rest of the roll, there might be 8 to 10 that are technically excellent but not as good as the "A" shots. These "B" shots have a different value and are candidates for digital manipulation. The "outs" are normally tossed in the recycling bin, but use of digital imaging techniques can turn them into "B" list images and can even turn "B" list shots into "A" list photographs. The tools and techniques covered in Part III will get you there.

The next three chapters will not only cover what I feel are the best image editing programs, they will demonstrate how to use these programs to accomplish some of the most basic and important editing techniques your digital photographs will need. These will be techniques that you can do in a wet darkroom, but you will find that their digital equivalents will make you a more productive—maybe even more creative—photographer. You'll also find ways that you can use software plug-ins to increase your photographic productivity and creativity.

EDITING IMAGES WITH ADOBE PHOTOSHOP

Adobe Photoshop is the professional's choice image editing program for the Macintosh and Windows. This chapter will look at the general subject of electronic image editing, focusing on Photoshop and the standards it has set.

Entering the Digital Studio

Regardless of platform and regardless of cost, all image enhancement programs do the same thing: They manipulate the pixels of a bitmapped image to achieve a desired effect. You might say this is similar to a photographer working in a darkroom; what he or she does is manipulate the silver grains in film and paper to produce a finished image. Both cases involve digital manipulation. The digital studio requires a computer, while your darkroom requires only your digits on your hands. Because most image enhancement programs have the same function, many of the basic tools

used are similar. Here's a quick look at some of the typical tools you can expect to find and what you can do with them:

- Cropping tool: Cropping an image focuses attention on the real subject of your photograph and eliminates distractions on the edges of the frame. You can also use digital cropping tools to change the shape of the image from portrait (vertical) to landscape (horizontal) orientation.

- Rotate: The rotate tool or command can similarly change the shape of the image from portrait to landscape orientation by simply flipping the image on end. Some image enhancement programs even have a command, tool or menu item called "Flip." One of the most useful functions for this tool is to rotate an image by just a degree or fraction of a degree to straighten out horizon lines or lopsided buildings.

- Color: Changing an image from color to black & white or vice versa is much easier digitally than in a traditional darkroom. Working in a wet-darkroom requires using special paper, like Kodak's Panalure and dim-bulb safelights, but digitally it requires only a menu pull. If you plan to use a photograph in a black & white newsletter or a book, converting a color image makes the size of the photographic file smaller, which takes up less on your hard disk and prints faster. What's more, some programs allow you to colorize black & white photographs! Like the infamous video process, the results of colorizing black & white photographs can be quietly beautiful or grating, depending on your taste and creativity. On a basic level, you can also use colorization techniques to add brown or sepia tones to create an old-time look.

- Brightness & Contrast controls: Can reduce or increase a photograph's contrast or brightness so the output looks better than the original. This is significantly easier to do digitally than using variable contrast paper in a traditional darkroom. This can be an important tool for the digital imager. It's been my experience that most Kodak Photo CD scans can always use more contrast.

- Lighten/Darken: You can use image enhancement tools to produce traditional photographic techniques like "burning" and "dodging" to improve a photograph's appearance. For new photographers, or those not familiar with darkroom work, burning is a term for selectively darkening part of an image to hide a distracting element or bring out something hidden by highlights. Dodging is the reverse process and selectively lightens part of an image.

- Pixel painting tools: If the original image is not in good condition, you can use image manipulation techniques to eliminate scratches, cracks, and creases on a photograph. All of these techniques can be combined to rescue old, and some not-so-old, photographs from being lost forever.

- Sharpening: Yes, sharpening. If there is one tool that's totally unique to digital imaging, it's sharpening. This effect is produced by increasing the contrast of adjacent pixels and can be applied to an entire image by using sharpen filters, or selectively, by using sharpen tools.

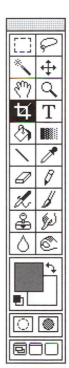

FIGURE 6-1:
The tool box of any image enhancement program, like Adobe Photoshop shown, gives you access to controls that allow you to change the look and shape of a photograph.

The tools used to accomplish these basic controls are similar in all image enhancement programs. In the next few chapters, I'll introduce you to several different programs and show how each of them works with photographs. Let's start with the most popular image manipulation program. It's so popular, it might be called...

An 800-Pound Gorilla

Author's note: As we look at some of the tools and tips about Adobe Photoshop, please keep in mind that the techniques shown will apply to many—if not all— of the image editing programs contained in this section of the book. Think of the examples as being not only cross-platform but cross-program. Many of the techniques are accomplished the same way—or in very similar ways—in many of the programs shown in Part 3. Software that does things really differently is noted, especially if that difference makes a particular technique easier to accomplish. The typical caveats apply; make sure that the program you try these techniques with really has that feature.

When it was introduced in 1990, Adobe's Photoshop quickly became the de facto image enhancement program for the Macintosh. In 1993, the Windows version, containing a feature set that is identical to the Mac, was introduced. While originally facing stiff competition from programs like (the now defunct) Aldus PhotoStyler, Adobe Photoshop still managed to grab a large share of the PC market. One measure of the program's success is the way third-party developers have created add-on filter packages for it. Because of the program's modular design, a veritable cottage industry of add-ons has grown up around the product.

On a basic level, Adobe Photoshop can be easy to use, especially if your needs are limited to only a few of the program's tools. Like Superman, Adobe Photoshop has a mild-mannered Clark Kent appearance that disguises its real power, but accessing this power can be challenging. Even Adobe Systems themselves issued a Classroom in a Book that includes a CD-ROM to train users in the many facets of using Photoshop. With the wrong system configuration of RAM and hard disk, the program can be slow—even agonizingly so. That's why Adobe licensed the source code of calculation intensive routines, so third-party developers could create software that

works with accelerator cards. The company has created an authorized "Adobe Charged" logo that manufacturers of accelerators and video cards can display on these products.

Memory Management

You may have heard that Photoshop is a memory hog and that to work with photograph and graphics files you need to have a large hard disk and lots of RAM to make it work without problems. That's only partly true. Let me explain: In order to operate on any file, Photoshop requires three to five times the size of the image. This means you'll need between 54 and 90MB of RAM to handle a 18MB Photo CD file, but Photoshop has a built-in virtual memory scheme (Adobe calls it a "scratch disk") that reduces RAM requirements by treating your unused hard disk space as additional RAM. In the above example, it would mean having at least 54MB of unused hard disk space.

To use the program's scratch disk feature, there should be enough room on your hard disk space for the other software you use and space for Photoshop's virtual memory. The program's Preferences menu lets you specify where the program should go to get this hard disk space and you can have both primary and secondary disks to use as scratch disks. If you don't have enough memory or scratch disk space, Photoshop will give you a "Not Enough Memory to Complete that Operation" error message, but this often occurs after the program has been working for a while.

Fortunately, there's an easy enough way to find out while you're working on a graphic image. In the lower left-hand corner of any picture's window, Photoshop displays information showing how much memory that particular image takes. By clicking on these numbers, you have the option of displaying File Sizes or Scratch Sizes. While the File Size information is interesting, I recommend you keep the window set to show Scratch Sizes. That's because the number on the left side will tell you how much memory all open windows are using, and the number on the right tells you the amount of RAM available. If the first number is larger than the second, the difference is the amount of Scratch Disk space required. If you don't have enough unused hard disk space—TILT!

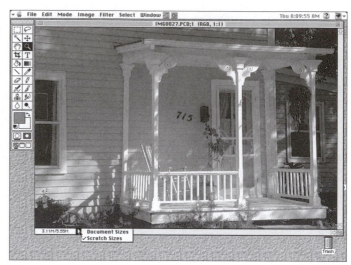

FIGURE 6-2: In the lower left-hand corner of a picture's window, Photoshop displays information showing how much memory that particular image takes. By clicking on the numbers, the program displays File Sizes or Scratch Sizes. The number on the left side tells how much memory all open windows are using and the number on the right tells you the amount of RAM available.

Photoshop Feature Overview

Here are some of the features that make Adobe Photoshop so popular with photographers, designers, and printers.

One reason for Adobe Photoshop's popularity on both platforms is its interface design. Unlike some graphics programs, an initial look at Adobe Photoshop's interface is non-threatening. After you launch the program, you'll see the default work area displaying the toolbox in the upper left-hand corner and the opened image to the right of the tool box. Initially, your image may be displayed smaller than the original. Don't worry—you can make it full size by selecting the magnifying glass tool in the toolbox and clicking anywhere on the image. If you've used even the simplest Paint program, you'll instantly be familiar with most of the tools, but if you're not, it won't take most photographers long to get the hang of it. Double-clicking some of the tools accesses their options and some tools can only be used after selecting part of an image. Specific use of many of these tools will be covered later, but here's a quick overview of some of them.

The operation of some tools, like the dodging and burning tool, will be instinctive to photographers. If you're not familiar with these terms, here's how they work: The dodging tool resembles a tool that has a wire handle with a circle at one end, resembling a small paddle. When working with negatives in a

FIGURE 6-3:
The non-threatening
design of Adobe
Photoshop's interface
is one reason for
its success.

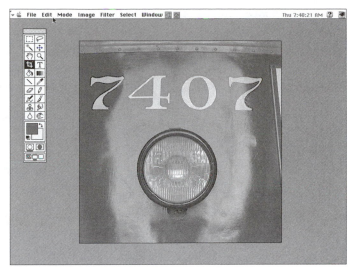

darkroom, the dodging tool is waved under the enlarging lens to "hold back" light from striking the light sensitive paper. Since less light strikes the paper, the area underneath it is *lightened*. This is also true in Adobe Photoshop. The burning icon looks like a hand because, typically, a darkroom worker uses his or her hands to cover all of the photograph except a small area that would let additional light strike the paper. The dodging tool works the same way—it *darkens* an area. The Burning and Dodging palette contains controls to let you vary the size of the area being burned and dodged and also offers a "Sponge" tool that desaturates an area that is rubbed over. Other tools, like the rubber stamp, will be new to you, but you'll find them to be useful. Don't overlook the Cropping tool. Images acquired from scanners and some Photo CD scans can include extraneous material around their edges.

Cropping an Image

■ Step 1: Here I opened a Photo CD image of a streetcar that was shot on Tri-X film using a square-format camera (Figure 6-4). The black area to the left and right of the image is part of the Photo CD scan as is the white edge surrounding the image itself. (This is a negative so that edge is white. If this was a transparency, the edge would be black.)

FIGURE 6-4:
Photo CD scans often include extraneous material around their edges. This is especially true for Pro Photo CD scans made from 120 negatives (or transparencies) shot in cameras using the 6x6 cm. square format.

This extraneous material around the image adds nothing to it but additional file space, so cropping is clearly called for.

■ Step 2: I clicked on the cropping tool icon in the toolbar. (The icon resembles the same kind of cropping tool photographers have been using for a hundred years.) Using the Cropper, you can click and drag to select a specific area on the photograph (Figure 6-5). Don't worry if you don't draw the cropped area perfectly. When you

FIGURE 6-5:
After selecting the cropping tool, you can use the cross-hairs shaped cursor to select an area that you want to be cropped.

finish selecting the area to be cropped, you'll notice little squares, or "handles" in each corner of the selection. By using the mouse and clicking on any one of the handles you can drag any side of the rectangle (or square in this case) to make the cropping you desire.

■ Step 3: When I finished selecting the true negative area of the image, the cross hairs changed to a scissors icon. Clicking anywhere inside the selected area cuts out the cropped area (Figure 6-6).

Adobe Photoshop includes the kind of painting tools you would expect to find in a typical graphics "paint" program, including Paint Bucket, Gradient Line, Eyedropper, Eraser, Pencil, Airbrush, and Paintbrush. The colors used by these painting tools are called the foreground colors, and the background color is the color that replaces part of an image when you use the eraser. You might think of foreground and background colors as the digital paint trays that you will dip one of the digital paint tools into. How these tools work will be explained in this and subsequent chapters. The gradient tool creates gradient color between foreground and background. I also like the way the Brush palette gives you the option of using a hard edged or a soft edged brush. Soft edged brushes make the best retouching tools. Adobe Photoshop lets you tweak color balance of an image and allows for independent adjustment of shadows, highlights, and mid-tones. The Rotate, Stretch, and Distort options let you alter image shapes.

FIGURE 6-6: After you finish making a selection with the Cropping tool, the cross hairs cursor changes to a scissors. Clicking anywhere inside the selected area causes the image to be cropped to the final shape.

FIGURE 6-7:
Photoshop's palettes let you flip back and forth much as you would a card file to find the features and capabilities you need to produce a specific effect.

The interface of the current version of Adobe Photoshop includes a new palette design featuring a tabbed "card file" look (Figure 6-7). This design enables you to flip back and forth between the options covered by a particular palette. The program remembers which are your favorite palettes and where you like them placed on the screen. The next time you open Adobe Photoshop, it displays everything the way you left it. Any palette can be collapsed to take up less screen real estate if you have a small screen or the screen you use is getting crowded. Users of 20-inch or larger monitors will probably want to keep all their palettes open at once, while those of us with smaller screens might take advantage of the collapsible feature. One of Photoshop's handiest palettes is Commands, which lets users assign a function key to frequently used commands (for example, I'm always using Sharpen with newly opened Photo CD images). The buttons can be arranged in any order, or they can be color-coded and displayed in multiple columns.

One of Photoshop's neatest features has been its ability to let you work with an image in different channels. A channel is similar to a "plate" in commercial printing. If you're working with an RGB (red, blue, green) format image, the Channels palette allows you to view or edit it in either the red, blue, or green channel. The new Channels palette also displays thumbnails of each channel and as before, the Option menu allows you to create and name channels you can use as masks. Now pixographers can add "layers" to their bag of tricks. You may have seen animation programs with similar overlay features that are often called "vellum" and similar names. You can treat these layers as overlays that can contain filter effects or text that can be handled separately from the image to enhance it. Users can also attach an 8-bit mask to any layer that will let them vary the opacity or effects of any given layer without changing or distorting any layer information.

Sharp Dressed Image

The first thing you should do with any image is sharpen it, as I mentioned previously. While Photoshop provides a Sharpen menu and Sharpen command, I suggest you use Unsharp Mask instead. Here's why: Unsharp Mask includes a preview window that allows you to see the sharpness of the finished image before it's sharpened. Unsharp Mask's preview window allows you to easily see the effect of your sharpening. Further preview controls

FIGURE 6-8: Unsharp Mask provides a dialog box with a preview window and Plus and Minus boxes that let you zoom in and out of an image. When you move the Amount slider, it displays the actual percentage of sharpening to be applied and the preview window displays what that sharpening looks like.

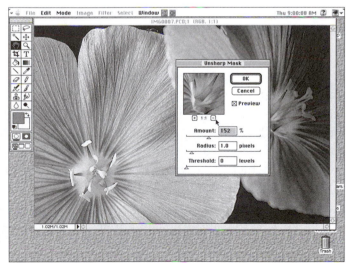

include Plus and Minus Zoom boxes underneath the preview window. Clicking on the Plus box zooms into the image, and clicking on the Minus box zooms the preview window out. There are three sliders that let you control sharpness and unsharpness, but I recommend that you ignore all but the topmost one until you gain more experience. Sliding the Amount slider displays the actual percentage of sharpening that will be applied to your photograph. Don't be afraid to apply more than 100 percent to a Photo CD! The preview window continuously updates the effect of sharpening on the image, so keep moving the slider until the preview looks as sharp as you want.

Color

After sharpening, the next most important step is making sure the color and saturation of the image is what you want it to be. The easiest and fastest way to accomplish this is by using the Variations command in Photoshop's Image menu. When Variations is selected, you will see a large dialog box that displays before and after preview windows in the upper left-hand corner along with ten more previews. The first seven windows display the original image in the center, while the surrounding sides show what that image will look like when more red, blue, green, yellow, cyan, and magenta are added to it. The intensity of the color corrections is controlled by a slider allowing you to go from Fine to Gross amounts of corrections. All you need to do is look at the image you like best and click on it. Instantly the original image in the center will be updated, and the before and after images in the left-hand corner are updated to reflect any changes.

There are also three vertical preview windows that allow you to lighten or darken the image. More fine tuning is provided by radio buttons above the Fine/Gross Slider. These buttons give you control over an image's Shadows, Midtones, Highlights, and Saturation. Again, it's just a matter of looking at the previews and selecting the one that looks best to you. Experienced photo lab operators will recognize this process as a "ring-around" in which different densities and filter packs are applied to test prints to find the combination that works best. Unlike a ring-around, Photoshop's Variations is instantaneous, and if you don't like the effect after you've clicked OK and it's been applied to the image, you can always use the program's Undo command to start all over again.

Adobe Photoshop lets users create original artwork, correct and retouch color or black & white scanned images, and prepare color separations. The program includes a full set of image editing tools, allowing you to add color or take it away, execute delicate retouching, or produce special effects. You can also mask part of an image and import it into a page layout program. Additionally, you can do selective color correction. Another choice is the new Replace Color feature that lets you isolate a color or range of colors and replace that color by adjusting hue, saturation, and lightness. This feature, like almost all the new filters and features (except Clouds for some reason), includes a preview window in its dialog box so that you know what the effect will look like before you apply it. This preview function is especially useful to those people using Adobe Photoshop on unaccelerated 030 or 386 computers.

COLOR PLATE-1: The Variations dialog shows before and after previews, seven windows displaying the original image in the center, and three vertical previews that allow you to lighten or darken the image. The previews surrounding your original image show what that image will look like when more red, blue, green, yellow, cyan, and magenta are added to it. All you need to do is look at the image and click on the one that looks best.

Selection Tools

Proper use of Photoshop's selection tools is critical for achieving even the most simple effects. Before any special effect can be applied to an entire image or just a portion of it, the affected area must first be "selected" using one of Photoshop's tools. Adobe Photoshop offers three selection tools: Marquee, Lasso, and Magic Wand. The Marquee is used when you want to make regularly shaped selections. Double-clicking the Marquee tool opens its control palette and lets you choose either a rectangular or elliptical selection shape. The Lasso is a freehand selection tool you can use to outline irregularly-shaped objects. Macintosh users can also use it to create Polygons by pressing and holding the Option key (PC users should use the (ALT) key) and clicking on various points around a subject.

The Magic Wand, Photoshop's most powerful selection tool, selects not on the basis of shape, but on similarity of color. When you click on an individual pixel in an image, the Magic Wand selects pixels that have the same color plus similar shades of that color. How many similarly colored shades are selected depends on the Tolerance specified in the Magic Wand's palette.

The smallest Tolerance value you can enter is 0 and the largest is 255. The default is 32, and a little trial and error helps you refine the number you will want to set for a given photograph. Keep in mind that Tolerances will vary based on the image. A good rule of thumb is that when selecting a predominantly solid color, lower tolerances work best. But be careful. If you set Tolerances too large, you will select areas you don't want. To assist with the selection process, Photoshop's Select menu offers additional commands that increase the efficiency of whatever tool you may be using. The Grow command, for example, temporarily doubles the Tolerance range for the Magic Wand. Another way to increase the selection being made is to use the Similar command. When you do, the selection can jump over areas to find other colors that fit within the specified Tolerance.

When using the Magic Wand, Halo, or Marquee to select certain kinds of objects, a halo may appear around part of that selection. These extra pixels are caused by Photoshop's built-in anti-aliasing feature. (Sometimes when a graphic is displayed on a monitor, you'll see jagged edges around some objects. These rough edges are caused by an effect called aliasing. Techniques that smooth out the "jaggies" are called anti-aliasing.) Photoshop's built-in anti-aliasing partially blurs pixels on the fringe of a selection and causes additional pixels to be pulled into the selection. If you see this problem, the best way to eliminate these "halo" pixels is by using the Defringe command found in the Matting submenu of the Select menu. Before you can apply it, however, the selection must be "floating." To make it float, select Float from the Select menu. Then you may safely select Defringe. When you do, a dialog appears that asks how may pixels wide you want to Defringe. Typically you will only need to Defringe one pixel wide, but depending on the image you may want to slightly increase the pixel width.

Changing Color Intensity

Here's a simple example of using selection tools to select and change the color intensity of something in a photograph:

- Step 1: For this photograph, my goal was to make the water bluer and darker. You would think that the best way to select the pool's water would be with the Marquee tool, but like much of what occurs in nature, this pool does not have perfectly square edges. It does, however, have straight lines. So the Lasso tool was used to select

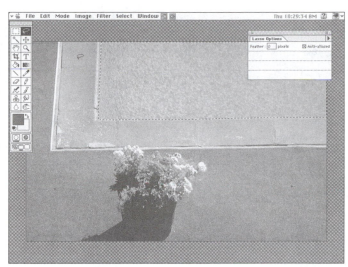

FIGURE 6-9:
The Lasso selection tool can be used to select polygons. To do this, press and hold the (OPTION) key (on PCs, use the (ALT) key) to select however many points are necessary.

five different points around the pool (Figure 6-9). To make it select a polygon-shaped object, I pressed and held the Option key—PC users should use the (ALT) key.

■ Step 2: The Variations command (Figure 6-10) was used to select a color that is bluer and darker than the original color. This is achieved by clicking on the small image in the dialog to produce different hues and densities. A slider varies the intensity of the differences in the images. Move the slider to the left and the differences are subtle, move them to the right and the differences are dramatic. In fact, that's a good tip. If you're not sure of how you want to tweak an object's color, move the slider all the way to the right to see an extreme representation of the color. This will help you determine if a photograph or object in the photograph is too warm or too cool. Then move the slider back to the middle and make your choices. To keep you from getting lost among the variations, two small images at the top show the original image and the state of the one you are working on.

■ Step 3: Before clicking the OK button, compare the photograph shown in the "Current Pick" to the image in the "Original" window to see if it achieves the result you want. When you're satisfied with how the corrections look, click the OK button to apply the color and density Variations you have selected (see Figure 6-11).

FIGURE 6-10:
Step 2: To intensify the color of the water in the pool, the Variations command can be used to select a color that is bluer and darker than the original color.

FIGURE 6-11:
After using the Lasso tool to select an area and using Variations to tweak color and density, the original photo looks untouched. Manipulating images—without them looking like they are manipulated—is part of the power of Photoshop.

Built-In Filters

Filter freaks and manipulation mavens will be glad to know Adobe Photoshop's built-in filter collection that created its splendid reputation is alive and well. The digital filters that Adobe includes with Photoshop are not unlike the glass and plastic filters currently residing in your camera bag. Like these filters, their digital equivalents are placed over your lens—your digital workspace—to change the overall appearance of the image. On the practical side, the new "scratch and dust" filter can be made to clean up less than pristine originals or the inevitable dot speck that jumps into my Nikon Coolscan when scanning a 35mm negative or slide. Then there's the mondo cool Clouds filter that adds clouds to images when Mother Nature doesn't cooperate.

Making Clouds

Photoshop 3.0's Clouds command can transform dull, empty (what photographers call "baldheaded") skies into cloud-filled ones. Before you can start making clouds, you need to select a Foreground Color. To do that, double-click the left-hand box at the bottom of Photoshop's toolbar. (The right-hand one is for Background Color.) Photoshop uses these colors to generate clouds by using random pixel values between foreground and background colors, so it's a good idea (if you want a natural-looking sky) to select white as the background color. After your colors are chosen, use your favorite selection tool to select the sky area and then choose Clouds from the Render submenu of the Filters menu. If you find the effect looks artificial, use Photoshop's Undo command and while pressing the Shift key, choose Clouds again for a more subdued look. If you want a more sensational sky, you'll need the Difference Clouds command in the Render submenu. In this mode, Clouds are initially generated normally, but before being applied, the filter subtracts the pixel values of the Clouds from the pixel values of your image. This results in less natural but much more dramatic sky effects.

Let's get specific: For the photograph of the eagle sculpture shown in Figure 6-12, my goal was to provide a more interesting sky than was present when the photograph was made.

■ Step 1: With the Tolerance set at 15, the Magic Wand was used to select the background. To my surprise, it did not select the entire sky.

FIGURE 6-12:
Using the Photoshop's Magic Wand, I tried to select all of the sky area. When that didn't happen, I used the program's Select/Grow command to select all of the sky I wanted to change.

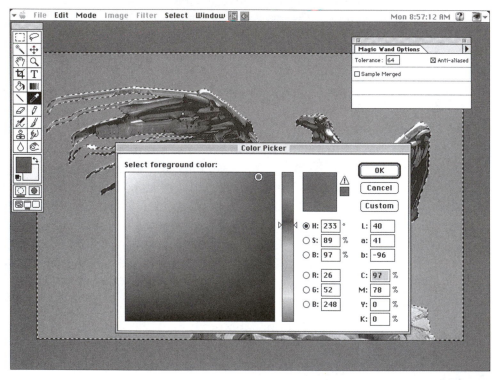

FIGURE 6-13:
Since Photoshop's Render Clouds commands work by using the Foreground and Background colors, the best way to get a natural looking sky is to select a "sky blue" foreground color and "cloud white" for the background color.

At that point, I had two choices: I could increase the Tolerance, or just hold the Shift key (which keeps the current selection) and click the Magic Wand in unselected areas to select areas that will be added to my original selection. Even though this sky seems uniformly blue, it took a total of six Shift-Clicks to select it.

▨ Step 2: Since I still didn't get all the nooks and crannies selected around the eagle, I used the Select/Grow command to give it the final touch.

▨ Step 3: Next, I chose a color that was similar to the original sky as a Foreground color and white as a Background color (Figure 6-13).

▨ Step 4: Then I selected Clouds (Figure 6-14). The effect created by this Render filter was a natural "puffy cloud" look (Figure 6-15).

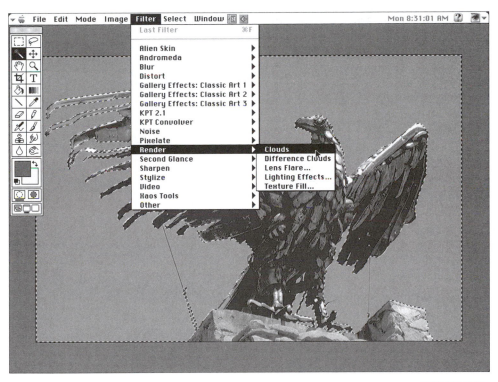

FIGURE 6-14:
Photoshop's Render Clouds command can turn the most "baldheaded" gray sky into a "picture perfect" one.

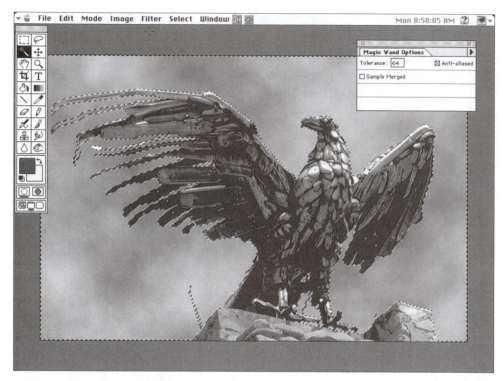

FIGURE 6-15:
Using an algorithm that blends selected foreground and background colors, Photoshop's Render Cloud command can create a sky that looks natural—even if that wasn't the case when you shot the original image.

■ Step 5: To get a completely different look, I changed the background color to red, and applied Difference Clouds (Figure 6-16). Because the contrast between eagle and sky in the Cloud command was not extreme, you could leave the image at this point.

■ Step 6: Since I preferred the Difference Clouds image, I used the Defringe command to remove any halos around the wires holding the eagle upright (Figure 6-17).

FIGURE 6-16:
To add a more dramatic look to your photograph, select Difference Clouds from Photoshop's filter menu. This filter subtracts the pixel values of Clouds from the pixel values of your image and can result in less natural but much more dramatic sky effects.

Another useful filter for photographers is Lighting Effects, which can be used to apply textures and (what else?) lighting effects to an image. There's a Mezzotint filter that designers will love but photographers may save for a special image. Last, Adobe has added the Filter Factory feature from Premiere 4.0 enabling would-be filter producers to create and name custom plug-ins. I expect (and hope) this will be a fertile ground for shareware creators.

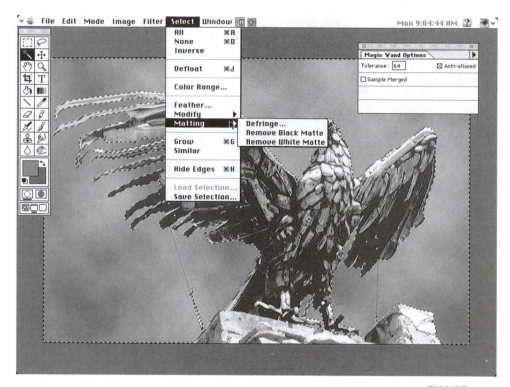

FIGURE 6-17:
The Defringe command can remove any "halos" that might appear around a selected area when any manipulations—such as Clouds and Difference Clouds—are applied. Remember that Defringe will only work on what Photoshop calls "floating" sections, so use the Float command on the section before applying Defringe.

File Translation

Adobe Photoshop is also the closest program to a universal graphics file translator that you will find. It supports 33 different file formats, almost twice as many as its competitors. Standard import and export file formats include Encapsulated PostScript (EPS), Adobe Illustrator, Photo CD, PixelPaint, TIFF, MacPaint, JPEG, Raw, Scitex CT, Targa (TGA), DCS, PCX, Amiga IFF/LBMl, BMP, PICT, PIXAR, and HAM. Unlike similar packages, Adobe Photoshop reads and writes CompuServe GIF files. Photo CD images can be loaded through the Open dialog or through Kodak's Acquire

module. I prefer the Kodak module because it provides access to all six Image Pac files and will automatically (if you check a box) sharpen an image while it is importing it into Adobe Photoshop. (Use of the Photo CD Acquire module is covered in Chapter 9.)

Softening Edges

Not all photographs should have hard edges, and often a soft-edged look works better for some applications, so let's see how to soften edges. Let's start by opening the image of a brachiosaurus (see Figure 6-18).

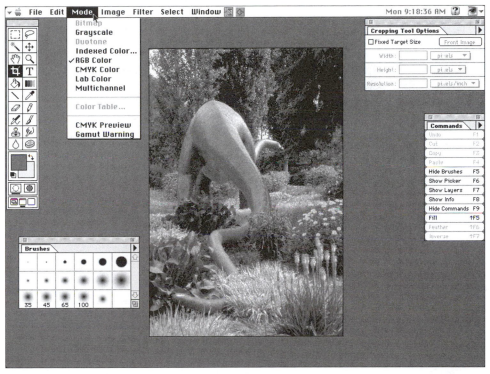

FIGURE 6-18:
Photograph of full-sized model of a brachiosaurus (made at the Utah Field House Museum in Vernal, Utah) from an original 35mm slide digitized using Kodak's Photo CD process.

■ Step 1: Select a background color—in this case, white. Do that by clicking on the color box near the bottom of Photoshop's tool palette. Background color is the large box on the right. Double-clicking it brings up the Background Color Picker.

■ Step 2: You don't have to use white just because I did. Clicking the Custom button on the Color Picker gives you access to a full range of PMS colors that you can use to match the color of the object the design will appear on. After selecting the background color, click on the Marquee tool in the upper right-hand corner of the palette. This brings up an Options dialog box, giving you several choices of selection shape—including rectangular and elliptical. This image worked better with the rectangular option, so it was selected from the Shapes' pop-up menu. At this point you will also have to choose a number for the

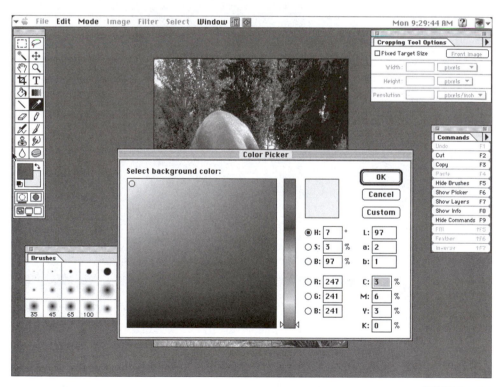

FIGURE 6-19:
The Background Color Picker lets you select the color
that the photographs will blend into. In this case, white was selected.

Feather field. The amount of Feather selected determines how large the area of softness is. Since the feathered edge extends both inside and outside the selection area, whatever number you enter will be doubled in the final image. Experiment with different numbers until you see the effect you prefer, but if you need a place to start, try 10. For this example, I selected 16. Then use the selection rectangle to define the area in the photograph that will be eliminated during creation of the soft edge.

■ Step 3: The area selected can be as big or small as you like, but cannot be any smaller than the number of pixels you specified in the Feather box. Next, use the Inverse command from the Select menu to reverse the selected area. What happens is that the command will define the area that will be deleted as a "frame" around

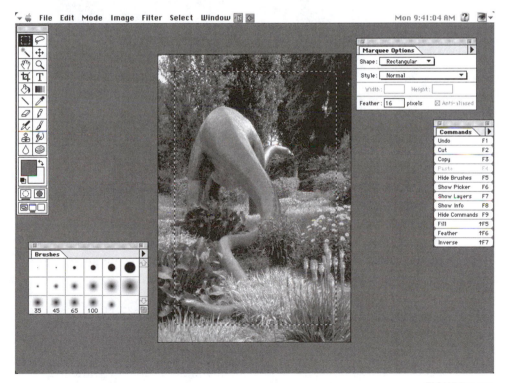

FIGURE 6-20:
Use the selection rectangle to define the area you want to delete and blend.
Afterward, use the Inverse command from the Select menu to choose
an area that creates a temporary frame around the photo.

FIGURE 6-21:
Once the area has been defined, click the delete key and your soft edge will be created. You can vary the softness and width by experimenting with the amount of pixels being feathered.

your photograph (Figure 6-20). If the selected area looks too wide—or too narrow—start over by deselecting. After you've gotten the frame exactly the way you want, hit the Delete key on your keyboard and you're finished (Figure 6-21).

- Step 4: If you're not happy with the results you see on the screen, choose Undo Clear from the Edit menu and start over. Very few steps are involved in creating soft edges, and achieving the effects you want is a matter of defining the amount of feather and the width of the area to select. Practice until you find a combination of these elements that creates the look you prefer.

Spicing Up Edges

If you're tired of the hard-edged photographic look and want to make digital images look more interesting, I recommend you try Photo/Graphic Edges from Digimation Corp. This CD-ROM contains 650 different edges that can be used with Adobe Photoshop and desktop publishing programs like Quark XPress or Adobe PageMaker. All the edges are 400 dpi TIFF files and can be enlarged up to 175 percent without degradation. Edge sizes vary from 3x3 to 8x10 but can be resized or shaped. Styles vary from traditional darkroom, including film holder edges or the arty filed negative carrier look, to customized artistic effects. Some edges are black but can be colored or have drop shadows added by using Photoshop. The disc contains three catalogs of edges: Overlay, Underlay, and Composite.

Turning a boring hard-edged image into one with an interesting jagged-edged look is easier than you think.

 Step 1: Start by opening an photograph in any graphic format you like. In this case, a Pictures on Disk image was saved as a TIFF file in PhotoWorks plus and imported into Photoshop. Use Image Size in the Image menu to find the size of the photograph and make a note of it. Then copy the image onto the Clipboard (see Figure 6-22).

FIGURE 6-22:
To use Photo/Graphic Edges, it is important that the size and resolution of the edge's image be exactly the same as your original photograph. Use Photoshop's Image Size dialog to find the specifications for the original. Later you will use this same dialog with the edge image to change its specs to match your photographs.

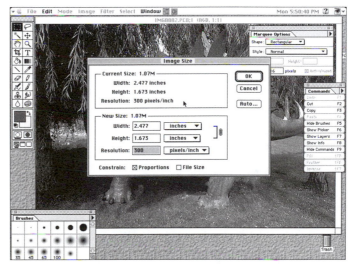

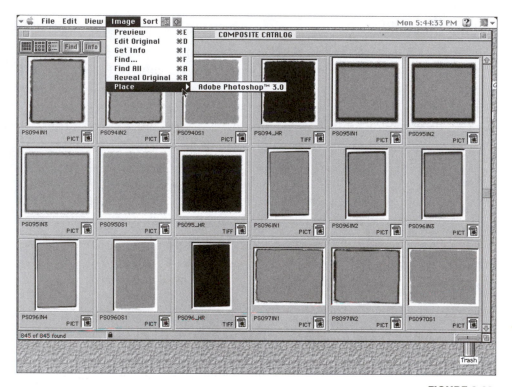

FIGURE 6-23:
The easiest Photo/Graphic Edges to work with in Photoshop are Overlays, which
can be imported into your program, resized to fit, and placed on top of your image.

- Step 2: All of the catalogs on the Photo/Graphic Edges CD-ROM use
 Kudo Image Browser's format, which allows you to import images
 directly from the catalog into Photoshop. The coolest edges are in
 the Composite catalog. After you to find the edge you want and
 select it, Kudo Image Browser's Direct Place command imports it
 into your DTP program (Figure 6-23).

- Step 3: You'll need to make the edges part of the image before import-
 ing the "edged" image into your DTP program. Fortunately, this is
 easy to do: Start with a digital image and copy it onto the Clipboard,
 as in Step 1. Still within Photoshop, open the Edges file you like ,and
 use the Image Size command to make it exactly the same size as the

FIGURE 6-24:
Using Digimation's Photo/Graphic Edges, you can turn a regularly-shaped photograph into one with trendy ragged edges.

photograph on the Clipboard. At this point, there are two important things you must do: First, remember to unclick the Proportions box when setting Image Size. It's unlikely your image and the edge will have the same exact proportions. Second, make sure the resolution of the edge and the image match. Unless they do, you won't be able to go to the next step. Change the resolution of the edge to match the photograph. To wrap up the process, use the Load Selection command to select the Edges file and apply the Paste Into command to place the photo on the Clipboard into the edges (Figure 6-24). This procedure is the same for both Windows and Macintosh versions of Photoshop.

Photo/Graphic Edges also includes a collection of textures, which can be used to add textures or grain to any photograph. The disc also works with Fractal Design's Painter. Photo/Graphic Edges is available in either Windows and Macintosh versions and has a list price of $199.

Output

Adobe Photoshop supports Pantone color, automatic trapping, or CMYK editing for four-color process proofing and separations. Adobe Photoshop can produce output in many forms. My local service bureau produces 35mm

4x5 or 8x10 inch transparencies or negatives directly from Adobe Photoshop files. (For a discussion of the trials and tribulations that can be associated with working with a service bureau, see Part IV on output.) Others might want to use Adobe Photoshop's output to produce color separations. If you want, you can produce accurate monotone, duotones, tritones, and even quadtones. You can do independent editing of four-color process images, and the program's device-independent support allows you to calibrate output for precise color matching for different devices and paper stock.

A new CMYK preview feature allows users to quickly view a "soft proof" of an image displaying CMYK results without going through a full color image mode conversion. The Gamut warning feature lets printers know that a highlighted area is out of gamut. (Gamut of a color system refers to the range of colors that can be displayed or printed. Each of the color modes that Adobe Photoshop recognizes has a different gamut. CMYK, for instance, has the smallest gamut because it is limited to those colors that can be printed using process color inks. We'll get into gamut later in the section on output.) Users can take the new Sponge tool and either saturate or desaturate colors selectively to bring an image back into gamut.

The current Mac version of Adobe Photoshop provides native support for the Power Macintosh, and the latest Windows version provides full 32-bit support under version 3.1 and Windows 95, thus eliminating the sluggishness of earlier versions. Adobe Photoshop will come packaged with both floppy disks and a CD-ROM disc containing the program, along with goodies like user tutorials, 100 digital stock images, and a sample collection of third-party plug-ins. While the suggested retail price for Adobe Photoshop 3.0 is almost $900, street price is around $500, and registered owners may upgrade for under $150 plus a handling fee. Owners of the LE edition found in many scanners may upgrade to the full version for under $200. Adobe Photoshop 3.0 continues to prove that it is indeed the 800-pound gorilla of image enhancement programs, but there are contenders out there who want to challenge that title.

For specific examples, see the next chapter.

7

WINDOWS CONTENDERS

While the Apple Macintosh is usually thought of as *the* platform for producing graphic images, a surprisingly large number of excellent photographic and image enhancement programs are available for IBM-compatible computers running Windows. In the past year or two, software for Windows computers has made major inroads into the Mac's dominance of the graphics market and this is the case with photographic programs too. This chapter covers some of Photoshop's toughest competitors—all available for Windows users. You will also quickly discover that some of the best image enhancement programs include the word "paint" in their names. Don't let that confuse you. Hidden behind the graphics-sounding moniker are programs that can turn photographs from the ordinary into the extraordinary.

Author's Note: The programs in this section don't represent every possible Windows-based image enhancement program available—just those that I have used and consider the best. Among the missing are programs like Aldus' PhotoStyler, a great Windows photographic manipulation program that disappeared when Aldus and Adobe, two major graphics software manufacturers, merged.

Photo-Paint

One of the most popular programs in the Windows-only category is an impressive digital manipulation program from Corel called Photo-Paint. Corel's photo enhancement program is available in two different packages of the same version: one on CD-ROM and the other on a stack of floppy disks. There is no difference between the application contained in either version, and Corel charges an extra 50 bucks for the floppy disk version. Corel Photo-Paint has a list price of $199 for the CD-ROM version and $249 for the diskette version. As part of the CD-ROM package, Corel bundles 10,000 Clip Art images, 100 TrueType and Type 1 Postscript fonts, along with copies of the company's Mosaic image database product and screen capture utility. CD-ROM buyers get plenty more for less money!

Installing the program is simple and the program even has an option for those photographers with overloaded hard disks. This second setup option, which is available only on the CD-ROM version, installs just a few minimum files and allows you to run the program off the CD-ROM discs themselves. Be aware that running Photo-Paint off a CD may save hard disk space, but will slow the program down so much, you'll wonder why you spent extra money to get a computer with a fast Pentium processor. Photo-Paint is not, by today's standards, a disk hog, but when I did a minimum install of Photo-Paint and Mosaic (no fonts or photos) it occupied 13MB on my hard disk. While waiting for the program to install, take a few minutes and fill out the registration card. You will notice Corel will send a dollar to your choice of several charitable organizations listed on the registration form when you register the program. And don't forget the standard reasons why you should always register your software—discounts on updates and update notices.

After launching the program, you'll notice that Photo-Paint (see Figure 7-1) has a graphical interface that's both attractive and functional. On the left-hand side of the screen, there's a toolbox containing the kind of tools

FIGURE 7-1:
Corel's Photo-Paint has the type of graphical interface
most pixographers will find attractive and functional.

any good image enhancement program should have, including Zoom, Eyedropper, Pen, Brush, Fill, and Clone, as well as an Effects tool that can create special effects such as blending, smearing, smudging, adjusting hue or saturation, and tinting. A horizontal Ribbon Bar is located between the top of the work area and the menu bar. It contains buttons that give you access to the program's commonly used features. A Preferences function lets you hide the Ribbon Bar if you like.

Opening an Image File

Usually the least inspired part of any program—image enhancement or not—is the Open dialog. Corel has created an Open dialog along with

ancillary dialogs that allow you to preprocess images, especially from Photo CD, before they are actually "opened" inside the program. Why is pre-processing important?

- If you only need a small image, you can specify which resolution of the five available from Photo CD you prefer. This lets you ignore the 18MB file and save one appropriate for your specific applications.

- If you only need a grayscale image, you can make sure the file opened is a black & white image and not color. This means if you open an 18MB color image in black & white, it will only take 6MB on your hard disk or removable media drive.

- If you used the wrong kind of film, you can color correct an overall color shift. If you shot an image indoors using outdoor film and the image has an overall yellow cast, you can preprocess all the yellow out of the pho-tograph before it's opened. The same process is applicable if you used film balanced for 3200 degree Kelvin and shot the images outdoors.

- You can preprocess an image to remove the blue. Fluorescent lights, as is typical, can be tricky. You can preprocess some overall color shifts, but you'll also probably have to use the program's color con-trols to tweak it back to what appears "normal."

All these reasons to preprocess (and more) are applicable for any program that offers preprocessing capabilities, not just Photo-Paint. There are, for instance, add-ons that offer all these capabilities plus pre-cropping abilities for Adobe Photoshop and programs that accept Photoshop add-ons. (Note: The use of third-party plug-in filters is covered in depth in Chapter 9. For this section, the emphasis will be on those filters that are either built into or ship with a specific product.)

Now that you know why you want to preprocess an image, let's open a photograph.

I started by trying to open an image from a Seattle FilmWorks Pictures On Disk floppy disk. Since Photo-Paint does not read the SFW format, I

FIGURE 7-2:
As a "gateway" program, PhotoWorks Plus can take
Pictures On Disk image files and convert them into a graphics file
format that can be read by most image enhancement programs.

used PhotoWorks Plus (available with Pictures on Disk, see Chapter 3) to save the file as a 24-bit TIFF file (Figure 7-2). Photo-Paint has an impressive Open dialog and reads many different file types including CMX (Corel Presentation Exchange), CDR (Corel Draw), CCH (Corel Chart), BMP, GIF, JPEG, PCX, SCT, TIF, WMF, EPS, and Photo CD. Photo-Paint has a Preview window to let you see a thumbnail (small image) of the photograph before you open the file and had no problem displaying a preview or the TIFF file of a locomotive at the Colorado Railroad Museum (Figure 7-3).

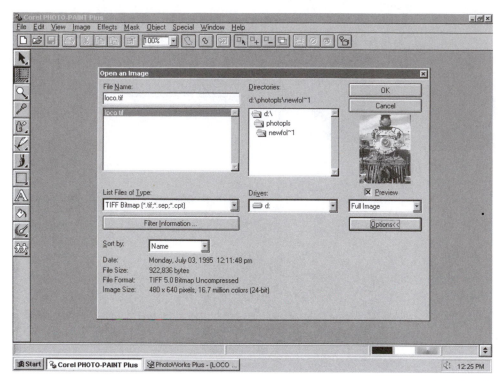

FIGURE 7-3:
Unlike some photographic programs, Corel's Photo Paint has an Open dialog that includes a Preview window showing what image you're getting ready to open.

Preprocessing a Photo CD Image

By comparison, using Photo-Paint to open an image on a Photo CD disc may seem more complex than a Pictures on Disk or other graphic file format, but this is where Photo-Paint shows the power of preprocessing an image before it's opened. Let's look at what Photo-Paint can do with a Photo CD image:

■ Step 1: Select Open from the File menu, and the Open an Image dialog appears. If the preview check box is checked, a thumbnail of the photograph will appear in Photo-Paint's preview window after you have clicked (selected) a Photo CD image (see Figure 7-4).

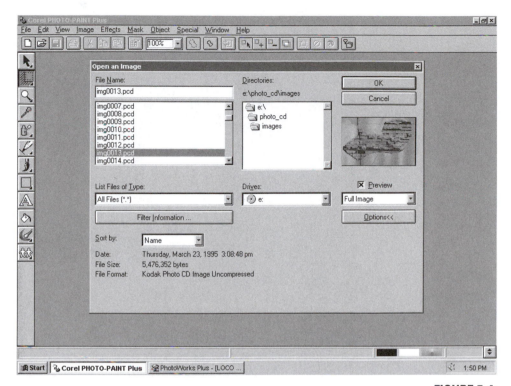

FIGURE 7-4:
When Photo-Paint opens a Photo CD image, it starts a multi-layered sequence of dialogs that allow image preprocessing. This is what you will see first.

▚ Photo CD Files: Where Are They?

When opening Photo CD images, be sure to get the Image Pac file from the Images folder inside the "Photo_CD folder" (or directory) and not the "Photos" folder. The "Photos" folder contains five folders—one for each resolution size—but the data inside those folders is what Kodak calls "entrance points." These are not image files and act like aliases linking those small files to the Image Pac files in the Images folder.

FIGURE 7-5:
Photo-Paint's Photo
CD Options dialog
continues the open
sequence for a Photo
CD image and allows
you to select which
of the five Kodak
ImagePac file
resolutions that you
want to use—and
what color depth.

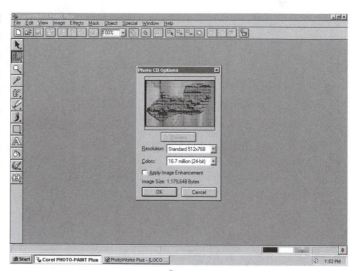

■ Step 2: When you click on the OK button, instead of opening the file, Photo-Paint opens the Photo CD Options dialog, which begins image preprocessing (see Figure 7-5). This dialog has a preview window and two scrolling windows that let you select what size and resolution image you want to open and what color depth they will be. In this example, I've selected the Standard (512x768) image at 16.7 million—or a color depth of 24-bits. Besides specifying image size, resolution, and color depth, checking the Apply Image Enhancement box gives you further preprocessing options.

■ Step 3: Checking the Apply Image Enhancement box and clicking the OK buttons brings up another layer—the Photo CD Enhancement dialog (see Figure 7-6). Most of the corrections in this dialog allow you to color-correct the image but they may not be readily apparent to the new digital imager. Those pixographers who have some darkroom experience will quickly adapt to this dialog, however.

■ Step 4: You're open! (See Figure 7-7.)

In addition to the Open dialog, images can be acquired through Photo-Paint's Acquire Image menu that supports all TWAIN-standard scanning devices.

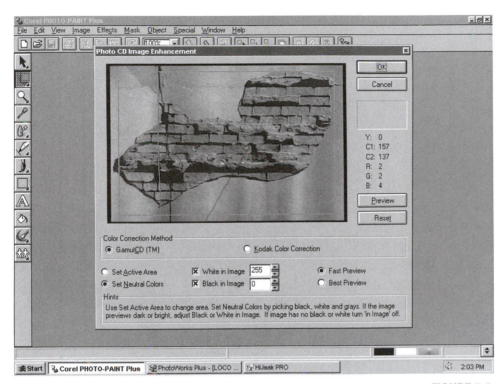

FIGURE 7-6:
Photo-Paint's Apply Image Enhancement dialog is the last step before
opening a Photo CD image. It lets you tweak the image's color before opening.

FIGURE 7-7:
It actually takes
longer to write about it,
but after the three
layers of preprocessing,
your Photo CD image is
finally opened and
ready for some serious
image enhancement.

Tools & Filters

Besides a normal compliment of image enhancement and paint tools, several items on Photo-Paint's toolbar sport "roll-outs." By clicking in the lower right-hand corner of tools marked with a darkened corner, you'll see an expanded menu of related tools. When clicking the tool you want on a roll out, it replaces the original tool shown in the toolbar. Another interface feature is the use of "window shades" that "roll up" out of the way leaving the heading only. Selecting Roll Down from that window's pop-up menu allows the entire menu to unfurl.

Photo-Paint ships with a series of interesting filters already installed. The manual states that the program accepts third-party plug-ins, but doesn't mention that the program's filter capability is compatible with Adobe Photoshop plug-in filters. What's impressive is the way Photo-Paint handles mundane built-in filters like Sharpen (see Figure 7-8). Unlike Adobe Photoshop, Photo-Paint lets you control the amount of sharpening, and you can see the effect in a preview window before applying the filter. The former SFW (Seattle FilmWorks) file needed some sharpening as all scanned images seem to need. (Even Photo CD images need to be sharpened.) I applied a 20 percent sharpening factor that looked good to me. This is one area where it helps to have a 24-bit display system. Subtle changes like sharpening can be over—

FIGURE 7-8: Corel Photo-Paint's Sharpen filter uses a dialog that lets you sharpen the image by a specific amount. Clicking the left mouse button increases the magnification of the image in the Preview Window, and clicking the right-hand button decreases the size.

or under—done by not being able to see on your screen exactly what an effect look likes before printing it or having it imaged as a transparency or negative.

Photo-Paint also has two Artistic tools called Pointillism and Expressionism. Both have interfaces allowing extensive control over how the effects are applied and a preview window that gives you a peek at the effect before it's applied to the entire photograph. Photo-Paint's Effects menu also includes some special effects from Kai's Power Tools, Paint Alchemy, and Alien Skin, along with some Photo-Paint exclusives like Glass, Psychedelic, and Page Curl. All of them provide preview windows and are applied without too much delay (on a 486/50 DX2 anyway) on moderately-sized files. If you're a big fan of texture screens sandwiched with photographs in the darkroom, you'll love the

FIGURE 7-9:
Using the Special submenu in the Effects menu gives you access to all kinds of fun effects. Here, the Psychedelic filter is applied to a Photo CD image of an antique fire truck. To see the final image, check out COLOR PLATE 2 in the book's color pages.

Photo Paint's built-in library of 40 canvases you can apply to your photographs using the Fill command. All you have to do is double-click the "paint bucket" icon, which brings you to a dialog box that lets you apply the texture to any image.

COLOR PLATE-2: After Applying the Psychedelic filter, the Photo CD image then had the brightness, contrast, and intensity tweaked using Corel Photo Paint's Brightness and Contrast dialog.

Photo-Paint is a great tool for Windows users and sports many innovative interface features, but nobody is perfect. On a system with 8MB or less, Photo-Paint can be a little sluggish when working with files bigger than 15MB, although that effect seems diminished when running under Windows 95. With a low RAM configuration, Photo-Paint's performance is not slow enough to make you fall asleep while waiting for something to happen, but enough to occasionally make you frustrated when working on images. This can be solved by adding additional RAM chips or SIMMs to your computer. The only other aspect of the program I didn't like is the User's Guide. While it's trendy to trash manufacturers for their instruction manuals, the truth is most companies, including Corel, have done a much better job in recent years. But the manual makes the assumption you have read it from cover to cover and remembered all the steps it takes to get you to a specific point. Not all readers will do it that way, and these unfortunates will spend a lot of time bouncing back and forth between sections. On the other hand, Corel has made excellent use of color throughout the book, so you will see in the book what's on the screen. With these few quibbles aside, I think the program is an excellent value and won't be intimidating for new photographers, making it a good introduction to image enhancement software.

Picture Publisher 5.0

Micrografx's Picture Publisher is another of the most popular image editing programs for the Windows platform, and with good reason. Let's start with the program's ability to read different graphics file types, including: TIFF, CMYK, GIF, BMP, PCX, TGA, Photo CD (including Pro format), JPEG, PP4, PP5, EPS, DIB, AVI, SCITEX CT, DCS, EPS, CDR, CGM, and WMF.

Picture Publisher supports all Photoshop-compatible plug-ins and offers direct scanner support. The CD-ROM that's packed in the box (there are floppies included, too) also contains an interactive on-line tutorial and a 300-image stock photo library. These may be useful for practice, but you'll probably prefer to use your own photographs.

Opening an Image File

Getting Pictures On Disk images into Picture Publisher is easy. First, launch and minimize Picture Publisher. Next, open PhotoWorks Plus and select the photograph you wish to move (export) to Picture Publisher. Select the Save As/Convert To command (it's in the File menu) to bring up the dialog that allows you to save the file in any number of graphics file

FIGURE 7-10:

A former Picture on Disk image, saved as a TIFF file, is opened with Picture Publisher's impressive open dialog box, which Micrografx calls the Image Browser.

formats. (I chose 24-bit TIFF and saved the file as park.tif onto the hard disk.) At this point you can close PhotoWorks Plus, or just minimize it. Next, maximize Picture Publisher, and select Open from the File menu. When you do, you will see the most impressive and comprehensive Open dialog found in any program—graphics or otherwise. On the right-hand side is a Drive/Directories/Mode window that lets you locate your file. If a preview thumbnail was created for your file, it will be displayed in the left-hand window, along with every other image in the subdirectory, in a contact sheet format. Double-clicking the image opens it and places the former SFW file onto Picture Publisher's work area. (If you save it, a preview thumbnail will be created.) You'll also notice that when the image is

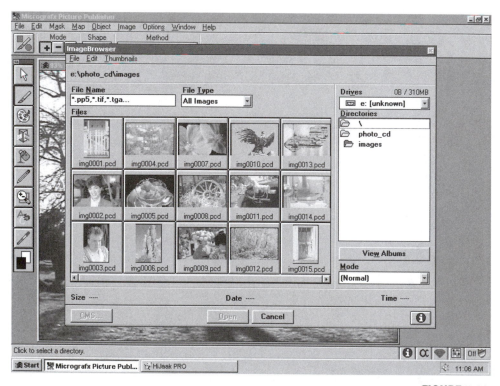

FIGURE 7-11:
Picture Publisher's Image Browser dialog displays thumbnails of all Photo CD images so you won't have to try to decipher Kodak's cryptic file names.

opened, it is opened in what other programs call "Fit to Window" mode. In other words, Picture Publisher opens the image as large as the work space allows, saving users a step. A small thing, but nevertheless impressive.

Opening a Photo CD image is even easier and shows off the excellent interface design of the Image Browser. Selecting Open from the File menu brings up the Image Browser box, and because Kodak includes thumbnails on Photo CD disc, you can see all the images on the disc instead of having to look at the reference print on the jewel box or trying to remember what the image number is. (Kudos to Micrografx for being one of the very few image manipulation programs to display and open portrait-shaped Photo CD images in the proper orientation.) To open an image, all you have to do is double-click the thumbnail. When you do, you're taken to Picture Publisher's Photo CD Open dialog. Some Photo CD images invariably include a black border around the image; unless you are a "let the edges show" purist you probably want to crop the edges off at some point. Picture Publisher lets you do so before even opening the file and displays the file size (based on the resolution you selected) and the size of the cropped image. The dialog has a Photo CD information window that displays some mundane facts about the image and, what is more important, shows the copyright information found on Photo CD Pro discs.

Tools and Toolbox Design

When you select a tool from the toolbar at the left of the screen, the toolbar changes to display the controls available to that tool. If you thought the Image Browser was impressive, selecting Effects (or typing (CTRL)-(E)) brings up the Effects Browser that gives you access to all of Picture Publisher's filters and image enhancement tools in a scrolling window. Again, it's a good idea to tweak the sharpness of any digital or scanned image before beginning any kind of manipulation, and the best way to sharpen within Picture Publisher is to use the Unsharp Mask tool and the Effects Browser. As you select a tool, the control panel changes to display controls appropriate for that effect. You can use the controls to tweak the image, then click the Preview button to see what that effect does to the portion of the image covered by the selector shown in the Preview window. If you want to see a specific part of the photograph, you can use your mouse to move the selector to cover a critical area of an image. Once you click on the Preview

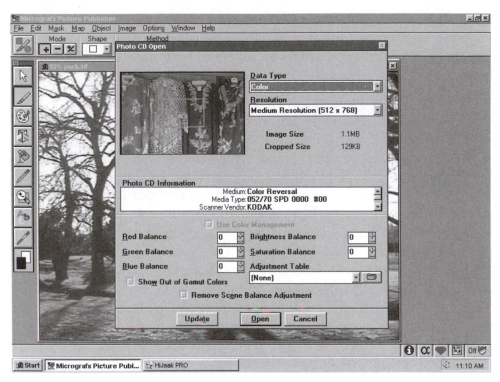

FIGURE 7-12:
Picture Publisher's Photo CD Open dialog lets you select the file size and resolution, as well as adjust color balance and crop a Photo CD image before it's opened.

button, the effect will be displayed in the Preview window, which is next to an original window so you can do a side-by-side-comparison.

The Effects Browser is one the nicest features of Picture Publisher and enables you to preview any effect that the program offers before it's applied. Micrografx also includes two other browsers in the package: Image Browser and Clipboard Browser. Image Browser lets you view visual thumbnails of images during Open, Save, and Import operations. Clipboard Browser lets you drag & drop an image from a collection of thumbnails onto the current image that you're working on.

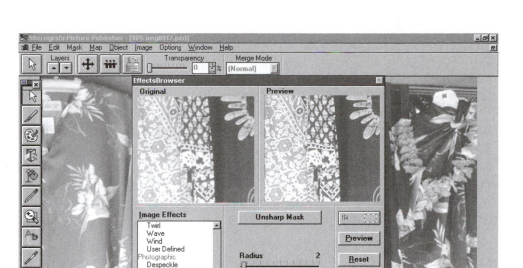

FIGURE 7-13:
Picture Publisher's Effects Browser lets you tweak image sharpness, brightness, and contrast as well as apply special effects. Here the Unsharp Mask is applied to a Photo CD image.

◆ Tip: Beware The Cropping Tool

One of Picture Publisher's most useful tools is the cropper. It works much like every other program's cropping tool except for one thing: As soon as you select the cropped area, the tool automatically does it. This is a real convenience but if you're mousing around and still have the Crop tool selected, an inadvertent mouse click will crop the entire image into the bit bucket. In other words, it's gone! If that happens all you have to do is select the Undo command from the File menu. Remember to be careful around the cropping tool. The No. 11 Xacto blade it uses as an icon is appropriate; this is one tool you can cut yourself with.

◆ Unsharp Mask vs. Sharpening

Let's clear up the semantics of sharpening an image. Unsharp Mask doesn't even sound like it will increase the sharpness of a photograph, but given a choice between Unsharp Mask or Sharpening, I prefer the former. That's because, in most—but not all—programs, Unsharp Mask can be controlled with more precision than Sharpen. The typical Sharpen filter works by simply increasing the contrast of adjacent pixels, while Unsharp mask works by exaggerating the sharpness (and contrast) of the edges of an image. The term Unsharp Mask is derived from the traditional darkroom technique of using a negative with a slightly blurred positive mask to make the image "pop out" of the photographic paper. Unlike this traditional method, the digital equivalent doesn't require the use of a pin registered Kodalith mask and special safelights to work. Using Unsharp Mask effectively is a matter of adjusting the controls in a dialog. Like Photoshop, Picture Publisher provides controls for Strength, Radius, and Threshold. Strength is the amount (Adobe calls this control "Amount") of sharpening in percentages from 1 to 200. (Photoshop lets you take this up to 500 percent.) For Radius, Micrografx provides a slider that lets you specify distance from an edge that you want sharpened. Low numbers mean that sharpening occurs close to an image's edge, and high numbers mean just the opposite. Picture Publisher gives you a slider that can be adjusted from 1 to 25 pixels. The Threshold slider lets you specify a comparison between adjacent filters and prevents sharpening unless the brightness of these pixels exceeds the Threshold. This control prevents *over* sharpening which can create just as ugly an image as an *under* sharpened one.

Filters and Filter Effects

Picture Publisher's Effects Browser includes filters and controls such as:

- Artistic filters including Charcoal, Oil Painting, Pop Art, Pastel, and Watercolor.

- Color Adjust such as Saturation, Balance, Brightness & Contrast, Dither, Gamma Correction, Hue Adjustment, Posterize, and Threshold.

- Distortion Filters including Add Noise, Blur, Color Noise, Edge Detection, Gaussian Blur, Graphic Pen, Motion Blur (my favorite), Polar to Rectangular, Prism, Tunnel, Twirl, Wave, and Wind.

- Photographic filters such as Despeckle, Remove Pattern, Smooth, Sharpen, Sketch Detail, and Unsharp Mask.

- Textures including Crystallize, Disturb, Emboss, Engrave, Facet, Metal, Mosaic, Pixelize, Splatter, and Stucco

- Three-Dimensional Effects like Cylinder, Pillow, Pinch, Punch, and Sphere.

While it's beyond the scope of this book to examine the entire menu, you will see that Picture Publisher has a full complement of special effects capabilities—enough to satisfy even the most ardent pixographer.

Combining Special Effects

One of the advantages of Picture Publisher (and all competent image enhancement programs) is the ability to combine effects to create a single image. Let me show you what I mean:

- Step 1: A Photo CD image of a fence in Georgetown, Colorado, was cropped before opening (using the Photo CD Options dialog) to remove a thin black border around it (Figure 7-14).

- Step 2: The Effects Browser's Unsharp Mask, set at 100 percent, was used to sharpen the image (Figure 7-15). A rule of thumb I have found to be useful is that a large, high resolution file needs more sharpening than a smaller one. The final test is to use your pixographer's eye to see what looks best on screen.

FIGURE: 7-14:
Picture Publisher's preprocessing cropping tool is used to trim an excess non-image area of a Photo CD photograph.

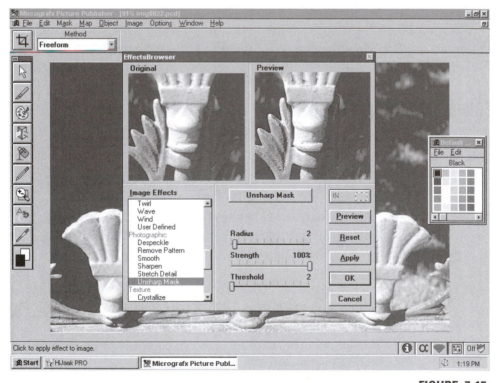

FIGURE: 7-15:
Picture Publisher's Unsharp Mask filter is used to sharpen the image a maximum of 100 percent.

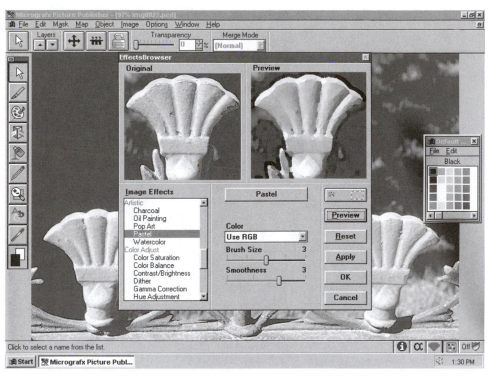

FIGURE: 7-16:
Picture Publisher's Pastel filter was applied while still inside the Effects Browser by clicking the Apply button—instead of the OK button. This saves time for impatient pixographers.

■ Step 3: To take the next step, I used the Pastel filter from the Artistic filter group to create an image more abstract than the original (Figure 7-16). Using the Apply button, instead of the OK button, I was able to stay within the Effects Browser and apply the next effect.

■ Step 4: Next, I used the Wind control in the Distortion group to add some motion to this static image. I clicked the OK button to apply the last filter.

What left is a photograph of a fence—with a difference (Figure 7-17).

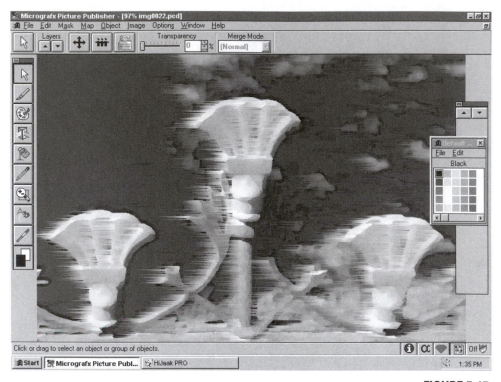

FIGURE 7-17:
The Wind filter was used to add some action to the still image.
How any effect is applied is up to you—just as in traditional non-
digital photography. You may like this image or hate it.

It's a Deal!

Picture Publisher may not have all the features found in Adobe Photoshop, but I've found it sold in computer superstores for under $100. On the other hand, Picture Publisher has features *not* found on Adobe's more higher-priced offering. Take Undo for example. You've already seen that Undo can be a powerful tool when manipulating images. Picture Publisher gives you an infinite number of Undos that will take you back to the last version of a photograph that you saved.

Another area in which Picture Publisher exceeds Photoshop's capabilities is editing text. Picture Publisher lets you make changes on screen, much as you would in any graphics or desktop publishing program, even after that text has been placed onto an image. FastBits and LowRez are two other features that make Picture Publisher unique—and useful—as an image editing tool. FastBits allows you to do quick retouching of a section of an image—without having to load the entire image into memory. This makes the program less of a memory hog and also makes manipulation of sections of a photograph go much faster. The same is true of the LowRez feature, which lets you work quickly on a low resolution version of your image, then when you're finished applies these changes to the full resolution image. It does this by creating a program-generated script of the tools and techniques you have applied to a photograph, then running the script in a post-production mode. This is a feature found only in more expensive programs, and when combined with Picture Publisher's other features, makes it one of the bargains in image enhancement software.

Paint Shop Pro

JASC's Paint Shop Pro is a combination photo retouching, paint, file conversion, and screen capture program with ease of use and low pricing making it the ideal digital imaging program for new users. The program also offers screen capture capability and support for TWAIN compliant scanners.

To work with a Photo CD image, you'll need to set Paint Shop Pro's Preferences to open a specific resolution or to ask before opening. You'll notice that the program does not support either the Base*16 files or the Base*64 option available with Pro Photo CD. Perhaps with Kodak's opening of the Photo CD format, JASC will add both file types to future versions. Paint Shop Pro also lacks a preview box to show what an image looks like before it's opened. This may not be a problem with images you've created with descriptive titles, but can be tricky when dealing with the cryptic names Kodak assigns to Photo CD images. On the other hand, Paint Shop Pro's Open dialog includes a Browse button that automatically creates a database of all the images on your Photo CD disc (Figure 7-18). Paint Shop Pro's Browser function is handy when working with Photo CD images and provides basic-level search functions, but would never be considered a replacement for a full function image management program.

FIGURE 7-18:
Paint Shop Pro's Open dialog includes a Browse button that automatically opens the program's PSP Browser module and creates a database of all the images on your Photo CD disc.

Paint Shop Pro has an attractive interface and offers all the basic image enhancement tools a beginner could ask for, including the ability to alter an image's hue, saturation, and lightness, or adjust its brightness and contrast.

Adjusting Brightness and Contrast

Here's how to change a photograph's brightness and contrast using Paint Shop Pro. This particular image is a triple-whammy in the contrast department. This photograph of a yellow street rod was shot with Agfa color negative film (which has slightly more contrast than most color neg stocks) on a bright, contrasty day, and the scan seemed a little contrastier than normal.

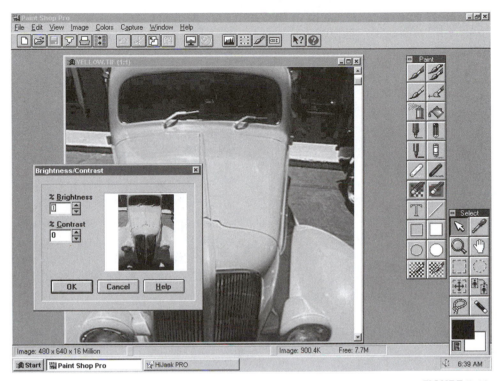

FIGURE 7-19:

Paint Shop Pro's Brightness & Contrast dialog may not take advantage of the sliders that many image enhancement programs use to adjust a photograph's brightness and contrast, but its scrolling windows are just as easy to use.

■ Step 1: Open the Adjust Submenu from the Colors menu and select Brightness & Contrast (Figure 7-19).

■ Step 2: Instead of the sliders that many image enhancement programs use, Paint Shop Pro uses scrolling windows that let you enter a specific amount of brightness and contrast. Or click on the up or down arrows to achieve the effect you want.

■ Step 3: You will want to make sure the contrast of the image matches the output device's ability to handle the contrast. (See Part IV for more information on output devices.) If the image on your computer screen has too much contrast—or too little for that matter—it will

not match the output of the printer or film recorder. As in all competent darkroom work, the best way to know limits is to test, test, test and evaluate the results of those tests. Initially, this may seem expensive, but will be much cheaper in the long run. In Part IV, I'll provide some common sense methods of matching the output to your original vision for a particular image.

No matter what kind of controls a program uses, it's up to you—and your photographic taste—to decide how much adjustment is enough. Much will depend on how you use the finished image. Will you have a slide made from the file, or will you just print it on a color printer? Each choice has its own contrast limitations, and you need to match your own taste to that of the output device. A good rule of thumb—to start with anyway—is to make the image look good on the screen and make notes of the adjustments you made. When evaluating the output, you will be able to know how much adjustment you will have to make in brightness, contrast, or both to get the result you're looking for. In many respects, the process is not unlike turning on the white or viewing light in your darkroom to evaluate a wet print to see if the exposure you gave it needs some fine tuning.

The program also lets you Flip, Mirror, or Rotate a photograph in single degree increments. Photographs can be cropped or have borders and frames added to them. The way Paint Shop Pro 3.0 crops an image is, however, somewhat awkward. You use the rectangular selection tool (from a floating selection tool palette) to define cropping, then choose Crop from the Image menu. In the floating Paint palette, the program has some unusual and fun paint tools. Besides Paint Bucket and Pencil, you'll find Charcoal, Crayon, Marker, and four different brushes, including user-defined versions. A Swap Brush allows replacement of a particular color with one you might like better. If a model shows up with a yellow hat, but you think green would match her dress better, don't worry about it. You can use the Swap Brush to replace a selected Foreground color with a Background one—and vice versa. There are also tools to help you sharpen a brush to accentuate edges or smooth or soften them. The Clone Brush (not to be confused with the Cloner) is great for cleaning up glitches in a scanned image. If your photo has a few dust spots, you can use Clone Brush to copy the areas around the speck and paint over the specks to make them disappear.

Selection is an important part of digital imaging, and Paint Shop Pro offers a floating palette of selection tools including Magic Wand, a Rectangular Selector, Oval Selector, and a selection Adjuster that lets you move and resize a selected area. Image enhancement capabilities include a Cloner for duplication of selected areas. Back before digital imaging, I did a portrait of a young couple with an antique Ford truck. The shoot was on private land that backed up to a golf course and the image with the couple's best expression included a twosome walking in the background. Using the Cloner, I would be able to "clone" the grass, and paint over the golfers to achieve the effect that I had to pay an artist to do. Image enhancement programs live and die by their built-in filters and their ability to work with external filters. Paint Shop Pro supports all Photoshop-compatible filters and uses a unique Filter Browser to apply and preview them. The dialog contains a list of filters and a Preview window allowing you to see what the effect looks like before applying it. If you like what you see, click the Apply button.

The program reads and writes 31 file types including Adobe Photoshop, RGB, BMP, DIB, RLE, CDR, CGM, CLIP, CUT, DRW, GIF, RLE, GEM, HGL, IFF, JPG, LBM, MAC, MSP, PCD, PCX, PIC (Lotus), PBM, PGM, PPM, RAW, RAS, TIF, TGA, WMF, and WPG. Additional formats can be added through the Adobe/Microsoft import filter interface that ships with Microsoft Word and Adobe PageMaker. Reading and writing different graphics formats makes Paint Shop Pro an ideal file conversion program too. The program also lets you batch process large numbers of image files to convert them into a common graphics file format. Paint Shop Pro 3.0 is not like your typical photo enhancement program. Instead, it resembles a toolbox containing many different graphics tools that can improve and enhance your photographs. At $69, Paint Shop Pro represents one of the best buys in Windows image enhancement programs. Here are a few more...

Bargain Photo Programs

I must confess that four of the five computers in our studio are Macintoshes of one configuration or another, and I have one Windows machine (I call it "Morty") which serves as kind of utility infielder. In no particular order, here are the programs you'll find on its hard disk:

Graphics Tools

DeltaPoint's Graphics Tools is a multi-functional photo/graphics program that includes modules for image management, file translation, and screen capture and image enhancement. The program's basic interface, called Media Manager, looks and acts like an image database system. It can collect and display images from a Photo CD or photographic files you may have stored somewhere on your hard disk. Media Manager also catalogs graphic and multimedia files, including sound and animations.

Graphics Tools is a Photo CD compatible program, but inside its OPEN dialog you'll have to select that specific file type or check "all types" before the program displays the contents of a Photo CD disc. After an image is selected, a thumbnail of the photograph is created and displayed. When a thumbnail is double-clicked, the program finds the original file, displays the image, and changes the interface into an image editing mode it calls Image Processor. This module's interface is intuitive and displays a wide range of enhancement tools, including color correction, color separation, and mapping and modeling. The "Test Strips" menu provides tools for manipulation, including rotating, retouching, and cropping. There are dialog boxes that let you manually tweak a photograph by varying its brightness, contrast, and gamma. If you discover you've gone a step (or two) too far in manipulation or retouching, Graphic Tools provides three levels of "Undo" that let you get your image back to where it looked "just right." The program reads 70 different file formats and can convert your photograph into any one of them. If you need it, the screen capture can be accessed no matter what program you're working on. I've seen Graphics Tools available for as little as $69.

Image Wizard

ImageWizard 1.03 is a photo/graphic enhancement program that supports 18 different graphics file formats, including Kodak's Photo CD Pro format. Photo CD discs are displayed in its OPEN dialog by their somewhat cryptic default file names, but by clicking a PREVIEW button you can visually search for a specific image. ImageWizard's toolboxes use photographic icons to show exactly which effect a tool will have on your picture. Some pixographers might feel this is like having pictures of hamburgers on the buttons of a McDonald's cash register, but I like the look of the interface and

feel this approach should decrease the learning curve associated with the program. ImageWizard includes tool windows with names like Filter Brush, Paint Brush, Area Tool, and Object Tools. If that's not enough, ImageWizard has image management and slide show features as well.

HiJaak Graphics Suite

If Paint Shop Pro is a great image enhancement program that does file conversions, HiJaak Graphics Suite is a great file conversion program that's added image enhancement and draw capabilities. Inset Systems introduced an improved version of HiJaak Pro and bundled it with several graphics tools, including Browser, Smuggler, and TouchUp. Browser is the first fresh take on an image database utility I've seen in a long time. It combines the now familiar "light box" look with a visual representation of connected drives that reminds me of Windows 3.1's File Manager. You can configure thumbnail size and spacing, as well as organize images in "collections" that can be searched for key word or caption information. The left side of the screen includes "buttons" that let you quickly move back and forth between all the utilities included in the HiJaak Graphics Suite. Smuggler is a utility that lets you search and retrieve files from inside your other applications. HiJaak TouchUp is a new digital imaging and paint program that reads all five standard Photo CD resolutions and includes the ability to print test strips for seven of the program's image control functions, such as brightness and contrast.

Creating a Brightness Test Strip with HiJaak

Creating test strips with HiJaak TouchUp is similar to creating test strips in a "wet" darkroom. While Photoshop's Variations command performs the kind of ring-around test or test strip that you would do in your darkroom—or have a professional lab do for you, TouchUp provides some control over how the test strips are made—just as you would in an analog darkroom. Here's how it works for brightness:

- Step 1: Open an image—any image.

- Step 2: Select Brightness from the Test Strip submenu of the Image menu. Your other choices include: Gamma, Contrast, Halftone, and

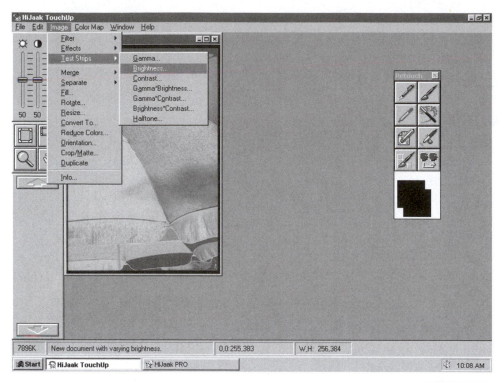

FIGURE 7-20:
HiJaak TouchUp's test strip feature can be found under the Image
menu and the Test Strip submenu, which provides seven different options.

combinations such as Gamma & Brightness, Gamma & Contrast, and
Brightness & Contrast (Figure 7-20).

■ Step 3: The Brightness Test Strip's dialog contains the same kind of
controls you would have if making a test in your own darkroom. The
first part lets you decide *how many* images will be in the test strip,
and below you can specify which brightness range you want the tests
to include. Rule of thumb: Most users will find that the smaller the
Brightness Range is, the fewer Number of Images are needed. The
dialog also lets you resize the image in the test strip. 50 percent is the
default, and making it any bigger just clutters your screen—unless

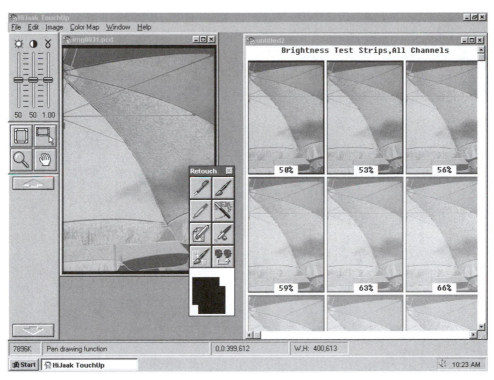

FIGURE 7-21:
HiJaak TouchUp's test strip dialog lets you set the number of images in the strip, their brightness range, size, and which color layers will be affected.

you have a 20-inch monitor. If you do have a 20-inch monitor, go for 100 percent! The last part of the dialog lets your adjust the brightness on specific layers of red, blue, or green—or all of them together.

- Step 4: When you've established your parameters for the test strip, click OK and the test strip appears on your desktop (Figure 7-22). At this point, you can evaluate the image on screen or print the test strip on your photo realistic printer and make you decision on the paper image, much as you would in a "wet" darkroom.

- Step 5: At this point, you would expect to click on the selected test and have the effect transferred to the image, but that's not how

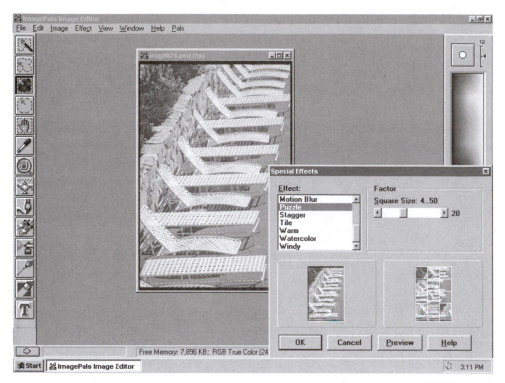

FIGURE 7-22:
When the test strip was displayed, I was sorry I didn't specify a smaller image size so I could see a side-by-side comparison of each test image. Keep that fact in mind when selecting a number of images.

HiJaak TouchUp works. Instead, you have to transfer your image data to the image by using one of the three sliders (brightness, contrast, and gamma) that are part of the basic interface of the program.

HiJaak TouchUp also lets you Resize, Rotate, Flip, and Crop a photograph to achieve desired results. There's even a few special effects filters, including Posterize, Etch, Emboss, Sculpt, and Pixelize. There are also multiple Undo levels, something lacking in more expensive programs, such as Adobe Photoshop. Draw capability is not something digital photographers often need, but it's nice to know you can do it without having to buy

another program. HiJaak Draw's palette includes 16 drawing tools, 2 text tools, and 3 selection tools. It also allows you to assign user definable colors for highlights, shadows, and intermediate levels. You can even create 3D extrusion with specified light sources. The heart of the suite is still HiJaak Pro, which remains my number one choice for Windows file conversion. It can convert both vector and raster formats, or simply choose your target application and let HiJaak Pro select the best export format. HiJaak Pro lets you view graphics files in 75 different formats and offers both DOS and Windows screen capture options.

Photo Factory for Windows

Photo Factory for Windows 2.0, from The MultiMedia Store, is a $69 enhancement program that's designed to work with Kodak's Photo CD, but reads other image files too. If you haven't yet made the jump to Photo CD (and why not?), I especially liked Photo Factory's slick OPEN Photo CD Image dialog. It automatically selects your CD-ROM Drive and displays thumbnails of all the available images in a vertically scrolling window.

While the program had no trouble with individual images, the OPEN Photo CD Contact Sheet didn't work with Photo CDs I created, but had no trouble with any Kodak Image Sampler CD. I have seen this problem before (including in Kodak's own Shoebox software), and it's caused by a problem with how DOS 6.2's SmartDrive handles CD-ROM caching. The MultiMedia Store includes a simple workaround in its README file, and if you don't normally read these files, here's a perfect example of why you should. (This conflict should disappear with Windows 95.) Like the other programs mentioned, Photo Factory includes image database functions, but that feature is secondary to its image enhancement capabilities.

Photo Factory has many cool image tweaking tools including Brighten Midrange or Brighten Shadows. Because these tools require the data contained in 24-bit files, they only work with 24-bit images. When you open a 24-bit image on a 256-color system it may not be displayed perfectly, but you can apply these functions, then convert the photograph into a 256-color file, and everything will look OK. Other tools like Mirror, Flip, and Rotate work with all kinds of photographs, but the Filters menu also includes some that only work with 24-bit images. The program also includes slide show features

that allow you to produce impressive on-screen presentations. MultiMedia Store's next version of Photo Factory will come on CD-ROM and include more image enhancement features, a more sophisticated import/export function, 50 original MIDI (Musical Instrument Digital Interface) songs, and 50 Photo CD images. The increase in price? Just ten bucks.

Image Pals

Ulead Systems Image Pals' "introductory price" of $129 lets it fit easily into the category of bargain image editing programs, but it's more than just an enhancement program. It consists of separate modules for image cataloging, screen capture, and file conversion. The modules, or "Pals," are called Album, Image Editor, Screen Capture, and CD Browser. Double-clicking CD-Browser automatically loads all the images on any CD-ROM or Photo CD disc residing in your CD-ROM drive. Browser's standard display mode is excellent and can be customized by changing the color of the background and size of the thumbnail. The "Pals" menu lets you bounce back and forth between the program's different modules. Images can be copied from the Browser into an Album for permanent storage and later retrieval.

Images can also be imported from any TWAIN-supported scanning device, and when an image is finished being scanned it's automatically added to an album. Once inside an album, you can assign a description, subject, and keywords for each photograph making it an ideal way to catalog your Photo CD images. You can view, select, search, or sort the photographs by file name, description, subject, or keyword. You can drag-and-drop images between albums and many different external applications. The Image Editing portion of Image Pals is no slouch and includes image retouching and painting tools, special effects filters, and color and tone adjustments. The Special effects dialog includes all the program's effects and has a preview window to let you see what changes will look like before you apply them. The space above the preview changes to reflect the special effect tool selected. Built-in effects include: Blast, Cool, Emboss, Facet, Fat/Thin, Fish Eye, Mosaic, Motion Blur, Stagger, Tile, Warm, Watercolor, and my favorite—Puzzle. You can use the cool "clone" tool to clone part of one image onto another. When you have all your photographs just the way you want them, you can combine them into a slide show using photographs, audio, video, and animation files.

This has been a whirlwind tour of several Windows image manipulation programs that I've found to be indispensable for my digital studio. Next, I'll take a look at some Macintosh image enhancement programs. Before you Windows readers skip ahead a chapter, take a few moments to read the section on Fractal Designs' Painter. In addition to being a highly competent Mac program, it's also available in a Windows version.

MAC-ING OUT

There are actually fewer Macintosh image enhancement programs than are available for Windows computers. This is, most likely, a reflection on the greater installed base of PC users, but the programs available for the Mac are impressive. Like their PC counterparts, several of the programs include the word "paint" in their title. Leading the contingent is a powerful Photoshop competitor that's also available for Windows users. It's from Fractal Design and it's called...

Painter

Before you even install the software, you know Fractal Design's Painter is going to be different. Instead of a shrink-wrapped box, the program is delivered in a Benjamin Moore-like one-gallon paint can. The can contains seven floppy disks and a CD-ROM. Unfortunately, the CD-ROM does *not*

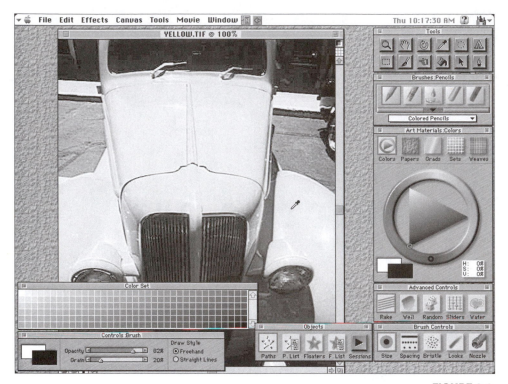

FIGURE 8-1:
Fractal Design's Painter looks different because it is different. Here, the basic seven tool palettes are shown, but they can be selectively hidden to unclutter the desktop.

contain the program. Instead, you'll find sample images and supplementary files, which means you'll have to install the program from the floppies.

As soon as you launch Painter, you know you're not in Kansas anymore. This program's interface is dramatically different from all previous image manipulation and enhancement programs covered in the book so far. The program's seven palettes are collapsible, so you can keep those that you use often scattered around the screen. Serious Painter users may wish to consider adding another monitor to display tools and palettes, or they may wish to get a larger monitor. My NEC 15-inch was crowded. Here's a quick look at a few of the available palettes:

- Brushes: This contains icons for five different tools, from a pencil to charcoal, and sports a "pushbar" that, when clicked, expands the palette to offer variants of that tool. Fractal Design calls this the "secondary" palette, and it can be "torn off" (and placed anywhere on the screen) if you have more than one secondary palette available at a time. A pop-up menu also provides 6 to 10 variations on the brush used. If you can't find it here, it doesn't exist.

- Tools: This palette contains the kind of basic tools you'd expect to find in Photoshop, Photo Paint, or Picture Publisher and includes brush, paint bucket, magnifier, and an assortment of selection tools.

- Control: This is a companion palette to Tools. When you select a new tool from the Tool palette, the Control palette changes to present the specific options for that tool.

Artistic Computing—Painting Photographs

For some reason, photographers have always envied painters. Even Stiegletz' early work was influenced more by European painters than photographers. And the artistic manipulation used by William Mortenson during the 1940's was clearly an attempt to make his images more *painterly*. If this look appeals to you, Painter can help—even if, like me, you do it just for fun.

Let's look at one way to make a photographic image look like a painting:

- Step 1: Let's start by opening a Photo CD image.

- Step 2: Make a clone of the file by selecting Clone from the File menu (Figure 8-2), and after it's opened, clear (delete) the apparent contents of the clone. (This is the officially recommended way to accomplish this effect, but as you will see at the end of this section, it's not the only way.) If your monitor is large enough, place the two files next to one another. If not, offset the files so you can see part of each one.

- Step 3: For this example, I selected the Pencil Sketch option of the Cloners Brush tool.

FIGURE 8-2:
By selecting Clone from Painter's File menu, all the effects that you apply to an image are applied to a duplicate—leaving your original untouched. (Photograph © Mary Farace)

■ Step 4: Choose Auto-Clone from the Esoterica submenu of the Effects menu. When you do, Painter starts applying dabs of paint from the pencil until your image is completely rendered. As you watch the image's progress, it will change as more paint is applied. When it reaches a point where you like what you see, click your mouse button to freeze it (Figure 8-3).

As I mentioned before, Fractal Design suggests *clearing* the image before painting it, but interesting effects can be achieved by doing everything as outlined above—except omitting the clearing step.

FIGURE 8-3:
Using the Auto-Clone command after selecting a painting style from
the Cloner's Brush tool applies that style to the untouched cloned image.

Turning Day into Night

If you want to make selective tonal adjustments based on the color of a
specific area, Painter's Magic Wand will let you isolate specific sections of
your photograph. Let's use this technique to turn day into night:

■ Step 1: I started by opening a photograph of a New Mexico mission
from Corel's New Mexico stock photo disc.

■ Step 2: Like any scanned image, the photograph needs sharpening,
which gave me the chance to use Painter's unique sharpening func-
tion. Selecting the Sharpen command from the Focus submenu in the

FIGURE 8-4:
Painter's Sharpen command is unique compared to other image
enhancement programs' similar controls. Painter's dialog lets you
adjust not only Radius, but also shadow depth and highlight intensity.

Effects menu brings up a dialog that contains not only the Radius
control (that you would expect) but also controls for Highlight and
Shadow. These sliders determine the intensity of the highlights and
the depths of the shadows. Telling your "wet" darkroom friends
about this control will have them drooling (Figure 8-4).

■ Step 3: I wanted to change this daytime image into a nighttime one,
so I selected the brightly lit face (and its shadows too) of the mission
building. In Painter, you will notice that the Magic Wand is not a tool
but a command. And unlike most image enhancement programs,

FIGURE 8-5:
Painter's selection tools have names similar to other program's tools, but they operate quite differently. To select a range of colors in this photograph, all you have to do is drag the Magic Wand across the area you want to select.

implementation of this tool, it doesn't contain a dialog that lists a pixel range. Instead, you click and drag the wand across that part of the image that you want to select. When you do, the selected area is overlaid with a red mask. To select more areas, hold the Shift key and drag the wand across another area (Figure 8-5).

- Step 4: Since I wanted to create a moonlight effect, I used the Adjust Color (it's in the Tonal submenu of the Effects menu) and adjusted the Hue, Saturation, and Value sliders to achieve a blue look on the building (Figures 8-6 and 8-7).

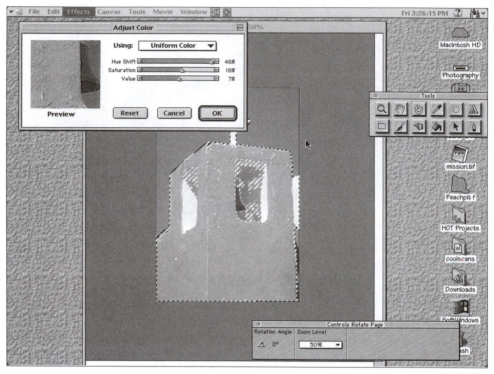

FIGURE 8-6:
After selecting an area on the photograph, Painter's Adjust Color sliders are used to change the overall color of the building and statue base.

FIGURE 8-7:
After applying the Adjust Color controls, the daylight shot of the mission begins to take on a decidedly nocturnal look.

■ Step 5: To take the image one step further, and keeping with the program's painterly direction, I summoned the Color Overlay dialog from the Surface Control submenu of Effects. This dialog gives option on type of overlay used, and I selected Paper Grain. I varied the Dye Concentration slider to give just a slight granular effect and clicked OK to apply (Figure 8-8).

COLOR PLATE-3: The result of sharpening, selection, tonal variation, and finally a texture effect changes a stock photograph of a mission made in daylight into a moody nocturnal image. A yellow moon was drawn with the circle tool and filled with the paint bucket with "yellow moony" looking color.

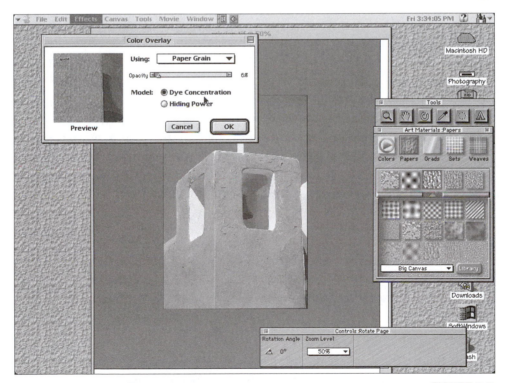

FIGURE 8-8:
Painter's Color Overlay dialog lets you vary the intensity of different texture effects that can be selected from a pop-up menu. Here the Paper Grain effect is applied to the overall photograph of the mission.

This has been a quick drive-by of Painter. It has many more features that can create dramatic graphics effects, but you must keep in mind that Painter is a paint program first and an image enhancement program second. The way it accomplishes everything from image sharpening to cropping is far different than the average Macintosh or Windows photographic program. I searched all over and never found a "real" cropping tool. To crop an image in Painter, you must use the rectangular selection tool to select the area you want and copy it onto the Clipboard. Then you have to open a blank document and paste the Clipboard's content into it. Nevertheless, no other programs have tools that allow you to apply the kind of artistic touches to photographs that Painter can. But the program can be sluggish applying these effects—even on a Power Macintosh. In its way, Fractal Design's Painter is very much an acquired taste. Nevertheless, if you are the kind of pixographer who is as comfortable with a drawing tablet as you are with a camera, Painter will be a perfect fit for you.

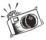 PixelPaint Professional

PixelPaint Pro is a 32-bit true color image creation, editing, and compositing program that has a tool set many users will find more intuitive than some dedicated photographic programs. One of the program's most interesting features is its ability to produce the effect of using the kind of textured papers that have all but disappeared when resin-based products became the norm instead of the exception. Pixel Resources calls this effect PixelPapers. The drawing/painting tools that are part of PixelPaint Pro's interface respond to the different PixelPaper surfaces much as they would to textured papers in the non-digital world. You can select from several different built-in textures or import any photograph or graphic to use as a paper.

Adding Textured Papers

To apply PixelPaper to your photographs:

- Step 1: Open your photograph using Pixel Paint Pro's Open or Acquire menus. PixelPaint Pro 3.0's Acquire menu also lets you scan images directly into the program. The Polar Bear image shown is from Corel's Bears disc.

■ Step 2: To open the paper palette, choose Papers from the Windows menu. To flip through the textures available, click on the turned up corner paper preview. If you click and hold, a pop-up menu will appear showing the entire list of available paper textures.

■ Step 3: To apply a texture, click the Apply button and the texture is applied to your image. (See Figure 8-9.)

■ Step 4: The PixelPaper dialog also lets you choose from matte or glossy paper and which direction light is hitting the paper. A combination of paper, surface, and lighting effects opens many possibilities to the pixographer interested in different paper effects.

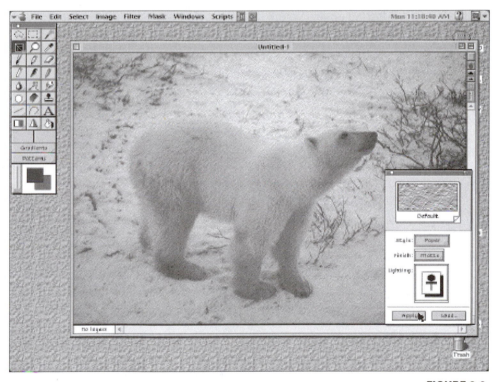

FIGURE 8-9:
Applying textures with PixelPaint Pro is easier than any other image editing program. Here a photograph of polar bear (from Corel's Bears stock photo CD) has a paper texture applied.

Bringing Sunset to the Model

Selection is one of the most important aspects for any image enhancement programs, and PixelPaint Pro has a wide selection of tools, including one of the most useful—Shrink to Fit. This selection tool gives you the power to place irregularly shaped and colored objects on different backgrounds more easily than most other image enhancement programs. Here's how it works:

- Step 1: Using conventional Magic Wand and similar tools, selecting an object that has different colors in it can be a problem, but PixelPaint Pro makes it easy. I started with a portrait from Corel's Models disc (Figure 8-10) that was made against a more or less simple background.

- Step 2: After selecting Shrink from the selection choice box at the bottom of the toolbox, the rectangular selection tool is used to draw a box around the model. Instantly, it is shrunk to fit her shape and eliminate the background (see Figure 8-11). The selection is then copied onto the Clipboard.

FIGURE 8-10:
Using a photograph from Corel's Models disc, PixelPaint opens it and rotates it into the proper orientation.

FIGURE 8-11:
Using Pixel Paint's
Shrink to Fit option, the
rectangular selection
tool is used to draw a
box around the subject
of the photograph.
Since Shrink to Fit was
selected, instead of
creating a rectangle
the selection shrinks
to fit the model.

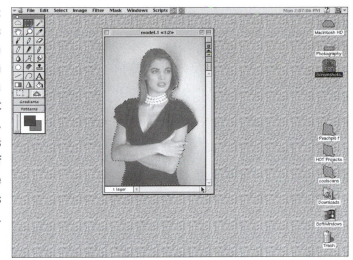

FIGURE 8-12:
PixelPaint Pro's Drop
command pastes an
active layer onto the
background of a docu-
ment. Once dropped, the
layer is no longer acces-
sible and the portion of
the image enclosed by
the selection tool
becomes integrated
with the background.

■ Step 3: Close the model photograph and open the Sunset image
(from Corel's Sunrise & Sunset CD). Use Command-V or the Paste
command to paste the image of the model on top of the sunset
photograph. Then use the arrow tool to place the model on the back-
ground wherever you want her to be. After she's in place, choose
Drop from the Select menu (see Figure 8-12).

Like Adobe Photoshop 3.0, PixelPaint Pro 3.0 has the ability to work with several live layers of artwork at the same time, although I'm not sure who was the first to get this feature to market. PixelPaint Pro also has a complete set of editing controls for color correcting images. You'll find menus and controls that let you adjust Hue & Saturation, Color Balance, Brightness & Contrast, and more. The Lighten and Darken tools can be used for dodging and burning, the Waterdrop and Finger tools let you remove an image's rough edges, and the Rubber Stamp Tool duplicates part of an image. The program's Straighten tool lets you adjust any images that were scanned in on a slight angle, and its Crop tool lets you trim unwanted portions of the scan.

Among the many tools photographers will like is the Impressionist Brush that allows users to adjust the shape and the orientation of each brush dab to achieve the desired effects. (The Undo command will be useful here as you experiment with different brush shapes and dabs.) Along with the Use as Pattern command (in the Image menu), you can transform the image in the active document into the foreground color and use any painting tool to repaint the image.

Creating an Impressionist Look

To color an image to make it took like an Impressionist painting:

- Step 1: Open an image. (In this case, it's a photograph from Corel's Flowers II stock photo CD.)

- Step 2: Next, select the Impressionistic Brush from the Tool Palette. This pop-up menu gives you the choice of two brushes: one large and one small. Unless you have something quite specific in mind, the larger brush will give the most dramatic results.

- Step 3: Use the Clone command to create a clone of the original, so your original image remains untouched (Figure 8-13).

- Step 4: Select the Impressionistic Brush palette from the Windows menus, which provides several different types of brush strokes. Then use your mouse to drag—artistically, if you're in the mood—across

FIGURE 8-13:

When trying any kind of new effect, it's always a good idea to work on a copy of the original—instead of the original. That way, if you end up with something you don't like, you can always start over. Here PixelPaint Pro's clone command is used to create an extra copy of the original flower photograph. (Photograph from Corel's Flowers II CD)

the image (Figure 8-14). Practice a bit and try to keep your strokes limited to one click-and-drag passage, otherwise you won't be able to Undo everything if you don't like the results.

Because of its features and toolset, I don't think of PixelPaint Pro 3.0 as a replacement for Adobe Photoshop—or whatever your main image enhancement program may be. Because of the way their features complement one another, I believe serious digital photographers will want to have both PixelPaint Pro and a digital imaging program. With a suggested list

FIGURE 8-14:
Using PixelPaint Pro's Impressionistic Brush command, you can apply brush strokes to your photographs. The palette includes several brush strokes styles and two different brush sizes. (Photograph from Corel's Flowers II CD)

price of $379, I think it is one of the better values in the Macintosh image enhancement market.

Color It!

I first heard about this interesting and inexpensive ($149.95) program from a *Shutterbug* magazine reader on the Internet. Color It! has an attractive, functional interface that belies its modest price, and can import a modest amount of different graphic file formats—no Photo CD, sorry. But as usual, there are workarounds for everything. Here's what I did to sharpen and stylize the photo of tulips taken from Corel's Flowers Photo CD disc:

- Step 1: I used Kodak's inexpensive Photo CD Access program to import the document, then saved it as a TIFF file that Color It! easily imports. (Some Apple Performas are bundled with Photo CD Access, and Kodak occasionally runs promotions and bundles the program with free Photo CD scans.) After that I was ready to launch Color It! and proceeded without any further difficulty.

FIGURE 8-15:
Color It! has a
Brightness/Contrast
control that, when you
click the "Live" box, lets
you see the effect of
your manipulation
of its sliders.

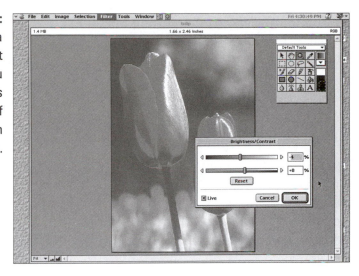

FIGURE 8-16:
Use the Add Noise filter
from the program's limited
filter menu to stylize an
image. Color It! also accepts
all Photoshop-compatible
filters, and when the capabili-
ties of these plug-ins are
added to the program's own
features, the program
becomes an impressive
and inexpensive image
enhancement program.

■ Step 2: The program has an Unsharp Mask function that I used to
tweak image sharpness but it still seemed soft so I used the
Brightness/Contrast adjuster to make the image snappier (Figure 8-15).

■ Step 3: As a final step, I used the Add Noise filter from the Stylize
submenu of the Filters menu (Figure 8-16).

The tool palette in the current version of Color It! has been simplified over the previous version's, and there's an "additional" pop-up menu that contains tools for Smudge, Gradient, Lighten Darken, Scissors, Crop, Bezier, and Zap. The Zap tool deletes selected portions of an image by just clicking on them.

Removing Dust Specks

It is not uncommon to find dust specks in digital images from scanners or even Photo CDs. Cleaning up the dust spots is easy, and the techniques and tools are similar whether you are working with Color It! or any image enhancement program. Using the tulip photograph as an example, let's use some of these tools to clean up a dust speck on the image.

- Step 1: The first step is to use the magnifying glass tool to enlarge the area around the dust speck.

- Step 2: Next, select the brush tool. You'll find that using a soft edge brush will make blending the color in the area around the speck easier.

- Step 3: Use the Brush size pop-up menu and select a small brush size—you want it to be smaller than the spot itself (Figure 8-17).

- Step 4: Use the eye dropper tool to select an area of color as close as you can to the spot itself. What this action does is "dip the brush" in that color.

- Step 5: Next, use the brush tool to make several dabs on top the spot. After a few taps of your digital brush, the spot will either disappear or almost disappear. Every now and then, a digital technique and analog one are identical. The reasons for using a small brush point and many small applications are the same as when using a real retouching brush and dyes—it's harder to make a mistake with small applications and the results always look better than using bigger brushes and few blobs of dye.

- Step 6: If some small traces of the spot/speck still appear, use the Blend tool (it looks like a water drop) to smooth over the area. At this point the spot will be invisible (Figure 8-18).

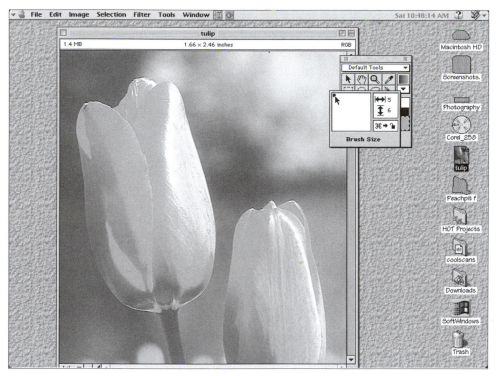

FIGURE 8-17:
Color It! has many pop-up menus that allow additional control over the tools. Here the brush size menu is used to resize the brush tip by clicking and dragging.

FIGURE 8-18:
A final touch in cleaning up any imperfections is to use the Blend (water drop) tool to smooth over the area that had been "touched up" using the brush tool.

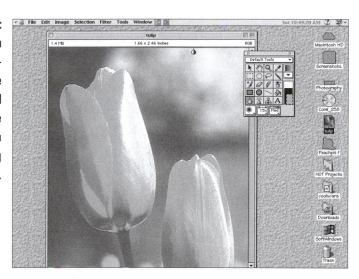

Color It! also features some unique commands, such as "Paint Is" and "Image Is." Paint Is affects which portions of the paint (or paste or filter) are laid down on the image. This is useful when you want to paste an image onto a second one, yet you want the white portions of the paste to be transparent. Set Paint Is to "Not Equal To" and the color bar to White. Image Is defines which portions of the image are affected. For example, you may want to change all black portions of the image to red. Select Image is and choose "Equal To" and set the color bar to black. The program will also produce four-color separations, a feature often missing from low cost image enhancement programs.

Eliminating a Distracting Background

Every photographer knows that when photographing sporting events ,you don't always get to stand where you would like and no manner of in-camera cropping can help you. That's when digital imaging can really make a difference.

Here's how to eliminate distracting backgrounds when you've been stuck in a less-than-perfect shooting position:

■ Step 1: I opened a photograph of two racing Porsches from Corel's Auto Racing CD. Since I didn't like the horizontal cropping, I used Color It!'s cropping tool to create an image shape that was almost square (Figure 8-19).

FIGURE 8-19:
Color It!'s Cropper works just the way you would expect. You click the tool and draw a selection rectangle around the image the way you want it cropped. At that point, the cross hairs cursor turns into a scissors, and you merely click the mouse in the middle of the cropped image to crop the photograph.

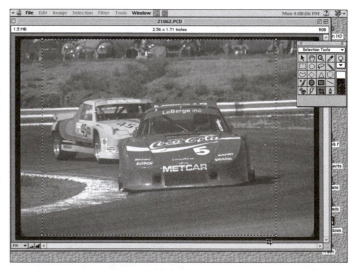

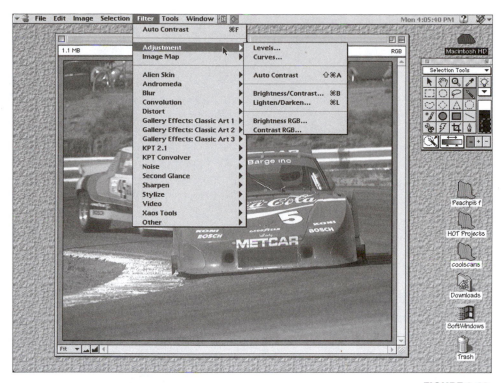

FIGURE 8-20:
If you're new to image editing, Color It! has a number of "autopilot" features that make tweaking images just a little easier. Color It!'s Auto Contrast feature will bump up the contrast of a flat image and lower it in one that's too contrasty.

■ Step 2: While this improved the looks of the photograph, the contrast seemed flat. So, I used the program's Auto Contrast feature to make the image look snappier (Figure 8-20).

■ Step 3: While Auto Contrast improved the image, I still had RVs and people on top of the small hill that distracted from the racing action. Next, I used the selection rectangle to select a portion of the hill covered with dirt and shrubs (Figure 8-21).

■ Step 4: Next, the selection was pasted into the photograph and placed at the top of the hill covering what was already there. To

FIGURE 8-21:
The first thing to do to eliminate the distractions on the top of the hill is to load the Clipboard up with what was already on the hill—dirt and shrubs. The selection rectangle was used to make a selection which was copied onto the Clipboard.

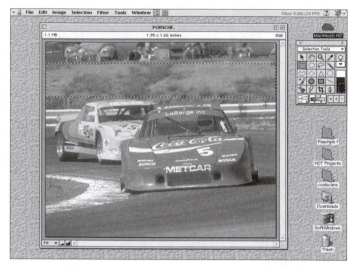

FIGURE 8-22:
After pasting the selection and placing it in the right place, the Flip Horizontal command was used to avoid a too-symmetrical look.

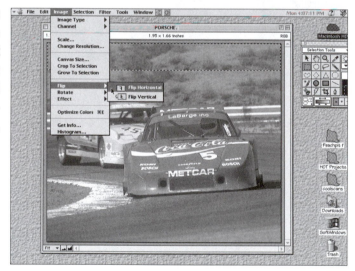

make the editing less obvious, I used the Flip Horizontal command to flip the selection and make it more asymmetrical (Figure 8-22).

Step 5: After the new grassy area was in place, the Smooth tool was used to hide the sharp edges caused by pasting the image of the other part of the hill (Figure 8-23). While working with the Smooth tool, it's a good idea to work with the image at a larger size. Use the

FIGURE 8-23:

After pasting the hard-edge section at the top of the hill, use the Smooth tool (it looks like a water drop) to knock off any hard edges.

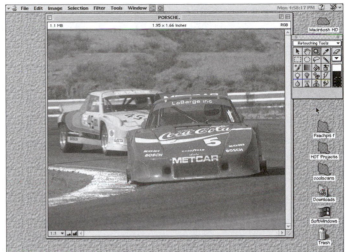

Magnifying Glass tool to enlarge the photo, then gently slide the Smooth tool across the hard edge.

Note: We'll see more of this photograph in Chapter 9, where it will be used for additional manipulation.

◼ Memory Management

Like all image enhancement programs, Painter and PixelPaint Pro work better when more RAM is available. Painter is as much of a memory hog as Photoshop. The suggested size for Painter is 13,390K, while Photoshop's recommendation is 13,284K. Effective memory management is important if you want to make *any* program run faster or just simply work with larger photographic images. The first step is to allocate as much RAM to the program as you can afford. On a Macintosh, use the Get Info command and set the "Preferred Size" for that program. Right now, I set PixelPaint Pro's Preferred Size to 12MB. The only problem is that I seldom have 12MB free, so I went to the next step.

Using Now Software's Now StartUp Manager, I created a limited set of Extensions and Control Panels to be loaded on startup. Since Extension and Control Panels are the first things loaded, they and System

Software are the biggest users of system RAM. My System Software, Extensions, and Control Panels took 4724K of RAM, but my custom loading sequence brought it down to 2076K, giving me almost 2.5MB more for PixelPaint Pro. Since few Extension and Control Panels are loaded, the system also runs faster. Now StartUp Manager lets you save this loading setup so you can use it whenever you're working with your enhancement programs. Now StartUp Manager is part of Now Utilities 5.0, a package of other useful utilities I consider indispensable for Macintosh users.

Color It! needs proper memory management too. MicroFrontier suggests checking "About this Macintosh" to find the largest unused block of memory and setting the program's memory allocation to 100K less than that. The program requires at least 3200K of RAM, but I set my "Preferred Size" to twice that. Color It! has its own virtual memory scheme, and MicroFrontier recommends you use the Memory Control Panel to turn off Apple's built-in virtual memory strategy to avoid performance degradation caused by conflicts with this method. Color It!'s virtual memory scheme requires 2 to 3 times the amount of capacity of the original image you're working on, not including the original. To work on a 5MB image, they suggest you have at least 15 to 20 megabytes of spare hard drive space. Color It! supports up to 16 undoes, something lacking in more expensive programs, and multiple undoes require additional disk space. I used the program's Preferences setting to reduce the number to six, which should be more than enough for most users.

Other Useful Mac Programs

Author's note: Like the previous chapter, the Macintosh image enhancement programs covered in this chapter do not represent the only image enhancement software that's available. The programs covered are those that I use on a daily basis and I feel comfortable recommending to other photographers—or other photographers have recommended to me.

Adobe Photoshop is the most popular image manipulation program for both Macintosh and Windows users, but the one feature most Mac users

don't like is its price. Even when purchased with discounts from mail order firms, the program's price tag can give you a severe case of sticker shock.

Maybe that's why Adobe introduced a CD-ROM package, called Audition, which contains limited editions of Photoshop along with their video editing program, Premiere. Audition is designed for aspiring graphic artists, hobbyists, and casual users who would like access to the same kind of sophisticated digital imaging software that's available to professionals. The disc also contains more than 700 stock photographs, dozens of QuickTime movies, interactive tips and techniques, technical notes, and on-line electronic documentation.

I know what you're asking: "How limited is the Limited Edition?" Photoshop LE lets users manipulate RGB, grayscale, and indexed-color (e.g., CompuServe's GIF) images using most of Photoshop's painting and retouching tools. The LE contains Photoshop's cool dodging and burning feature, its Adjust Variations color tweaking (color and density ring-around) function, and over 29 image processing filters. This version includes access to Photoshop's impressive "Plug-Ins" folder, which can hold third-party filters, scanner access modules, and system enhancements. What's missing? Photoshop LE omits some of its sibling's high-end features such as color separations, alpha channels, the pen tool, and the ability to rasterize Adobe Illustrator files. I can hear a whole bunch of you saying—"who cares!" I've seen this package advertised in the Mac Warehouse catalog for $150. Even without the Premiere video editing program this package would be a good deal. If you decide you love the program so much that you just have to have the full-boat version, you can upgrade to a full version of Photoshop directly from Adobe.

◆ An Oldie but a Goodie

Author's note: With the merger of Aldus and Adobe, Digital Darkroom has disappeared from sight. It's only included here in case you find a copy at a used computer store or other bargain venue. The truth is, if your image manipulation needs are modest, Digital Darkroom ain't a bad product.

Digital Darkroom was one of the first, maybe the first, digital imaging program available for the Macintosh, but Aldus treated this product like

a crazy aunt locked up in the attic. That's too bad because the program is an excellent grayscale editing program. Digital Darkroom's tool palette includes drawing tools, brush and selection tools, and an impressive gradient fill tool. You'll also find standard pencil, grabber, eraser, and paint bucket tools along with an eye dropper that lets you pick up grays from any selected area. A "Magic Wand" similar to Photoshop's (although DD was first) lets you select areas of similar values. There's a "paper cutter" or traditional scissors for straight-line cuts.

If you want to do tricks, Digital Darkroom offers transformations like rotate, stretch, distort, and slant (see Figure 8-24). The clever "add perspective" command lets you add shadows to a photograph or create 3D objects with photos mapped onto them. Digital Darkroom's "pouch" folder contains filters for emboss, sharpen, gradient blur, convolutions, and blur. You can "hand color" black and white photos with techniques much like using Marshall's oil colors—only digitally. Your results can be quietly beautiful or grating depending on your abilities. These same procedures can be used to add an old-time sepia tint to new or old photographs. All you have to do is select part of the photograph (or the entire thing), then apply touches of color from the colorization toolbox. You can import photographs in TIFF, PICT, PICT2, MacPaint, and ThunderScan formats. Photo CD and 24-bit color Photoshop images can be opened, but they will be displayed as grayscale. The program has an impressive print option that lets you apply the same kind of line screens your printer uses when making halftones.

PhotoFlash

Apple Computer's PhotoFlash is an image acquisition and enhancement program that includes a slide sorter "browser" that lets you catalog and select images from disk, Photo CD, or Apple's digital camera. Instead of a traditional toolbox containing brushes and erasers, PhotoFlash offers built-in enhancement features for removing dust and scratches and balancing exposure. Keep in mind that any scratch and dust removal filter works by softening clumps of pixels of a user specified range. As long as you keep that range quite low, you won't affect the image sharpness. But

FIGURE 8-24:
Digital Darkroom will read 24-bit color images as grayscale, like this color TIFF image taken on Kauai, Hawaii. Need an image for your newsletter that shows "relationships?" This one says it all and can be cropped to focus on the couple in the image to emphasize their relationship showing as much as the beautiful surroundings.

if you get carried away removing dust specks with this filter, overall crispness of the photograph will deteriorate. For big spots, hairs, or whatever, use the brush and eyedrop methods outlined earlier in this chapter. The program reads many different kinds of image formats, including Apple's new QuickTake format. PhotoFlash can also convert files from one type to another, individually or in batches. If you're involved in desktop publishing, you'll like PhotoFlash's ability to place an image directly into programs like PageMaker or Quark XPress. It's recommended for the desktop publisher and photographer who don't want to do complex enhancement or retouching.

NIH Image

NIH Image (the current version as I write this is 1.56b63) doesn't read many graphics file formats. As it stands, Image will only read uncompressed TIFF files—although it will import Text and MCID (files compatible with the IBM-PC based MCID image analysis system from Imaging Research). Image does, however, support Photoshop compatible plug-ins, including filters and Acquire plug-ins like Kodak's Photo CD. Installing this add-on makes acquiring Photo CD images with Image just as easy as using any other image enhancement program (see Figure 8-25). What makes Image especially interesting is that it is a *free* image enhancement program that can be found on most online services, like CompuServe or American Online.

The program was originally developed as a scientific and technical imaging tool by the National Institute of Health (so in a sense, as a taxpayer, you've already paid for it), but it has evolved to the point where the program has many features the experimental-minded Machead may appreciate. The program can acquire, display, edit, enhance, analyze, print and even animate images. Image can perform image processing functions, such as contrast enhancement, density profiling, smoothing, and sharpening and can draw lines, rectangles, ovals, and text. It will also let you flip, rotate, invert, and scale selections. There are currently three versions of Image: One's been

FIGURE 8-25: For a free photograph enhancement program, NIH program supports all Photoshop add-ons, including the Photo CD acquire module.

designed for Macintoshes that have math co-processors, one for the Power Macintosh (the latest version), and the other is for computers, such as the LC and Color Classic, which don't have a math co-processor chip. Here's how to tell the difference: The math co-processor version is marked FPU for "floating point unit." Image should also be available from user groups or services, like Educorp, that sell disks of shareware or freeware.

Enhance

Enhance from MicroFrontier is an 8-bit grayscale program that works with images from grayscale photographs or 1-bit graphics. It will open 24-bit color (including Photo CD) or black & white photographs, but will display them as 8-bit images. With its built-in filters, Enhance's toolbox lets you sharpen or smooth images. You can also skew, distort, or crop images, and the program's painting tools allow you to add lines and fill regions with gray tones.

Cachet

Cachet from Electronics for Imaging is a powerful Macintosh program that could easily fit the 800-pound gorilla category. One of the things preventing it from stepping into the simian's cage is an installer that's "selective." I had difficulty installing Cachet, and their tech support person told me their installer "doesn't like certain hard disks." A complete installation with all the reference images and color printer profiles provided can take 20MB, but I used the custom install feature to produce a folder that weighed in just over 2MB. EFI calls their program a "color editor," but it's powerful editing features make it useful for image enhancement as well. Its MultiChoice window makes Photoshop's Adjust Variations command look anemic. It provides a window with six exposure variations and the images in this window can be resized! A pop-up menu at the bottom of the window allows you to tweak the image's density even further, but the kicker is that it also allows you to adjust several other parts of the image, including color, white point, black point, midtones, contrast, highlights, and shadows. When you output to a color printer, you have the option of sharpening your image first to produce crisper output. You can choose from five sharpening levels, including "none." You can use Cachet to change an image's color balance from cool to warm or increase color saturation to

Technicolor levels. By using the program's masking features you can apply these controls to portions of an image. And best of all, you can create a script of these changes and save them for future use. It's an essential program for anyone working with photographs on the Mac.

They're Not Image Enhancement Programs But...

Here are two low cost color painting programs that can also be used for photographic manipulation. Expert Color Paint is a bargain-priced 32-bit color paint program with features that make it useful for image enhancement. Photo CD images are easily imported, but the thumbnail normally displayed in the program's Open dialog is not present. You can use Expert Color Paint to change an image's brightness and contrast, or blur, sharpen, or invert a photograph. The program has multiple "Undoes" which let you experiment with a photograph without having to save multiple copies at different stages of your manipulation. If you go too far, you can backtrack to the point where the image looked the way you originally liked it. Don't you wish your regular darkroom had "Undo?" The program's Lasso and Magic Wand provides selection options, and the text tools offer the usual fonts, styles, and alignments. You can also rotate objects by 90 or 180 degrees or free rotate in increments of .01 degrees. Expert Software has included other touches not found in more pricey packages, and I've seen it advertised as low as $27.50!

FIGURE 8-26:
Expert Color Paint can read and display 24-bit images with startling clarity. You can use the program to touch up defects or to improve the color of this image, made by Mary Farace, for use in a multimedia presentation, a tabletop book on flowers, or even a book on gardening.

FIGURE 8-27:
Apprentice is recommended
for those who have some
basic art background—or
would like to experiment with
traditional art techniques with
a digital interface. The pro-
gram can create artistic
looking photographs by using
the program's "reference"
feature. (Image courtesy
Delta Tao Software)

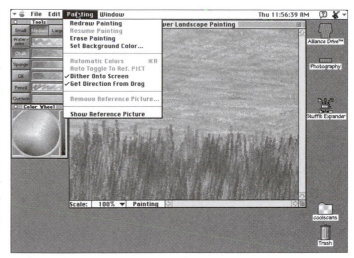

Delta Tao Software's Apprentice is a paint program that can be used to add artistic flourishes to photographs. Digital photographers can import a "reference" image from a Photo CD disc and use the photograph as a guide to produce artwork in natural-looking watercolors, oils, pastels, or charcoals. The program's interface is well designed and easy-to-use, and if you have any artistic ability at all, you can change your ho-hum photographs into a work of art. Apprentice has a sluggish screen redraw rate on 68030 machines, but I've seen it sold at trade shows for as low as twenty bucks.

Your might consider all of the Macintosh and Windows programs covered up to this point to be pretty versatile tools for image manipulation and enhancement—and they are. But there is another step you can take your pixography and that involves using add-ons and plug-in filters to enhance and increase a program's capabilities. To enter a new world of image enhancement, turn the page.

PLUG IN
TO CREATIVITY

If you're not already familiar with software plug-ins, you should be. But what are plug-ins anyway? And how do you use them and why should you even bother?

Fortunately there's no mystery surrounding any of those questions. Plug-ins are little applications that are used to increase the functionality of and customize off-the-shelf graphics programs. You can think of plug-ins as additional blades or tools for your Swiss Army knife, and selecting the right one can make a tough graphics job easier and a difficult job practical. Remember, McGyver never went anywhere without his Swiss Army knife.

One of the main features of plug-ins is that they are easy to use and easy to install. On a Macintosh, all plug-ins are installed in the same way: They are simply copied into the "Plug-in" directory or folder of a program, and after that, they appear as menu items in that program. On Windows computers they are placed in a separate directory, and often plug-in companies

provide an installer that makes placing the plug-ins in the proper place a no-brainer. One installed, these enhancement are, in effect, "plugged in" to your image enhancement program and become an integral part of it.

The Many Faces of Plug-ins

The de facto plug-in standard was created by Adobe for their Photoshop image manipulation program, but Photoshop plug-ins can be used with many programs, including U-Lead Systems' Image Pals for Windows, Fractal Design Painter for Windows and the Mac, and Aldus SuperPaint, Adobe Premiere, PixelPaint Professional 3.0, ColorStudio 1.5, and StataVision 3d for the Macintosh. Plug-ins come in three basic types: Acquire, Functional, and Special Effects.

Acquire plug-ins appear in a submenu of the Acquire item of your program's File menu. This submenu includes items that allow you to import or "Acquire" an image that will be used by your graphics program. Since many Functional plug-ins relate to producing color separations, they usually appear in the graphics program's Export menu. Special Effects (or image enhancement) plug-ins appear in the program's Filters menu. Plug-ins come in many varieties and allow you to customize a graphics programs to fit a specific job. Here's a look at some products in each category along with a description of what each does:

Acquire Plug-ins

Most Acquire plug-ins allow you to directly scan an image into your program without leaving it, but one of the most popular Acquire plug-ins is Kodak Photo CD Acquire 2.0.1, which lets you import Photo CD images directly into your image enhancement program. This makes it possible for programs that cannot normally read or import Photo CD files to do so. NIH Image, for example, reads few graphic file types but is compatible with Photoshop plug-ins. By adding Photo CD Acquire to it, the program is now Photo CD-aware. And while Adobe's latest version of Photoshop allows you to import a Photo CD image through its Open dialog, the methodology and steps are anything but logical. Kodak's plug-in makes it easy to find and open a Photo CD image and adds increased functionality beyond merely opening the file. The latest version (sixth) provides access to the higher resolution (4096x6144 pixels) images found on Pro Photo CD Master discs.

Opening an Image with Photo CD Acquire

Using Kodak's CD Acquire module to acquire Photo CD images—within any application—is just as easy as using the program's Open dialog. Here's how it works when opening an image from a Pro Photo CD disc:

Note: Kodak's Photo CD Acquire module will work with any of the image enhancement programs discussed in the previous two chapters that accept the Adobe plug-in standard. For this example, Adobe Photoshop was used, but the procedure will be identical for any compatible application.

- Step 1: Go to the Acquire submenu of the File menu and select Kodak Photo CD v 2.0.1. (The version number may be changed by the time you read this. This version has been around since Photoshop was at version 2.5.1)

- Step 2: This opens the first level of a two level dialog. (See Figure 9-1.)

- Start by selecting the image you want to open. To find it, go to the Images folder (directory) inside the Photo CD folder (directory). When you highlight a specific image, its thumbnail will appear in the dialog box.

- Step 3: No matter what you do next, check the sharpening box. By the time you get to this chapter, you know how I feel about sharpening scanned images.

- Step 4: You can also select which of the five available resolutions (six on a Pro CD disc) you want to open. The minimum setting for any kind of pixographic work will be the Base (512x768), and if you have enough memory, working with 16Base (2048x3072) will give even better results.

- Step 5: Set whether the image is RGB color or grayscale. In this case, the original photograph was a black & white image. Specifying grayscale opens the file in grayscale mode, which means this file will be one-third the size of a RGB image. The Image Info button gives you specifications on how this particular image was created, as well as any relevant copyright information on a Pro CD.

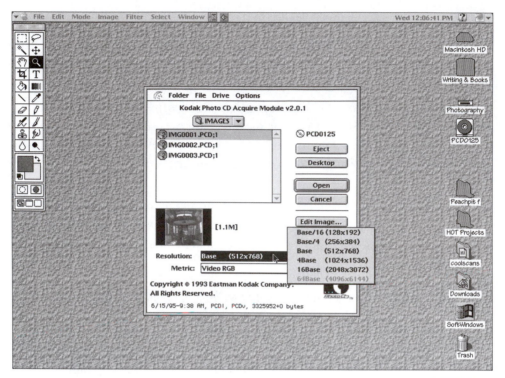

FIGURE 9-1:
Kodak's Photo CD Acquire module allows you to select the image you want to open, what resolution it will be, and even sharpen it—all before it's "officially" opened.

■ Step 6: Since this was a square 6x6 cm negative there is extraneous data in the scan. To make the file even smaller by eliminating this, you can go to the next level and click the Edit Image button. (See Figure 9-2.) This brings you to the next level where you can use the mouse to click & drag to crop the image into a square to match the original image. There are also color and density sliders you can use to color-correct an image here. You can't really use this to fine tune a color adjustment, but you can make gross adjustments and tweak it when the file is opened.

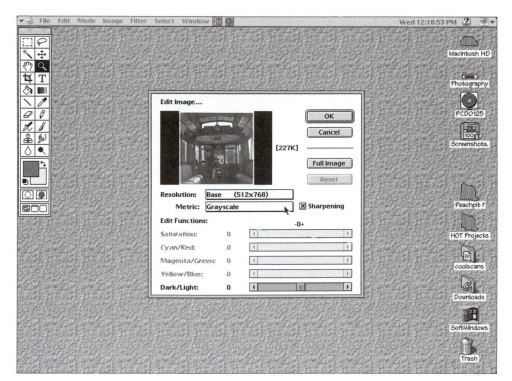

FIGURE 9-2:
The second level of Kodak's Photo CD Acquire module can be used
to crop as well as adjust the color and density of a Photo CD
image before opening it in your image enhancement program.

■ Step 7: Click the OK button to close the dialog's second level, then
click the Open button when you see the first to finally open your
Photo CD image. When it opens inside your favorite image enhance-
ment program it will be sharpened, cropped, and ready for whatever
you want to do with the image.

The Kodak Photo CD Acquire plug-in is available for both Windows and
Macintosh computers and has a list price of $59.95.

FIGURE 9-3:
After adjusting color, density, cropping, and picking a resolution, your preprocessed Photo CD image opens within Photoshop, ready for action.

Many scanner manufacturers include a plug-in allowing users to provide access to their hardware. When you purchase their Coolscan slide scanner, Nikon includes a scanner plug-in along with a stand-alone scanning application. While the application is useful, you can only save a completed scan in one of two graphics file formats. The plug-in, on the other hand, allows you to scan the item and save it in any file format your program supports. And, by having the item directly accessible within a graphics program, you can perform enhancements to the image before saving it or exporting it to another application, such as desktop publishing. For an example of a scanner plug-in used to scan a 35mm slide with the Nikon Coolscan, see Chapter 4.

■ Acquire Plug-ins for NIH Image

Remember Image, the National Institute of Health-developed image editing program we covered in Chapter 8? Here's some information for fans of that program:

The following Acquire plug-ins have been reported to work with Image:

Agfa PhotoScan

Canon CLC 500 Color Laser Copier with Electronics for Imaging interface

Computer Eyes /RT Pro

Datacopy 730GS scanner

Ektron 1400 series camera (Eikonix 4096x4096 CCD)

Graphics Unlimited Kingfisher frame grabber (grayscale only)

Howtek II slide scanner

La Cie SilverScanner (8-bit grayscale, 8-bit color, 24-bit color)

Kodak DCS-100 and DCS-200 digital cameras (grayscale and 24-bit color)

Kodak Photo CD Image Browser

Kodak RFS2035 scanner

Functional Plug-ins

Only one company, Second Glance Software, produces plug-ins that fall into all three categories, and they offer a Functional plug-in that should be of special interest to screen printers. PhotoSpot lets users produce spot color separations from within Photoshop by exporting separation documents for each color in your image. You can print directly from Photoshop or import a file into programs like Quark XPress or Aldus PageMaker to match other elements in your layout. Included in this package are three additional filter plug-ins that perform color reductions.

Acetone, the first of the three plug-ins, is a fast method for color reduction and remaps the tones in the image to the colors you specify for separation. You can access the remapping process with a color bar interface that lets the user nudge a color range toward another hue. And all images can be previewed and altered before finally applying this filter. Paint Thinner provides control over color reduction and posterization when making spot color separations. This filter's interface shows a preview of the image along with a palette of 256 reduced colors. To use it, all you have to do is select a range of image colors in the palette or on the preview and reassign them to a single spot color. Turpentine creates an eight-color diffusion tone image from your photographs. This technique can create color separations that have more vibrant colors than CMYK alone can produce.

Using a Plug-in to Posterize an Image

Just because PhotoSpot has been designed for screen printers doesn't mean pixographers can't use the tools to create some striking special effects.

Remember that photograph of the racing Porsches? Let's get it and take it to another level using Adobe Photoshop.

- ■ Step 1: The Acetone filter, which is part of the PhotoSpot package, appears under the Second Glance Filter menu (see Figure 9-4), along with another interesting plug-in—Chromassage—that will be covered later in this chapter.

- ■ Step 2: The first dialog that appears asks you how many colors you want to use. The default is six, but a good rule of thumb is that the fewer colors that are used the simpler—and more posterized—the image will appear. (See Figure 9-5.) After you select the number of

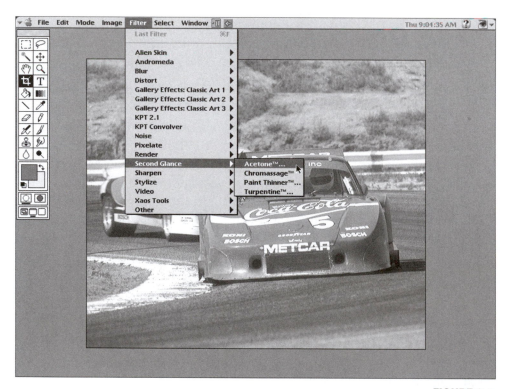

FIGURE 9-4:
When a plug-in is added to a program, it typically appears in the Filter window—usually as a submenu of the company's name. Here the submenu lists all of the Second Glance software's plug-ins, including the three PhotoSpot filters and Chromassage.

FIGURE 9-5:
Acetone's first dialog box lets you specify how many colors will be used in the initial iteration of your image. The more colors selected, the more realistic the posterized image will appear. Fewer colors means bolder, stronger images.

 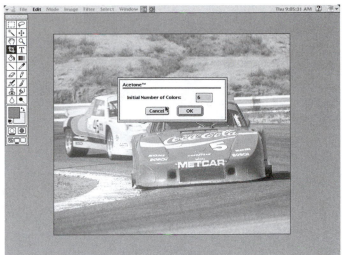

colors, the plug-in builds the color histogram that it will use to produce the initial posterization of the image that will appear next.

■ Step 3: Acetone provides before and after scrolling widows, so you can immediately see the effect of any changes you make. To add or subtract colors from the image you can click on the "Spectrum" window and click the appropriate buttons. In this case, I clicked on a brighter red to increase the colors to seven and clicked the Apply button. (See COLOR PLATE-4.)

COLOR PLATE-4: Acetone's control window provides a large preview of the filtered image along with a similarly sized one for the "before" image. The controls in the upper right-hand part of the screen let you add or subtract colors but, alas, there is no Undo.

■ Step 4: (Optional) After the filter is applied (Figure 9-6) you can use the Adjust Brightness/Contrast controls to make the image more snappy. (Acetone will tend to reduce an image's contrast.) You may also want to use Hue/Saturation to increase color saturation of the image.

Author's Note: At this point you can leave the image alone or take it to the next level. I have one more trick up my sleeve that I would like to add to this image to give it the feeling of "more power!"

FIGURE 9-6:
After applying the Acetone filter, you can leave the image alone or increase contrast or saturation. One way to save the adding contrast step is to select black as a color and apply it using Acetone's controls.

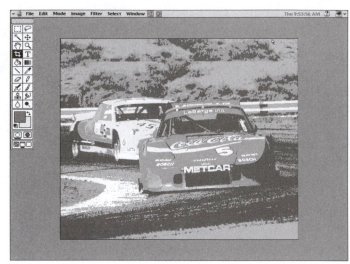

Right now, the PhotoSpot filter package is available only for Macintosh computers but a Windows version is planned. Its list price is $295.

Macintosh Plug-in Management

Programs like PixelPaint Pro, Painter, and Color It! accept Photoshop-compatible plug-ins. If you already have Photoshop installed, here's a method to make those filters and plug-ins do double (or triple) duty.

For Painter: When installing Photoshop, you'll notice Adobe's Installer creates a number of additional folders inside the Plug-ins folder. They are called: Acquire/Export, Extensions, Filters, Displacement Maps, Parser, and File Formats folders. When installing third-party filters, some users agonize over making sure these filters are placed in the right sub-folder. Don't panic! As long as all of your plug-ins are placed in the overall plug-ins folder, it doesn't matter which subfolder they are located in. I recommend you take all of your special filters and place them in a *new* folder inside the plug-ins folder. Name it something like "Joe's Original" or whatever—make it personalized. (See Figure 9-7.) When using programs in which you have to tell the program where your plug-in folder is located, like Fractal Design's Painter 3.0, you can specify "Joe's Original"—even though it's inside your Photoshop folder. Painter

FIGURE 9-7:
Many image enhancement programs allow you to specify which folder has third-party filters and even for those that don't, it's a good idea to create your own personalized filter that will allow you maximum flexibility using the tips found in the Plug-in Management sidebar.

will then have access to these third party filters without installing them on your hard disk a second time.

For PixelPaint Pro: Create an alias of your existing Photoshop "Plug-Ins" folder and place that alias inside PixelPaint Pro's "Filters" folder. When you launch PixelPaint Pro, all of those filters will be available without having to duplicate or relocate them. This means placing a 4K alias inside the Filters folder gives you access to 13.5MB of filters. This will work for all versions of PixelPaint Pro, but changes in versions 3.1 and later allows you to specify any folder as the official "filters" folder (much as you can do in Painter.) You can either use an alias or simply refer back to a folder in Photoshop's plug-ins folder.

For Color It!: Make an alias of your version of "Joe's Original" folder (or whatever you want to call it), rename it as "Plug-ins," and place that folder alias into the "Color It! Stuff" folder.

For Image: Filter plug-ins are accessed using the Plug-In Filters sub-menu. *Image* expects to find plug-ins in a folder named Plug-ins located in either the same folder as *Image* or in the System folder. For some reason, all of my alias tricks failed with Image.

If you find creating an alias can be more trouble than it's worth, you need a freeware Control Panel called Nom de Plume. It's the fastest, easiest way to create aliases I've found. Author Bill Monk created this Control Panel when he got disgusted with what he calls the "Alias Two-Step." "You know how it goes," he says, "dig through your Applications folder, select something, make the Alias, shuffle some folders, throw it

into the Apple Menu Items folder, pull down the Apple menu, notice that it's now about a mile wide, open the Apple Menu Items folder, and edit out the word "alias" to make it shorter. All this while cursing the length of time it takes for the I-beam to appear in the System 7 Finder."

Nom de Plume's dialog box, which resembles the standard Open dialog, lets you simultaneously select the item you want an alias created from, name it, then place it wherever you want. If you need to create a new folder, the dialog lets you do that too. Using Nom de Plume is so seamless it makes you wonder why Apple didn't make it a part of the system software. This utility is freeware but making copies for commercial purposes is prohibited. Nom de Plume is available exclusively through Ziff Communications on-line services and electronic publishing projects, and the author requests that it not be posted on other services.

Filters for Your Computer

Since the first time I saw the French-made Cokin filter system at Photokina '78, it's held a prominent place in my camera bag. Special effects, similar to what can be achieved with Minolta's Cokin modular camera filter system, are also possible with digital filters when used with image enhancement programs like Photoshop. Instead of screwing these filters onto the front of your lens, all you need to do is copy them into Photoshop's "Plug-Ins" folder and they'll appear within the program's Filter menu. Plug-ins are available in two basic types: "Filters" that produce a specific effect within user-definable parameters and "mini-applications" that create different kinds of effects depending on the creative ability of the user to manipulate their interface. All of the add-ons I'll introduce you to can be used with any program that accepts Photoshop-compatible plug-ins.

Gallery Effects

One of the first digital filter packages available was Aldus (now Adobe) Gallery Effects and it remains one of my favorites. This package is unique in that it, in addition to Photoshop plug-ins, includes a stand-alone Gallery Effects application. This program lets users apply filters directly to any digital image. Galley Effects is available in three different volumes and each one

contains 16 unique filters. For some reason Volume II only includes filters, while Volumes I and III contain both filters and the stand-alone application.

GE: The Plug-in

After installation, each filter appears as a submenu under a heading of Gallery Effects: Classic Art in Photoshop's Filters menu. When you open a filter, a thumbnail of your image appears in a Preview window. Two smaller windows, labeled Before and After, display the area covered by a "Preview Frame" which you can position over the most critical part of your image. Most filters include sliders which let you increase or decrease specific filter attributes. If you discover a combination of settings you like, it can be stored using the Saved Settings command. Here are some my Galley Effects favorites:

Turning an Image into Mosaic Tiles

Mosaic, from Volume I, draws your image as if were made up of small, side-lit tiles.

　■　Step 1: Filters are seldom applied to a "raw" photograph. This Photo CD image from Corel's Rome disc (Figure 9-8), was opened in Adobe Photoshop using the Photo CD Acquire module, then sharpened. The

FIGURE 9-8: Here a photograph of Roman architecture (from Corel's Rome stock Photo CD disc) is opened. It's the starting point for application of the Gallery Effects' Mosaic filter.

Variations dialog was then used to change the tone of the image from a "cool" daylight shot to one that more resembles a warmer late afternoon mood.

■ Step 2: Select Mosaic from the Gallery Effects Volume I submenu in the Filters menu (Figure 9-9).

■ Step 3: This opens the Mosaic dialog box that contains controls that let you vary the size and type of tile and the width and color of the grout. (See Figure 9-10.)

FIGURE 9-9:
Under Galley Effects Volume I in the Filters menu, a sub-submenu appears listing all of the special effects filters that are available as part of this package. While Aldus/Adobe could have combined all three volumes under one heading, having them separate makes it easier (for me anyway) to keep track of the different filters.

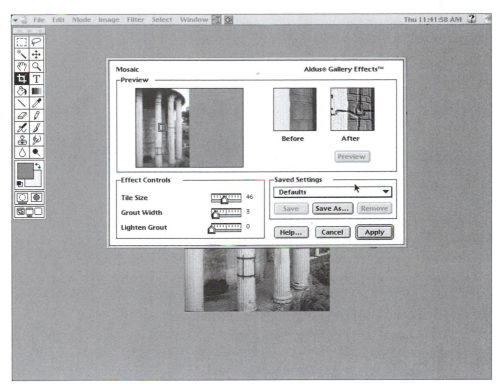

FIGURE 9-10:
If you find a combination of settings on the three Mosaic control sliders that you really like, you can save them and have that combination available using the Save As button. They can be recalled in the future under the Saved Settings pop-up menu.

■ Step 4: Before playing around with the sliders, move the selection square—that's the white box in the middle of the Preview windows—around to find the place where the After image will give you an idea of what your final image will look like. When you find a setting that looks good, click Apply. (See COLOR PLATE-5.)

COLOR PLATE-5: The final result of using the Gallery Effects Volume I Mosaic filter on a photograph from Corel's Rome stock Photo CD disc.

Colored Pencil, from Volume II, redraws your image to appear like it was created with colored pencils on a solid background. Important edges are

retained and given a crosshatched appearance while the solid background shows through the smoother parts of the photograph.

Coloring a Gorilla

Let's go ape with a simian photograph from Corel's Ape stock Photo CD:

- Step 1: Open the Photo CD image of the handsome Mountain Gorilla and use Adobe Photoshop's Unsharp Mask command to sharpen the image (Figure 9-11).

- Step 2: Then select Colored Pencils from The Galley Effects Volume II submenu (Figure 9-12). Whenever a subject has eyes—whether human or simian—I like to place the selection box over their eyes. If, after manipulation, the eyes don't look right, the finished photographs won't look right either. The controls on the Colored Pencil dialog are Pencil Width, Stroke Pressure (how dark the colors appear), and Paper Brightness (contrast by any other name...). Play with the controls and try the extreme ends of the sliders to see what the effects look like before applying them.

FIGURE 9-11: This photograph of a Mountain Gorilla from Corel's Ape Photo CD disc is the starting point for transforming a drawing using Galley Effects Colored Pencils filter.

FIGURE 9-12:
Galley Effects Colored Pencil
dialog includes adjustments
for Pencil Width, Stroke
Pressure, and Paper
Brightness. As with all Galley
Effects filters, you can use the
Save As feature to save the
settings you used so they can
be recalled in the Saved
Settings pop-up menu.

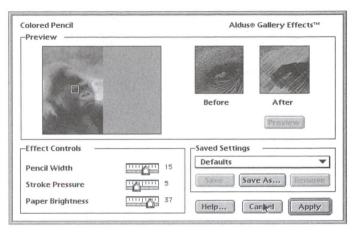

■ Step 3: Click Apply and you're done. The photograph of the gorilla has been transformed into a pencil sketch—all with a few mouse click and drags. (See COLOR PLATE-6.)

COLOR PLATE-6: Using only a few slider controls in the Gallery Effects Colored Pencils dialog, you can transform a photograph of a Mountain Gorilla (from Corel's Apes stock Photo CD disc) into a drawing.

Volume III is so new I don't have a favorite yet, but some cool effects in this package include Water Paper, Torn Edges, Stained Glass, and Neon Glow. Each volume is available for both Windows and Macintosh computers and the Mac versions are accelerated for the Power Macintosh.

GE: The Application

Aldus Galley Effects appears to have been created for people, like me, who need to create arresting artwork, but for lack of training and experience don't have the necessary technical expertise. Installation of the Gallery Effects application is easy to do. To install the Gallery Effects stand-alone application, you'll need at least 2.9MB spare on your hard disk. To install all the files on the four disks, you'll need at least 4.9MB. Documentation for Gallery Effects is complete and includes information on all the effects in the package, as well as four-color illustrations showing how to achieve the effects shown with your own artwork.

The best part of this process is that the experimentation itself is fun. Since Galley Effects reads many file types but doesn't read GIF files directly, you'll need software to convert the images into PICT2 or TIFF format. Many different shareware programs (e.g., GIF Converter, QuickGIF, and GIFFER) are available for download from on-line services like CompuServe to convert graphics files into GIF files. Gallery Effects isn't a speed demon, but I maximized its performance by setting the memory size in its Get Info box at double the 1500K recommended. The best way to use the program is to start with a disk full of files and browse through the manual looking for effects you like. Often the manual gives some tips that require other software, like Photoshop, but more often than not, Galley Effects' own brightness/contrast and color balance controls work fine without external help.

When you open a file, you'll see a small thumbnail of the image, and a selection rectangle that you can place wherever you want. Some images get to be large and if the file you try to open is too big, you'll get a message telling you to select a portion of the image to open. When you click on the thumbnail, you see a rectangle with handles which you then manipulate to select the final image size. This process of selection is slower than, say, the way ThunderWare accomplishes the same thing with its scanner software, but it gets the job done. I've encountered software that said the file was too big and then tossed me out, but Galley Effects doesn't do that. I liked that.

All the effects have a similar dialog box to the plug-ins. The image covered by the selection rectangle is shown in a small box labeled "original." By using the preview button, you can see the effect achieved in an adjacent window labeled "effect." What worked for me was moving the rectangle around to a few areas, then tweaking the controls before hitting the Apply button. The rendering of the whole image will take some time depending on how large the file is and what your hardware configuration is, but I found the process wasn't annoyingly slow. If you find certain control settings you like, they can be named and saved for future use by using the "Stored Control Settings" portion of the dialog box.

Like all of the filters in this chapter, each effect can be applied singly or with other effects—even from different manufacturers. Users can apply effects to selected areas or the entire image, building effects on top of one another. Linnea Dayton and Jack Davis' "The Photoshop Wow Book" from Peachpit Press includes several color pages showing the effects of all the

filters in Volume I and II on the same image, but sometimes the effects will vary depending on the image itself. If all this sounds like fun, that's because it is. Using Gallery Effects is as much fun as playing a computer game.

Kai's Power Tools

If Gallery Effects reminds me of playing a game, working with Kai's Power Tools 2.0 is like putting together a puzzle in which, depending on the techniques you use, the pieces can be assembled to produce different images. When I met Kai Krause at MacWorld '94 I was knocked out by the potential of Kai's Power Tools. Watching a virtuoso like Kai manipulate images is like watching Itzhak Perlman play the violin. It looks easy, but the best results will be obtained with practice, practice, practice. KPT, available in either the Windows or Mac versions, consists of four mini-applications and a bunch of fun filters. Some filters and mini-applications appear under KPT 2.0 in the Filters pull down menu, while others appear under the appropriate filter type in Photoshop's standard filter categories. Look at the items in the Filter menu and its submenus and you'll discover where the items contained in Kai's Power Tools are located. (See Figure 9-13.)

FIGURE 9-13: With a photograph from Corel's Trees & Leaves stock Photo CD loaded, the KPT submenu displays some of the filters and applications available. But these aren't the only places Kai's Power Tools show up in the Filters menu.

Enhancing Color and Adding Drama

Kai's Power Tools can be used to enhance an image or convert it into another reality. Let's take a look at the same close-up of the leave shown in Figure 9-13 and see what KPT can do:

- Step 1: After opening, sharpening, and cropping (to remove a black edge) this photograph from Corel's Trees & Leaves stock Photo CD is ready to go in Adobe Photoshop.

- Step 2: As I mentioned before, KPT filters appear in several items in the Filters menu. Here, KPT's Sharpen Intensity filter appears in the Sharpen submenu. (See Figure 9-14.)

FIGURE 9-14:
Unlike most filter packages, the many different elements found in Kai's Power Tools appear in many other submenus in your image enhancement program's Filters menu. Here, the Sharpen Intensity filter appears under the Sharpen submenu.

COLOR PLATE-17:
This is the print used in the "print-off" that compared a commercially produced print made from a slide to one produced with the Fargo Pictura. In every way the quality of the Fargo dye-sub print was a good as a commercial silver-based image.

COLOR PLATE-18:
This Base*16 Photo CD image was opened in Photoshop and a 100 percent Unsharp Mask was applied. The cropping tool was used to focus the attention on Mary Farace and her bear friend. Finally, the Image Size menu was used to resize the image to 4x6 inches, which resulted in a 6MB file that printed in just a minute or so on the Fargo FotoFun!

COLOR PLATE-19:
This image was created on a Lasergraphics LFR Mark III film recorder at 8000 lines of resolution.

Imaged on a Lasergraphics LFR Mark III DPM

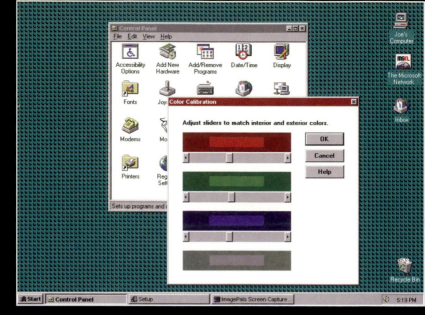

COLOR PLATE-15:
The final step in installing HiJaak Graphics Suite is the Color
Calibration dialog that lets you adjust sliders to match your system's
color capabilities to the one built into Inset Systems' software.

COLOR PLATE-16:
This photograph of a
brachiasaurus was
made at the Utah Field
House in Vernal, Utah on
Kodak slide film and
digitized using Photo CD.
The largest resolution
image was printed on
the Stylus Color using
Epson's Glossy paper.

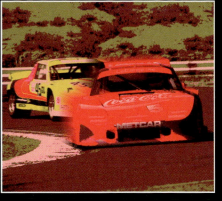

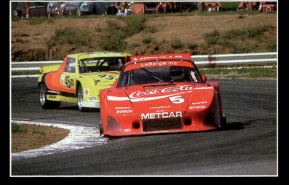

COLOR PLATE-13:
The original image of the racing Porsches, from Corel's Auto Racing Stock Photo CD. While it's a great action photo, the manipulated image in COLOR PLATE-12 represents an interpretation of that image. Is it better or worse?

COLOR PLATE-12:
After using two different image enhancement programs and two different plug-in filter packages, the manipulated image of the racing Porsches is finished. How does it compare to the original?

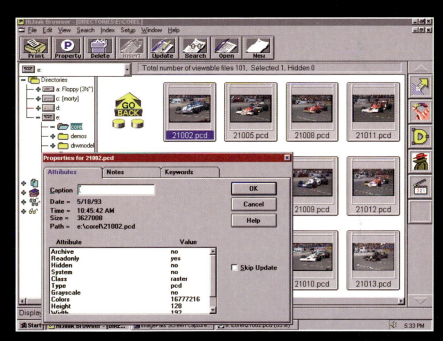

COLOR PLATE-14:
HiJaak Browser allows you to enter data about each image in its database through the Properties dialog. The program will automatically fill in some data about the technical aspects of the image in the large window.

COLOR PLATE-10:
This highly manipulated—
colorwise, anyway—
image may be a bit
extreme for some readers
but it does demonstrate
the potential that
Chromassage has for
creating visually
dazzling images.

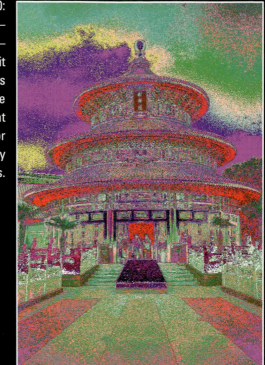

COLOR PLATE-11:
This image of a head
of lettuce from Corel's
Vegetable Stock
Photo CD has been
transformed into a fun
picture using the Pastel
Bubbles option of Xaos
Tools Paint Alchemy.

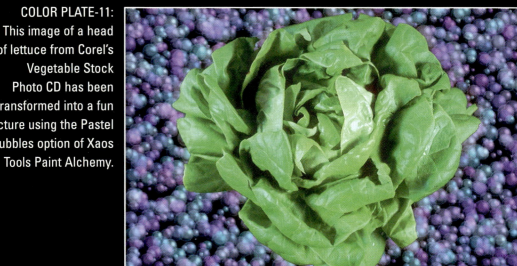

COLOR PLATE-8: The studio portrait from Corel's Models disc is enhanced by a replacement of the gray seamless paper studio look to an out-of-this-world, multi-colored background created by Kai's Power Tools Fractal Explorer.

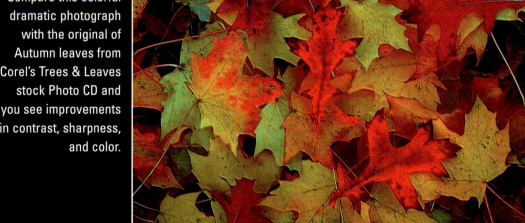

COLOR PLATE-9: Compare this colorful dramatic photograph with the original of Autumn leaves from Corel's Trees & Leaves stock Photo CD and you see improvements in contrast, sharpness, and color.

COLOR PLATE-6
Using only a few slide
controls in the Gallery Effects
Colored Pencils dialog, you
can transform a photograph
of a Mountain Gorilla (from
Corel's Apes stock Photo CD
disc) into a drawing

COLOR PLATE-5:
The final result of using the
Gallery Effects Volume I Mosaic
filter on a photograph from Corel's
Rome stock Photo CD disc.

COLOR PLATE-7:
Applying Kai's Power
Tool's Sharpen Intensity
filter to a photograph
from Corel's Trees &
Leaves stock Photo
CD makes an already
interesting image
even more so.

COLOR PLATE-3: The result of sharpening, selection, tonal variation, and, finally, a texture effect, changes a stock photograph of a mission made in daylight into a moody nocturnal image.

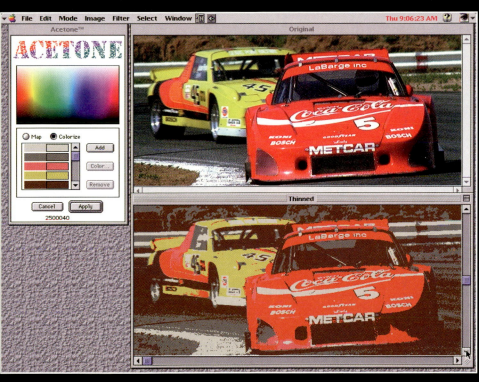

COLOR PLATE-4: Acetone's control window provides a large preview of the filtered image along with a similarly sized one for the "before" image. The controls in the upper right-hand part of the screen let you add or subtract colors.

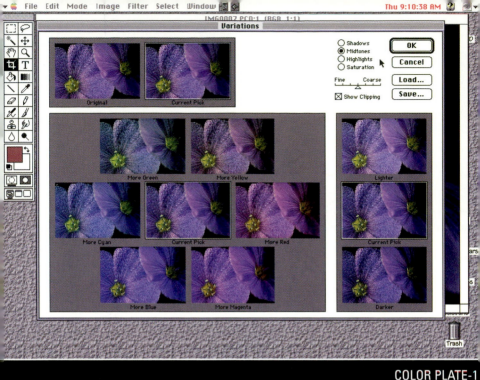

Adobe Photoshop's Variations dialog shows before and after previews
seven windows displaying the original image in the center, and three previews
that allow you to lighten or darken the image. The previews show what that image will
look like when more red, blue, green, yellow, cyan, and magenta are added to it.

COLOR PLATE-2:
After Applying
the Psychedelic
filter, the Photo CD
image then had
the brightness,
contrast, and
intensity tweaked
using Corel Photo
Paint's Brightness
and Contrast dialog.

- Step 3: Applying the tool is just a matter of selecting it. The results can turn an ordinary photograph into a dramatic one. (See COLOR PLATE-7.)

COLOR PLATE-7: Applying Kai's Power Tool's Sharpen Intensity filter to a photograph from Corel's Trees & Leaves stock Photo CD makes an already interesting image even more so.

Creating Your Own Unique Backgrounds

KPT's interface is the most attractive and ultimately the most intuitive I've seen in any graphics program. In a previous chapter, I showed you how you could paste a studio photograph of a model on top of an outdoor location. In this example, I'll change the studio background into something that is out of this world. Let's see what can be done with another image from Corel's Models stock Photo CD:

- Step 1: I started by opening a studio portrait of a model with Adobe Photoshop. (See Figure 9-15.)

- Step 2: The main reason I increased the contrast was to maximize— without destroying the image—the difference between the model's black leotard and the dark gray seamless background. This made my

FIGURE 9-15: Not all images need sharpening. For this portrait from Corel's Models disc, I cropped off the black edges and used the Brightness & Contrast tools to bump up the contrast a bit.

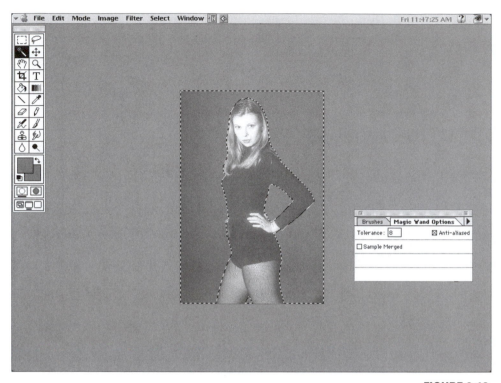

FIGURE 9-16:
To select the background on a photograph in which foreground and background have similar tones, set the Magic Wand Tolerance level below 10. In this case a setting of eight was used, but it took 10 to 12 Shift-clicks to select the entire background.

selection of the background easier with Photoshop's Magic Wand tool. I set the tolerance at eight—anything larger would have selected part of the model's leotard—and made multiple clicks on the background until it was totally selected. (See Figure 9-16.)

Step 3: Next, I chose KPT's Fractal Explorer to apply a colorful look to the monochromatic background. I used the plug-in's pop-up menu, which contains dozens of alternatives and selected Fiery Dripping Curtains. Additional controls that will manipulate that section are on the left and right-hand side of the main, center window. (See Figure 9-17.)

FIGURE 9-17:
KPT's Fractal Explorer dialog box is a classic example of the innovative interface design that HSC Software has brought to plug-in filters. In addition to a pop-up menu containing dozens of built in fractal designs, controls on the left and right allow you to tweak those designs to provide an almost limitless number of possibilities.

■ Step 4: When the preview window in the center of the dialog looks the way you want it, click the Apply button in the lower right-hand corner. This filter took approximately 17 seconds to apply and KPT features a thermometer-type gauge showing how long the effect will take to apply. (See COLOR PLATE-8.)

COLOR PLATE-8: The studio portrait from Corel's Models disc is enhanced by a replacement of the gray seamless paper studio look to an out-of-this-world, multi-colored background created by Kai's Power Tools Fractal Explorer.

Other applications included in the package are Texture Explorer which lets you generate any kind of texture, background, and material which can then be applied to photographs, text, backgrounds, or objects. KPT's Gradient Designer lets you mix up to 500 colors at one time and provides 16 combinations of mode and looping, opacity, and the ability to blend to "no color." Gradients on Paths lets you wrap any blend of colors around a free-form path or text selection. Julia Sets allows users to generate and explore using fractals or fractal segments for masking and mapping. These applications alone would be a good deal, but MetaTools also includes 29 filters including Glass Lens, which lets you turn any image, or part of an image, into a sphere; Sharpen Intensity which goes way beyond Photoshop's sharpen filter; and Hue Protected Noise.

New Stuff

Plug-ins, like all software, are not stagnant. As I write about Kai's Power Tools, the folks at MetaTools, Inc. are already planning on the next version. What can we expect to see in KPT 3.0? Here's what you might expect: KPT 3.0 will sport two new interface extensions. The first, Spheroid Designer, will create a multi-illuminated sphere with varying colored light sources, including positive and negative light. The second extension, Interform, will mathematically interpolate between two textures generated by Texture Explorer and provide either still or animated output. And instead of throwing KPT one-step filters all over the Filter menu, they will be grouped into user interfaces, which will (unlike the current version) allow users to create and preview effects in real time before applying them. Some of the new filters sound like fun: Smudge Darken or Lengthen, Page Curl, and Vortex Tiling, among others. KPT 3.0 also promises to have significant speed improvements, larger preview windows, graphical presets, and compatibility with Adobe's video editing program, Premier. This new version will ship for Power Macintosh and Windows 95 and NT.

Keep in mind that competitors in the plug-in sweepstakes are not just sitting by idly, they too will be creating new filters and add-ons that make plug-ins one of the fastest growing categories in imaging software.

KPT Convolver

At first glance, you'll be asking "is KPT Convolver a plug-in or an application?" You notice it's different as soon as you launch Convolver. Its diamond-shaped 3D interface contains two windows: a small "Before" and larger "Preview." In the upper left-hand corner are buttons that activate one of Convolver's three modes: Explore, Design, and Tweak. When one of the modes is selected, controls that affect the others are dimmed or "asleep." When the Explore mode is selected, three more buttons appear, allowing users try different filters whose results are displayed in 15 variations or "tiles" in the Preview window. Clicking the Mutate Genes button generates 15 new tiles. You can click on any one of the 15, and this tile becomes the basis for which the next round of mutations is built. Two other buttons control how much each tile is different from one another.

The Genetic Diversity button has a pop-up menu that lets you set five different levels of diversity from Minimum to Maximum. Gene Influences lets you vary your choice of Blur/Sharpen, Embossing, Edge Detection, Hue, Saturation, Brightness, Contrast, and Tint. You can select any or all of them to be used in the mutations. Design Mode lets you apply two different filters at one time and contains sliding arrows that allow you to set how much or little the effects will be implemented. Results are displayed as 15 tiles in the Preview window. Tweak Mode contains 14 filter controls that allow you to tweak the image's color, sharpness, and contrast.

Turning Autumn Leaves into Fall

Let's take a look at how to improve another image from Corel's Trees & Leaves stock Photo CD:

- ▦ Step 1: The original image of Autumn leaves was opened and the black edges trimmed off using Adobe Photoshop's cropping tool. The composition, while attractive, needs a little improvement to make it an attention-getting image. (See Figure 9-18.)

- ▦ Step 2: KPT Convolver was selected from the Filters menu (Figure 9-19).

- ▦ Step 3: I started in Tweak mode by using the Sharpen control, because, as you know by now, all Photo CD and many scanned

FIGURE 9-18.
The original image of Autumn leaves is quite good, but was obviously made on an overcast day. So the composition, while attractive, needs KPT's Convolver to make it an attention-getting image.

FIGURE 9-19:
KPT's Convolver interface allows you to work in three modes: Tweak, Design, and Explore. You can use one or all of them for exploring the potential of your digitized images.

images invariably need some sharpening. Unlike Photoshop's own Sharpen command, Convolver displays a number (in percentage) in the bottom of the windows indicating how much sharpening is being applied. Most of the percentages I put to use were smaller than the large numbers (usually over 100 percent) required using Photoshop's Unsharp Mask. For the image of leaves, only 14 percent was required.

■ Step 4: Next, I used the Color Contrast to kick the contrast up a bit—10 percent—before moving into Design Mode. (See Figure 9-20.)

FIGURE 9-20:

One of the best ways to compare your original versus the current state of manipulation of it is to use KPT's Convolver Split Screen. The split screen feature is, however, only available to those users who have explored the plug-ins interface in enough depth to acquire the "stars" needed to access this feature. For information on Convolver's Star system, read on.

■ Step 5: Both Design and Explore modes provide a ring-around type look at applying effects. Clicking on one of the squares (diamond shaped polygons, actually) makes that version of your image active. After you see what you like, click Apply and the effect is rendered. (See COLOR PLATE-9.)

COLOR PLATE-9: Compare this colorful dramatic photograph with the original of Autumn leaves from Corel's Trees & Leaves stock Photo CD and you see improvements in contrast, sharpness, and color.

Part of Convolver's design includes a star system that rewards photographers who frequently use certain features with enhanced versions of those features. As you use certain features more than others, stars—which in turn add enhanced capabilities to those features—appear. That's right, the program actually modifies itself, automatically, if you use a feature enough. There are five possible stars that you can achieve (so far, I've only achieved four star status), and the awarding of each is accompanied by the appearance of a dialog box that includes a brief explanation of how to use the new feature. You can recall this dialog by holding the Option key and clicking on a star. This pops up the original dialog explaining what the new feature does. The second star lets you convert the Preview window into a split screen and toggle a side-by-side comparison of your manipulated image with the original. The fourth star confers what I call M&Ms. This is a 3x3 matrix of 3D circles that remind me of M&M's and allow you to save the status of the image you are currently manipulating, while allowing further explorations without having to worry that you may not find the proper combination of filters and variations to achieve that effect again. It adds a level of nine Undoes, something Photoshop sorely lacks. Why aren't these features built-in from the beginning? HSC's Kai Krouse tells me the idea is to provide as simple an interface as possible and to provide only those tools a user needs as he or she requires them.

MetaTool's manual recommends you start in Explore mode, add effects in Design mode, and touch up the finished image in Tweak mode. In practice, I was more comfortable doing the opposite. Convolver's Tweak mode contains controls that *are* available within Photoshop, and, for the first time, enables you to quantify the changes you make. Using Design and Explore modes lets you produce effects not possible with any other Photoshop add-

on. Convolver works with any image enhancement program that supports Photoshop plug-in standards. It has a list price of $199 and is available for both Windows and Macintosh computers. You don't even need an image enhancement program to use Convolver. The Macintosh version is accelerated for use on a Power Macintosh and comes bundled with MicroFrontier's Color-It! (see Chapter 8). The PC version is packaged with a LE version of Micrografx Picture Publisher (see Chapter 7) and is shipping in both 16- and 32-bit versions for Windows 95 and Windows NT.

Chromassage

This plug-in from Second Glance software provides Photoshop users with color table manipulation, palette rotations, and color "injection" into 24-bit images. Effects can range from posterizations to color effects you couldn't otherwise imagine. Chromassage appears under the Second Glance item in Photoshop's pull-down Filters menu. (There's room for more items, and the other Second Glance plug-ins relate to scanning and color separations.) The filter's interface features an interactive preview of your image as it is being modified. Tools include current and modified color palettes, "jog wheel" type sliders that roll the color palettes back and forth (and up and down) to provide a dazzling amount of color choices. There's an "injector" that can be used to place a user definable amount of color on the image. A variety of color palettes are installed, or users can import the colors used in a favorite photograph. Since results can vary from dramatic to dramatically bad, each step in the process has an Undo function to set things back the way they were before you started playing with one of Chromassage's many functions.

Changing a Pagoda's Color Palette

So let's play with a photograph of a pagoda made by Mary Farace:

- Step 1: The Photo CD Image was opened in Adobe Photoshop and rotated 90 degrees clockwise to place it in the vertical or portrait position. (See Figure 9-21.)

- Step 2: Then the Chromassage filter was opened in Second Glance submenu of Photoshop's Filter menu. The dialog contains a large preview window and a pop-up menu that contains 26 different

FIGURE 9-21: This photograph of a pagoda in Disney World was made by Mary Farace on color negative film, digitized with Kodak's Photo CD process and opened in Adobe Photoshop.

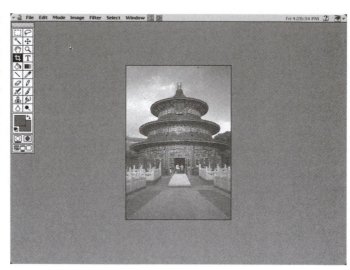

pre-configured color palettes and, by using the jog wheels, can produce an infinite number of color combinations. (See Figure 9-22.)

■ Step 3: Now the real fun begins. I started by selecting the Japanese palette, whose colors then appear at the top palette. Then selecting all (⌘-Ⓐ on the PC), I used the "hand" tool to drag the palette to replace the working one below it. This made major changes in the image, but I still used the jog and shuttle wheels for bigger changes. The best way to use the right-hand wheel is to click-and-hold. This causes a radical change of colors in the Preview window. When you get something you like, use the left-hand wheel a mouse click at a time to fine tune the colors. When you like what you see, click Apply and the color palette in your original photograph is replaced with the one you "massaged." (See COLOR PLATE-10.)

COLOR PLATE-10: This highly manipulated—colorwise, anyway—image may be a bit extreme for some readers but it does demonstrate the potential that Chromassage has for creating visually dazzling images.

Second Glance Software's Chromassage may be a filter that only does one thing, but the effects it creates are infinitely variable.

FIGURE 9-22:
The Chromassage dialog contains two parts: First, there's a large preview window that lets you see the effects of any changes in the image's color palette. Second, there are two color palettes indicating the existing one and your manipulated palettes. This existing color palette can be manipulated a hue at a time or radically changed by selecting an entire new palette or using the jog and shuttle wheels to make changes.

Paint Alchemy

Xaos Tools (pronounced chaos) offers three packages that can produce striking images. Paint Alchemy is a Macintosh-only product that makes it easy to produce dynamic, creative imagery. Paint Alchemy lets you use many different built-in effects or you can create your own. To get started, there's 101 preset brushing styles, and each one is fully customizable and resolution-dependent to apply special effects such as Pastel, Ripple, Vortex,

Threads, Smoke, and Bubbles. Their latest version, which is accelerated for the Power Macintosh, features a striking new interface with easy access to all settings for brush stroke coverage, color, size, angle, and opacity. You can even animate the effects and export them as QuickTime video clips using Adobe Premiere or Equilibrium's DeBabelizer.

Making Pastel Bubbles

One of my favorite effects, Bubbles, might take 20 minutes to accomplish using Photoshop's standard controls, but Paint Alchemy achieves the same effect within a few minutes. Here's all there is to it:

- Step 1: Just because an image appears ordinary, doesn't mean you can't have fun with it. Here I started with a photograph of a head of lettuce from Corel's Vegetables stock Photo CD. Using Photoshop's Magic Wand tool, I selected the dark background area around the head of lettuce. (See Figure 9-23.)

- Step 2: Next, I selected Paint Alchemy from the Xaos Tools submenu of Photoshop's Filter's menu (Figure 9-24).

FIGURE 9-23: A photograph from Corel's Vegetables stock Photo CD provides a starting point for Xaos Tools Paint Alchemy program. The original image was cropped (to remove a black border), sharpened, and the contrast increased using Photoshop's Bright & Contrast controls.

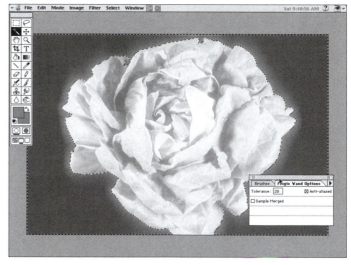

FIGURE 9-24:
Like a well-behaved plug-in (and not all are, as you will shortly discover), Paint Alchemy appears in the Xaos Tools submenu of Photoshop's (or any compatible program's) Filters menu.

■ Step 3: This opens Paint Alchemy's dialog, which includes a pop-up menu containing 101 pre-defined styles. Once a style has been selected, you have total control over it. For example, I selected Pastel Bubbles (because I like the soft-colored highlights). I also had control over the size of the bubbles, their opacity, and the color of the bubbles' highlights (See Figure 9-25).

It's a good idea to use the Preview button to see what effect any changes you make have on the original image before applying it. When you see what you like, click Apply to finish the image. (See COLOR PLATE-11)

FIGURE 9-25:
Using the Pastel Bubbles option of Xaos Tools Paint Alchemy plug-in.

COLOR PLATE-11: This image of a head of lettuce from Corel's Vegetable stock Photo CD has been transformed into a fun picture using the Pastel Bubbles option of Xaos Tools Paint Alchemy.

Paint Alchemy's interface lets you adjust every aspect of a brush stroke, including color, size, angle, transparency, and the brush itself. When you click on any aspect, another dialog appears allowing for infinite customization. You can also import any PICT file to create your own brush, which can then be saved as a completely unique filter. If creating your own brushes doesn't appeal to you, you can always use one of the 36 built-in brushes and vary their setting using the controls provided in the interface.

Xaos Tools has two other packages that complement its line of plug-ins: Fresco and Terrazzo. Fresco is a collection of 80 texture images that have

been especially designed to be rich in luminosity, subtle in color, and have surface depth. These can be used for backgrounds and textures and can be combined with your photo/graphic imagery. The package is on CD-ROM and contains files in three formats: 300 dpi, 72 dpi, and 640x480 pixels as an 8-bit PICT file. A browser is included that allows you to have a look at these images, but Xaos Tools provides a glossy, four-color insert that shows exactly what the backgrounds look like. If you'd like to create your own backgrounds, check out Terrazzo. This plug-in has been designed to create "tileable" textures and patterns from any image source—including your own photographs. The plug-in's interface displays the source image, the active symmetry, and resulting tile, as well as the pattern generated from the repeating tile. There's several different pull down menus and sliders that allow you to control the look of your patterns and textures. You can adjust lightness/darkness, hue/saturation/color, and luminosity.

The Black Box

The Black Box from Alien Skin Software is a collection of ten Photoshop-compatible filters designed to allow novice digital imagers to create effects that were once limited to more experienced users. It's also the only set of filters that lets you edit transparency in Photoshop's layers. (See Chapter 6.) For instance, Black Box's Drop Shadows plug-in eliminates a 12-step process to accomplish the same effect. Here's a quick look at the ten filters and what they do:

- Drop Shadow: Makes part of an image appear to float above the rest of the image and casts a "dropped" shadow.

- Glow: Puts a neon glow—user defined by size, width and color—around part of an image.

- Glass: Creates the appearance of a piece of shiny glass covering your photograph.

- Outer Bevel: Puts a 3D slanted edge around the *outside* of an object or image.

- Inner Bevel: Puts a 3D slanted edge around the *inside* of an object or photograph.

- Carve: Makes part of an image look like it is dented or carved out of the rest of the image.

- Cutout: Turns a selected portion of an image into a hole, using appropriate shadows.

- HSB Noise: Hue-Saturation-Brightness noise, lets you add what appears to be TV static or "snow" to a selected part of an image's color.

- Swirl: Smears the image using simulated whirlpools.

- Motion Trail: Makes part of an image look like it is moving. This plug-in is significantly better than Photoshop's own Motion Blur because it gives you control over the direction, length, and opacity of the blur.

Adding Blur to Racing Cars

Let me show you how Motion Trail works for the third and last manipulation of the photographs of the racing Porsches.

- Step 1: After opening the file of the racing Porsches, I used Photoshop's Magic Wand to select a portion of the left side of the car. Since I wanted to blur the left-hand side of the car, I wasn't picky about what was selected, unlike typical selections.

- Step 2: Then I chose Motion Trail from the Alien Skin submenu of the Filter's menu. (See Figure 9-26.)

- Step 3: Alien Skin's Motion Trail dialog box gives total control over the direction, length, and opacity of the blur, and you can see the effect in a Preview window. Now's the time to play with the dialog's different settings before applying. (See Figure 9-27.)

- Step 4: Once you like the Preview, click Apply and you're finished. (See COLOR PLATE-12 and COLOR PLATE-13.)

FIGURE 9-26:

After posterizing the photograph of the racing Porsches from Corel's Auto Racing stock Photo CD with Second Glance Software's PhotoSpot, The Black Box's Motion Trail was selected.

COLOR PLATE-12: After using two different image enhancement programs and two different plug-in filter packages, the manipulated image of the racing Porsches is finished. How does it compare with the original?

COLOR PLATE-13: The original image of the racing Porsches, from Corel's Auto Racing stock Photo CD. While it's a great action photo, the manipulated image in COLOR PLATE-12 represents an interpretation of that image. Is it better or worse? You be the judge.

Black Box is available in a Macintosh version that is accelerated for the Power Macintosh and a 32-bit accelerated version for Windows 95 and NT. The program is fully compatible with Adobe Photoshop 2.5 or later for

FIGURE 9-27:
The Black Box gives you much more control over direction, length, and opacity of the trail than Photoshop's own Motion Blur filter.

Windows and the Mac, MicroFrontier's Color-It! 3.0 or later for the Macintosh, Micrografx Picture Publisher 4.0ak or later, and Corel's Photo-Paint 5.0E3 or later for Windows computers. As I write this, it is not compatible with Fractal Painter, PixelPaint Pro, or Paint Shop Pro, but my guess is these compatibility problems will be solved. But caveat emptor. Check with Alien Skin about compatibility with your favorite program before spending $119.

So Many Plug-ins, So Little Time

This has been a quick overview of plug-ins for image enhancement programs, but the popularity of Photoshop-compatible add-ons is spreading to

other programs. Adobe's PageMaker 6.0 is compatible with these plug-ins and includes built in Photo CD import and image manipulation capabilities. The same is true for Deneba's Canvas 5.0 drawing program. It will offer image enhancement capabilities in addition to its already impressive drawing features. And don't forget to cruise the graphic and photographic forums on CompuServe, America Online, and Prodigy looking for plug-ins that can add functionality to your favorite program. For example, there's a great shareware program out there that adds a large copyright symbol to your images. This is a good idea when posting a copyrighted image on a service or providing a digital preview for a client.

As you can see, plug-ins are definitely a growth industry. So, who needs plug-ins? Everyone!

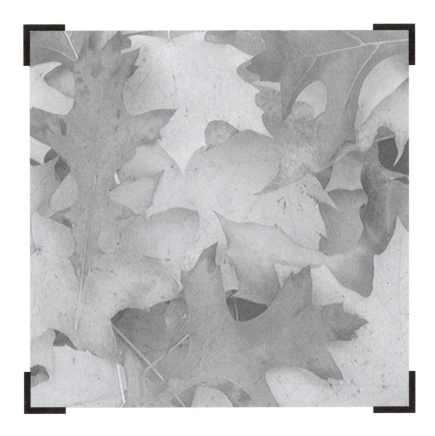

PART

P A R T IV

OUTPUT

In Part IV, I will introduce you to the next step in working with digital images—output. For some reason, image output is one of the least talked about elements that make up the final aspect of the digital imaging process. Images can be output in many different ways: An image can simply be viewed and cataloged on a monitor. Photographs can be transferred to other computers in digital form via floppy disk or any kind of removable media drives, like SyQuest or optical media, or even over the phone lines, and viewed on *another* computer. A printer attached to your computer can produce a grayscale or color page.

If, in the past, the selection of photorealistic printers was limited and expensive—all that has changed. Now you can use the growing number of inexpensive color printers from companies like Apple and Epson to print your images directly from your computer. The quality of this output is far from photographic, but it isn't bad—considering the cost. More expensive photo-quality output is available from dye-sublimation printers, but the

printers themselves and the consumables get expensive. One approach that straddles both alternatives is to output your image to a color laser copier, such as Canon's. This service is available from many service bureaus and, depending of the quantity of prints you need, can be cost-effective.

Or, the image can be converted back into a silver-based form. You can reverse the process from digital to analog and have your digital image output as film. Larger service bureaus and professional labs have equipment that can take your enhanced digital image and output it as a slide or 4x5 and 8x10 sheet film. Once back into silver-based form, you can use this image to project or make prints in the traditional manner. In this final section of the book, you will find out about using printers and what is available from service bureaus. But before getting started with outputting images, you might want to first think about how you will organize these images.

IMAGEBASES AND SCREEN SAVERS

In this chapter, we will look at what you look at—images. In this case, we'll look at how to organize your images, how best to display them on your monitor, and even how to make them into screen savers.

Image Management

Long before Kodak introduced the Photo CD format, photographers needed a method to organize and store their images. In the past, this was usually accomplished by using plastic pages and vinyl binders, metal filing cabinets, and archival boxes. The problem with every *analog* image filing solution is that it can be difficult, under the press of a deadline, to maintain an orderly system. "Tomorrow I've got to get organized," was a lament heard from photographers all across the country. When computers started storing pictures as data, the typical response of many graphics professionals was to

stuff the images into folders or directories, often labeled with cryptic names, on their hard disk. The problem became not just "where did I put that photo," but "what did I call that file?" Image database—or imagebase—programs, when properly organized, can answer both of these questions.

All of the imagebase programs that I will introduce you to have several things in common: They store and display a thumbnail of the photograph and have space for captions, catalog numbers, and filing locations. You can search through caption data to find specific images.

If, for instance, you're looking for all your photographs that were made in Utah, you simply type the word "Utah" into the program's find function, and it will list all the images it found with Utah in the caption information.

Some programs offer additional features such as the ability to rotate or flip the image, while some Windows programs, like Image Pals, include image enhancement capabilities that enable users to improve their photographs. While not a substitute for a full-featured image manipulation program, programs like Graphics Tools and Image Pals may be all some photographers need for both image management and image enhancement. Since many of these can also catalog video, animation, and sound files, these applications could properly be called multimedia databases instead of just image databases.

In this chapter, I will introduce you to the crème de la crème of imagebase programs. The products selected are those that fit the way photographers work and will emphasize those features that are important to them, including ease of use, a variety of thumbnail displays, the ability to caption then search for a specific image file, and the ability to handle many different kinds of graphics file formats. Based on the questions I receive from photographers, the how-to sections included will demonstrate how to load your graphics files into a specific program, with an emphasis on using Photo CDs.

I include many different programs, because not all photographers work the same way. Some prefer that the thumbnail size reflect the size of the file, while others want all of them to be the same size for consistency's sake. Some shooters want an attractive, elegant interface, while others want "just the facts." There's something here for everyone.

Cross Platform Imagebase Solutions

This first group of programs is available in both Macintosh and Windows incarnations. As you will see, though, sometimes the versions differ so much they might almost be considered different programs.

Creating an Image Browser Catalog

Imspace System's Kudo Image Browser, my favorite Macintosh image database, is now also available in a Windows version that can produce bigger databases and accept more file types. Here's all you have to do to create an imagebase of your files:

- Step 1: Double-click Kudo Image Browsers' icon to launch it. Before it opens, you see a dialog box asking you to name the catalog you're about to create. Since I wanted to catalog images made at Disney World, I called the file (surprise) "Disney World." (See Figure 10-1.)

- Step 2: The next dialog asks you where the images are. It can be a folder or directory, a hard disk, or, in this case, a Photo CD. (See Figure 10-2. DO NOT select the disc, as shown in the illustration.) Remember that Photo CDs can contain five (or six) different resolution images in their ImagePac format, so selecting the disc itself will load all five (or six) image into your database. The best way to load

FIGURE 10-1:
The first thing you see after launching Imspace System's Kudo Image Browser is a dialog asking you to name the image database that you are about to create.

Photo CD images is to work through the folders and directories until you find the one labeled "Images," inside the "Photo_CD" folder/directory. Use that folder to load your images into Kudo Image Browser. You can also create a new catalog by dragging a folder (or disk) full of files and dropping it on top of the Kudo Image Browser icon, and you'll be prompted through the same series of dialog.

■ Step 3: Kudo will begin to load everything in the folder. One of the advantages of using the "Images" folder is that all of the photographs will be cataloged in the proper orientation; portrait images will be shown vertically and landscape-oriented ones will be shown properly. (See Figure 10-3.) If Photo CD images are loaded any other way, they will be displayed horizontally *only*.

If, for any reason, Kudo didn't display an image the way I wanted, a Rotate Thumbnail command lets me put things straight. Users can view the contents of the catalog in three modes: Small Gallery View displays thumbnails (only) at one-quarter their normal size; Galley View shows thumbnails along with their file type and name; and List View displays thumbnails with all the data you have entered for it. You can preview an image by double clicking it, and the "Better Colors" box displays your photographs (on an 8-bit system) better than any Mac or Windows program I've tested.

FIGURE 10-2:
Since Kodak's ImagePac format contains five (six in Pro format) different resolution image, select the folder/directory labeled "Images" inside "Photo_CD." See Step 2; DO NOT select the CD.

FIGURE 10-3:
By selecting the "Images" folder in Step 2, all Photo CD images will be loaded
into the imagebase in the proper orientation either as portrait or landscape.
(All photographs © Mary Farace)

Clicking the Find button brings up a dialog that lets you search by key-word, file name, file type, or location. You can use scroll bars to visually browse for an image, which works fine for small catalogs, but for larger files you might prefer to use the "Riffle" function. In the lower right-hand corner of the screen, "Riffle" sequentially displays thumbnails at a rate of ten frames a second.

Besides drag-and-drop cataloging, Kudo Image Browser's "Drag & Place" feature allows you to select and drag a thumbnail directly into position in a document opened by Quark XPress and Aldus PageMaker 4.2 or later. The only downside to the program is that, unlike Aldus Fetch (more on this Mac-only program later), Kudo is unable to read compressed graphic files. This is more of a problem for service bureaus than the typical photographer. I'm willing to overlook this minor shortcoming because of the way the program works 99.95 percent of the time.

ImageAXS

ImageAXS, from Digital Collections, Inc., offers drag-and-drop cataloging on both Windows and Macintosh versions. The Macintosh version features an elegant dark gray (almost black) interface, while the Windows variation uses an attractive, though less classy, light gray interface. The current Mac version displays portrait Photo CD images in landscape mode, but the Windows version displays them in the proper orientation. There are many changes planned for the next version, and I assume this difference in orientation of Photo CD images will be resolved to match the next Windows version. (See What's Next for ImageAXS.)

ImageAXS includes buttons that make it easier to navigate than some menu-driven programs, and the Windows version includes a full-featured toolbar. Multiple keywords can identify files stored in an AXS collection and there are eight user-definable fields for text, which makes ImageAXS look and feel more like a traditional database program. The caption field stores up to 32,000 characters. All file information, keyword, and user-definable fields are searchable using the program's VCR-like Search buttons. Like a real database, there are seven field search comparators like "contains," "does not contain," "begins with," and "does not begin with." The Macintosh version includes a menu item that lets you launch Apple Computer's PhotoFlash image enhancement program, but the Windows version's superior interface makes it a different and better program.

◼ What's Next for ImageAXS

The next version of the ImageAXS imagebase program will include several features that will make it an even better cross-platform program than it already is. The first change will be the implementation of a single file format that will be readable by both Windows and Macintosh versions of the program. The second will provide all of the functionality of the Windows version with the attractive interface design of the Mac version. In other words, the new ImageAXS will be the best of both worlds. Other goodies include: an expanded number of user definable fields, the ability to assign *hundreds* of keywords, all of the views will be printable, and the program will be able to store an almost unlimited number of records. The new version will support Macintosh, Power Macintosh, Windows NT, and Windows 95.

Loading Images with Kodak's Shoebox

Kodak's Shoebox 1.0 lets Macintosh and Windows users catalog Photo CD images easily, although surprisingly, there's no drag-and-drop option. In its place, a Load Photo CD command searches out Photo CDs on your system, loads the disc, and displays its contents. How easy is it? Let me show you:

- ▤ Step 1: After launching the program, go to the File menu and select Load Contact Sheet. You will notice that Shoebox has already looked at your CD-ROM drive and seen that disc PCD1106 is present. (See Figure 10-4.)

- ▤ Step 2: Using the Load Contact Sheet command, Shoebox loads all of the images into the image base. Not surprisingly, it places Photo CD images into a catalog in their proper orientation. The interface resembles a series of mounted slides arranged on a lightbox. If you don't like the white background, you can use the Settings command to change it to any color you prefer. (See Figure 10-5.)

After the image database has been created, you can use the Add Folder or Add Objects commands to bring in non-photo CD images. The program's Catalog command allows you to index, view information, sort thumbnails,

FIGURE 10-4: Kodak's Shoebox imagebase program is so tuned in to Photo CD discs and images that, when launched, it already knows the ID number of the Photo CD disc in your CD-ROM drive.

FIGURE 10-5:
Looking more like a lightbox than a shoebox, Kodak's imagebase program features an interface that looks liked mounted slides placed on a lightbox—and all vertical images are properly oriented.

and update the catalog. Shoebox's Display menu lets you search the database, select and sort thumbnails, and even create a slide show.

The program lets you design both your own index and search, and you can choose as many fields as you like. This includes offering large keyword and caption fields that let wordy photographers enter several paragraphs. Once a catalog is created, Shoebox's search function makes it easy to find the exact image you're looking for.

Kodak recently updated the Mac version of ShoeBox and made some important changes. The latest version provides resizable Get Info and Search dialogs, and is easier to use with multiple monitor systems. They've also increased overall performance, improved handling of high-resolution

images, and provided a more convenient way to sort field names in the search dialog.

Macintosh Only Programs

Imagebase programs originated on the Mac and one of the first—maybe the first—was Aldus Fetch. Since the Aldus/Adobe merger it's now called...

Adobe Fetch

Fetch was one of the first Macintosh image databases. Its drag-and-drop feature allows users to create new catalogs by dragging a folder or Photo CD icon on top of Fetch's icon. When you launch the program, you're prompted to create a new catalog or add to an existing one. The program then brings you back to the "Add/Update Options" dialog which lets you control what file types you catalog and how they will be displayed.

Fetch displays images by showing a relative image size relationship, so files that are physically bigger than others are shown that way. I prefer to see all of the thumbnails displayed the same size. Unlike other programs, Fetch displays all portrait mode images properly and not in landscape mode, but the Preview option in the Add dialog does not let you see Photo CD images.

Some users may like Fetch's lightbox interface because it provides a "white balance" to the images, but I prefer to be able to control the way the interface appears. The program lets you assign an unlimited number of keywords (up to 31 characters in length) to any image, making it possible to find it later when searching through the catalog. Besides keywords, you can assign a description, or caption, of up to 32,000 characters to a specific image.

When doing a search a spinning dog bone icon appears, and when Fetch finds what you're looking for, it barks at you. I liked that. Fetch includes a XPress Extension that allows you to grab a cataloged image and drop it right into Quark's DTP program.

Cumulus

Canto Software's Cumulus is not only a new mid-sized car from Chrysler, it's a European image database program. I was unable to test a full, working

version of the program, but here's what I discovered while working with a beta version of Cumulus. The program uses a drag-and-drop interface that worked well, but portrait-oriented Photo CD images are imported in landscape mode. Fortunately, there's a "Rotate Thumbnail" which allows you to put things straight. Cumulus' interface is attractive and provides a gray border to the control interface, while the images themselves are displayed on a Fetch-like white background. You can create an unlimited number of records per database and the number of open databases is also unlimited. The program is networkable, and any number of clients may access any number of databases. Version 2.0 should be available in native PowerPC format and should turn what is already a very fast retrieval engine into a screamer.

Windows Only Programs

One of the interesting trends in imagebase programs for the Windows platform is that the Windows only products are almost always small suites of graphics tools that include image enhancement, screen capture, file conversion, and other functions in addition. These programs are, in essence, Swiss Army Knives of graphics, and every photographer I know has at least one of these multi-bladed tools. (I have three.) If you have one of Victorianox products, you'll want, at least, one of these too.

Your Pals

Image Pals 2.0 consists of a series of modules, or "Pals" that include Album, Image Editor, Screen Capture, and CD Browser. Double-clicking CD-Browser automatically loads all of the images on any disc (or Photo CD) sitting in your CD-ROM drive. The display is excellent, and all Photo CD images are displayed with the proper orientation. (See Figure 10-6.)

Browser's interface can be customized to fit your aesthetic sensibilities and lets you change the color of the background and size of the thumbnail. A "Pals" menu lets you bounce back and forth between the program's different modules. Images can be copied from the Browser into an Image Pals album for permanent storage and later retrieval.

Images can also be imported from any TWAIN-supported scanning device, and when an image is finished being scanned, it's automatically

FIGURE 10-6:
Image Pal's CD Browser opens images from Photo CD—in the proper orientation—faster than any Macintosh or Windows program, including Kodak's speedy Shoebox.

added to an album. Once safely inside an album, you can assign a description (up to 4096 characters), subject (up to 127 characters), and keywords (Maximum of 32 words) for each thumbnail. You can view, select, search, or sort the thumbnails by file name, description, subject, or keyword. You can drag-and-drop thumbnails between albums and to and from many applications as well as File Manager.

Graphic Tools

DeltaPoint's Graphics Tools is a multipurpose image database, enhancement, screen capture, and file conversion program that seems to do a little of this and a little of that. While the interface of its Media Manager is attractive,

in default mode it displays thumbnails smaller than other programs. Fortunately, there's a dialog that lets you control thumbnail size by selecting the horizontal or vertical size space the image will be placed in. If you select a square format, your portrait and landscape images will be displayed at the same size. Since it takes a long time to resize all of the images in a collection, be sure to determine the size you want to make your image area before you've created a huge catalog.

Graphics Tools displays Photo CD images in the proper orientation, and like ImageAXS for Windows, it has a toolbar to help you navigate through the program. Since Graphics Tools is a multipurpose program, I didn't expect the search function to be well realized. But I was wrong. You can enter a name, image type, and date cataloged as well as a 32,000-character description. The program will search for all these items.

Opening Files with HiJaak's Browser

HiJaak Graphics Suite is a great file conversion program that's added image enhancement and draw capabilities. Its Browser is the first fresh take on an image database utility I've seen in a long time. You can configure thumbnail size and spacing as well as organize images in "collections" that can be searched for by keyword or caption information. The left side of the screen includes "buttons" that let you quickly move back and forth between all the utilities included in the HiJaak Graphics Suite. Let's open a disc full of photographs with HiJaak's Browser:

- ■ Step 1: You can launch HiJaak Browser directly from the Start menu in Windows 95. (See Figure 10-7.)

- ■ Step 2: Browser's interface combines the now familiar "light box" look with a visual representation of connected drives. It reminds me a little of Windows 3.1's File Manager list of drives and their contents. On the left side of the screen is a list of directories or folders and on the right there is room for thumbnails. (See Figure 10-8.)

- ■ Step 3: To add images from the Photo CD in your drive, you click on the drive in the left-hand window and select Update from the Search menu. This brings up a dialog that updates all of the thumbnails

FIGURE 10-7:
Windows 95 Program menu lists all of the modules that
make up HiJaak Graphics Suite—including HiJaak Browser.

displayed in the right-hand window. You can also click on the Update
button in the toolbar to update an individual thumbnail. When the
screen is fully updated it will look like Figure 10-9.

■ Step 4: Like any good imagebase program, HiJaak Browser allows
you to enter information about each individual image which may
later be searched by clicking the Search button on the toolbar.
Assigning what Inset System calls "Properties" is just a matter of
clicking on the Properties button on the toolbar and filling in the data
in the dialog for the image in question. (See COLOR PLATE-14.)

FIGURE 10-8:
HiJaak Browser interface combines thumbnails with a visual list of directories (folders) that let you move between the drives and see the contents of their graphics files.

COLOR PLATE-14: HiJaak Browser allows you to enter data about each image in its database through the Properties dialog. The program will automatically fill in some data about the technical aspects of the image in the large window, while users can assign a descriptive caption as well as add Notes and Keywords that can later be accessed though HiJaak's Search function.

Collage Complete

Inner Media's Collage Complete is a rarity in this assortment of image database programs. Inside its box are two versions of the program: one for

Figure 10-9:
When thumbnails are being updated, you will see this dialog, and as each individual thumbnail is finished, it will appear on the screen. Thumbnail size can be user-controlled from Small (which I think is too small), Medium (which is shown here), to Large (if you don't have too many images to catalog).

Windows and one for DOS! This is an impressive program that has detailed dialogs for creating catalogs and adding images to them. All my test images were attractively displayed in Collage Complete's interface, and Photo CD images were shown in their proper orientation. The program's cataloging system lets you load in a Photo CD, then group, save, retrieve, or view your images as an individual collection.

The program provides three options for thumbnail display: small, medium, and large. Unless you have thousands of images and want to see as

many of them as possible, select the large size. Like Graphics Tools, Collage Complete includes image enhancement, file conversion, and screen capture functions. Using any of the program's other functions is easy and intuitive. An attractive toolbar that takes care of all of the program's different functions is present on the left-hand side of the screen at all times, And even when working on an image, the catalog sheet remains on screen. I liked that.

Screen Savers

Digital imaging doesn't have to be serious—it can be fun too.

There was a time when your computer really needed a screen saver. If anything stayed on your monitor too long, it would "burn" into the screen's phosphors, leaving a "ghost" image. Screen saver software prevented this from happening with ever-changing on-screen images that prevented the phosphors from being incinerated.

Today's use of resilient phosphors make screen burn-in highly unlikely, and we probably don't need screen savers at all. But that doesn't mean we don't want them. Screen savers have become a fashion statement. The kind of screen saver you use says a lot about the kind of person you are. They proclaim your college alma mater, vocation, musical taste, or attitude. But I think of screen savers as digital potato chips—once you start you can't stop.

You can create your own customized screen savers using photographs you may have taken on a recent trip, during the holidays, or celebrating the birth of a new child. These screen savers make great gifts for computer-owning friends and relatives. Images can also be transferred digitally by floppy or any kind or removable media and viewed on another computer.

PhotoWorks Plus for Windows

A PhotoWorks Plus album is a collection of photographs that, like the real thing, lets you decide which photographs are included and how they are organized. The photographic images are not actually stored in the album file. Instead, the thumbnails act likes pointers telling PhotoWorks Plus where the files are stored on your hard disk. This allows you to include the same photographs in more than one album, without eating up valuable hard disk space. PhotoWorks Plus albums, in addition to being the starting point

for the creation and production of screen savers, are a form of imagebase, so an explanation of how they are produced ties the last section to this one.

Making an Album

Using PhotoWorks Album Wizard makes it easy to assemble an album. When you click the Wizard button in the toolbar, this is what you will see:

- Step 1: The first dialog (see Figure 10-10) shows a vertical slide image and states that this Album Wizard lets you specify an album title and description, select the thumbnail size, select the floppy drive, and specify the album name. Click the button labeled Next> to move to Step 2.

FIGURE 10-10:

This is the first screen you will see when creating an album from Pictures On Disk floppies when using PhotoWorks Plus Wizard.

FIGURE 10-11:
The second screen in PhotoWorks Plus Album Wizard lets you name the album file and write a description of the album's contents.

■ Step 2: The top of the next dialog allows you to enter a title for your new album. The bottom includes a section for you to enter a description of the contents of your new album. (See Figure 10-11.) You must enter an album name, but the description can be written later using PhotoWorks' basic interface and instructions. Click the button labeled Next> to move to Step 3.

■ Step 3: This step lets you select which size thumbnails you want to see displayed in your album. PhotoWorks Plus allows you to choose from four different-sized thumbnails, which are listed in a vertical row. (See Figure 10-12.) As you click on a button that represents a size, the dialog changes to show the exact size of that thumbnail to

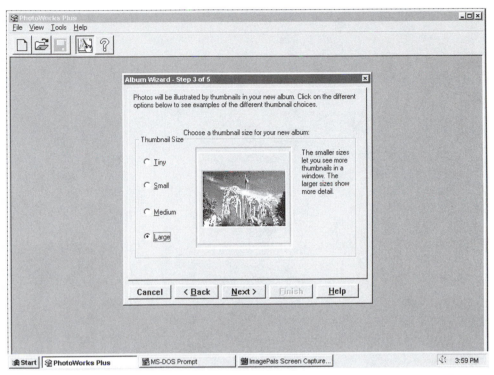

FIGURE 10-12:

This screen in PhotoWorks Album Wizard lets you decide which size thumbnails will appear in your Album. Your have four choices: Tiny, Small, Medium, and Large.

help you select the one you want. Click the button labeled Next> to move to Step 4.

▪ Step 4: Lets you select which floppy drive contains your Pictures On Disk images. (See Figure 10-13.) The default is the A drive, but a scrolling window lets you pick the one that fits the way your particular system is configured. Once the drive is selected, click the button labeled Next> to move to Step 5.

▪ Step 5: Click the Finish button and the Album Wizard will begin to assemble your PhotoWorks Plus Album. (See Figure 10-14.) At this point you're ready to turn that album into a screen saver.

FIGURE 10-13:

The next to last step in PhotoWorks Plus Album Wizard checks to see in which floppy disk drive your Picture On Disk disk is located. The A drive is the default.

FIGURE 10-14:

The last step gives you a few tips about how to work with albums after you've created them. It starts the process in motion of opening all of the Pictures On Disk images and writing their thumbnails into your new album.

Making a Screen Saver

Instead of working through PhotoWorks Plus, double-click the icon labeled Screen Saver Setup inside the PhotoWorks Plus program group. This brings up a dialog box that contains all of the elements that can be part of your own personalized screen saver. At the top is the name of the album file. Screen Saver Setup picks the most recent album that you've opened, but you can click the Browse button to find the exact album you want to convert into a screen saver.

The next section lets you specify whether you want to show the photographs in the sequence used in the album or in a random order. A radio button is provided for each; just click the one you want. Random fits my personality, but you may prefer them to be the way you arranged them in

FIGURE 10-15:

The Screen Saver Setup dialog box contains all of the controls and commands needed to turn your album of photographs into a customized screen saver.

the album. The transitions and delays will be as you have previously select-
ed in the Slide Show dialog. If you haven't already set this up, now is the
time to minimize Screen Saver Setup and launch PhotoWorks Plus and set
these parameters.

The next option is whether or not you want titles displayed. This is a per-
sonal choice, but I find that titles always distract from the smooth running of
any screen saver or slide show. Leave 'em in if you like. The last item to set is
password protection. This will be valuable for those members of the CIA who
are designing screen savers of Momar Khadaffi's hideouts, so the rest of us
normal people can probably skip this option. Click OK and you're ready to
enable the screen saver.

Creating Cross Platform Screen Savers with After Dark

PhotoWorks Plus provides image enhancement and "gateway" capabili-
ties in addition to merely generating screen savers, but if you're a Macintosh
user or are using another Windows-based image enhancement program,
one of the least expensive ways to create screen savers is by using Berkeley
Systems' cross-platform After Dark software package. And best of all, the
product has a street price of under $30.

If you're one of the few people in the computing universe who hasn't
heard of After Dark, let me introduce you... Berkeley Systems' popular
package consists of 30 animated screen saver displays, such as the leg-
endary Flying Toasters and Fish Tank modules, but the one that
pixographers will be most interested in will be the Slide Show module. As
with PhotoWorks Plus, you need to do some preliminary work before cre-
ating your screen saver. Instead of an "album" of images, you'll need to
assemble a folder or directory of images. For Macintosh users this requires
assembling a group of photographs in PICT format. Windows users can use
BMP, RLE, TARGA, PCX, or GIF files.

Let's make a slide-show-style screen saver using images from Photo CD
and After Dark.

> Step 1: I started by making a "Slides" folder to store the images that
> would be used in the slide show. While you can use an enhancement
> program to open and convert Photo CD images into an acceptable

FIGURE 10-16:
Before creating a slide show, Kodak's Access Plus is used to convert Photo
CD files into PICT format for use in the Mac version of Berkeley Systems' After Dark.

format, a less expensive method—keeping with After Dark's low
price—is to use Kodak's Access Plus software. After launching the
program, I loaded a Contact Sheet to see the images on the disc.
Then I clicked on one of the images of a dinosaur to select it and
chose Export from the file menu. This brought up the Export dialog
(see Figure 10-16) that let me select the number of colors in the
image, its resolution, file format, and finally the location where I
wanted it placed. In this case, I put it in the previously created
"Slides" folder. Choice of resolution is important because it will ulti-
mately determine how large the image will be displayed on your
screen; it's based on how big you would like to see the image and
what your screen size is.

FIGURE 10-17: After creating a folder/directory full of properly formatted images, open After Dark's Control Panel and select Slide Show.

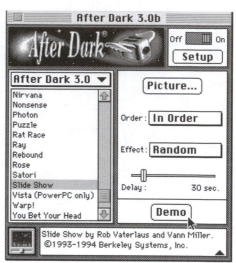

■ Step 2: The next step to create your personalized screen saver is selecting the After Dark Control Panel and choosing the Slide Show module. (See Figure 10-17.)

■ Step 3: Clicking the Picture... button (Slides on the PC version) allows you to select the folder/directory containing your images. (See Figure 10-18.) In case you're wondering, your folder/directory of Slides/Pictures can have up to 128 images, which should be enough for even the most diehard screen saver fanatic.

FIGURE 10-18: The Picture... (Slides on the PC) button brings up a dialog that lets you select the folder/directory where your slide show images are stored. If the file format includes a thumbnail (PICT doesn't) it will display them too.

Step 4: Once the images have been selected, you can use the pop-up menus on the Control Panel to set the various functions of the slide show. The Order menu lets you show the images in alphabetical or random order. The Effects menu gives you your choice of the transitional effect used between the images as they appear. Choices include Cut, Radial, Wipe, Split, Blinds, Checkers, Bars, Fade, Dissolve, and Random. The last thing to set is the Delay between images. This is accomplished by moving a slider.

Step 5: Just like a "real" screen saver, Berkeley Systems provides a Demo button to let you tweak all of the Step 4 adjustments to make sure you're happy with the final appearance of your screen saver. After that, you can treat your personalized screen saver just like any other After Dark module.

The True Test

To many, the real test of a digital image is what it looks like in printed form. To find out what kind of printer will produce the kind of results a photographer will be satisfied with, read the next chapter.

COLOR MANAGEMENT AND COLOR OUTPUT

In this chapter, we'll look at three topics that relate to output: color management, photo-realistic printers, and film recorders. This chapter emphasizes desktop solutions—output that can be completely controlled by a single user. For that reason, the three different printers discussed are not the only photo-realistic printers that are available—far from it. What the three printers have in common is that they provide the highest quality at the lowest price for the image format that they output. Some pixographers are interested in having film be the final product of their labors, but film recorders can get expensive—there are *no* low-cost solutions—and color management can be tricky. Which brings us back full circle to color management. What is it and why do you need it?

Color Management

Color management problems are not limited to computer-based imaging. You've probably already encountered difficulties managing color if you've ever shot any color negative film. Remember when you looked at the contact sheet, proofs, or prints from that important roll of color negative film? If you looked at the prints and complained that they were "too light" and "that wasn't the color of that car I photographed—it was much greener" you have already run into the reason that you need color management.

Those same problems happen with your computer imaging system for reasons similar to what happens when color negative film is processed and printed. There are two basic reasons why you may be unhappy with the output from your digital image.

How Devices Reproduce Color

Every output device has a range of colors that it can accurately reproduce. This range is called the *gamut* of the device. Every device from every manufacturer, whether it is a monitor or printer, has a unique gamut. Each device's gamut is part of a standard area of color science called "color space," and different types of devices work in different color spaces.

Because of the way they are designed and constructed, monitors, for example, work in a different color space than printers, and this creates part of the problem that is color management. If you find that the output of your color printer doesn't match what you see on screen, you are beginning to understand the need for color management. The reasons for problems are that the color on the display is "in gamut" for the monitor, but not for the printer. And the problem is compounded by the fact that the gamuts of desktop devices, like film itself, are relatively small when compared to the spectrum of visible light.

How Devices Communicate or Don't

The other problem about precise color management has to do with the way that computer peripherals communicate with one another. The predecessor to desktop color management existed only in dedicated, computerized systems used by printers called *color electronic publishing systems* or CEPS. Many

of the new desktop imaging hardware and software products are manufactured by different companies and none of them communicate in the same color language.

Color Management systems that solved these problems were developed for desktop use. Shortly, I will introduce you to several of them, but before that I'll provide an alternative that I call...

Common Sense Color Management

Many of the devices you already own have some degree of color management built into them. You may discover that all you really need to do to minimize "out of gamut" problems is to make sure that you've done all you can to maximize their color management controls.

Monitor Setup

One path to common sense color management is to take advantage of the color tools already built into your image enhancement software. Take Adobe Photoshop, for example. This program, among others, has a Monitor Setup option in its Preferences menu. (See Figure 11-1.)

This lets you set the Gamma, White Point, and Phosphors for your specific monitor. If you're not familiar with these terms, here's a quick overview:

FIGURE 11-1:
Adobe Photoshop's
Monitor Setup option
is located under the
Preferences menu.

■ Gamma measures the contrast that affects the midlevel grays (the midtones) of an image. Adjusting the gamma lets you change the brightness of the middle range of gray tones without affecting the shadows or highlights. Gamma for your particular monitor can be adjusted by the Gamma Control Panel that Adobe includes with the Mac version of Photoshop. (See Figure 11-2.) The PC version has a Calibrate function built into the Preferences submenu.

■ White Point, sometimes called the *Highlight Point,* is one of the end-points on a curve (the *Shadow Point* is the other) that defines the dynamic range of the photograph. (For more on Dynamic Range, see Chapter 4.) Adobe suggests the default of 6500 degrees Kelvin.

■ Phosphors are the different colored (red, blue, green) dots used by different manufacturers in their monitors. The pop-up menu contains all of the common phosphors used by CRTs, but there is an optional menu that lets you set the specifics for your monitor.

Don't let all this techno-speak scare you. Many of the available monitors already are included into the pop-up Monitor menu in the Monitor Setup

FIGURE 11-2:
The Gamma Control
Panel included with
the Mac version
of Photoshop.

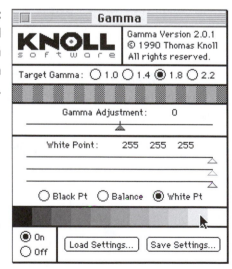

Option, so all you have to do is select your monitor from the menu, and data in all three of the above categories will be entered.

But what if your monitor's not one of them? That happened to me recently when I purchased a new NEC XE15 monitor. It was nowhere to be found in the Monitor Setup Dialog, so I called NEC customer support and they provided me with the data I needed. Remember that this data, along with all of your preferences, is stored in a separate Preferences file. When you install a new version of Photoshop, it automatically writes over your "Prefs" file, destroying all the data in it. It's more than a good idea to back this file up onto a floppy disk so you can reinstall it when installing any new version of Photoshop.

Some programs force you to set up your monitor when you install them. A good example is Inset System's HiJaak Graphics Suite for Microsoft Windows. While installing it, you will be given two dialogs that will let the software match your monitor. This is the opposite of the approach that Adobe has taken which matches the monitor to the software. Before completing the installation of HiJaak Graphics Suite, you will see the following two dialogs:

▨ Display Type: This dialog displays twelve different versions of an image of a red rose. (See Figure 11-3.) All you have to do is pick the one that looks the best.

▨ Color Calibration: This dialog provides four sliders and four color panels for red, blue, green, and 18 percent gray. (See COLOR PLATE-15.) Inside each color panel is a color section controlled by the sliders. You move the sliders back and forth until the color in the center of the panels matches the color of the color surrounding it. If you do a good job on the three color panels, you won't have to adjust the gray one. It will automatically change as you tweak the red, blue, and green sliders.

COLOR PLATE-15: The final step in installing HiJaak Graphics Suite is the Color Calibration dialog that lets you adjust sliders to match your system's color capabilities to the one built into Inset System's software.

FIGURE 11-3:
As part of the installation of HiJaak Graphics Suite, the installer presents you with a dialog showing 12 versions of a red rose. This sets the software for your system's graphics hardware and, in a triumph of interface design, you don't even have to know what it is—just which picture looks best.

Printer Setup

There is another simple way to insure that the color you see on screen matches the output. Look at all of the options in your Print or Page Setup dialogs that are part of the drivers supplied by the printer manufacturers. Here're some examples based on two of the printers that will be featured later in this chapter.

■ Fargo Pictura 310: The driver for this 12x20-inch dye sublimation hides its color management choices under an Expert button in the

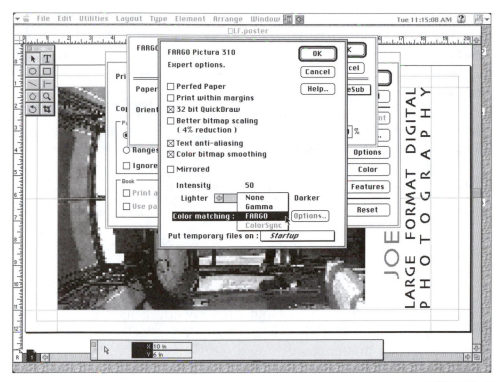

FIGURE 11-4:
You really don't have to be an expert to use the Expert option in the Print dialog
used by the Fargo Pictura 310 dye sublimation printer. In addition to text anti-aliasing
and other options, the dialog provides for your choice color matching software. Unless you
are using a dedicated color management system, I urge you to select the "Fargo" option.

Print dialog. (See Figure 11-4.) In addition to None and Fargo, the
Color Matching pop-up menu will display any "official" color man-
agement software installed. The default is "None." If you have no
other color management option, please select "Fargo" for reasons
I will explain shortly.

▪ Fargo FotoFun!: This snapshot-size dye sublimation printer has a simple
print dialog box, but make sure you check the "Fargo Color Match" box.
(See Figure 11-5.)

FIGURE 11-5:
The Print dialog for the Fargo FotoFun! dye sublimation printer has few options, but check the "Fargo Color Match" box or all of the color tweaking you do with your image enhancement program will be wasted.

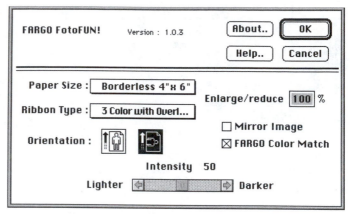

These are just a few examples, but I think you get my drift; check the Print or Page Setup dialog associated with the driver delivered with whatever kind of color printer you use.

Test Strips for Your Printer

You remember making test strips in the darkroom, don't you? For darkroom neophytes, a test strip is a small sheet of photographic paper that is placed on your print easel to make different exposures on—as you block part of the strip with a piece of black cardboard—so that you can see the effects of different exposures, contrast, or color filters on the image.

One of the best ways to home in your color printer is to create your own tests strips and analyze the results. One Windows-based program, DeltaPoint's Graphics Tools, has a test strip function built in; other users will have to make their own using a process similar to the one below for programs like Adobe Photoshop.

> ▩ Step 1: Make sure you have correctly set up the monitor and printer, then make a print of a photograph that has a wide range of colors in it. Then, critically evaluate the print for color balance. In the case of my first print from the Fargo Pictura 310, it looked slightly green.

■ Step 2: Color shifts are easier to evaluate with a black & white print because you won't be misled by any color information in that part of an image. You will be looking for neutral blacks, grays, and whites, with no trace of other colors. That's why it's a good idea to run this test with a black & white image. So, open a black & white photograph or a color image in grayscale mode using the Metric pop-up menu in Kodak's Photo CD Acquire menu.

■ Step 3: Use the Mode menu to convert the grayscale image into RGB. I know this sounds backwards but in order to apply color corrections you need to have a "color" image—even one that's really black & white.

■ Step 4: Use the rectangular selection tool (the marquee) to select a vertical strip of the photograph, much as you would have selected a small area to appear on your test strip in the darkroom. Using the Variations dialog from the Image/Adjust menu, set the slider all the way to the left—the lowest setting. Since my print was too green, I added one "click" on the slider on the Red variation.

■ Step 5: Repeat the above step by selecting another strip next to the previous one, calling up Variations, and adding two "clicks" of red. Then repeat it again, each time adding a new strip and additional red. (If your photograph is too magenta, you will be gradually increasing the amount of green. In short, you want to add the complimentary color to the color you have too much of.)

■ Step 6: Print the test image and evaluate it. The reason for using a black & white image will now be apparent. The colored strip you are looking for is the one that is the most neutral in color. In evaluating my test, the strips varied in color from a cyan on the left to a deep reddish brown on the right. The most neutral area was two steps in. So to make my black & white and color prints neutral, I have to add two "clicks" of red before I print them on the Pictura.

Color Management Systems

Author's Note: The following brief introduction is not meant to make you an expert in color management. This is a sufficiently large subject that would require

a book larger than this to do it justice. This section is included to introduce you to the topic, and provide a few details on some of the products available.

Color Management Systems (CMS) is software that helps you produce accurate and faithful reproduction of your original color images. A good CMS must address two major aspects—calibration and characterization—and all successful systems must include both of them.

■ Calibration stabilizes the inevitable variables in the way any device reproduces color. All kinds of variables—including your working environment—can affect the way a device is calibrated. To produce optimum results, all of your color-reproducing devices must maintain a consistent, calibrated state. A variety of calibration products are available depending on the device and manufacturer. For example, LightSource offers a monitor calibration tool called the Colortron for Macintosh systems that establishes a baseline to keep colors consistent throughout the reproduction process.

■ Characterization establishes the relationship of your calibrated device to what is referred to as a "device-independent reference color space" or RCS. This "color space," which you can think of as a Mr. Rogers' Neighborhood where all color devices get along, describes how a device reads, displays, and stores color values. Photo CD devices, for example, store color in a format Kodak calls YCC. This is data that was originally RGB but has been transformed into one part of what scientists call luminance but the rest of us call brightness (this is the Y component) and two parts (the CC) of chrominance or color and hue. This system keeps file size under control while maintaining the Photo CD's "photographic" look. Monitors display color in the RGB color space. In the device-independent reference color space, both Photo CD and the monitor share a common basis in color.

There are different color management systems available that work with both Macintosh and Windows platforms. Here are two popular ones.

Kodak Precision

Next to Crayola, if you can't trust Kodak to get the colors right, who can you trust? Kodak is a member of the International Color Consortium (ICC), a group of eight of the largest manufacturers in the computer and digital imaging industries. The consortium works to advance cross-platform color communications and has established base-level standards and protocols in the form of the ICC Profile Format specifications, to build a common foundation for communication of color information.

Kodak's cross-platform Precision Color Management Software is really a framework that allows users or third parties to create device profiles, called Precision Transforms, or PTs, for any scanner so that users spend less time color correcting and more time working with their photographs. The software also creates PTs for converting Photo CD images to any Kodak color-managed application. There are many optional packages that extend the use of Precision. The Color Printer Profiles Pack includes Device Color Profiles for 16 popular color printers and is expected to be updated regularly to add new printers to the package. Other add-ons include:

- CMYK Pro-Pack: Contains six generic CMYK device color profiles.

- Device Color Profile Starter pack for Adobe Photoshop: Contains software that automatically converts Photo CD images to CMYK for optimal color matching to the original. This is important because each time you make a color space conversion, there is some loss of data. By converting Photo CD images directly into CMYK, a more accurate color match is possible.

- Kodak Peripherals Pack: Contains profiles for a variety of Kodak-labeled devices including their printers. These profiles are used by the Precision Color Management System when outputting images to a Kodak device.

Kodak is encouraging the use of Precision by bundling it with popular programs, including the latest versions of Adobe PageMaker and Photoshop for the Macintosh and Windows and Micrografix' Picture Publisher for Windows.

Apple ColorSync

Apple is spreading the use of its Mac-based ColorSync color management system by including it with system software and updates to system software. One of the main features of ColorSync is ease of use for Mac users. Some of its features are:

- Color Matching Method (CMM): This is a routine used by a color management system to apply transformations to color data. Apple's CMMs transmit color information between documents and have been designed to be compatible with other companies' CMMs.

- ICC compatibility: ColorSync supports all profiles that conform to ICC profiles specifications, allowing the same device profiles to be used across multiple platforms.

- Postscript support: Postscript is a page-description language used to communicate page layout information from the computer to the output device.

- Support for more than four-color devices: ColorSync supports devices that use more than the standard process colors, such as Hi-Fi color printing. Hi-Fi color uses more that the basic (Cyan, Magenta, Yellow, Black) colors in the printing process to produce more vibrant color.

There is some competition for a "standard" in color management systems but as long as you are consistent with the one you use and with the one used by your service bureau (see Chapter 12), you should have no problems. The biggest question is if you need a color management system at all. If you are a designer or advertising photographer, you must have some kind of color management system in place. If you're not, you may or may not need one. Before investing in a CMS, try some of the tips in the Common Sense Color Management System. If these tips work, you're all set. If not, take a look at the Kodak Precision and ColorSync systems or find an alternative. For specific advice on what color management system will be best for you, consult your service bureau and a friendly printer. Remember these are the people that will have to deal with your digital files, and they have a lot of experience in what works and what doesn't.

 # Three Easy Printers

In this section we'll look at three printers that will bring smiles to pixographers' faces as well as their wallets. First, we will examine the Epson Stylus Color, an 8.5x11-inch printer that delivers true photo quality with a street price around $500. Next, we'll see the Fargo Pictura 310 dye sublimation printer that can print up to 12x20 inches with a street price just under $4000. Finally, there's Fargo's FotoFun!, a 4x6 snapshot-sized printer that delivers high-end quality for a price tag under $400.

Epson Stylus Color

Shortly after the Epson Stylus Color ink-jet printer was introduced, I started getting e-mail asking about it. Most of the buzz had to do with the price and performance of the printer. Here was an ink-jet printer selling for less than $600 that claimed to produce photo-realistic results. Unlike its competitors, the Stylus Color's piezoelectric technology uses mechanical vibrations, instead of heat, to fire ink onto paper. Instead of the thermal approach favored by Canon, Apple, and HP, the Stylus Color places more uniform, consistent ink droplets and can deliver up to 720 dots per inch (dpi) resolution on specially coated Epson paper. It will also print text and color images at 360 dpi. (See Figure 11-6.)

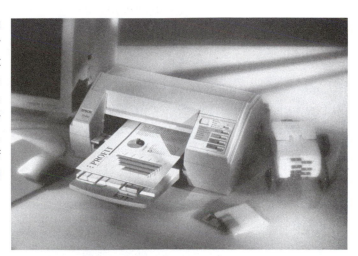

FIGURE 11-6:
The Epson Stylus Color is an ink-jet printer that uses piezoelectric technology to produce photographic quality output at up to 720 dpi. (Photo courtesy of Epson America)

Unlike some color ink jet printers, the Stylus Color uses two ink cartridges: one for black and one for Cyan, Magenta, and Yellow. This means if you print a lot of text or black & white photographs, you will have to replace the black cartridge more frequently than the color cartridge. Other ink jet printers mix all three colored inks and produce a muddy black.

Street prices for the black ink refills are about $17, with the color cartridge going for about $35. Other consumables, like 720 dpi paper, costs $25 for a 200-sheet ream. The paper tray holds 100 sheets of paper, 50 transparencies, or 10 envelopes. The Stylus Color is compatible with Macintosh and IBM-PC and compatible machines and has both serial and parallel ports built in. For the PC, four scaleable fonts and five bitmapped fonts are built in. On a Mac, the Stylus Color worked with every TrueType and PostScript font I threw at it.

Using the printer is simple. All you have to do is install the driver software on your Mac or PC and run a few set-up routines. These routines are used to make sure the color and black heads are properly aligned. It takes about ten minutes to run the tests. Once completed, the heads are aligned, and it's a matter of using the Print command. When you do, you'll see a dialog that includes an option box that allows you to print at 360 or 720 dpi in color or black & white. The dialog also asks what kind of paper you're going to be using.

For non-photographic applications, the Stylus Color easily handled every kind of paper or label I tried, but for printing color photographs the best results were achieved using Epson's own 360 or 720 dpi paper. I have a friend who's trying to find a less expensive alternative to the Epson paper, but every time I do a side-by-side comparison of the latest paper, he's discovered, the Epson product beats it hands down.

But what you really want to know is how well the Stylus Color prints photographs. Using images from Photo CDs and scanned by my Nikon Coolscan, I tried printing images at both 360 and 720 dpi. The 360 dpi output looked pretty good—until I compared them with the same shot printed at 720 dpi. The big advantage of printing at 360 dpi is that it is much faster than printing at 720 dpi. Working with a 2048x3072 pixel Photo CD file adjusted to print at approximately 4x6 inches, it took about four minutes to print at 360 dpi. The same image printed at 720 dpi took almost 22 minutes.

Keep in mind that printing times will depend on the resolution of the original image, the size of the print, and the amount of RAM and the speed of the computer you're using. I tested the Stylus Color on two different Macintosh models, a Mac IIci and a Power Macintosh 8100, and the times given are those when connected to the IIci. On both machines, the Stylus Color performed flawlessly with the Power Mac producing noticeably shorter print times. This was helped by the introduction of a driver in native format.

In general, the printed image represented the on-screen color of the image pretty well, but my experience showed that having the ability to view a photograph at 24 bits makes a big difference. When viewed on an 8-bit system, the color balance on some images seemed slightly warmer at 360 dpi than the on-screen image, and slightly cooler at 720 dpi. When viewed at 24 bits, the printed and on-screen images are much closer in color balance.

Paper Can Make a Difference

When compared with a print made on a dye-sublimation printer, the output from the Epson Stylus Color, while it looks like a photograph, doesn't feel like one. Keep in mind that a dye-sub printer will cost anywhere from $1000 to $6000 more than the Stylus Color and cannot function as a general purpose printer.

Unlike a dye sublimation printer, which uses one specific type of paper stock, Epson offers three for the Stylus Color. Both the 360 and 720 dpi Epson paper have a semi-matte finish and are somewhat on the thin side. Recently, they have begun offering a Glossy paper that produces impressive results. One of the problems with the paper is that it is expensive. Epson Glossy paper has a list price of $60 for a 30-sheet box. Consequently, not all computer outlets that sell the printer stock the Glossy paper stock. Many of them do stock the Hewlett-Packard Premium Glossy (C3833A) paper that is less expensive but is still not cheap.

The results I have seen from printing high resolution Base*64 (4096x6144) Pro Photo CD files with the Hewlett-Packard Premium Glossy were impressive. In the examples I saw, the original images were from medium- and large-format negatives that produced 80MB files able to take advantage of the printer's ability to print at 720 dpi.

When I talked with Epson America about using Hewlett-Packard's Premium Glossy paper with the Stylus Color, they told me that Epson users will get even better results with their new glossy paper, while H-P users should get better results with Hewlett-Packard's glossy paper. The reason for this is that the inks in the both printers are formulated to match the papers used in them. Remember, H-P ink-jet printers use thermal technology in their head designs, while the Epson features a piezzo electric design. Since the Epson printers sprays less ink than the H-P, it should have some bearing on the paper design.

In comparing output from the two papers, the Epson paper seems smoother and slightly more glossy but for reproduction use, you would not be able to tell which was which. Whatever paper you decide to use, make sure you have the current Epson driver software that includes a setting optimized for glossy paper. For an example of what the output of the Stylus Color looks like, take a peek at COLOR PLATE-16.

COLOR PLATE-16: This photograph of a Brachiasaurus was made at the Utah Field House in Vernal, Utah on Kodak slide film and digitized using Photo CD. The largest resolution image was printed on the Stylus Color using Epson's Glossy paper.

The Stylus Color features everything you could want in a general purpose ink-jet printer and photo realistic output, at a price tag that I have seen advertised as low as $499. As the beer ads say, "it doesn't get much better than this."

Picture Perfect Printer

The Fargo Pictura 310 dye-sublimation printer has 300x300dpi resolution and delivers continuous tone, photo-realistic 24-bit color or 256-level black & white prints, as well as fast wax thermal color proofs. The printer can print photographs as large as 12 inches wide by 20 inches long. (See Figure 11-7.) The Pictura plugs into the Centronics parallel port of your Windows computer, and Fargo supplies a NuBus interface board for Mac users. Installing the parallel interface is a snap and gives you two printer ports, so you can continue to use whatever laser or ink-jet printer you use on a daily basis.

And in an age when everything seems to be made offshore, the print engine for the Pictura 310 is made in the good old USA. At $4995 list price (often dis-

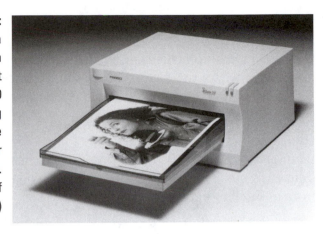

FIGURE 11-7:
Fargo's Pictura 310 is a 300 dpi dye-sublimation printer that can print images up to 12x20 inches in size, making it ideal to create mini-posters for promotional purposes. (Photo courtesy of Fargo Electronics)

counted to just over $3000), the price tag may seem a little high until you realize that, up to this time, dye-sublimation printers capable of this size have typically cost $15,000. The consumables are similarly priced for professional or serious photography. Fargo sells the 12x20 dye-sublimation material as a kit containing 100 sheets of paper and a thermal ribbon, at a price that works out to be $6.59 per print.

Installation of driver software takes only a few seconds, and while the instructions for setting up the printer leave something to be desired in clarity, there are two important tips. First, to avoid creating splotches or blobs on your prints later on, handle the ribbon by the edges. Second, after placing the paper in the tray, make sure the side and back printer guides are snug. This is especially important to maintain registration because the Pictura makes four passes—once for Cyan, Yellow, Magenta, and Black—of the paper when it prints an image in dye-sublimation mode. The first is through the yellow portion of the ribbon, the second through the magenta, the third through the cyan, and finally the black layer is printed. Keeping the paper flat makes sure that the four passes are in perfect registration, and during the time I had the printer, I never had any serious registration problems.

The big question of course is "how good is it?" The Pictura prints faster in wax thermal mode than it does in dye-sublimation mode, but the quality of the output suffers when compared to the dye-sub mode. (Like the Stylus, the first step in printing—rasterizing the image and saving it to disk before

printing—is the slowest part of the process.) Since wax thermal material is less expensive and the process faster, it's great for a quick proof. You can also use wax thermal to make transfers for T-shirts or ceramic coffee mugs. This is one area where the Picture really shines, since it can print up to 12x18 T-shirt transfers.

My next step was to challenge my custom lab to a "print off." I gave them an original transparency of an image I already had on Photo CD and asked them to make an 8x10 print from it. They responded by printing it three different ways: Type R, Type C from a 4x5 Kodak internegative, and Type C from a 4x5 Fuji interneg.

The first print I made was completely unmanipulated. Since it was a little green, I applied two clicks of Magenta from Photoshop's Variations filter. Next I used Unsharp Mask to tweak the image's sharpness and increased the contrast—all of which was visible on my monitor. No burning or dodging was done.

Here's how the Fargo output stacked up against the lab prints: All of them were acceptable and if I was paying for them I would be satisfied. The type R was the best. It was the sharpest and most neutral in color balance, but I felt the sky and water were dull—especially when compared against the Fargo print. The C print from the Fuji internegative was too yellow and not as sharp as the Type R or Fargo print. The C Print from a Kodak internegative was warm and was in between the Type R and Fuji internegative in overall quality. The final result was that the Fargo print was as good, maybe better, than the best lab print. And yes, the lab manager agrees with me. The Fargo dye sublimation print is shown in COLOR PLATE-17.

COLOR PLATE-17: This is the print used in the "print-off" that compared a commercially produced print made from a slide to one produced with the Fargo Pictura. In every way the quality of the Fargo dye-sub print was a good as a commercial silver-based image.

◗ But How Long Will it Last?

When assessing the quality of printer output, pixographers appear to be divided into two groups: The first is looking for an inexpensive printer that can deliver quality results. At this time, the Fargo Primera Pro (the 8.5x11-inch mode) and Pictura printers are the best available solution.

The second group is composed of photographers who want to be able to include "acceptable" looking photographs in their correspondence and newsletters. This second group will love the Epson Stylus ink-jet Printer.

Remember the dye-sublimation process was originally designed as a proofing media, not to be the final product. According to Fargo, dye sublimation prints will not last as long as a properly processed color prints, but other than dye-transfer prints, most conventionally processed silver-based color prints have a limited life too. Dye-sublimation prints should have a long life, but like video tape, no one has yet done a definitive archival study. Deterioration of the image and color is mostly caused by exposure to UV radiation. The best advice is to store the print properly (cool, no direct light) and place it under UV protective glass. This glass, available at many framing shops, can reduce 99 percent of UV emissions. Yes, it is expensive. Also be sure to save a back-up of the digital image using Photo CD or similar storage media.

PhotoFun! Makes Printing Fun

It's a fact of life that while dye-sublimation printers provide the most photo-realistic output, they are also the most expensive. Fargo Electronics has managed to break the price barrier with its new PhotoFun! dye-sublimation printer which has an average street price of $399. The PhotoFun! breaks the dye-sub price barrier by limiting the maximum print size to a snapshot-sized

FIGURE 11-8:
The toaster-sized and bargain-priced Fargo FotoFun! is the lowest priced dye-sublimation printer available and prints high-quality 4x6-inch snapshot sized prints. (Photo courtesy of Fargo Electronics)

4x6 inches. PhotoFun! is a compact printer that has a small footprint measuring approximately 7x9.5 inches and resembles (to my eyes anyway) Polaroid's Power Processor for its instant 35mm Polachrome and Polapan films. (See Figure 11-8.)

PhotoFun! uses a three-color (CMY) ribbon that also has a fourth component that provides a clear UV coating to protect the prints from finger prints and moisture. The printer comes packed with a 36-print ribbon and 36 sheets of paper. Installing the ribbon is no big deal, and there's even a diagram inside the printer that shows you how. Wondering where you install the paper? Paper is fed in one sheet at a time, and the driver tells you when to insert it. (More on that later.)

The compact manual includes information for connecting the PhotoFun! to either Macintosh or Windows computers. Installing the software driver as well as the ribbon and paper is straightforward. Connecting the printer is also simple: On the Macintosh version, you plug in a printer cable from the serial port (labeled printer or modem) on the back of the computer and connect it to the printer. If you want to have more that one printer connected, you might consider an A-B box that will let you switch between the PhotoFun! and your "regular" printer.

The only false note in setup is the chunky external power supply that takes up a lot of space on your floor. At least Fargo didn't make it a plug-in design. Otherwise it would cover your entire power strip. The upside is that the power supply is designed to work in any country from the US, Japan, Europe, and Australia.

Now that we're all set up, let's make a print:

- Step 1: Open your favorite image processing program, load a digital image, then open the program's Page Setup from the File menu. For such a small printer, the information shown in Page Setup gives you control over how the image will be printed. You can set the page orientation, paper size, ribbon type, and color density. (See Figure 11-9.)

- Step 2: To print your image, select Print from the File menu, click the minimalist Print dialog and the PhotoFun! starts to work. The first step is a rasterization process that converts the file into printable form and saves it to disk. I though that it would take longer with bigger files, but both 1MB and 6MB files took about the same time to

FIGURE 11-9:
The driver that Fargo includes with the FotoFun! enhances the standard Page Setup dialog (in Photoshop) to let you set the page orientation, paper size, ribbon type, and color density.

FIGURE 11-10:
The "bare bones" Fargo FotoFun! print dialog.

rasterize. The Fargo FotoFun! Print dialog is bare bones. If you've done everything correctly in Page Setup, all you have to do is make sure that the RGB button is clicked and click the OK button. (Even though you are printing from a CMY ribbon, the image is an RGB one as seen on your monitor.) (See Figure 11-10.)

- Step 3: While this is going on, a dialog displays which percent of the rasterization is complete. It gets to 99 percent in just a minute or so, then you wait for 100 percent to appear. When the printer's internal rollers start to spin, insert the paper—glossy side down—and wait. It takes just a minute or two for the completed print to roll out. (See COLOR PLATE-18.)

COLOR PLATE-18: This Base*16 Photo CD image was opened in Photoshop, and a 100 per-cent Unsharp Mask was applied. The cropping tool was used to focus the attention on Mary Farace and her bear friend. Finally, the Image Size menu was used to resize the image to 4x6 inches, which resulted in a 6MB file that printed in just a minute or so on the Fargo FotoFun!

Output quality from this little 203 dpi printer is impressive, but keep in mind the old computer adage Garbage In Garbage Out. When 18MB Photo CD files were sized to 4x6 inches, reducing them to 6MB, the quality of the output was superb. Some 72 dpi GIF images I tried were acceptable but far below that from Photo CD. Print quality, from good scans, is as good as you will get from the neighborhood minilab, and it take less time to make a print with PhotoFun! than it takes to drive to your local film processor for reprints.

In addition to snapshots—you can also print two 2x3-inch wallet-sized photos on the same sheet of paper—Fargo offers an optional photo post-card kit ($39.95 for 36 prints) that uses a heavier weight media that is preprinted with the appropriate address and postage indicators on the non-image side. You can print a photo on the image side, write a "wish you were here" message on the other, and drop the card in the mail. The optional FotoMug kit ($29.95) includes four mugs and a tool that allows users to transfer images printed by PhotoFun onto the mug's surface. And the trans-ferred images are permanent and dishwasher safe.

A Brief Look at Film Recorders

This overview of color film recorders (CFR) is included because many photographers are interested in creating their own digital 35mm slides or negatives.

All desktop film recorders work in essentially the same way: A camera is enclosed in a small box and is focused on a very high resolution black & white monitor. It makes three exposures of the image, each through sepa-rate red, blue, and green filters to produce the final image. If this sounds slow to you—it can be.

In reality not many photographers actually purchase or use film recorders. One of the reasons is they have typically been designed to meet the needs of people producing slide presentations and not photographers. The image-making needs of these two groups are quite different, and pre-senters are less inclined to go ballistic if a photograph used in a chart is slightly off-color than the typical photographer. Remember also that a film recorder introduces two more variables into the color management stew: the emulsion of the film used and how that film is processed.

Here's a test: If you are one of those photographers who have used slide duplicators from companies like Pentax, Bessler, and Bogen to make slide dupes and enjoy working with various filters and contrast reduction methods to produce the "perfect" dupe slide, you're ready for desktop film recorders. In truth, working with a film recorder is easier than using a slide duplicator but a similar mindset is required.

A Few "Rules of Thumb"

To help you evaluate which kind of Color Film Recorder you should get, here's a few "rules of thumb:"

- Select a CFR that offers *at least* 24-bit images and 16 million colors and has 4000 lines of resolution. This way the output will have excellent clarity and sharpness with smoothly ramped continuous tones and accurate color.

- Match the film recorder to your budget. Slides generated with in-house film recorders typically cost, according to The Hope Report, about 55 cents each, with the cost of the CFR amortized over two years. Service Bureau slides, while they have an oft-quoted $6 per slide cost, have an actual cost of $29.18, again according to the latest Hope Report. (Most of this cost difference is due to problems with the submitted files which are usually the results of the user's unfamiliarity with the creating application or an attempt to use as many features of the presentation program at the same time to produce "creative" slides. This results in having to have the same slide remade several times in order to achieve acceptable results, doubling and even tripling the cost of making that single slide.) You need to balance your needs with the cost of the film recorders, which start at $6000 and go up from there.

- Choose a CFR that is compatible with both Mac and Windows, as well as providing network support. This will make it easy for you to adapt to a new system if you decide to change platforms or choose to sell the film recorder at some time. At the same time, make sure the CFR has true "plug and play" capabilities to make it easy to install and operate, as well as portable.

■ Make sure the film recorder has a removable film back. This will give you the flexibility of using 35mm slide or negative film, as well as using sheet film or Polaroid back—for an instant proof.

■ Lines vs. Pixels

It is common in film recorders to express resolution in terms of lines of resolution instead of pixels. This is a term left over from television but is, in practice, the same as pixels. The most common resolution for desktop film recorders is 4000 lines and all the pixel counters out there may be asking if that is enough. One of my *Shutterbug* readers with a background in broadcast television did a test I would like to share with you. "I've scanned slides taken with a Nikon F4 with a Microtek 35T film scanner at a resolution which produced a 7MB image and then output the same image back to 35mm slide film with a Polaroid CI-5000 film recorder at 4000 line resolution. When the two slides are projected sequentially with an image diagonal of 5 feet at 15 feet from the viewer, the difference between the input slide and the output slide is slightly more than a 'just noticeable difference,' but only slightly. I don't think the difference would be obvious if the viewer couldn't see the slide change. The implication, to me, is that something a little over 4K horizontal resolution would be usable for most practical applications."

Here's a quick look at three popular desktop film recorders:

Lasergraphics

Lasergraphics is know for high-quality, no-nonsense film recorder design and construction. The 36-bit LFR Mark II is a 4000-line recorder and the 36-bit Mark III does an impressive 8000 lines. (See Figure COLOR PLATE-19 for an example.) Out of a 69-billion-color palette, the CFRs deliver 16.8 million colors. Both models are networkable, cross-platform, and have a special CRT which eliminates the "haloing" effects that can show up in images made on negative film. Imaging speed is quick too. The Mark II can create a 4000-line (4096x2731) slide in 1 minute and 20 seconds, while it takes the Mark III just under 5 minutes to image an 8000-line (8192x5262) slide. Both models have built-in rasterization capability so that the film recorder does the work instead of tying up your computer. In addition to 35mm, backs are available for 120/220 film in 6x7 cm format, 4x5

sheet film, as well as a Polaroid back for making test shots. List price of the Mark II is $14,995 and the Mark III costs $19,995.

COLOR PLATE-19: This image was created on a Lasergraphics LFR Mark III film recorder at 8000 lines of resolution.

Mirus

Mirus was one of the first, if not *the* first, manufacturer of desktop film recorders, and the FilmPrinter Turbo II is their latest in a line of products aimed at both presenters and photographers. It's called the Turbo for a good reason—it images a 36-bit slide in 70 seconds. The FilmPrinter Turbo II has user-selectable resolutions of 1000, 2000, and 4000 lines at 16.7 million colors. The Turbo II accepts all 35mm film stocks. Because of the internal camera's design, it allows you to squeeze 26 usable exposures out of a 24-exposure roll. The film recorder has both SCSI and parallel ports built in, making it compatible with both Mac and Windows computers. The list price is just under $7000.

Polaroid

Polaroid's HR-6000 film recorder (See Figure 11-11) is a 24-bit CFR that creates images using a proprietary 33-bit (11-bits per pixel) color exposure process to produce smooth continuous tones up to 16.7 million colors. The

FIGURE 11-11: The Polaroid Digital Palette Color Film Recorder, the HR-6000, is a cross-platform product capable of creating analog images in different film and print formats (Photo courtesy Polaroid Corporation).

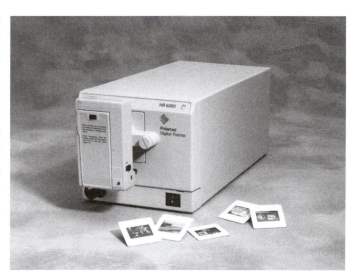

HR-6000 has optional backs including 35mm film and (not surprisingly) Polaroid instant prints in two sizes and a 4x5 sheet film back. This enables the film recorder to support more than 20 different film types. The CFR is compatible with both Macintosh and Windows computers and has a list price just under $6000.

There will come a time when you will want film output and you are not yet ready to make an investment in time and money for your own film recorder. When that day comes—and it will come—that's when you will need the services of, yup, a service bureau. To find out the why, where, and how of working with service bureaus, see the next chapter.

SERVICE BUREAUS

What is a service bureau? And what can a service bureau do to assist photographers seeking to turn their digital images into analog format—or maybe the other way around?

In this chapter, we will find what service bureaus can do to make a pixographer's work and life a little easier—and vice versa. In the different sections, you will find answers to some of the typical questions photographers have about working with service bureaus, especially how to deliver your digital images to them. But let's start with a question from a real amateur photographer that illustrates the confusion surrounding service bureaus and his frustration in finding one that can help him.

 # What's a Service Bureau Anyway?

I received the following e-mail message on CompuServe one day: "What is a service bureau? How does it differ from a regular printer? I use a Windows-based machine, and every printer I called can only use files created on a Mac. I would like to try digital imaging, but if I cannot have them printed by anyone, it doesn't seem to be worth the effort."

First, let's clear up some confusion about the name service bureau. "Service bureau" is a term left over from the bad old days of computing when only the high priests and their acolytes had access to computers and few "real" people could afford to own a computer. Instead, they had to take their data—in punched card form—to companies who did own computers and for a fee would process their data for them. Today's service bureau can digitize your analog photographs using scanners or Kodak's Photo CD process or turn digital images into analog form, including prints, slides, or negatives. As you can see by this simplified definition, few of the average print shops could be actually called service bureaus, but many commercial photo labs offer these capabilities.

As far as Windows vs. Mac is concerned, by now you should know that there are as many—maybe more—image enhancement programs available for Windows as the Mac, and any competent service bureau will be able handle digital images from Windows computers as well as Macintosh. If the service bureau you contact can't handle PC-based graphic files, keep looking. If you live in a small town that doesn't have many professional labs, look in publications like *Windows Sources* or *Computer Shopper* for ads from service bureaus that specialize in working with photographers.

 # Finding a Service Bureau

A service bureau can take many forms. It can be a small specialized facility that only provides Kodak Photo CD service or a large commercial lab, like Denver's Cies Sexton, which offers a wide range of digital input and output services. Some service bureaus cater to the prepress market and can provide four-color separations directly from your Photoshop or PageMaker digital files. The key to using any service bureau is not too different from finding the right professional color lab:

■ Compare: Talk to your photographer friends and find a service bureau that can provide the services you need at a price you can afford. While price alone is not a major consideration, it *can* be used to compare facilities that offer a real standard product or service. In my area, I can pay $3 or $.70 each for a Photo CD scan. Photo CD Pro scans range from $4 to $18. In each case, my experience with the lowest cost Photo CD provider has been as good as the highest price.

■ Test: When a photographer gets a new piece of equipment, the first thing he or she does is shoot a test roll of film. That's also a good idea when dealing with service bureaus. Take a representative group of images and divide it into two groups. Send one to one service bureau and one to the other. Many companies like Adobe and Kodak offer coupons for a small number of free Photo CD scans. Use these coupons for a risk-free test of a service bureau.

■ Evaluate results: When the images or scans come back, evaluate the entire experience, not just the quality of the service bureau's output. Were the scans/files delivered when they told you they would be? Is the price the same that was quoted? After that look at the results. One Pro Photo CD provider I tested was unable to provide the index print that slips in the cover of the CD's case. "I couldn't get the color right," he told me. If he couldn't get the color right on the index print, I was concerned that he wouldn't be able to get the color right on the Photo CD scans. (My test to him was 4x5 sheets of black & white film.) Look at the scans on your monitor. In the case of Photo CD, open all five (or six) file resolutions. I found one low-cost provider whose lower resolution scans had a missing line of data (one pixel wide) horizontally across each image.

■ Decide: Once you've made a decision, stick with that service bureau— through thick and thin. People who change labs—"lab hoppers"—are never satisfied. All labs—and all a service bureau really is a lab— make mistakes. What differentiates a good one from a bad one is not just the quality of their product but how they treat you when they make a mistake. What you need to know is how quickly they correct their

mistakes and how they treat you during the process. I sent my work to a large, local color lab for many years and they were great, until I asked them to re-do an order. At that time, I was "punished" for asking for remakes and my correction order was placed at the bottom of the orders in progress. Don't let that happen to you!

Delivering Images

The next question many photographers ask is "what's the best way to deliver your images to a service bureau?" Like many questions about digital imaging, there is no simple, single answer. Part of the problem is that photographers are used to having a standard way of delivering a processed or unprocessed image to a commercial photo lab: film. When you hand over unprocessed transparency film, the lab returns mounted slides or sheets of film. The question then becomes what kind of "digital film" exists to make images both portable and compatible with any given service bureau? Not only is there no one standard, there are many kinds of removable media devices that can be used to make your digital images portable. Here's some of the most popular methods.

Modem

The simplest way to transmit the large image files that image enhancement programs, like Photoshop, can produce to a service bureau is to send them by modem. Fast modems are available at very modest cost and no other method delivers your files right now. Many service bureaus will even provide free software for you to upload your images. The only disadvantage of this approach is that, depending on the speed of your modem, it can take several hours to transmit an image. On the other hand, you can upload images during a weekend and they'll be ready first thing Monday morning.

Getting photographic data to a service bureau can be done by modem or by using a removable storage device. A modem fast enough to transmit an 18MB image in a reasonable time will be almost as expensive as a SyQuest drive. In fact, the drive might be cheaper. If you know how to look for bargains, affordable removable drives are available. Pick up a copy of *Computer Shopper* magazine and scan the ads for low-priced drives from mail order

dealers and don't be afraid to purchase a used drive. As 88MB and larger SyQuest drives become more popular, there are going to be lots of 44MB drives available in used computer stores and in the classified section of your local papers.

Floppy Disks

Since compression utilities for PCs, such as PKZIP, can compress a file over multiple floppy disks, this is a viable alternative for those users who want to avoid using expensive removable storage devices. Compression programs make a file smaller by reducing the amount of unneeded space it occupies on a disk. PKZIP is a popular compression shareware program for IBM-PC and compatible machines, and similar programs, like StuffIt, are available for the Macintosh (see Figure 12-1). Unless you use the software to create a "self-extracting" file, a decompression utility is needed to bring the file back to its original size. If you use the program to create a self-extracting archive (SEA), the compressed file will be larger than merely compressing it. No compression program can compress a 18MB photograph to fit on a single disk, but spreading it across several floppies will let you handle larger image files. Compression may be the least expensive way to transport images, but it has two potential drawbacks.

FIGURE 12-1: StuffIt Lite, a shareware utility, is one of a family of shareware, freeware, and commercial compression programs available from Aladdin Systems. Graphic and other files can be compressed, across several disks if necessary, with just a mouse click.

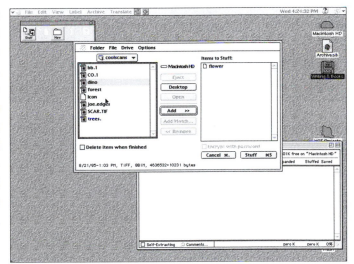

■ The service bureau must have the identical software (and often the same version number) you used to compress the file.

■ If you send six disks and request a ten-dollar 35mm slide, your lab may charge a premium for extra handling. Depending on how often you do this, compression software may not be the least expensive way to get your images to a service bureau.

One of the problems plaguing the use of floppy disks as digital image storage media is file size. The old rule of thumb that "the bigger the better" is very much alive in digital imaging. For example, a 2040x3072 black & white Photo CD image takes 6MB of disk space, and as you decrease the file's size, the image quality begins to suffer. To get the best results, a file resolution of 4096x6144 image takes about 72MB in color. At this resolution, a black & white image takes about 24MB, which is still too big for a floppy disk.

Compression is one answer but not the best one. You'll have to spend several hundred dollars for some kind of removable media to transport your data to a service bureau, but photographers shouldn't look at this as "lost money." When you become involved in digital imaging you begin a new phase in your photography. To get started in nature photography, for example, you have to invest several thousands of dollars in long focal length lenses, blinds, and other hardware that this discipline demands. Becoming a digital imager requires investment too, and a removable drive costs a lot less than a good, fast 400mm lens.

Removable Media

One alternative is to use a removable storage drive. Because optical cartridges have a lower cost per MB, they would be my recommendation if you only use them for storage. If you keep a cartridge connected to your computer and use it as a secondary hard disk, the slower access times of optical drives will drive you crazy. A SyQuest (magnetic) drive has almost identical access times to your hard disk, and the cost of cartridges won't take you to the poor house.

There also other varieties of drives available with capacities ranging from 88MB to 270MB per cartridge. Then there's Iomega's Zip drive. I keep a 100MB

Zip cartridge called "Basics" on-line at all times. I created another cartridge labeled "Photography" and installed all my Photo CD and image enhancement programs on it. When I want to work on photographs, all the related programs are available simultaneously. When I produce an image or series of images, I temporarily copy them to my hard disk, insert another Zip cartridge, copy the files to that cartridge, and take it to my photo lab for imaging.

How many slides or prints a storage device will hold depends on the device and the image size. If you're working with color images, a 44MB SyQuest drive has room for two 18MB color images or seven black & white ones. If you're interested in using smaller disk sizes (the 44, 88, and 200MB drives use a 5-inch mechanism), the 3.5-inch drive 270MB SyQuest will hold 15 color or 45 black & white images on a disk the same size, only thicker, than a floppy disk. If you prefer small optical drives, a 128MB optical disc can hold 7 color images or 21 black & white ones. If you are willing to accept less quality (lower resolution = smaller file size), you can squeeze more images onto either disk type.

If you decide to get a used removable drive, use one of the many Windows and Mac disk utilities that have an "Emergency" disk to check it out. Instead of installing a program, you insert a floppy disk and run the program directly off the floppy. All of these programs will check the integrity of hard disks as well as removable media devices, like SyQuest. Symantec's Safe & Sound is one of the easiest to use programs of this type that I've found. All you have to do is insert the disk into the drive, then turn the computer on. Safe & Sound goes on to check all drives, built-in and removable, attached to the system. It doesn't get much easier than that. (Safe & Sound is only available for the Macintosh.)

A less expensive alternative to removable cartridge drives is a tape drive. The QIC (Quarter Inch Cassette) format is more standard than any other form of mass storage and most service bureaus accept images on tape. An internally mounted drive, such as Colorado Memory's Jumbo 350MB tape drive, has a street price of $140 and their external unit, called the Trakker 350, is also available. Tape is also the least cost way to back up your hard disk.

Your final decision should be dictated by what works best for your service bureau or lab. If they prefer images to be delivered on 128MB optical cartridges, that's what you should use. If they're set up to work with

SyQuest magnetic cartridges, then that method will be your best. When a lab accepts either one, your decision should be based on what fits the way you work.

Cies Sexton, like many service bureaus, supports all SyQuest formats, both 5-inch and 3-inch up to 270MB. (*Note: the new SyQuest EZ135 format was not yet in general use when this chapter was being written.*) They also support Iomega's Bernoulli removable media in the 90 and 150MB sizes, as well as their 100MB Zip drive. Optical drives supported include the 3-inch 105MB and 230MB models, as well as the larger 650MB 5-inch drives. They also can work off tape formats, such as Exabyte. But what do you do when a service bureau doesn't support your favorite removable media drive? I asked Cies Sexton's Kevin Elliott what they did in this case. "If a client has a device we don't support, some of them just bring us their hard drives. We plug them in and we can transfer stuff on and off of it. It's not a big deal to hook another SCSI device in as long as it doesn't take some really strange driver."

What a Service Bureau Can Do for You

One way to think of a service bureau is as a large computer that instead of having electrons running around inside it has a group of people running around. The job of these people, like the electrons, is providing users with data in a form they can use. And like a computer, the categories of products and services that a service bureau provides can be broken down into input and output.

Input

"Input" in service bureau terminology usually refers to the first step in the digital imaging process: acquisition. Typically this involves converting a silver-based image form into a digital one. If a photographer wants to have their photograph, transparency, image, negative, or whatever translated into digital form, service bureaus will have a lot of different methods of doing just that. Communication with a service bureau is important if you want to have an image scanned and find that the results are what you expected.

Like a commercial photo lab, they can't read your mind about what you intend to do with a specific image. A photographer might request a low resolution scan, then want to make to a mural with it; communication with your service bureau is important.

A 20MB file from a scanned image can produce 8x10 output at 300 dpi, so photographers are going to have to quadruple the size of their file if they want to produce a mural-sized print. That's where storage can become a problem. If a photographer is looking for the service bureau to scan their image and follow all the way through to output, it's not a problem because storage then becomes the service bureau's responsibility.

As you can see, when requesting scans it's a good idea to know what you want to do with the final image and how big it might be. A 4x5 transparency or a negative at 1000 dpi translates into a 60MB file. You can get an excellent second generation original made from this file, but if you want to go to larger sizes, your file size has to get larger too.

Service bureaus provide scanning services using film, drum, and flatbed scanners. Some service bureaus seem to prefer scanning prints instead of negatives and this makes some photographers wonder, "Wouldn't the quality of a negative be higher than a scan of a print?" That's not necessarily true. Because it's produced from the original instead of a second generation image, the quality of a negative scan should be better than from a print, but the quality of the scan—bit depth, resolution, and dynamic range—has a lot to do with the final result. You can have an excellent quality scan from a print made on a high-resolution 36-bit flatbed scanner or a low-res one made from a 24-bit film scanner.

Remember that a print is just an interpretation of an image. All of the prints of W. Eugene Smith's "Walk to Paradise Garden," as well as his famous portrait of Albert Schweitzer, were made from copy negatives of highly manipulated prints, not original negatives. One reason that some service bureaus prefer to work with prints is that flatbed scanners can handle images made from any film format. Whether an image is scanned from film or a print, the quality of the scanner is just as important as the analog image that begins the process. For low volumes of scans from negatives or transparencies, Photo CD remains the best and least expensive way to get high-quality scans.

In dealing with service bureaus, you may notice that they seem more concerned about the size (in MB) of an image file than its resolution. Since file size is directly related to resolution—the greater the resolution, the larger the file—this is understandable. Larger files take longer to rasterize, longer to output, and make greater uses of a service bureau's resources. This is reflected in the prices of some of the services.

Earlier in this chapter, I gave you some insight into the price ranges for Photo CD scans in my area. As it turns out, the costs of other scans vary even more. The reason: Price of other types of scans varies depending on the final resolution of the image. A high-resolution (and high quality) transparency will cost more than a low resolution one. A survey of service bureaus in my area showed costs ranging from $7.50 to $100 to scan a transparency.

Output

Output from a service bureau can take three forms: film, paper, and digital. The reason that a good service bureau offers so many choices is the applications for digital images span many uses. Let's take a look at your options and reasons you might select one form of output over another.

Film

If you need to make many conventional (silver) prints from your manipulated image, the least expensive way to make reprints is from a film original, or in this case "second original." One of the biggest problems photographers face when they try to take an image created on their computer and convert it into film is how to translate that on-screen image into analog form. (See Figure 12-2.)

Some service bureaus offer file-to-film imaging using the large format-capable LVT (Light Valve Technology) film recorder, and it does a wonderful job in producing high-quality film output. At 4000 dpi, the LVT film recorder can produce 4x5 or 8x10 negatives or transparencies at a higher resolution than any currently available film recorder. A service bureau or commercial lab can take an 8x10 negative produced on the LVT and print murals as large as 10x20 feet that will look as good and sharp as if they were produced from a contact internegative or transparency.

FIGURE 12-2:
One of the most important quality control aspects that a service bureau has to monitor is color balance. Here Cies Sexton's CEO Ed Cies and General Manager Kevin Elliott evaluate large format film recorder output at a color controlled work station. (Photo courtesy of Cies Sexton Photographic Imaging)

The downside to this process is that it's expensive. The cost for imaging a 4x5-inch transparency can be $145 or more. That may be within reach for a commercial photographer involved in a big bucks advertising shoot, but is much too expensive for the average professional or advanced amateur.

Many photographers are really interested in an affordable way to make 35mm slides from images created with enhancement and manipulation programs. The alternative is to image files with less expensive 35mm film recorders, such as were discussed in the previous chapter.

Service bureaus typically charge five to ten dollars for 35mm slides created with these devices, but results can be uneven and unpredictable. That's because most service bureaus got started in digital imaging producing presentation graphics for slide shows and their film recorders do a great job with files from programs such as Microsoft PowerPoint or Adobe Persuasion. Out of the box, many 35mm-only film recorders won't even

image a Photoshop file, but some lab managers have discovered workarounds that enable them to use this kind of film recorder. Because service bureaus, like photo labs, vary in their abilities, you should always run a few tests.

One service bureau function I haven't found, until recently, is the ability to turn digital images into inexpensive 35mm negatives. Someone who offers this service in color and black & white is Ursula Krol at Digital Photo, in Alberta, Calgary, Canada. Her contact information can be found, along with all other companies mentioned in the book, in Appendix A. U.S. residents should ask her for instructions to minimize customs complications when sending packages back and forth across the border.

Paper

Paper output is one of the most traditional from photographic presentation. While many professional photographers can afford printers like, Epson and Fargo printers mentioned in the last chapter, some beginning digital pros or advanced amateurs may not. The service bureau can fill that need as well as provide output in larger sizes up to including and mural-sized images.

One of the simplest services is making conventional silver prints from a negative or transparency that has been created from an original digital image. This range of service falls under the general heading of standard professional color lab services, and if your service bureau is not a lab, you can take that now-analog piece of film to any competent lab and have prints made in any size and quantity. What service bureaus can offer in the area of paper-based services is output that cannot be produced by a traditional commercial photo lab.

Take mural sized prints, for example. One of the new output devices that facilities like Cies Sexton are adding is the Rastergraphics printer, which can output images up to 53 inches wide and as long as a client needs, directly from a digital file. The Rastergraphics gives a service bureau client that choice of having large prints made without the cost of creating an expensive LVT or other film recorder's output second original.

On the other end of the spectrum is less expensive color paper output. For smaller, inexpensive prints, many service bureaus also offer output in

the form of color prints from the Canon laser copier. While no one would mistake the output from a laser copier from a "real" photograph, the quality is an excellent way to make studio promotional material or to use as a proofing medium. Another proofing medium offered by service bureau is dye-sublimation prints made on expensive printers from Sony and Kodak.

Output from a dye-sublimation printer would also be a good way to evaluate your digital experiments. It probably is not the best way to check your image for color balance, but—because dye-sub prints are not that expensive— it's a good way to see how your special effects look before having costly film recorder output produced.

Digital

In addition to having your images output in analog—paper or film— form you can have them delivered in a digital form. The most obvious would be placing the images on some form of removable media that was covered in the Input section, but there are alternatives here too.

CD-R (CD-Recordable) is another way to get large files back from a service bureau. Photographers can use a CD-R disc to hold files as large as 80MB and access them on the same CD-ROM drive connected to their computer they use for Photo CD. This is also a good way to store "ripped" files that can be as large as 300 or 400MB.

RIP stands for raster image processing, which happens when you convert vector information, such as a PostScript file, into raster information. All imaging devices, even the Fargo printer mentioned in the last chapter, save a temporary RIP file to disk, then print from that file. Once stored in ripped form, the service bureau can output the file to a film recorder, printer, or even laser copier.

Another advantage of choosing a service that has a Rastergraphics printer is that the device only requires a small RIP file to produce excellent quality output. A file containing 20MB of information won't look any better than if it had been digitized at a higher resolution and contained 100MB worth of information. A film recorder, on the other hand, requires a larger RIP file because it outputs continuous tones and you don't have the luxury of having dots or a line screen to break things up.

 # What You Can Do for a Service Bureau

Dealing with service bureaus is like working with any photographic service provided. Communication is important but submitting your digital information in a proper way is just as import. Especially if you don't want any surprises when you get your (often expensive) output back. Here are some common problems that photographers make and how to avoid them.

Format

The biggest problem new pixographers encounter is having the input image formatted differently than the output one. A 35mm slide has an aspect ratio of 1.5:1. If your original image has a different ratio than that, you are forcing your service bureau to make a decision. Do they deliver the image with black borders on two edges of the slide to maintain the ratio of the image you sent or do they enlarge the image to fill the 35mm frame?

A good service bureau will call with that question but even great labs get busy and a phone call can get forgotten. What's worse, they could call you and your response is "I want to fill the frame." Something has to be cropped. Who is going to make that decision—the service bureau or you? If it's you, they may have to send the image back to you for cropping, further delaying the completion of the project.

The best way to make sure that your image has the proper ratio is use your image enhancement program's Show Rulers command to "eyeball" if your photo has the proper dimensions. The next step is to open the Image Size dialog. (See Figure 12-3.) A typical dialog includes two data sections: one displaying data for the original image and one to use to make changes in this data. Typical Image Size data includes length, width, and resolution. Use the cropping tool (and ruler as a guide) to trim the photograph into a shape that has the proper ratio. By doing it at this stage you are making sure that the image retains all the information and nothing important is missing. You can't expect a service bureau to know what to keep and what to eliminate, so it's up to you to make sure your image is formatted correctly.

FIGURE 12-3:
The Image Size box in programs like Adobe Photoshop should be checked before sending a digital image file to a service bureau. This is the place to make sure that the format of the digital image matches the ratio of the requested output.

```
┌──────────────────────── Image Size ────────────────────────┐
│  ┌─ Current Size: 436K ──────────────┐   ┌─────────┐        │
│  │       Width:  4.347 inches        │   │   OK    │        │
│  │      Height:  6.597 inches        │   └─────────┘        │
│  │  Resolution:  72 pixels/inch      │   ┌─────────┐        │
│  └───────────────────────────────────┘   │ Cancel  │        │
│                                           └─────────┘        │
│  ┌─ New Size: 436K ──────────────────────────┐  ┌─────────┐ │
│  │     Width:  [4.347]   [ inches  ▼]         │  │ Auto... │ │
│  │    Height:  [6.597]   [ inches  ▼]    ]⑧   │  └─────────┘ │
│  │ Resolution: [72]      [ pixels/inch ▼]     │              │
│  └────────────────────────────────────────────┘              │
│  Constrain:   [X] Proportions   [ ] File Size                │
└──────────────────────────────────────────────────────────────┘
```

Missing Pieces

"The next biggest problems service bureaus have," Kevin Elliott of Cies Sexton told me, "when with working with photographers is not getting all the stuff a service bureau needs to create an image." This problem gets worse if a file includes multiple images or types.

Let's start with type. While service bureaus have many hundred of different fonts in their systems, they may not have the Hobo Bold Italic you used in your studio name. I know. I use the Skia font for my promotional material. When working with a printer service bureau, I call and ask if they have it. If not I make sure I include a PostScript or TrueType version of the font on disk when I submit my other digital files. That's why it's also a good idea to send a paper copy of what you expect the output to look like. If you forget a font and the service bureaus default is Courier, the quality control people will compare what you sent with what was output and will call and ask "Where's the font!"

Missing Linked Files can be a problem when submitting a PageMaker or XPress file that contains multiple images that have not been saved as part of the original files. Having the ability to link files instead of making them part

of the original file can save hard disk space but you have to remember to send those linked files to the service bureau. That way, a test print—if only a black & white laser output—can help the service bureau and you too. Use the test print as a check list and check off each item—font or image—to make sure they are included in the package you are submitting for output.

How Original?

Believe it or not, one of the hardest things service bureaus have to deal with is clients that don't bring the most original generation of an image that they have. Some users submit a duplicate slide or a dupe of a dupe of a print rather than using the original negative or transparency.

"When people bring in a dupe," Kevin Elliott told me, "it's not only a second generation image, but it usually has some dirt on it or scratches or something else that wasn't on the original." Your best results will be obtained by giving the service bureau the first generation, or the closest to the first generation you possibly have.

Kevin added, "In probably half of the cases when we call and ask if they have something more original, they do." Just as a service bureau cannot read your mind about any future uses you may have for a particular image, they also don't know what photographs and what generations you have in your office or studio. The quality of the material submitted will be reflected in the quality of the output.

Advice for the Digitally Inclined

I asked Kevin if he had any words of advice for photographers. "The best advice that I would give to photographers," he told me, "is educate yourself very well and then practice." I second that motion and as I wrap up the main text of the book, I want to pass along some experiences I have had in the wild, wild, world of digital imaging.

Starting Over?

Many photographers have forgotten how long it took them to become really good at creating silver-based images, and now they're trying to compress the time it takes them to attain the same level of proficiency in digital

imaging. You really have to start all over again. If you think of how many frames you threw away before you got that "really good one," you have to expect that in digital imaging, too—to go through the same amount of rejects—because you don't grow unless you make mistakes. You have to push yourself to go beyond the comfortable images you're used to shooting and take it to the next level. When you're moving into digital imaging, you're reaching for even higher levels and must be prepared to experience a higher than normal failure rate. Don't worry. It's part of the normal growing process.

Versionitis

Be careful you don't catch this insidious form of computer virus that affects the user, not the hardware. Just because somebody comes out with a new version of a hardware and software product doesn't mean you have to rush out and buy it. You wouldn't toss out a serviceable lens just because your camera company has produced one that's smaller, lighter and has a wider aperture.

I'm still using a non-autofocus 200mm F4.0 Nikkor lens with my brand new Nikon N90s body to produce salable images that are as good today as when I purchased the lens over 20 years ago. Most service bureaus support many different software and hardware configurations. That doesn't mean you shouldn't upgrade, but do so only if it's affordable and you can use the new features.

Exercise Restraint...

...at least at first. When photographers first get involved in digital imaging, they have a tendency to go overboard in enhancements. This same phenomena was prevalent in the early days of desktop publishing, when wide-eyed dtp'ers crammed as many different fonts onto a single page as they can. One of the problems with trying many different imaging techniques at the same time is that the results probably won't be as good as you hoped or as good as you saw on the monitor. The worse part of your evaluation process is that you won't know why. You wouldn't test a new lens, camera, and filter system at the same time—for this same reason. The key is to stop thinking of digital photography as something different. It's not. It is the next logical step in creating photographic images.

But Experiment Too

Besides exercising restraint, you should experiment, as long as you know you're experimenting. If you want to over-enhance and try something weird, that's OK, as long as you realize you are experimenting and learning at the same time.

The least expensive way for you to experiment and get some experience is to scan images at low resolution using one of the lower-resolution Photo CD files. This will make all your enhancements and manipulations go faster, no matter what kind of computer system you use. For output, use dye-sublimation prints or laser copier output to evaluate your progress. Practice using low cost input and output methods before getting output from the expensive LVT film recorder. That's not the place to experiment. Your first LVT file has to be perfect because it's very expensive to do it again.

Digital Fears

One of the biggest fears many photographers have is that if they don't jump into digital imaging right, they're going to fall behind the technology and never catch up. Not true. I've been involved in computers for over 30 years but still manage to learn something new each day. Digital photographers should try to learn something new every day too. Because if you don't learn something new on a regular basis, you're going to stagnate, both creatively and technically.

It doesn't matter *when* you get involved with digital imaging. All of the changes that are going on the industry make it impossible for one person to know it all, and what is true today will be obsolete tomorrow. My advice: Start with images digitized using Kodak's Photo CD process and use an inexpensive image enhancement program, like MicroFrontier's Color-It! to practice some of the digital imaging techniques found in these pages. And don't forget to play too.

Via con Dios.

Author's Note: This chapter is based on two extensive interviews with Kevin Elliott, General Manager of Cies Sexton Photographic imaging in Denver, CO. I would like to thank Mr. Elliott for his time and views on the state-of-the-art for a digital imaging service bureau.

AFTERWORD

"Just because you can do something doesn't mean you should."

They've said that about everything from medical research to the space program. Now some people are asking the same question of digital imaging and digital images. The question revolves *not* around the content of the image but the ownership. In truth, it's the realities of the Copyright Act of 1976 coming face-to-face with digital imaging technology and its capabilities that give some people the ability to steal an original photograph from its creator. The problem began in the art world but is spreading to a desktop near you. In this case, the question of image ownership might be called...

Yes, But Is It Art?

There appears to be some controversy in the art world about using "other people's" photographs to create "new" artwork. Besides the obvious copyright and plagiarism implications, this trend has parallels with similar discussions on the effects of digital imaging on commercial and stock photography.

Let's begin with the art world: Some photographer's work is being digitized by artists who use computers to heavily manipulate the original image. When finished, these artists call the final creations "their own." These people feel there is nothing wrong with what they're doing, but most photographers would disagree. When someone copies your work for any purpose, there is only one word for that process and it's not art—it's theft.

The inherent wrongness of stealing the creative output of one artist by another seems so obvious, that I am amazed there is any debate going on at all about this subject. The Professional Photographers of America (PPA) in their pursuit of copyright violators has taken the perpetrators to court and won large judgments each time they've prosecuted.

In other areas of copyright litigation, FBG, a New York stock agency, received an out-of-court settlement for $20,000 from a newspaper that was illegally copying one of their photographer's images. When a New Jersey Federal District Court awarded photographer Edward Sarkis Balian $156,000 in a copyright infringement case, he wrote, "I think a message should be sent to these defendants and frankly to those people who are similarly inclined. I think the way to get the attention of a thief is to hit him in the pocketbook."

But have the thieves gotten the message? Part of the problem is thieves and potential thieves have not gotten the message. More attention needs to be given to the theft of intellectual property, but the media and even large segments of the photographic press have ignored many of these stories. Perhaps, since the forestalled trade war with China was based on that country's lack of respect of intellectual property rights, media coverage may shine more light on this problem.

But most of us are not concerned about offshore rip-off artists; we have home-grown ones to contend with. I have, on several occasions, found clients who were unlawfully using some of my photographs and all it took

to solve the problem was a phone call pointing out that it's not nice to steal. By the time most people get to the first grade, they should have learned that lesson, but the problem goes deeper than greed.

The Rodney Dangerfield of Art

Of all the arts, photography is often treated as one step above the production of a "paint-by-numbers" canvas. I think the origin of this prejudice goes back to the ease with which contemporary cameras make it possible to produce a good quality photograph. It wasn't always that way. When William Henry Jackson photographed the American West using 11x14 glass "wet" plates, the mere act of taking any photograph was difficult. Now, modern cameras make it almost impossible to create a technically poor image. People who call themselves "artists" equate this ease of creation with artlessness. But these same people who think it's easy to take a photograph of Uncle Bernie and Auntie El at Yosemite, forget that paintings made by chimpanzees and gorillas have sold for big money at auctions. Does that make painting less of an art form? Now, I don't want to insult any of our higher primate readers, but I think there's a difference between artifice and art.

Artists who "borrow" photographers' work for their own creations do so because they don't believe it's stealing. They don't think it's stealing because it's "found art." Much as some artists create sculptures using found objects, others feel any photograph is fair game for the same approach. Unfortunately, they're kidding themselves. Just because you find something doesn't mean it's yours. And just because it's possible with digital scanning techniques to copy a photograph from a magazine, newspaper, or catalog, doesn't give anyone the right to treat it as found art. It is, in fact, stolen art.

All artists, no matter what medium they work in, start with a blank canvas. When Rembrandt started painting "The Night Watch," he didn't have a bunch of clip art of soldiers he pasted onto a canvas, then "interpreted" them into the moving painting he created. Like all real artists, he started with a blank canvas, like you and I start with an unexposed film frame or blank computer screen. Just because technology exists that allows images to be converted from one form to another, doesn't give any artist or photographer the right to start their process—not with a blank canvas—but with one in which all the hard work has already been done.

It's possible that today's climate of not accepting responsibility for one's actions makes it easier for digital deadbeats to justify their theft of other people's images. So it's up to us to educate everyone that art is the property of the creator, not the borrower.

Pogo Was Right . . .

...when he said, "we have met the enemy and he is us." Although photographers have the high moral high ground on this issue, what do they do? Instead of rooting out the evildoers and making sure they're punished, photographers too often blame the technology that makes this theft possible. Talk about shooting the messenger! I hate to be the one to break it to any digital Luddites out there, but digital imaging isn't going away any time soon.

The answer is not, as one respected writer and stock shooter recently suggested in print, the formation of a photographer's union! Such a union, he postulates, would enable photographers to control "the distribution and (thus) the pricing of what is produced."

Having a union presupposes withholding labor will cause problems for the person who previously paid for that labor. Except in a few cases, no client—big or small—would care if all of the photographers that supply them with images decided to withhold that labor. These clients have businesses to run and will quickly find plenty of "replacements" to supply those images.

Part of the function of such a union would also be to do something about stock photographers who are "selling out and demeaning their work and images." This is something I can support. I am surprised by the furor created by individuals and organizations over low cost stock photography CD-ROM disks when these same individuals and organizations have done nothing to combat photographers selling silver-based images at bargain basement prices. My suspicion is that as long as the low-ballers were not affecting these critics' incomes, they simply ignored this problem.

For most of us, low-priced images in silver or digital forms are nothing new. There are always photographers who give away their work. Before he created his civil war photographs, Matthew Brady publicly complained about the new Daguerreotypists who had no grasp of the technical aspects

of their new profession and who were willing to sell portraits for less than fair market value. Competition, fair or unfair, is part of capitalism and learning to deal with that is part of personal and professional maturation.

The truth is that sooner—not later—digital imaging is going to replace conventional film for all professional uses. The effect of digital technology on amateur photography may take longer but that's going to happen too. Just as the Daguerreotypists were aghast at the coming of the glass plate negative and tintype, their frustrations didn't change the inevitable.

So get real, get digital. The question of the use of digital technology to steal photographs is not a technical one, it's a moral issue. Stealing is wrong, whether you do with a computer or at the point of a gun. The result is the same: You are taking something that doesn't belong to you and enriching yourself at someone else's expense. Stop blaming the messenger and let's start going after the crooks.

GLOSSARY

A Dictionary of Digital Imaging

ACCESS bus: Not an acronym. This motherboard slot standard provides two-way communications between peripherals and the CPU. ACCESS bus eliminates the need to install complex files or drivers.

ALIASING: Sometimes when a graphic is displayed on a monitor, you'll see jagged edges around some objects. These rough edges are caused by an effect called aliasing. Techniques that smooth out the "jaggies" are called anti-aliasing.

ANALOG: Something that has an infinite number of values and is analogous to a representation of the "real world." A traditional photographic print is an analog form, but when this same image is scanned, it is broken into digital form, containing bits of information.

BBS: Bulletin Board Service that can accessed by a modem. Many companies, like Epson and Fargo, provide bulletin boards so their customers may download the latest printer or scanner drivers.

BIOS: Basic Input Output Systems. This is that part of a motherboard, or auxiliary card, that controls the input and output devices connected to it.

BIT: Binary Digit. The smallest unit of information a computer can work with. Each electronic signal is one bit and computers combine these into 8-bit groups called BYTES. When 1024 (not one thousand) bytes are combined you get a KILOBYTE, often called just plain K. When you lasso 1024 kilobytes, you have a MEGABYTE (MB) or meg.

BIT DEPTH: This specification refers to the number of bits that are assigned to each pixel. The more bits you have, the more photo-realistic the screen image.

BITMAP: Graphic files come in three classes: bitmap, metafile, and vector. A bitmapped (formerly know as raster) graphic is composed of a collection of tiny individual dots or pixels. The simplest bitmapped files are monochrome images composed of only black and white pixels.

This is any shape, including photographs, that is composed of individual dots or pixels. Monochrome bitmaps have a single color against a background (see Monochrome), while images displaying more shades of color or gray need more than one bit to define the colors. Images, like photographs, with many different levels of color or gray are called deep bitmap, while black and white graphics are called a bilevel bitmap. A bitmap's depth is permanently fixed at creation. The screen shots that accompany this story have resolutions of 72 dpi (dots per inch). No matter what I do, I can't change this. I can make them bigger, but not better.

BIT RESOLUTION: Often called color depth, measures the number of bits of information a pixel can store and determines how many colors can be displayed at once.

BMP (WINDOWS): Often pronounced as "Bump." This acronym is a file extension (see Extension) for a specific kind of Windows-based bitmap graphics file.

BUFFER: This term refers to space that is (typically) reserved in memory to hold temporary file information.

BUNDLED: Part of a software or hardware package, which may or may not be a good deal.

CCD: Charged Couple Device. The type of optical/digital technology commonly used in flatbed scanners.

CCH: Corel Chart (graphics file format).

CDR: Corel Draw (graphics file format).

CEPS: Color Electronic Publishing Systems is a dedicated, computerized system used by printers for color management.

CFR: Color Film Recorder. A device that translates images onto photographic film. All desktop film recorders work in essentially the same way: A camera is enclosed in a small box and is focused on a very high resolution black & white monitor. It makes three exposures of the image, each through separate red, blue, and green filters to produce the final image.

CGM: Computer Graphics Metafile. A vector graphics format that is designed to be portable from one PC-based program to another.

CISC: Complex Instruction Set Computing. See RISC.

CLONE: Sometimes you will hear IBM-compatible computers called clones, although that term has taken on a pejorative connotation since former "clone" makers like Compaq Computer and Dell actually sell more IBM-compatible computers than IBM does.

CMS: Color Management Systems are (mostly) software-based systems that are used to match the color you see on your monitor to the output device—printer or film recorder—so that what you see on the screen is what you get as output. You might think of this as the last step in the WYSIWYG process. Recently, programs like Adobe Photoshop and PageMaker are including Kodak's Precision Color Management Software as part of their package. The software alone is useless unless you have device profiles (an integral part of any color management system) for the monitors and output devices you use. Device profiles must be created for specific monitors, such as the NEC XE15, and specific output devices like a Mirus film recorder. Some companies, like Fargo Electronics, provide their own CMS for their printers.

The reason the "mostly" appears at the beginning of the definition is that some color management systems include devices that attach to your moni-

tor to allow precise matching of a special color, such as Kodak Yellow or Petty Blue.

CMX: Corel Presentation Exchange (graphics file format).

CMYK: Cyan, Magenta, Yellow, and Black. Yeah, I know black doesn't begin with a "K" but it does end with one. Blame this tortured acronym on the same printing industry that's saddled us with "picas."

COLOR DEPTH RESOLUTION: Measures the amount of color information each pixel can display. See bit resolution.

COLOR MATCHING METHOD (CMM): A routine used by a color management system to apply transformations to color data.

COMPRESSION: This is a technique that lets you make a file smaller and consequently take up less space by removing irrelevant information from the file.

CONTROL PANEL (Macintosh): A Control Panel is a small program, like Nom de Plume that does something specific for your computer system or application. Each utility has its own panel for controlling various features or settings. Back when System 6 was the only game in town, they were called CDEVs.

CONTROL PANEL (Windows): In Microsoft Windows, the Control Panel window contains many small utilities that allow you to customize the way your interface looks, as well as adjusting the settings of hardware and software.

CPU: The microchip or Central Processing Unit, that powers the computer. There are two basic families of CPUs: Intel and Motorola. There are alternative microprocessor chips to Intel but they all follow Intel's standard. How well any chip processes data is determined by how many bits of information it can process at one time. The larger the number of bits it can simultaneously process, the faster the processing speed. Think of it as a highway. The more lanes you provide, the more cars can travel on it at one time. A 32-bit CPU, for example, processes data twice as fast as a 16-bit model. How fast the CPU of a microcomputer operates is measured by its clock speed which is measured in megahertz (MHz) or thousands of cycles per second. The faster the clock speed, the faster the CPU can process data and processing speed is extremely important to digital photographers. If

you see a computer labeled 486/50, you know it has a 486 CPU running at a clock speed of 50 MHz.

CRT: Cathode Ray Tube. A propeller-head's word for the picture tube inside your monitor.

DEFAULT: Is an automatic decision that your software or hardware makes for you and will automatically be carried out unless you make some changes. Most programs allow the default setting to be changed by simply typing in your own preferences.

DIGITAL: This is information represented by numbers, or in Max Headroom's case "a person translated as data."

DIMM: The newest computers have switched from SIMM (Single Inline Memory Modules) to Dual Inline Memory Modules that have RAM chips mounted on both sides of the circuit board. This means the motherboard can have more memory with the same number of slots for RAM. But as is typical in most computer hardware innovations, SIMMs will not fit a DIMM slot and vice versa. Several companies have, however, introduced DIMM converters that allow SIMMs to be installed in an adapter that will fit a DIMM slot. This allows users to save their old SIMMs when upgrading to a DIMM-based computer.

DISPLAY: See Monitor.

DMA: An acronym for direct memory access. Expansion cards installed in a PC use it to access system memory directly without going through the CPU.

DOT PITCH: The distance between the red (center) dot of two adjoining pixel triads. The smaller this number, the sharper the picture will be.

DOWNLOAD: In computerese this term means "to receive information" from an external source. This is usually done via a modem retrieving information from a Bulletin Board Service (BBS) or an online service like CompuServe, but it can also be done from a digital source, like a digital camera, to a computer. The opposite term is upload.

DPI: Dots per inch. If a device has a resolution of 300 dpi it means that there are 300 dots across and 300 dots down. The tighter this cluster of

dots is, the smaller the dot becomes. The higher the number of dots; the finer the resolution.

DRAG & DROP: This is a feature of graphical user interfaces (GUI) that lets users perform different operations by using the mouse to drag an icon representing a document or photograph on top of another icon.

DRAM: This is a wirehead term for Dynamic Random Access Memory. DRAM cannot hold information for a long time and requires that the computer refreshes it ever few thousandths of a second—that's why it's called *dynamic*. DRAM is the typical RAM chip found in SIMMs.

ELF: Extremely low frequency radiation produced by computer monitors.

EPS, EPSF: Encapsulated PostScript format. A metafile format for graphics files that are designed to be imported into another application, such as a desktop publishing program. This file type contains two elements: the bitmapped image and the PostScript code that tells your printer or output device how to print the image. (see PostScript)

EXTENSIONS (IBM): In DOS and Windows, file names are divided into two parts. The first part (before the period) is the file name, and the extension (after the period) indicates the kind of file it is. A DINO.BMP file identifies the file as a bitmapped graphic. BMP is the acronym for Windows bitmap graphic file.

EXTENSIONS (MACINTOSH): See INIT.

FATWARE: Large, overweight programs that consume more RAM and more hard disk than the previous version of the same program.

GAMMA: Measures the contrast that affects the midlevel grays (the midtones) of an image.

GAMUT: The range of colors that any output device can accurately reproduce.

GIF: (Pronounced like the peanut butter.) The Graphics Interchange Format developed by CompuServe is the Rodney Dangerfield of graphics file formats—it don't get no respect. It is completely platform-independent and the same bitmapped file created on a Macintosh is readable by a Windows graphics program. A GIF file is automatically compressed, and consequently takes up less space on your hard disk. Because some software considers

GIF files to be "indexed" color, (see below) not all graphics programs read and write GIF files, but many do. The "get no respect" aspect of GIF is that often R and X-rated photographs in GIF format are available from on-line services and bulletin boards. Some people have come to associate the file format with these types of images, therefore leading to erroneous assumption that a GIF file is automatically one that features erotic images.

The future of the GIF format, at this time, is uncertain. When CompuServe developed the format, it used, as part of the design, the Lempel-Ziv-Welch (LZW) compression algorithms believing this technology to be in the public domain. As part of an acquisition, UNISYS gained legal rights to LZW and a legal battle has ensued. The way it stands now, reading and possessing GIF files (or any other graphics file containing LZW-compressed images) is not illegal, but writing software which creates GIF (or other LZW based files) may be.

GUI: Graphic Users Interface. *In the beginning* there was the command line interface in which, if you wanted the computer to do anything, you needed to tell it so in precisely defined terms. Leave out a comma or period or forget to capitalize and you got an error message. A Graphic Users Interface was developed by Xerox for their never-produced Star computer. Instead of a command line, you used a mouse to click on little pictures, called icons, to make the computer do what you wanted. The Macintosh popularized this approach to computers, which was followed several years later by Microsoft Windows which let IBM-PC and compatible users forever forget what a command line was.

HERTZ: It's not the rental car company but hertz with a small H. Often abbreviated as Hz, this is a measure of electrical vibrations per second. Those of us around from the old days of radio remember the term as "cps" or cycles per second.

HIGH RES: High resolution. The more information (or pixels) filling your screen means that images will appear in finer detail, with smoother edges.

IBM-COMPATIBLE: Refers to a computer made by any manufacturer that follows the standards set by IBM when they introduced their first personal computer.

ICC: International Color Consortium, an industry group that works to advance cross-platform color communications and has established base-level standards and protocols in the form of the ICC Profile Format specifications, to build a common foundation for communication of color information.

INDEXED COLOR: There are two kinds of indexed color images: ones with a limited number of colors and pseudocolor images. The number of colors of the first type is usually 256 or less. Pseudocolor images are really grayscale images that display variations in gray levels in color rather than shades of gray and are typically used for scientific and technical work.

INK JET: This kind of printer works by spraying tiny streams of quick-drying ink onto your paper. Circuits controlled by electrical impulse or heat determine exactly how much ink—and what color—to spray to create a series of dots or lines that combine to form a printed photograph.

INTERLACED: On a non-interlaced monitor, the electron beam making scans takes two passes to form a complete image, while an interlaced monitor traces each row consecutively.

IRQ: An interrupt request line is a communication channel between any card installed in a IBM-PC compatible computer and the CPU.

ISA: Industry Standard Architecture. This is another buzzword for the expansion slots found in the IBM-PC and compatible machines. Unlike older expansion slot designs, the ISA slots allow the installation of plug-in boards that can transfer data 16 bits at a time. They will also accept 8-bit cards from the original IBM-PC standard, but the speed will be limited to that of the original board's design.

JPEG: Is an acronym for a compressed graphics format created by the Joint Photographic Experts Group, within the International Standards Organization. Unlike other compression schemes, JPEG doesn't use a single algorithm, and it is what the techies call a "lossy" method. LZW compression is lossless—meaning that no data is discarded during the compression process. JPEG was designed to discard any information the eye cannot normally see. JPEG is an excellent way to store 24-bit color images and is superior on-screen to 8-bit photographs when viewed on a good monitor, but the compression process itself can be slow.

MCA: Micro Channel Architecture is found only on some IBM brand PS/2 machines and in few others. This standard was touted by IBM as the next big thing in bus design, but not many manufacturers were as enamored of it as IBM was.

METAFILE: This multifunction file type accommodates both vector and bitmapped data within the same file. While seemingly more popular in the Windows environment, Apple's PICT format is a metafile.

MIDI: A student at the Naval Academy in Annapolis, Maryland. NOT! Although pronounced "middie" it stands for Musical Instrument Digital Interface, a standard that describes how computers and MIDI-compatible musical instruments interface. MIDI is both a hardware item that refers to plugs and connectors allowing these instruments to be connected to your computer or sound board, and a set of rules for how music should be encoded so that the instruments and computer can communicate.

MONITOR: Another word for the box containing the screen, its power supply, and other components that enable you to see a digital image displayed. That's why you often hear some monitors called "displays."

MONOCHROME: A monochrome monitor displays one color on a different colored background. In the Macintosh environment this means a black & white screen, while in the IBM world it can also be amber or green on a black background.

MOTHERBOARD: A plastic board containing printed circuitry and chips that make "the machine go ping." It holds the RAM, device controllers, and the main processing chip called the CPU, or Central Processing Unit. There are those who call the entire box a CPU. In the Apple environment you will often hear the motherboard called logic board, while motherboard remains more popular with the IBM-PC and compatible users. Occasionally a product will be called a "daughterboard." This kind of product, like Mirror Technologies Charge Card, attaches to another card in the computer or the motherboard itself.

MS-DOS: Often called just DOS. Microsoft Disk Operating System is used by IBM-PC compatibles. "Real" IBM computers use a version called PC-DOS. This is a command line interface that enables users to interact with their computers by typing commands. It preceded Windows on IBM PCs and compatibles but Windows versions, up to but not including Windows 95, require DOS to function properly. With Windows 95, Microsoft has eliminated the requirement for MS-DOS to be installed before

installing this latest version of Windows. Window 95 does have a DOS emulation mode to allow users of older software to run these programs.

MULTISCAN: A multiscan monitor automatically matches the signal sent to it by the graphics card (or Apple motherboard).

MULTISYNC: A trademark of NEC Technologies for multiscan.

NTSC: National Television Standards Committee. NTSC sets the standards that apply to television and video playback on resolution, speed, and color.

OBJECT ORIENTED GRAPHICS: See Vector.

OCR: Optical Character Recognition. This is a technique used by scanning software to convert scanned text documents into a form that can be edited with a word processor. In other words, OCR software "optically recognizes" characters scanned in, essentially changing graphics into words.

PAL: European video standard similar to NTSC.

PCD: This is an extension used in the IBM-PC environment to describe Kodak's Photo CD graphics file format. PC users also use .PCD as a file extension for Photo CD image files.

PC-DOS: Personal Computer Disk Operating System. This is IBM's version of MS-DOS and for all practical purposes is completely identical.

PCI local bus: Personal Computer Interconnect is the faster successor to the VL bus and often will sit alongside an ISA slot on a motherboard. Until recently, PCI slots were limited to IBM and compatible machines. In their next generation of Power Macintosh computers, Apple Computer is abandoning their propriety NuBus slot architecture in favor of the PCI bus. If you can't beat 'em join 'em.

PCMCIA: Acronym for Personal Computer Memory Card International Association. The cards that are referred to in the organization's title are small credit-card sized modules and were originally designed to plug into standardized sockets of laptop and notebook sized computers. To date, there have been three PCMCIA standards: Type I, Type II, and Type III. The major differences between the types is the thinness of the cards. Type III are 10.5mm thick. Type II is 5mm thick, and Type I is 3.5mm thick. The modules come in many types and vary depending on the type and thickness. There are PCMCIA cards for additional memory, hard disks, modems—you

name it. It seemed pretty obvious that this would be quickly adapted to digital cameras as a means of storing large image files.

PCX: Not an acronym (it doesn't stand for anything) and is a bitmapped file format originally developed for the popular program, PC Paintbrush. Most Windows and DOS graphics programs read and write .PCX files.

PICT: Another meaningless acronym, this time for a metafile file. As a well-behaved metafile, PICT files contain both bitmapped or object-oriented information. Some people love PICT files because they are excellent for importing and printing black & white graphics, like logos. Others hate them because they don't always retain all of the information in the original image. I've had both experiences.

PIXEL: Pixel is an acronym for picture element. A computer's screen is made up of thousands of these colored dots of light that, when combined, can produce a photographic image. Pixels—the stuff digital photographs are made of—behave similarly to the silver grains that make up the negative or positive images in the film you use. Thinking of pixels as film grain will get you on the road to understanding how digital imaging works.

PIXEL RESOLUTION: Measures the number of dots of light on a monitor.

PIXOGRAPHER: A term coined by some would-be Lewis Carroll at a computer trade show to describe photographic artists who are taking George Lucas' quote ("As digital imaging comes into wider usage, we are gradually moving this medium (motion pictures) away from a strict photographic interpretation of reality into one that is more painterly.") to heart by creating images that extend Ansel Adams concept of "previsualization" to the next level.

PMT: Photomultiplier Tubes are a type of sensing technology used in drum scanners.

PNP: Plug & Play slots are similar to the ACCESS bus in their ability to communicate. This is the "next great standard" developed by Microsoft as part of the long-awaited Windows 95 operating system. Plug & Play slots allow the computer to recognize any card inserted into it through exchange of information. For the user this means lower setup costs, ease of use, and reduced need of technical support. Every Macintosh computer has always had plug & play capabilities, but Apple Computer never bothered to give a name to this feature.

PORT: A connector found on the back of your computer where you plug or attach a cable from a peripheral device, like a monitor.

POSTSCRIPT: A programming language created by Adobe Inc. that defines all of the shapes in a file as outlines and interprets these outlines by mathematical formulae called Bezier (Bez-e-ay) curves. Any PostScript-compatible output device, whether it's a film recorder or laser printer, uses the definitions to reproduce the image on your computer screen.

PPA: Professional Photographers of America.

PRECISION TRANSFORMS: Also called PTs. These are device profiles defined as software and are used in color management systems.

RAM: It means Random Access Memory. RAM is that part of your computer that temporarily stores all data while you are working on it. Unlike a floppy disk or hard drive, this data is volatile. If you lose power or turn off your computer, the information disappears. Most contemporary computer motherboards feature several raised metal and plastic slots that hold RAM in the form of SIMMS (Single Inline Memory Modules).

RASTER: See Bitmap.

REFRESH RATE: This measures, in Hz (Hertz), how often an image is redrawn on your screen. If the refresh rate is too slow, you get flicker. 60 Hz is standard but flicker may be apparent in some larger, brighter screens. That's why many monitors have now standardized on 70Hz and some go as high 87Hz.

RGB: Red, Green, Blue. Color monitors use red, blue, and green signals to produce all of the colors that you see on the screen.

RISC: Reduced Instruction Set Computing. RISC chips, like the PowerPC, are programmed with fewer, simpler instructions and since they break each operation down into small, simpler steps, it can perform these operations faster.

RSC: The device-independent reference color space used by color management systems to establish the characteristics of a particular color device.

SHAREWARE: The shareware method of distribution permits you to "try before you buy," but does not entitle you with a license to use the software

beyond the trial period. The trial period is typically 30 days, and if you would like to continue using the product after that time, you must register (pay for) the software.

SIMM: Single In-line Memory Module. This is a small circuit board that holds RAM chips. See RAM.

THUMBNAIL: This is an old design industry term for "small sketch." In the world of digital photography, thumbnails are small low resolution versions of your original image. Since they are low resolution, they are extremely small files.

TIF, TIFF: Tagged Image File Format is a bitmapped file format developed by Microsoft and Aldus. A TIFF file (.TIF in Windows) can be any resolution from black & white up to 24-bit color. TIFFs are supposed to be platform independent files, so files created on your Macintosh can (almost) always be read by a Windows graphics program.

TRIAD: The three pixel clump of red, blue, and green pixels.

TWAIN: No not Mark Twain, not even Choo-Choo Twain... TWAIN is a hardware/software standard that allows users to access scanners from inside Windows applications. In addition to scanning, typical TWAIN software allows users to adjust brightness and contrast.

UNIX: A multi-user, multi-tasking (doing more than one thing at the same time), multi-platform operating system originally developed by Bell Labs for mainframe and mini-computers back in the bad old days of computing. Like the Internet, UNIX is constantly being overhyped as "the next big thing." Its main popularity now seems to be in universities and some large businesses and while there are many implementations of UNIX for PCs and the Mac, none have caught on. The main reason is that the operating system requires large amounts of memory and hard disk space.

VECTOR: A vector graphic is defined in terms of shapes. Each image file is represented by a mathematical description of the shapes that comprise that image. These graphics are sometimes called "object-oriented." This is the same technology Adobe uses with its PostScript fonts and has the same advantages—you can make any image as big as you want and it will retain its the same quality. Regardless of its file type, vector graphics are displayed as a bitmap on your monitor.

VESA: The Video Electronics Standard Association set standards for high resolution video devices such as monitors and video circuits. VESA also developed a standard for IBM-PC and compatible machines called VL-Bus (VESA Local) for video boards and slots that can be plugged into the motherboard.

VGA: Video Graphics Adapter. A standard VGA system displays 640x480 pixels to display 16 colors at one time. At 320x200 pixels, the monitor can show up to 256 colors.

VIDEO DRIVER: A small software program that enables your computer and the video card to communicate with the monitor.

VIRTUAL MEMORY: This is a method of using hard disk space as if it were RAM. If you're working with a digital imaging program that requires more RAM than you have installed, Windows will go out to your hard disk and grab the amount of space you need—as if it were RAM—and use it to store data.

VL: VESA Local Bus. (See VL bus)

VL Bus: Stands for VESA Local Bus. VESA means Video Electronics Standard Association. This is a group of industry manufacturers who set standards for high resolution, high performance video devices. VL bus cards will not work in an ISA slot.

VLF: Very low frequency radiation produced by computer monitors.

VRAM: Video Random Access Memory. In all newer Macintosh (and some IBM-PC and compatible) systems, the video card function is built into the motherboard, but space is provided for Video Random Access Memory SIMMs. Additional VRAM provides greater bit depth and is usually so inexpensive, I recommend that you spend the few dollars it takes to have the maximum amount installed when you purchase the computer.

WMF: Windows Metafile Format. A vector graphics format designed to be portable from one PC-based program to another.

XGA: Is a type of video adapter developed by IBM for the PS/2 computers. It puts out a resolution of 1024x768 pixels with 16-bit color allowing it to display 65,000 colors.

YCC: The color model used by Kodak in its Photo CD process. This involves the translation of data that was originally in RGB form into one

part of what scientists call luminance but the rest of us call brightness (this is the Y component) and two parts (the CC) of chrominance or color and hue. This system keeps file size under control while maintaining the Photo CD's "photographic" look. Sony uses the same system in its professional Betacam video system.

ZFP: Zero Foot Print. This term is used to describe peripherals that take little or no additional desk space when installed. Often this means they are designed to sit under an existing peripheral or the computer itself.

APPENDIX A
LIST OF MANUFACTURERS

Adobe Systems Inc., 1585 Charleston Road, P.O. Box 7900, Mountain View, CA 94039-7900. 415/961-4400.

AGFA, 200 Ballardvale Street, Wilmington, MA 01887-1069.

Aladdin Systems, Inc., 165 Westridge Drive, Watsonville, CA 95076. 408/761-6200, FAX: 408/761-6206.

Alien Skin Software, 2522 Clark Avenue, Raleigh, NC 27607-7214. 919/832-4124, FAX: 919/832-4065.

Apple Computer, 1 Infinite Loop, Cupertino, CA 95014. 408/996-1010.

AXS Marina Village Parkway, Alameda, CA 94501. 510/814-7200, FAX: 510/814-6100.

Berkeley Systems, 2095 Rose Street, Berkeley, CA 94709. 510/540-5535, FAX: 510/540-5630.

Caere Corp., 100 Cooper Court, Los Gatos, CA 95030. 800/535-SCAN.

Canon Computer Systems, 2995 Redhill Avenue, Costa Mesa, CA 92626. 714/438-3000, FAX: 714/438-3099.

Canto Software, 800 Duboce Avenue #101, San Francisco, CA 94117. 415/431-6871, FAX: 415/861-6827.

Colorado Memory Systems, a division of Hewlett Packard, 800 S. Taft Ave, Loveland, CO 80537.

Connectix Corp., 2655 Campus Drive, San Mateo, CA 94403. 415/571-5100, FAX: 415/571-5195.

Corel Corporation, The Corel Building, 1600 Carling Avenue, Ottawa, Ontario, Canada K1Z8R7. 613/728-8200, FAX: 613/728-9790.

DataViz, 55 Corporate Drive, Trumbull, CT 06111. 800/733-0030, FAX: 203/268-4345.

DeltaPoint, 2 Harris Court, Suite B-1, Monterey, CA 93940. 408/648-4000, FAX: 408/648-4020.

Delta Tao Software, 760 Harvard Avenue, Sunnyvale, CA 94087. 408/730-9336.

Deneba Software, 7400 S.W. 87th Avenue, Miami, FL 33173. 305/596-5644, Fax: 305/273-9069.

Dicomed Inc., 12270 Nicollet Ave., Burnsville, MN 55337. 612/895-3000, FAX: 612 895-3258.

Digimation Corporation, 1 Cate Street, Eldredge Park-Portsmouth, NH 03801.

Digital Photo, Ursula Krol, Unit 83, 2300 Oakmoor Drive SW, Alberta, Calgary, T2V 4N7 Canada.

Digital Vision, Inc., 270 Bridge Street, Dedham, MA 02026. 617/329-5400.

Dycam, 9588 Topanga Canyon Boulevard, Chatsworth, CA 91311. 818/407-3960, FAX: 818/407-3966.

Eastman Kodak Company, 901 Elmgrove Rd., Rochester, NY 14653-5200. 800/235-6325.

Educorp Computer Services, 7434 Trade Street, San Diego, CA 92121. 619/536-9999.

Envisions Solutions Technology, Inc., 822 Mahler Road, Burlingame, CA 94010. 415/692-9061, FAX: 415/692-9064.

Epson America Inc., 20770 Madrona Ave., Torrance, CA 90503 310/782-0770.

Equilibrium Technologies, 475 Gate Five Road, Suite 225, Sausalito, CA 94965. 415/332-4343, FAX 415/332-4433.

Expert Software, 800 S. Douglas Road, North Tower 355, Coral Gables, FL 33134-3128. 305/567-9990.

Fargo Electronics Inc., 7901 Flying Cloud Drive, Eden Prairie, MN 55344. 612/941-9470.

Fractal Design Corporation, 510 Lighthouse, Suite 5, Pacific Grove, CA 93950. 408/655-8800.

Fuji Photo Film USA Inc., 555 Taxter Road, Elmsford, NY 10523. 800/755-3854, Ext. 8253.

Halcyon Software, 1590 LaPradera Drive, Campbell, CA 95008. 408/378-9898, FAX: 408/378-9935.

Hewlett-Packard, PO Box 58059, MS511L, Santa Clara, CA 95051-8059. 800/SCANJET.

ImageWare Software, Inc., 4330 La Jolla Village Dr., Suite 270, San Diego, CA 92122. 619/457-8600.

Imspace Systems Corp., 4747 Morena Blvd., Suite 360, San Diego, CA 92117. 800/488-KUDO, FAX: 619/272-4292.

Inner Media Inc., 60 Plain Road, Hollis, NH 03049. 800/962-2949, FAX: 603/465-7195.

Inset Systems, 71 Commerce Drive, Brookfield, CT 06804-3405. 800/374-6738, FAX: 203/775-5634.

Insignia Solution, 1300 Charleston Road, Mountain View, CA 94043. 415/694-7600.

Iomega Corporation, 1821 West Iomega Way, Roy, UT 84067. 800/777-6654, FAX: 801/778-3190.

JASC Inc., 10901 Red Circle Drive, Suite 340, Minnetonka, MN 55343. 612/930-9171, FAX: 612/930-9172.

Leaf Systems, 250 Turnpike Road, Southboro, MA 01772-1742. Digital camera products are marketed and distributed by Sinar Bron Imaging Systems, 17 Progress Street, Edison, NJ 08820. 908/754-5800, FAX: 908/754-0203.

Logitech, Inc., 6505 Kaiser Drive, Fremont, CA 94555. 510/795-8500.

Media Cybernetics, 8484 Georgia Avenue, Silver Spring, MD 20910. 301/495-3305.

MetaTools, Inc., 6303 Carpinteria Avenue, Carpinteria, CA 93013. 805/566-6200, FAX: 805/566-6274.

Micrografx, 1303 E. Arapaho, Richardson, TX 75081. 800/733-3729, FAX: 214/994-6334.

Microsoft, One Microsoft Way, Redmond, WA 98052-6399. 800/426-9400.

MicroFrontier, Inc., P.O. Box 71190, Des Moines, IA 50325. 515/270-8109.

Microtek Lab, Inc., 3715 Doolittle Drive, Redondo Beach, CA 90278. 310/297-5000.

Mirror Technologies, 5198 West 76th Street, Edina, MN 55439. 800/643-3384.

The MultiMedia Store, 5347 Dietrich Road, San Antonio, TX 78219-2997. 800/597-FOTO.

NEC Technologies, Inc., 1255 Michael Drive, Wood Dale, IL 60191-1094.

Nikon Electronic Imaging, 1300 Walt Whitman Road, Melville, NY 11747-3064. 516/547-4200.

Orange Micro, 1400 N. Lakeview Ave, Anaheim, CA 92807. 714/779-2772.

Pacific Micro, 201 San Antonio Circle, Mountain View, CA 94040. 415/948-6200, FAX: 415/948-6296.

PhotoPhase Inc., 805 Veterans Blvd., Suite 200, Redwood City, CA 94063. 415/599-9087; FAX: 415/365-0450.

Pinnacle Micro, 19 Technology, Irvine, CA 92718. 800/553-7070.

Play Inc., 2890 Kilgore Road, Rancho Cordova, CA 95670-6153. 800/306-PLAY, FAX: 916/851-0801.

Polaroid Corporation, 565 Technology Square, Cambridge, MA 02139. 800/343-5000, FAX: 617/386-9339.

Primax Electronics, 254 East Hacienda Ave, Campbell, CA 95008. 800/338-3693.

Reply Corporation, Reply Corp., 4435 Fortran Drive, San Jose, CA 95134. 800/801-6898.

Ricoh Corporation, 3001 Orchard Parkway, San Jose, CA 95134. 408/954-5326, FAX: 408/432-9266.

Seattle FilmWorks, 1260 16th Avenue West, Seattle, WA 98119-3401. 800/445-3348.

Second Glance Software, 25381-G Alicia Parkway, Suite 357, Laguna Hills, CA 92653. 714/855-2331, FAX: 714/586-0930.

Sony Electronics, 1 Sony Drive, Park Ridge, NJ 07656. 800/352-7669, FAX: 408/943-0740.

Storm Software, 1861 Landings Drive, Mountain View, CA 94043. 415/691-6600, FAX: 415/691-6689.

Symantec Corporation, 175 W. Broadway, Eugene, OR 97401-3003. 503/345-3322, FAX: 503/334-7488.

SyQuest, 47071 Bayside Parkway, Fremont, CA 94538. 510/226-4000.

Thunderware, 21 Orinda Way, Orinda, CA 94563-2565. 510/254-6581, FAX: 510/254-3407.

Ulead Systems, 970 West 190th Street, Suite 520, Torrance, CA 90502. 310/523-9393, FAX: 310/523-9399.

Ultima International, 3358 Gateway Boulevard, Fremont, CA 94538. 510/659-1580, FAX: 510/440-1217.

UMAX Technologies, 3353 Gateway Blvd., Fremont, CA 94538. 510/651-8883.

Xaos Tools, 600 Townsend Street, Suite 270 East, San Francisco, CA 94103. 415/487-7000, FAX: 415/558-9886.

APPENDIX B
A LOOK AT
FLATBED SCANNERS

Scanning The Horizons

The following chart will help you compare the features of available flatbed scanners. See Chapter 4 for more general information.

Notes:

1. Scanning speeds are those provided by the manufacturer and are based on color scans for color scanners and black & white for grayscale scanners.

2. When data was not available from manufacturers, it is indicated by "n/a" for not available.

3. If a space is not filled, it means that data is not applicable to that particular scanner.

4. * = optional

	Artec ViewStation	Agfa StudioScan	Agfa StudioScan II	Agfa Arcus II	Agfa Horizon Plus
Color	24-bit	24-bit	30-bit	36-bit	36-bit
Grayscale	8-bit	8-bit	10-bit	12-bit	12-bit
Optical Resolution	300x600 dpi	300x600 dpi	400x800 dpi	600x1200 dpi	1200x1800 dpi
Interpolated to	2400x2400 dpi	2400x2400 dpi	2400x2400 dpi	2400x2400 dpi	2540 dpi
Scanning Area	8.5x14	8.5x14	8.5x14	8.5x14	11.7x16.4
No. of Passes	n/a	one	one	one	three
Dynamic Range	n/a	n/a	n/a	3.00	3.20
Scanning Speed (approx.)	52 sec @ 300 dpi	15ms/line	15ms/line	15ms/line	2.5ms/line
Footprint	21.5x13.8x5.6	21x13.4x2.5	21x13.4x2.6	23.6x16.1x7.9	n/a
Interface	Mac, PC, OS/2	Mac, PC, UNIX	Mac, PC, UNIX	Mac, PC, UNIX	Mac, PC, UNIX
Image Editing Software	Photoshop, PhotoStacker	Photoshop LE	Photoshop LE	Photoshop	Agfa software
OCR Software	TextBridge, BizCard Rdr.	OmniPage Direct	OmniPage Direct	n/a	n/a

	Apple Color One Scanner	Canon IX-3010	Canon IX-4015	Epson E-1000c	Epson E-1200c
Color	24-bit		24-bit	30-bit	30-bit
Grayscale	8-bit	8-bit	8-bit	10-bit	10-bit
Optical Resolution	300 dpi	300 dpi	400 dpi	400x800 dpi	600 dpi
Interpolated to	1200 dpi	1200 dpi	1200 dpi	1600x1600 dpi	1200 dpi
Scanning Area	8.5x14	8.5x11.7	8.5x11.7	8.5x11.67	8.5x11.67
No. of Passes	one	one	one	one/three	one/three
Dynamic Range	n/a	n/a	n/a	n/a	n/a
Scanning Speed (approx.)	n/a	10 sec @ 300 dpi	20 sec @ 400 dpi	60 sec @ 400 dpi	16ms/line
Footprint	13.4x21.5x4.3	11x15x3	11.3x16x3.1	16.5x27.4x9	14.5x22.5x6.5
Interface	Macintosh	Windows	Mac & PC	Mac & PC	Mac & PC
Image Editing Software	OFOTO 2.0	Image Assistant	OFOTO 2.0	Adobe Photoshop LE	Adobe Photoshop
OCR Software	n/a	OmniScan Plus	OmniPage Direct	TextBridge OCR	n/a

	Envisions 6200	Envisions 6600s	Envisions 8800s	Envisions 24-Pro	Dynamic Pro30
Color	24-bit	24-bit	24-bit	24-bit	30-bit
Grayscale	8-bit	8-bit	8-bit	8-bit	10-bit
Optical Resolution	300x 600 dpi	300x600 dpi	400x800 dpi	1200x600 dpi	1200x600 dpi
Interpolated to	4800x4800 dpi	4800 dpi	6400x800 dpi	2400x2400 dpi	2400x1200 dpi
Scanning Area	8.5x11	8.5x11	8.5x11	8.5x14	8.5x11
No. of Passes	three	one	one	three	one
Dynamic Range	n/a	n/a	n/a	n/a	3.00
Scanning Speed (approx.)	5x7 in 38 seconds	5x7 in 24 seconds	5x7 in 17 seconds	5x7 in 70 seconds	5x7 in 30 seconds
Footprint	13.2x20.7x5.1	13.2x20.7x5.1	13.2x20.7x5.1	14x21x5.7	11.4x16x3.2
Interface	Mac & PC	Mac & PC	Mac & PC	Mac & PC	Mac & PC
Image Editing Software	Adobe Photoshop*	Adobe Photoshop LE	Adobe Photoshop*	Adobe Photoshop LE	Adobe Photoshop
OCR Software	Xerox TextBridge*	n/a	Xerox TextBridge	Xerox TextBridge	Xerox TextBridge

	Hewlett-Packard ScanJet 3c	Hewlett-Packard ScanJet 3p	Microtek ScanMaker III	Microtek ScanMaker IIHR	Microtek ScanMaker IISP
Color	30-bit		36-bit	24-bit	24-bit
Grayscale	10-bit	8-bit	12-bit	8-bit	8-bit
Optical Resolution	600 dpi	300 dpi	600x1200 dpi	600x1200 dpi	300x600 dpi
Interpolated to	2400 dpi	1200 dpi	2400x2400 dpi	2400x2400 dpi	1200x1200 dpi
Scanning Area	8.5x14	8.5x11	8.3x13.5	8.5x13	8.5x11.67
No. of Passes	one	one	one	three	one
Dynamic Range	n/a	n/a	3.4	n/a	n/a
Scanning Speed (approx.)	30 sec @ 300 dpi	5 sec @ 200 dpi	20ms/line	3ms/line	44 sec @ 300 dpi
Footprint	14.5x23x4.1	11.4x16x2.3	14.8x24x5	14x19.1x4.7	14x19.1x4.7
Interface	Mac & PC	Mac & PC	Mac, PC	Mac, PC	Mac, PC
Image Editing Software	Photo-Paint/Photoshop	HP PictureScan	Adobe Photoshop	Adobe Photoshop	Adobe Photoshop LE
OCR Software	Calera WordScan	Calera WordScan	OmniPage Direct	OmniPage Direct	OmniPage Direct

	Microtek ScanMaker IIG	*Microtek ScanMaker II	Mirror 1200	Nikon ScanTouch	Ricoh IS50
Color	24-bit	24-bit	24-bit	30-bit	8-bit
Grayscale	8-bit	8-bit	8-bit	10-bit	8-bit
Optical Resolution	300x600 dpi	300x600 dpi	1200 dpi	565x1200 dpi	400 dpi
Interpolated to	1200x1200 dpi	1200x1200 dpi		2400x2400 dpi	1600 dpi
Scanning Area	8.5x13.5	8.5x11.69	8.5x11.75	8.5x14	8.56x15
No. of Passes	three	one	one	three	one
Dynamic Range	n/a	n/a	n/a	n/a	n/a
Scanning Speed (approx.)	70.3 sec @ 300 dpi	n/a	n/a	30 sec @300 dpi	5 sec @300 dpi
Footprint	13.5x20.2x4.6	14x19.1x4.7	13.1x18.5x4.8	14.8x23.6x6.3	15.4x21.3x4.3
Interface	Mac, PC	Mac, PC	Macintosh	Mac & PC	Parallel, SCSI-2
Image Editing Software	Adobe Photoshop LE	ImageStar/Color it!	n/a	OFOTO	n/a
OCR Software	OmniPage Direct	OmniPage Direct	n/a	OmniPage Direct	n/a

	Ricoh IS60	Ricoh IS410	Ricoh IS510/520	Ricoh FS2	UMAX Vista T630
Color				30-bit	24-bit
Grayscale	8-bit	8-bit	8-bit	10-bit	8-bit
Optical Resolution	600 dpi	400 dpi	400 dpi	600 dpi	300x600 dpi
Interpolated to	2540 dpi	800 dpi		1200 dpi	4800x4800 dpi
Scanning Area	8.27x14	11x17	11x17	8.27x14	8.5x11.7
No. of Passes	one	one	one	one	three
Dynamic Range	n/a	n/a	n/a	n/a	n/a
Scanning Speed (approx.)	5 sec @ 300 dpi	2.1 sec @ 200 dpi	10 in/sec @ 200 dpi	20 sec @ 300 dpi	28 sec @ 200 dpi
Footprint	15.4x21.3x4.3	27.5x19.7x5.5	25.9x17.8x12.3	15.28x21.1x4.33	13.2x5.1x20.7
Interface	Parallel, SCSI-2	Parallel, SCSI-2	SCSI-2	SCSI-2	PC & Mac
Image Editing Software	n/a	n/a	n/a	n/a	ProLab Image Folio
OCR Software	n/a	n/a	n/a	n/a	Wordlinx

	UMAX Vista S6	UMAX Vista S8	UMAX PowerLook	UMAX Gemini D-16
Color	24-bit	24-bit	30-bit	30-bit
Grayscale	8-bit	8-bit	10-bit	10-bit
Optical Resolution	300x600 dpi	400x800 dpi	600x1200 dpi	800x800 dpi
Interpolated to	4800x4800 dpi	6400x6400 dpi	2400x2400 dpi	9600x9600 dpi
Scanning Area	8.5x11.7	8.5x11.7	8.3x11.7	8.3x11.7
No. of Passes	one	one	one	one
Dynamic Range	n/a	n/a	3.00	n/a
Scanning Speed (approx.)	21 sec @ 200 dpi	21 sec @ 200 dp	66 sec @ 600 dp	20 sec @ 400 dp
Footprint	13.2x20.7x4	13.2x20.7x4	13.1x21.2x5.5	13.1x21.2x5.5
Interface	PC & Mac	PC & Mac	PC & Mac	PC & Mac
Image Editing Software	Adobe Photoshop LE	Adobe Photoshop LE	Adobe Photoshop	Adobe Photoshop
OCR Software	OmniPage Direct	OmniPage Direct	n/a	OmniPage Direct

INDEX